33 Raphael Samuel, *Theatres of Memory: Past and Present in Contemporary Culture*, London 2012, pp. 39–40.

34 Field and Millett 1998.

35 Steve Poole, *The Politics of Regicide in England, 1760–1850: troublesome subjects*, Manchester 2000, p. 46; John Barrell, *Imagining the King's Death: Figurative Treason, Fantasies of Regicide, 1793–1796*, Oxford 2000.

36 Valenze 2006.

37 Trentmann 2009, p. 290.

38 *OBP*, March 1755, Stephen M'Daniel, John Berry, James Egan (otherwise Gahagan), James Salmon (t17550301-1).

39 Hodgkin 1902, p. 95.

40 Caroline Bressey, 'Contesting the Political Legacy of Slaver Kenwoo and And House, Sw

41 #113; Barn. numismatic britnumsoc. of-wood-saws 2021, https:// …numismatic-history- …c/ (accessed 28 February 2022).

42 Trentmann 2009.

43 Briony McDonagh, 'Disobedient Objects: Material Readings of Enclosure Protest in Sixteenth-Century England', *Journal of Medieval History*, vol. 45, no. 2, 2019, pp. 254–75.

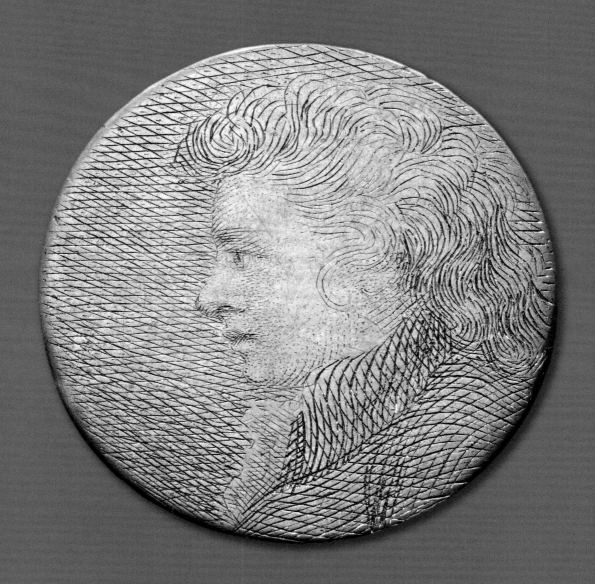

#094

Part one

The Collection

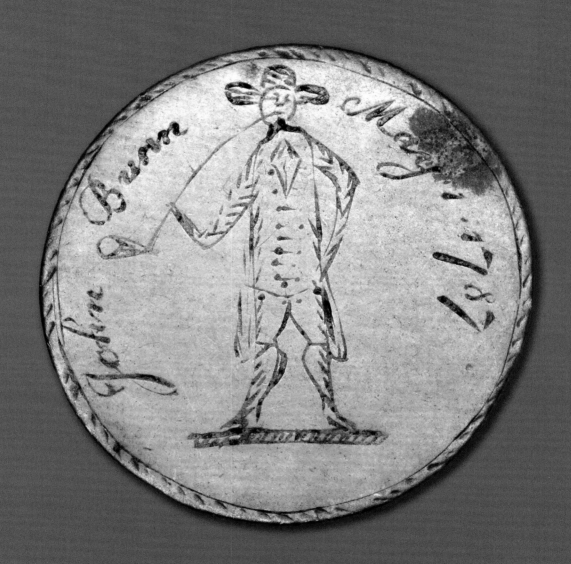

#132

1

The Collector

A Life in Coins

Timothy Millett

Throughout my career in the antiques trade one type of object has held my imagination above any other: the engraved coin.

A.H. Baldwin & Sons

As a teenager I used to spend a week or two in the holidays at the family firm of A.H. Baldwin & Sons. With hindsight I realise that I was being monitored by my potential employers to see whether I had an aptitude for the business. If I lasted the course, I would be the fifth generation of the family to join the company. This was a line that my grandfather, Douglas Mitchell, liked to repeat.

A.H. Baldwin & Sons was not like any other. Established in 1872, it had become one of the top numismatic establishments by the end of the nineteenth century. It was also a business that had a reputation for aloofness. Very rarely did Baldwin's take on new staff and, when it did, they were middle-aged men with a proven record in the business. I was the first teenager to cross the threshold in many decades, almost literally. Moreover, my knowledge was minimal at best.

Baldwin's operated rather like a rarified private club. Collectors regarded as deserving were cultivated. Collections were built in partnership with the expert over many decades and in very many instances would be bought back from the family following the collector's death. Clients who became true insiders received a number, which was then used to refer to them within the office. This was the gold standard of belonging.

Into this unusual world I arrived, presumably because the business recognized a need for younger blood. I can't believe that I was brought in because I had so far shown any obvious talent. Far from it, rather than latch on to the Roman gold aureus or Renaissance medals, the thing that first grabbed me in the numismatic world was a group of defaced 1797 cartwheel pennies and most notably one with the legend, 'Gibbs Lord Mayor. Pelted with Rotten Eggs 1845'. On the reverse where Britannia sits beside a shield, the shield has been

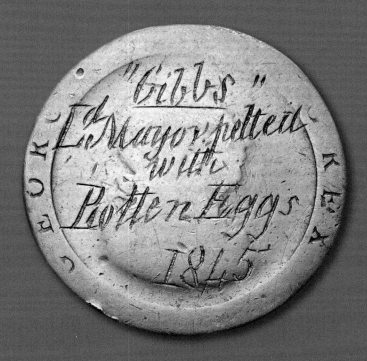

#037

Michael Gibbs (*c.* 1780–1858) was an active and controversial figure in City of London politics from 1818. Churchwarden of St Stephen's Walbrook from the 1820s, he embedded himself in philanthropic circles, as Treasurer of the Royal Sea Bathing Infirmary (1833), and of the City of London National Schools (1836). In 1834, Gibbs became chair of the newly formed City of London Poor Law Union covering 98 parishes, a position to which he was continuously re-elected. He was elected Alderman of Walbrook Ward (1838–51).

In 1843, parishioners of St Stephen's Walbook accused Gibbs of irregular accounting, withholding the parish books, mismanagement, failure to insure the church and letting it fall into disrepair.

As the affair attracted increasing popular and press attention, his critics estimated that Gibbs had received over £23,000 in parish money during the period 1824–43. When Gibbs finally produced his accounts, circulated first in the newspapers, they showed that the parish owed him money. The dispute then moved into the Courts.

Gibbs's notoriety came to a head in 1844 with his election as Lord Mayor of London for 1844–45. *Punch* reflected that the occasion should be a day of fasting and civic humiliation: 'Gibbs has been elected Mayor – a result that, like the funds of St. Stephen's, Walbrook, there appears to be no accounting for'. The procession on 9 November drew considerable unwanted attention, with calls from the crowd of

'Where's your account?' and 'How do you turn nines into noughts?' Hawkers sold a new ballad about the adventures of one 'Gobble Gibbs'.

So great was the fear of unrest and 'unpleasant feeling' that Gibbs had agreed to a change of route. An advertisement in *The Times* the previous Wednesday may have been responsible: 'To Egg Merchants and Importers, wanted from 300 to 500 chests of eggs of low quality, to be delivered into warehouses in London, on or before Friday next, the 9th instant.' A communication from Portsmouth in the same paper reported that 'Upwards of 100 l. worth of rotten eggs have been purchased within the last few days from the various importers in this and the adjacent towns by London agents for service on the 9th inst. In London.'

The *Morning Chronicle*, adopting a tone of moral outrage at the spectacle of *The Times* baiting Gibbs, nevertheless succumbed to pleasures of punning: 'This is egging on the ruffians and blackguards of the metropolis with a vengeance!… *The Times* is determined that nothing shall be wanting to complete the ovation of Mr. Alderman Gibbs.' It was a prospect that also appealed to the anonymous engraver of #037.

Sources: *Evening Mail*, 13 October 1843, 11 November 1844; *Weekly Chronicle*, 30 December 1843; *Globe*, 4 April 1844; *New Court Gazette*, 9 November 1844; *The Times*, 6 November 1844; *Morning Chronicle*, 7 November 1844; *Punch*, September 1844.

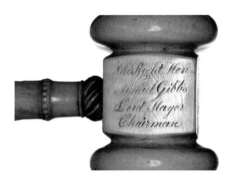

fig. 1 Michael Gibbs's gavel; Lord Mayor and Chairman of the City of London Poor Law Union

turned into a caricatured face inscribed 'Gibbs' and Britannia is shitting on it.

The discovery of the Gibbs token was a golden moment for my collection. It began a pattern. Following that first sighting, I pieced together the history of Alderman Michael Gibbs, known by his contemporaries as 'Gobble Gibbs'. And in a neat linking of objects, some years later I was able to acquire the gavel he used as Chair of the Poor Law Commission (fig. 1).

Discovering coins

A feature of A.H. Baldwin, which differed from competitors, was thinking in the long term. Areas of the business that were out of fashion would be sorted away in the basement and left until their time came again. These created a slow and almost museum-like atmosphere. Coins would be priced and ticketed, and, especially between the Wars,

many prices remained unchanged. During my time, cabinets of seventeenth-century tokens with items priced in shillings were simply converted to present-day prices. For common varieties, I generally worked on the principle of 3/- equalling £30.

The first significant task that I was given at Baldwin's was to go through a cabinet of fine Matthew Boulton Proof coinage, sorting out die varieties. This involved minute study of the ship beside a seated Britannia, counting the stays of the rigging: the ships were less than one centimetre in height. My early days were also spent sorting Peek Frean biscuit tins full of rolled-up eighteenth-century tokens. These had in many cases been put away during the Second World War and remained in obscurity ever since. One keen collector from the Longman publishing family had sold up in 1958, and dozens of tins that I was sorting had remained dormant for decades.

None of the current incumbents of Adelphi Terrace showed any interest in tackling these and so by a process of elimination tokens became my first serious foray into the business. And within these rolls I would occasionally find another engraved coin that I could keep to one side.

Resolving to make myself a useful asset to the company, I soon met one of Douglas Mitchell's favourite customers, Dennis Vorley. He collected tokens of all types. It may have been that, as a former police training instructor, those related to crime had special appeal to him. However, he had never shown any interest in the stories behind his collection or in contacting record offices. Over many decades, my grandfather had sold him very cheaply all the engraved coins he came across. I got

to know Vorley well. When he realised my interest, he invited me down to lunch with his family at Sandgate. He then offered to sell me back any of his collection that I fancied. Through this rare generosity I acquired in 1984 about seventy coins, essentially the area of the collection related to transportation, which was my main focus at this point.

Numismatic sweepings

Even in the early 1980s engraved coins were regarded essentially as numismatic sweepings, deserving little or no attention. Private collections were something of a grey area in Baldwin's. Another colleague, Simon Bendall, had a private collection of Byzantine coins for which he subsequently produced a book.[1] These were so obscure that his interest was, like mine, tolerated or more likely ignored.

A measure of how the numismatic world regarded engraved coins is the lead article in *The Bazaar, Exchange and Mart* for 4 February 1936: Ernest B. Smith's 'Medallions Made by Gaol Birds' (fig. 2). The following gives a flavour:

> They form a branch, albeit a rather eccentric one of coin collecting… every engraved coin may be regarded as unique, but it does not follow that [it] is therefore valuable. As a matter of fact the demand is very limited and the most artistic and curious specimens cannot be valued at more than a few pence.[2]

The article goes on to report that a few years previously a London auction had included a large collection of these coins, formed by a gentleman

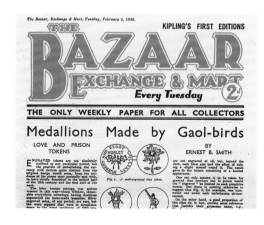

fig. 2 *The Bazaar, Exchange and Mart,* 4 February 1936

over a period of forty years. 894 coins sold for a total of £8-17/-, of which 38/- came from a single lot of 21 silver pieces. Across the collection, the average value per item was 2½d.

Another early collector was Ella Pierrepont Barnard (1864–1934). Her 'cabinet' held:

> about 490 Coins and Tokens in silver and copper, engraved as keepsakes, love tokens, records of births, deaths and marriages, and others, with representations of ships, etc., mostly 18th and 19th Century, a curious lot almost impossible to again get together.[3]

Many of Pierrepont Barnard's engraved coins can now be found in the British Museum, but it was her article in the *British Numismatic Journal* of 1918 that was something of a bible for me when I first searched for anything written on the subject.[4]

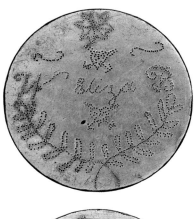

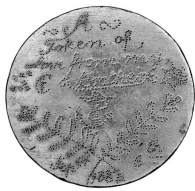

Coin #169

My own rather random acquisition of items continued through the 1980s and 1990s, with dealers offering me engraved coins before they reached the general trays. I was the best buyer. There was an occasional burst of high excitement when a group appeared at auction but that was very unusual. When the remainder of Dennis Vorley's collection was broken up and sold at Bonhams in 1994, my area of interest and knowledge had moved on significantly. With a gap of ten years, I now had a better idea of what might constitute a convict token, and with that, greater insight into what was on offer: 'Lot 96. Pricked lettering; Pennies (7), smaller (3), most with details of births, deaths, c.1820's and 30's. Fine and very fine.'[5] I bought that group of convict tokens for £30. This auction was an important moment, with a very substantial number and variety of subjects. Particularly striking were a number of coins raging against authority, such as a George IV penny engraved across the face, 'Patron of Vice and Frivolity The Fine English Gentleman' (#048, p. 62).

Out of the shadows

Things would no doubt have continued in the same vein for years to come but for a chance conversation in 1995 with the PR company Cawdell Douglas prior to the Summer Olympia Antiques Fair: the *Independent on Sunday* wanted to write an article about dealers who were also collectors.

In many ways this seemingly insignificant article was the moment when engraved coins came out

It included images of some wonderfully engraved coins. Best of all, number 275, 'A Token from John Chapman Aged 20 1832', immediately reminded me of something that I had seen elsewhere. This was probably the first time that I realised that one hand was often involved in making groups of tokens. I have subsequently come across others produced by this individual, including #169 in this Catalogue.

of the shadows. The journalist Marie Woolf was particularly interested in the part of my collection related to convict love tokens, or what prisoners at the time knew as 'Leaden Hearts'.[6] These were coins engraved in prison and given as a parting gift when a convict was about to be taken off to the hulks, prior to transportation to Australia.

The *Independent on Sunday* was syndicated to other papers around the world, including Australia. I subsequently learnt that there had been great scepticism in the editor's office just before going to print. No one had ever heard of convict love tokens, so were they a concoction? The piece was almost dropped at the last moment. I was also told that rarely had an article generated so much attention. I suspect that this was partly due to the burgeoning enthusiasm for genealogy, and to Australian interest following by the 1788 bicentenary.

Within a matter of days, I was interviewed for Australian television. The following year Paul Donnelly of the Powerhouse Museum in Sydney organized an exhibition at the Hyde Park Barracks, followed by an Australian tour in 1998. In 1999, the British Museum displayed my convict love tokens and the exhibition then travelled to the Galleries of Justice in Nottingham.

One of the most rewarding results of the exhibitions and press attention was to introduce me to a whole new group of people who were interested in the subject. That in itself was a novelty, and it resulted in a book on convict love tokens.[7] I was now meeting academics, mostly social historians, who approached my collection from perspectives totally new to me. However, their interests connected with my own: I had always seen the coins opening a door to an unseen world.

The developing collection

In 2008 the National Museum of Australia bought my collection of convict love tokens, but I still had many engraved coins on topics other than transportation to Australia. I immediately started collecting convict tokens again, this time with a slightly different focus. One area I wanted to develop was a very rare type produced for the 'celebrity' criminal between *c*.1776 and 1787. Here were criminals who knew that they were going to hang, and the symbolism employed on these coins trumpeted their trade with pistols, pick locks, horses and lanterns. As a group, these small Georgian halfpennies were quite different in style, symbolism and size from the later Australian convict tokens based on the cartwheel penny. The men they commemorated were upfront, their bravado evident. There was nothing coy about the epitaphs. This was to be their moment of fame.

New perspectives on the collection

Writing my chapter has made me very aware of the history of this collection. I can see how the story developed. As a teenager I often had a few of these coins with me: the true obsessive ready to catch any unsuspecting victim. No one was interested. They could not even read them without a powerful magnifying glass.

Nevertheless, I became increasingly aware that what I was putting together had real substance and

so I treated the coins very differently, hoovering up anything that came my way for my own private cabinet. A couple of times a single item took off at auction and I became doubly secretive. My position in the numismatic trade put me at a massive advantage from a buying point of view.

Producing the two exhibitions and the *Convict Love Tokens* book changed my attitude, however. It may still have been eccentric in the numismatic world but outside I quickly realised that others could see the subject from a completely different angle. I was contacted by the poet Arnold Rattenbury, a splendidly warm and entertaining character, who sent me writing inspired by the collection.[8] I was also in touch with Professor George Rudé, a significant social historian who had previously written about two of my star convicts, the Luddites Thomas Burbury and Benjamin Sparks.[9]

Jump ahead twenty years to this current project. One of the problems I have always had is convincing people that the public at large would appreciate the subject. The person who has now done most to unlock it for a wider audience is Dave Cousins. Having spent decades trying to find someone who could really capture the spirit of the collection, it is difficult for me to over-emphasize the brilliance of Dave's photography. His work with groups of mixed tokens, many with dramatically different shades and metals, is a work of art in itself. Dave demonstrated that the collection is in fact highly photogenic; he eliminated the problem of seeing the items properly, making it possible for people to relate to them. Perhaps more surprising, one or two youngsters who saw them at trade fairs

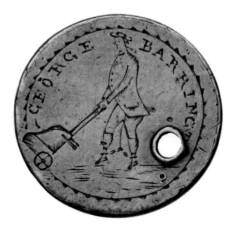

fig. 3 Coin sold at St. James's Auction 27 June 2016. George Barrington, born in Ireland and a successful London pickpocket, was transported to Australia in 1791. His life was the source of several romanticized accounts.

regarded them as 'cool', not something that I had ever associated with my business.

Dave Cousins's work has also opened my own eyes. The quality of the photography brings to light details which had previously passed me by. Combined with Gary Oddie's Catalogue at the end of this volume, the research process has become more systematic. New connections become visible. For example, setting the sixty convict tokens I have acquired since 2008 alongside the National Museum of Australia's convict website revealed many new links, some of which are explored in Sophie Jensen's contribution to this book (Chapter 8). Quite often I have had just the glimpse of a topic to pursue, so working with other people has added

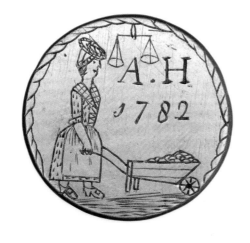

Coin #133

noticing resemblances between items and then reconstructing their historical context. Created between 1776 and 1787, these very rare coins depict 'celebrity' criminals. They fit into a precise chronology, from the end of transportation to the American colonies until the establishment of the New South Wales penal colony, a period when punishment was particularly harsh. Engraved on the small Georgian halfpenny, their style is distinctive. The quality of engraving is generally good and there is evidence that the same hand produced multiple examples. In advertising the tools of criminal trade, there is a sense of bravado and self-promotion about many of these tokens. Was this a moment of glory that preceded inglorious death and possible dissection? Were these objects made by enterprising individuals to cash in on criminal notoriety and the popular spectacle of execution? The details reminded me of William Hogarth's image of *The Idle 'Prentice Executed at Tyburn* (1747), which includes a hawker selling copies of the condemned man's 'Last Dying Speech & Confession' to the crowd (#108, #138, pp. 214–15).[10]

fresh ideas to knowledge accumulated through long experience as a collector. The wheelbarrow is a case in point.

Over forty years I have come across at least six tokens which feature a wheelbarrow, all from the period *c.*1770–1800 (fig. 3). The latest I have seen dates from 1805. Is this telling us something? There are three examples in the current book: #054, #133 and #138.

Coin #133 from 1782 depicts a woman at work. Above her hang scales of justice – or are they, as Susan Whyman argues in this book, the tools of her trade? Each new instance adds something tantalizing and distinctive (#133).

Until further examples and historical sources emerge, the specific meanings of the wheelbarrow remain elusive. But another group of tokens demonstrates what can be achieved through

Unlike the cartwheel pennies of the Australian era, which address friends, family and lovers, many of the Newgate tokens from the 1770s and 1780s name only the convicted man (#108, #135). A second obvious difference with the later Leaden Hearts is the prominent display of picklocks and other tools, which mimic heraldic conventions. Those earlier tokens have a different feel.

The 1797 cartwheel penny contained 1 oz. of copper. Over time, many were melted down for their metal content, so only a small proportion of

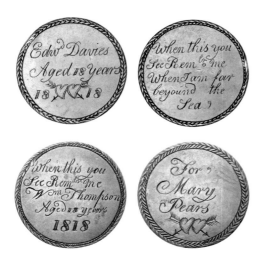

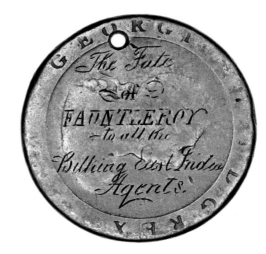

Coins #194 and #035

Coin #277

those produced have survived, making it difficult to answer some important questions. How many engraved coins were produced? Did engravers work at country fairs and city festivals? Did port engravers in Gosport (#139 and #142) and Portsmouth specialize in sailors' farewells? What percentage of the Australian convict tokens were made by a limited number of people? I know of at least fifteen pieces produced by the same hand in Newgate in 1817–18:

1. George Morris (NMA collection)
2. Joseph Smith (Sydney Museum Hyde Park Barracks)
3. Elijah Swainson (1) (NMA collection)
4. Elijah Swainson (2) (Unknown ex-St James Auction 2016)
5. Francis Brereton (private collection)
6. John Camplin (NMA collection)
7. Edward Davies (Timothy Millett collection) (#194)
8. David Freeman NMA collection
9. William Kelly (Timothy Millett collection) (#182)
10. William Maskell (1) (Beedle reference) (NMA Collection)
11. William Maskell (2) *To sister* (Museums Victoria)
12. William Nicholson/Nichols (NMA collection)
13. Thomas Spicer (1) (NMA Collection)
14. Thomas Spicer (2) (Museum of London)
15. William Thompson (Timothy Millett collection) (#035)

What proportion of one man's total output do those fifteen represent? And how many convicts had a go at making their own love token? Not so many, I suspect. How many convicts heading for

Australia gave a Leaden Heart? The period between 1830 and 1845 appears to be the most prolific.

In my experience, convict tokens were highly personal and individual. They differ for example from the memorials for Henry Fauntleroy, the disgraced banker executed in 1824 (#034, #049, #277). Fauntleroy tokens are not uncommon even today, all engraved in a similar hand. 100,000 people attended Fauntleroy's public hanging at Newgate. Were hundreds of these pieces produced, like a 'Last Dying Speech', as a business opportunity? (#277)

Voices lost to history

I have been interested in this subject for over two thirds of my life. My abiding fascination has been with voices otherwise lost to history. As a dealer, most of the objects I encounter are the work of the established order. That early job at Baldwin's, putting Peck reference numbers on a collection of Matthew Boulton patterns and proofs, was mind-bogglingly dull, but I also recognized that I was dealing with products of industrial manufacture. Engraved coins were the polar opposite. Far from speaking for the establishment , here were coins that voiced people's feelings, regularly at the expense of those in authority.

To produce an engraved coin requires determination and patience, as anyone who has tried will tell you. Real intent has gone into these. I have come across quite a few convict tokens which have had names removed. This once-treasured gift had become an embarrassment, either to the receiver or a later generation. However, such is the nature of

Coins #129 and #089

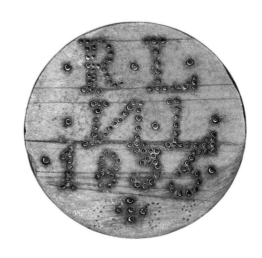

Coin #282

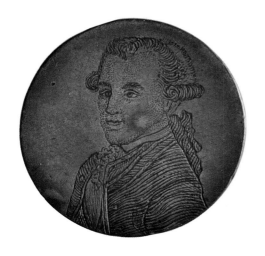

fig. 4 Portrait of John Wilkes engraved on to a George II copper halfpenny with 1768 added to the obverse. 1768 was the year of Wilkes's triumph in the Middlesex election and his subsequent imprisonment for seditious libel.

engraving and the depth it achieves that ninety percent of the examples that I have come across can still be deciphered with time and patience.

As Gary Oddie has observed of my collection, production quality depends on the individual's standing in society. Silver coins professionally engraved tend to be for sailors and to record middle-class family and life events (#129, #089 and #282). Politically motivated examples are generally well constructed with a vigour that often suggests the maker's engagement with the political moment (fig. 4). But it is at the bottom of the pile within the prison system where many of the most amateurish and, to my mind, most

fascinating examples can be found. Cartwheel pennies roughly engraved or pin-pricked often have a desperate, last-minute feel about them. These form a relatively small group where somebody for the only time in their life is having a go. Produced by the untutored, the letters get smaller, the coin runs out of space and sometimes the attempt is abandoned halfway through. One example from 1835 in the British Museum reads: 'If you wait until I return you may wait until the day of doom'.[11]

The changing world of collecting

When I arrived at Baldwin's, the pre-eminent coin auctioneers were Glendining & Co of 7 Blenheim Street, then part of Phillips and now Bonhams, off Bond Street. Glendining's held dozens of auctions a year, so this became a regular haunt of mine. Going through large lots of hundreds of items developed my eye as a dealer. Two items very early in my career came from such a large lot. In 1982, I persuaded the trade buyer to sell me two items for £35. They are #122, Robert Stephenson of Mare Street, Hackney, 1777, and #105, John Wainwright Chimney Sweep, 1793.

Alarm bells first started to ring at a Glendining's sale on 21 March 1990, with lot 89, '[A] Cartwheel Penny eng. Wm. Nicholson Transported for 14 years Jany 14th 1818. Estimate £50 – £80.' I recognized the item as one of the emerging Newgate group and expected to buy it for £200 maximum. It came to auction as part of a large collection of medals put together over decades. The numismatic trade values a genuine collection and one-owner

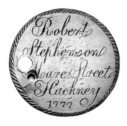

Coin #122

sales always attract a lot of attention, with other trades often showing an interest. Lot 89 sold for nearly £800 to one of the major London book dealers, who had picked up on the word 'transported'. Thankfully, William Nicholson was not immediately traceable and I was able to buy the coin some years later for about the figure I had in mind. The convict's name was William Nichols.

But the greatest threat to the development of collections came from outside the numismatic world. If online auctions had existed in 1990, the Millett collection would have been a very sorry affair. Another example from the same Glendining's sale demonstrates the issue, a collection of silver school prize medals: 'Lot 26 – two medals – Honiton, Mr. Woodgate's Boarding School, Reward of Merit, 1843– plus another, Estimate £50 – £80.' Today, local interest would pick up on this immediately.

During the 21st century, the internet blew open the numismatic world, in which 1790s tokens for the London Corresponding Society had been valued at a few pounds. Historians came to them from a completely different angle

and recognized their significance. Museum curators – beyond specialist departments of coins and medals – made space for the stories such objects told. These changes are reflected in the prices now commanded at auction. In 2019, a very interesting silver engraved coin related to eighteenth-century maritime history was sold as a single lot for about £1400. A convict token with a proven history was sold in the West Country for over £1600. The *Antiques Trade Gazette*, the main trade paper, even included a picture and description a week before the sale, and plenty of people noticed.

These items deserve the attention that they are getting. They are unique. I like to think that I have made stars of many convicts. In 1831, Mary Ann Whitlock, a 22-year-old farm labourer from Norfolk who had already been arrested for vagrancy, was transported for stealing a purse containing half a crown. Her token reads 'Adieu Dear Aunt Adieu.' Her life in England and latterly in Tasmania makes grim reading. Her token, now in the cabinet of the National Museum of Australia in Canberra, gives her story a hearing which in life she seems never to have got.[12]

Conclusion

During the time that I have been collecting, opinion has moved away from the *Exchange and Mart* headline, 'Medallions Made by Gaol-Birds'. Modified tokens and coins are now a recognized entity within numismatics. I would argue that it was a new generation of social historians who embraced the subject and saw something that numismatics largely failed to see. These were the

people who enabled me to broaden my horizons and appreciate the wider significance of these objects.

Those parts of the collection associated with crime and convict history are the most complete and self-contained. They have attracted most attention to date: the first book and exhibitions based on my collection in 1998 and 1999 focused on this very topic. I have also found the period 1776–1787 the most rewarding to investigate in recent years, especially as I have uncovered links between items and identified further examples.

But I have an equal love for the collection's social and political elements. I am hoping that these will gain more notice through this book. After all, who cannot be fascinated by a man who spent hours engraving 'The man who did this was born without a shirt 1840'?

1 S. Bendall and P.J. Donald, *The Later Palaeologan Coinage*, London 1979.
2 *The Bazaar Exchange and Mart*, 4 February 1936.
3 Sotheby's, 18 December 1934. Mrs Pierrepont Barnard decd. Lot 164.
4 Ella Pierrepont Barnard, 'Examples of Engraved Coins Selected from a Collection Formed by Mrs Ella Pierrepont Barnard', *British Numismatic Journal*, vol. 14, 1918, pp. 151–98.
5 D.G. Vorley, Bonhams, 13 December 1994, lots 1–131. Michele Field and Timothy Millett (eds.), *Convict Love Tokens: The Leaden Hearts the Convicts Left Behind*, Kent Town, South Australia 1998, p. 9.
6 Field and Millett 1998.
7 'Arnold Rattenbury. Obituary', *Guardian*, 30 July 2007, https://www.theguardian.com/news/2007/jul/30/guardianobituaries.booksobituaries (accessed 4 January 2021).
8 George Rudé, *Protest and Punishment: The Story of the Social and Political Protesters Transported to Australia, 1788–1868*, Oxford 1978.
9 https://www.metmuseum.org/art/collection/search/399844 accessed 8.1.21.
10 Field and Millett, p. 101.
11 www.love-tokens.nma.gov.au/search?q=whitlock (accessed 27 February 2022).

2

A Cartoonist's Perspective

Martin Rowson Connects a Type of Engraved Coin with William Hogarth's Vision of Georgian London

Martin Rowson

I'm not sure if my interest in the eighteenth century was a consequence of my obsession with cartoons, or vice versa, although I can pinpoint the moment when I fully understood it was my destiny to become a professional political cartoonist: it was on reading my sister's school history textbook *An Illustrated History of Britain 1780–1950*, published in 1953. I was ten years old, and the book had been passed from one teenage schoolgirl to the next for at least 16 years already. Its passage stopped right there, as I was determined to keep this treasure trove. Indeed, I still have it.

As thankfully continues to be the case in history books (the reproduction fees are small but eventually build up), this one was packed with cartoons to illustrate and enliven the text, from William

Hogarth and James Gillray, via George Cruikshank and John Tenniel, to Bernard Partridge and David Low, and I instantly fell in love. These things magically wove together everything that, at the age of ten, I was interested in: drawing, history and politics, on top of being funny. David Low's mocking depiction of Hitler was a masterclass in what makes cartoonists count in the way it drove the dictator mad with fury (Low was on death lists; his cartoons were cut out, by hand, from editions of the *Evening Standard* that made it to Germany); but the ones that really got their hooks into me were the Hogarths, Gillrays and Cruikshanks. I remember sneaking some old steel pen nibs from my father's desk as I proceeded to teach myself to draw the way Hogarth engraved and Gillray etched.

From there, over the years, came a deeper fascination with Georgian England and, more specifically, Georgian London. In *The Fatal Shore*, his classic study of the first Australian penal settlements, the art critic Robert Hughes describes the place from whence most of the original settlers were transported. His description serves as a brilliant encapsulation of how we still largely view the 1700s: 'a highwayman or two, a drunken judge, and some whores for local color; but the rest is all curricles and fanlights. Modern squalor is squalid but Georgian squalor is "Hogarthian," an art form in itself.'[1]

Although this isn't quite fair to Hogarth, you get the drift. The point about Hogarth, like all the other satirists whose work and outlook helped define the age, is that he was a man called Hogarth who, as he walked down those Hogarthian mean alleyways, was not himself Hogarthian. Exactly like Swift, Hogarth when confronted with the savagery of the day-to-day would not just shrug and walk away. What many people since have seen as a defining savagery in the work of eighteenth-century satirists exists solely in what they depict; its absence in themselves was what drove them, savagely, to comment on the quotidian savagery of society at large.

So, on first sight of Timothy Millett's extraordinary collection of 'treated' coins from the period, the initial temptation is to see some kind of 'spirit of the age', a rumbustiousness in cocking a snook at authority by defacing the King's image, then washing down your jovial mockery with beer and the roast beef of Old England. I detect something much deeper, however.

It is merely coincidence that both Hogarth (1697–1764) and Gillray (1756–1815) and the largely anonymous authors of the palimpsests scratched on many of these coins all worked on metal. Less of a coincidence is that they were also, in their different ways, creating a strange, chimerical mix of art (high or folk), and journalism. By journalism I mean the type of art represented by Hogarth's *Gin Lane*. While Hogarth made his money pursuing every opportunity he could, including oil painting, murals, printmaking, engraving, portraiture, *Modern Moral Subjects* and simple, mocking satire, *Gin Lane* and several other specific images (like Hogarth's notorious portrait of the politician John Wilkes) are closest to journalism because they exist solely as a printer's sheet of metal and an image reproduced on paper for circulation to as large an audience as possible. Both *Gin Lane* and Wilkes were, moreover, polemical: the former like a tabloid headline, screaming about the dangers of artificial stimulants to society; the latter like a tabloid demolition job. The essence, though, lies in the *circulation*: after all, apart from blood, this word is most usually associated with print journalism and coinage.

I find this a fascinating parallel, even if it is rather obvious. There is an even more precise parallel if you compare the final print in Hogarth's *The Stages of Cruelty*, published the same day as *Gin Lane* on 15 February 1751, with the token marking the punishment and death of John Jones, shackled in irons for attempting to break out of Newgate Prison and then hanged on 19 June 1776. Two naked, executed men, one in Hogarth's *The Reward of Cruelty* (fig. 1), the other on the John

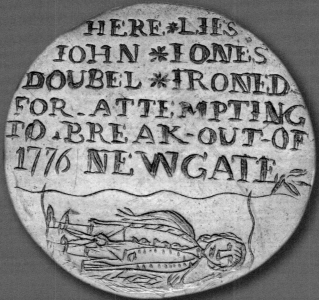

HERE *LIES
IOHN *IONES
DOUBEL *IRONED
FOR.ATTEMPTING
TO.BREAK-OUT-OF
1776 NEWGATE

#010

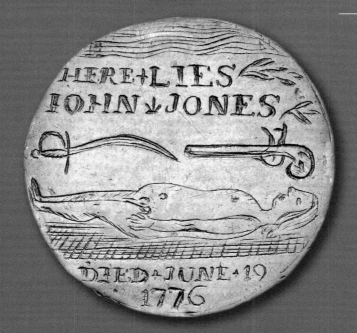

HERE+LIES
IOHN↓JONES

DIED+JUNE·19
1776

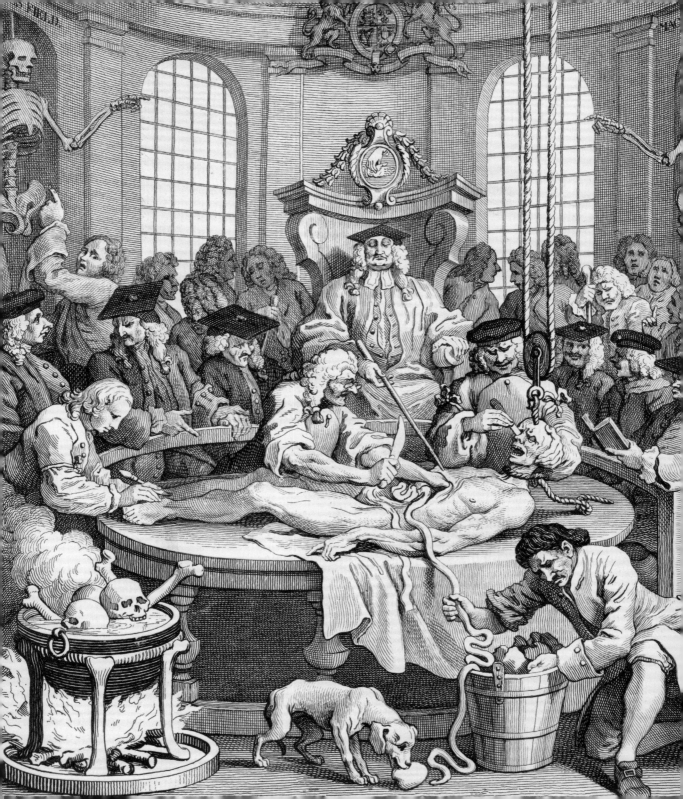

Jones token (#**010, p. 45**), serve to tip our rather careless view of Georgian London on its head. The ultimate cruelty that Hogarth and John Jones's memorializing engraver indict isn't the casual cruelty Hogarth depicted in the previous three prints of *The Stages of Cruelty*. It is the calculated, judicial cruelty of the state. The anatomizing in *The Reward of Cruelty* is performed in the name of science, but it looks exactly like an horrific cannibal feast as it imposes the ultimate punishment on the recipient of Enlightenment justice, denying the chance of redemption through resurrection of the body on the Day of Judgement. This refinement of state cruelty also underpinned the introduction of gibbeting as an additional punishment in 1752, leaving hanged bodies to rot, denied Christian burial. In many ways, the crude scratched image of Jones's naked body is far more powerfully poignant than anything Hogarth could show second-hand.

Finally, another parallel strikes me, between then and now, and also between then and an even older then. The satirical prints that inspired me to choose my career were and are part of a mainstream media in which I continue to expose our masters to brutal mockery in ways, I hope,

occasionally are just as savage as those of my illustrious forebears and heroes. I'd say that across the centuries we'd be united in our hope that our work would be seen by as many people as possible, and that it would amuse, delight, shock or disgust our readership, making them think less of those people who have placed themselves in positions of authority over us. But most of all, it is public, political art, part of the ceaseless, raucous, political conversation that runs through history.

These coins are also public property, after the nature of coinage in circulation, although the messages and images scratched into them are much more personal and private, and may never have received more public notice than a brushed fingertip until they fell into the hands of collectors with a beadier eye. Nonetheless, a parallel is obvious: it's the mainstream versus social media, *The Times* up against Twitter, two centuries ago.

Then again, nothing changes much, and never has. Throughout the Mediterranean basin there are wells dating back to classical times, filled with little strips of lead on which, two millennia ago, men and women scratched curses and death threats against their enemies and neighbours and masters and rulers, which they then cast down into Hades in the expectation of eventual fulfilment. Meanwhile, Juvenal was writing his satires, and someone somewhere was doubtless scratching a heartfelt 'fuck you' in Latin over the faces of Domitian or Trajan embossed on a coin.

fig. 1 William Hogarth, *The Reward of Cruelty*, 1751. Courtesy of The Lewis Walpole Library, Yale University

1 Robert Hughes, *The Fatal Shore*, New York 1987, p. 53.

The cartwheel penny
Courtesy Dix Noonan Webb Ltd.

252 **Obv.** 'May we have in Our arms Whom
We love in Our hearts, Catharine Shearer
[Edinr?] 1783, My heart is true to non but
you', around two hearts.
Rev. 'George Dun', above cannon on
carriage on shaded ground.
Details Cu, 27.2mm, 7.11g.

253 **Obv.** 'ROBERT MOTT', in ornate border.
Rev. Large wheatsheaf, shaded background,
simple border.
Details Cu, 27.3mm, 5.60g.

254 **Obv.** 'ONCE THESE TWO HEARTS IN
LOVE WAS JOIND NOW ONE IS FREE
THE OTHER CONFINED', around a plinth
with a heart depicting an altar of love.
Another heart with two wings above.
Rev. 'REB 1788', in ornate border.
Details Cu, 27.4mm, 5.09g.

255 **Obv.** Stag running left, chased by two dogs.
Rev. 'JS', in floral style.
Details Cu, 28.2mm, 7.28g.

256 **Obv.** 'LOVE TRUE', around two hearts in
simple wreath.
Rev. 'GHL 1779', in border.
Details Cu, 27.8mm, 7.26g.

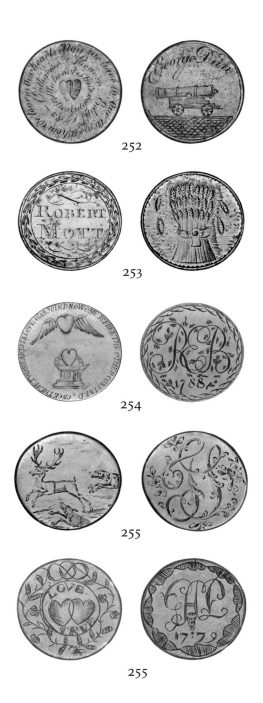

252

253

254

255

255

257 **Obv.** Large ornate crown.
Rev. Worn original coin.
Details Cu, 28.8mm, 9.93g.
Host UK, 1/2d, 1695–1701.

258 **Obv.** Bust of man facing left. Simple border.
Rev. Smooth surface.
Details Cu, 27.3mm, 7.16g.

259 **Obv.** 'John Mason London 1765'.
Rev. Christ hanging from cross between
decorative motifs. Ornate border.
Details Cu, 27.4mm, 6.55g.

260 **Obv.** 'Lewis Davis Jane Hail 1775'
Rev. Original coin.
Details Cu, 28.4mm, 8.86g.
Host UK, 1/2d, 1770–75.
Ref. Dyer

261 **Obv.** Fox on haunches, looking upwards at
foliage. Broad engine turned border.
Rev. Original coin, worn and damaged.
Details Cu, 28.7mm, 6.97g.
Host UK, 1/2d, 1806–07.

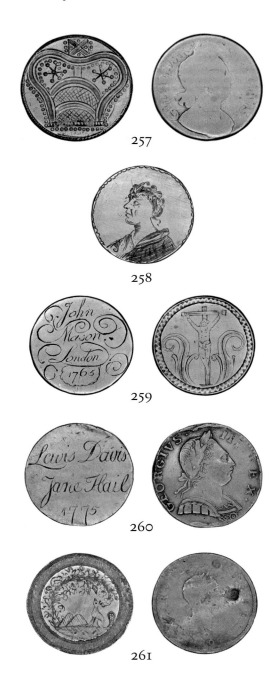

257

258

259

260

261

262 **Obv.** 'T.E.R Mar. 13 1742'.
 Rev. Original worn coin.
 Details Cu, 27.8mm, 7.14g.
 Host UK, 1/2d, 1694.
 Ref. Dyer

263 **Obv.** Dog walking left on shaded ground
 towards branch, bent over, with detail now
 scratched out.
 Rev. Three-masted ship sailing right on
 shaded sea.
 Details Cu, 27.3mm, 7.15g.

264 **Obv.** 'Sarah BLACKEDER 1759' above
 angel's head with wings.
 Rev. 'SB' on ornate device.
 Details Cu, 27.2mm, 8.17g.

265 **Obv.** 'J M BAKER'.
 Rev. 'Bound April 12 1797'.
 Details Cu, 26.7mm, 6.35g, pierced for
 suspension.

266 **Obv.** 'J·D', with crude flower above, heart
 and simple wreath below.
 Rev. 'W∗T', above heart and simple wreath.
 Details Cu, 27.3mm, 8.61g.

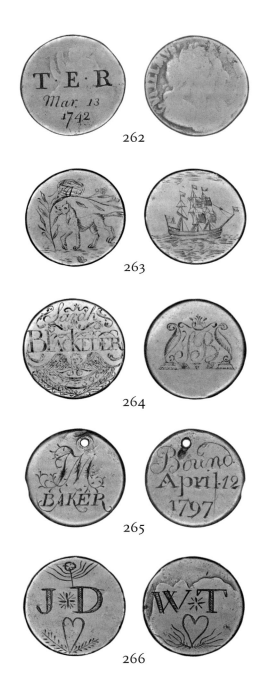

262

263

264

265

266

267 Obv. 'John Burges'.
 Rev. 'Sabridgeworth Herts'.
 Details Cu, 27.4mm, 8.06g.
 Host UK, 1/2d, 1719–24.

268 Obv. 's h p' around naval bust
 facing right.
 Rev. Four-storey building with
 central tower on shaded ground.
 Details Cu, 36.0mm, 18.11g.
 Ref. Maidment

269 Obv. 'JT DIED Jan 21 1829' on fallen
 memorial. Willow tree to right, hilly
 scene in background.
 Rev. Original coin.
 Details Cu, 33.8mm, 14.99g.
 Host UK, 1d, 1806.
 Ref. Dyer

270 Obv. 'Curtis, Reigate,'.
 Rev. 'CARPENTER TURNER &c'
 in banner that makes the shape of a
 swan facing left.
 Details Cu, 26.8mm, 6.24g.

267

268

269

270

271 **Obv.** 'Sarah Weaver 1764 [JW]' within a floral design.
Rev. Smooth surface, possible faint trace of silhouette.
Details Cu, 27.4mm, 6.14g.

271

272 **Obv.** '[IT]', within beaded border.
Rev. '[LL]'.
Details Cu, 27mm, 7.14g.

272

273 **Obv.** 'Joseph, Till, March, ye 2[5]th, 1736'
Rev. Man sitting in chair blowing a horn in his left hand, staff in his right, sword on belt. Chequered floor.
Details Cu, 28.6mm, 8.81g

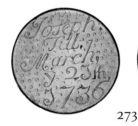

273

274 **Obv.** 'Agness Gorden aged 16 years the 11 of July 1797', within geometric border.
Rev. Two hearts pierced, bird with sprig in beak. Ornate border.
Details Cu, 32.6mm, 21.84g.
Host UK, 1d token, 1787–91.
Ref. Dyer

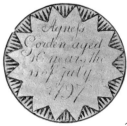

274

275 **Obv.** Wheatsheaf on a signboard (?),
sickle above. Border.
Rev. 'JW', either side of a man
carrying a cylinder (barrel, dustbin?)
on shoulder. Ornate border.
Details Cu, 27.6mm, 7.61g.

276 **Obv.** 'SARAH WOTTAN FORGET
ME.NOT AD 22', with a small flower
motif.
Rev. 'CHRISTOPHER . AD . 22'
around 'HARRISS', and a small flower
motif.
Details Cu, 35.9mm, 23.77g.

277 **Obv.** 'The Fate of FAUNTLEROY to
all the Bilking East India Agents'
Rev. Original worn coin.
Details Cu, 35.8mm, 26.5g, pierced for
suspension.
Host UK, 1d, 1797.
Ref. Poole, Dyer, Millett

278 **Obv.** 'IB JW', pierced heart dividing
'1795', and bow below.
Rev. Original very worn coin.
Details Ar, 32.9mm, 12.86g.
Host UK, 2/6, 1696–1701.

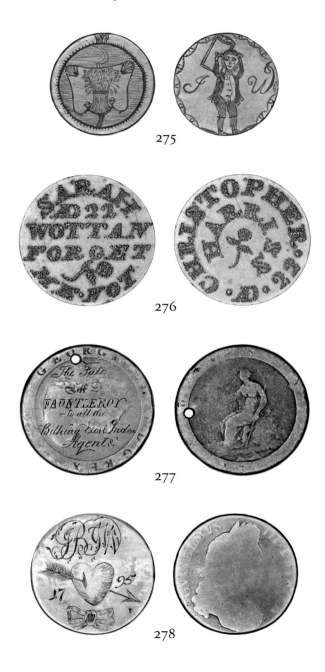

275

276

277

278

279 **Obv.** 'Willm. Lycken'.
Rev. '1st June 1788'.
Details Cu, 26.5mm, 7.74g, edge raised and modified.
Host UK, 1/2d, 1740–54.

280 **Obv.** Two hearts containing 'W' and 'R' with crossed arrows below, two birds above. Border.
Rev. Man standing facing left with gun at shoulder. Dog reaching up, birds flying around edge, tree to right.
Details Cu, 36.0mm, 25.55g.

281 **Obv.** 'CB ANNO 1787', in exergue. Empty chair, brushes above and either side. Border.
Rev. Shield with arms comprising two trees, bird above. Crown above, foliate garniture around. Concentric border.
Details Ar, 41.4mm, 26.82g.

282 **Obv.** '.R.L..N.L..1835.' with letter 'N' retrograde.
Rev. Original worn coin.
Details Cu, 35.9mm, 26.22g.
Host UK, 1d, 1797.
Ref. Dyer, Millett

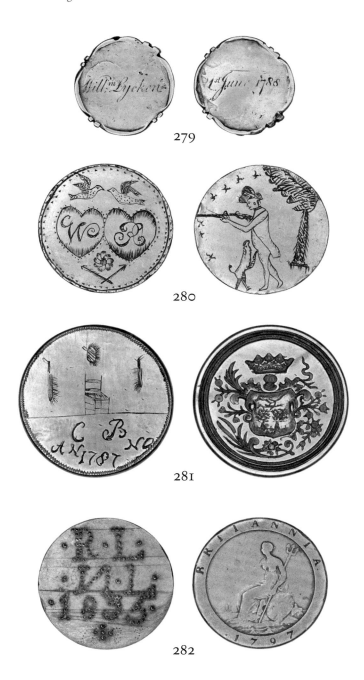

279

280

281

282

283 **Obv.** All retrograde: 'S. Eddy' in
 centre, with 'Portrait Painter &
 Gives instructions in drawing on
 Resenable Termes'.
 Rev. Original worn coin.
 Details Cu, 35.8mm, 25.69g.
 Host UK, 1d, 1797.

284 **Obv.** 'John Horn Born Jany 14 1788',
 with geometric border.
 Rev. Original coin.
 Details Cu, 40.9mm, 54g.
 Host UK, 2d, 1797.
 Ref. Dyer

285 **Obv.** 'RECEPTION OF THE
 ARCHBISHOP 1791', with border.
 Rev. Smooth surface.
 Details Ar, 34.6mm, 5.93g, pierced
 for suspension.

286 **Obv.** Portrait of Prince Regent
 (George IV), facing, with medal and
 Garter Star. Shaded effect.
 Rev. Hatched surface.
 Details Cu, 35.7 × 30.2mm, 8.94g.
 Host UK, 1/2d, 1806–07.

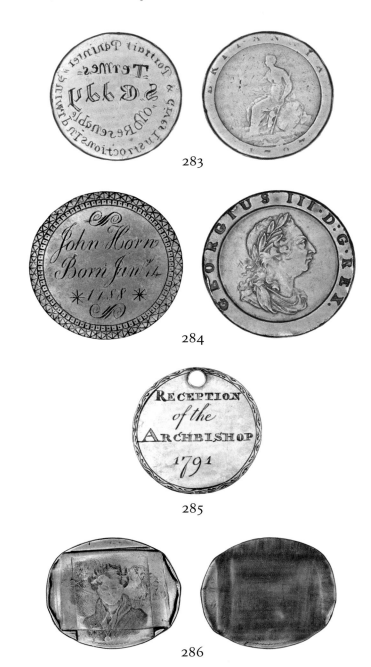

283

284

285

286

287 **Obv.** 'WHEN THIS YOU SEE.
REMEMBER.ME.AND.BEAR. ME
IN.YOUR.MIND NOT.TO
Rev. FORGET.YOUR.ABSENT.
FRIEND.NOW.HE.IS.CLOSE
CONFIN.D MK EG'.
Details Cu, 35.7mm, 24.01g.

288 **Obv.** 'J.P E.P 1824' around two
hearts doubly pierced.
Rev. 'A TOKEN OF LOVE' around
two doves holding a letter in their
beaks.
Details Cu, 35.6mm, 22.52g.

289 **Obv.** 'Confined within strong walls.
Convicted by perjury and when im
in a foreign'.
Rev. 'land dear friends Remember
me. Robert Hartless. Aged, 41, 1839
prepare to meet thy god'.
Details Cu, 35.7mm, 23.28g.
Ref. Dyer

290 **Obv.** 'One of three coins found in a
Cabinet of the late Lord Nelson on
board HMS Victory'.
Rev. Original very worn coin.
Details Cu, 35.5mm, 25.68g.
Host UK, 1d, 1797.

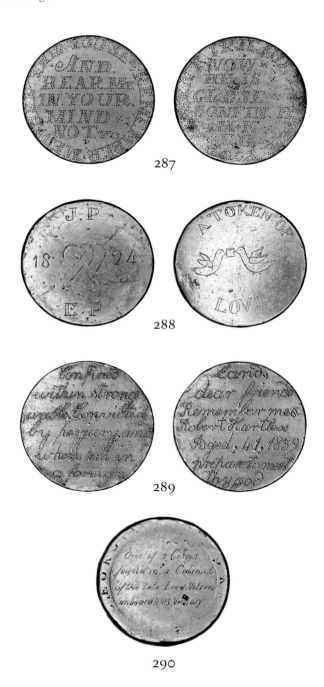

287

288

289

290

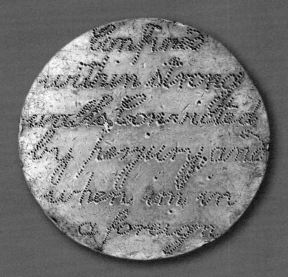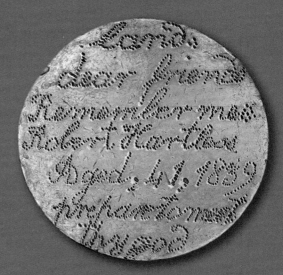

#289

———

Robert Hartless was probably transported twice. In January 1820 he was convicted at the Leicester Borough Quarter Sessions of receiving stolen goods. He was sent to the prison hulk *Justicia*, moored at Woolwich, and sailed on the *Shipley* to Tasmania, arriving in September 1820.

A record made on the *Shipley* described Hartless as a native of Leicester, a wool comber and sorter, 22 years of age; 5ft 4 inches tall, dark ruddy complexion, black hair and dark eyes. He received his Ticket of Leave in 1829 and Certificate of Freedom in 1834. Anne Hartless was born on 13

February 1830 to Robert and Susanna Hartless, at Green Ponds (now Kempton), Tasmania.

Then, in March 1839, the year this token was made, Robert Hartless, 45, was convicted at the Leicester Quarter Sessions of stealing wool and sentenced to transportation for life. This time he went to the prison hulk *Fortitude*, where he was described as a wool sorter, widowed, able to read and write, and of 'character v bad… transported before'. In December 1839 he arrived in New South Wales on board the *Barrosa*.

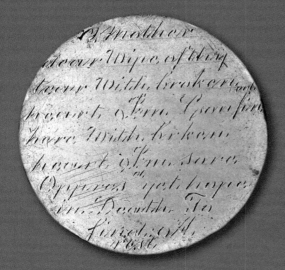 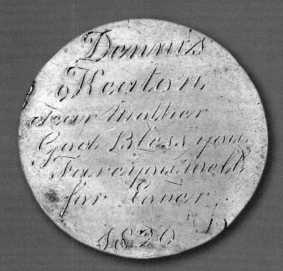

#296

Dennis Keaton was hanged at Newgate prison on 29 March 1820 for the crime of 'uttering' or passing forged banknotes.

In Autumn 1819, Edward Voss (18) and Dennis Keaton (17) went on a spending spree around London and its environs, including Hampton, Ilford, Stratford Green, Plaistow and Limehouse. Voss dressed as a naval officer and 'the boy' Keaton acted as his servant. They were finally arrested at the Three Daws in Gravesend. At their trial an inspector from the Bank of England identified 17 forged notes passed by the pair.

#314

—————

William Fegen, aged 29, was sentenced to seven years' transportation at the Warwick Borough Sessions in January 1842, for theft from a dwelling house.

On the prison hulk *York*, moored at Gosport, he was described as a painter and glazier. In October 1842 he was sent to Gibraltar on the *Owen Glendower* which served as a hulk with the prisoners labouring on dockyard construction.

291 **Obv.** 'JUNE 14th 1833', above woman
dressed in gown and hat, facing man
in tall hat, holding hands. 'E.S. & G.S.'
below.
Rev. 'When this You see Remember
me When I am far AWAY'
Details Cu, 35.8mm, 23.91g,
attempted piercing on obverse.

292 **Obv.** 'Dear Sister keep this in
Remembr-ance of me'
Rev. 'Edward Cowell A 18 Sentenced
7 years 1838 July 2nd'
Details Cu, 35.7mm, 23.51g.
Ref. Dyer, Lloyd

293 **Obv.** 'Charles Mance Aged 21 Years',
with feather and sunburst filler
design.
Rev. 'There's something awful in the
word Adieu When breath'd to those
that I do love so true', with feather
filler design.
Details Cu, 35.9mm, 23.78g

294 **Obv.** 'WILLIAM TOUNG &
ELZABETH CHETHAM' around two
hearts doubly pierced, bowl of fruit
above; two birds with sprigs below.
Ornate border.
Rev. 'The World his Whide for Me
to range, I love my choise To well
to change', heart and wreath below,
ornate border.
Details Cu, 35.8mm, 22.26g.

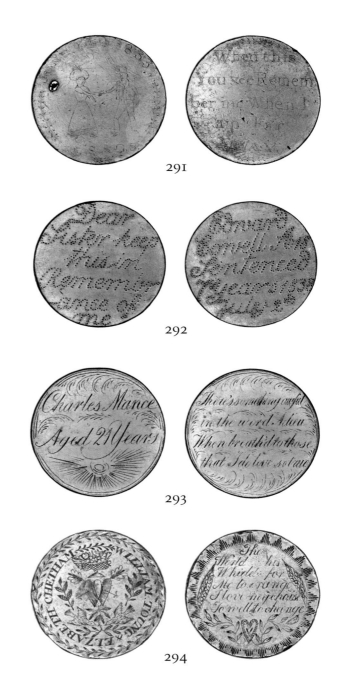

291

292

293

294

295 **Obv.** '[…]' around man [with a pipe in his right hand, tankard of foaming beer in left]. Small hearts at either side of feet.
Rev. 'WHEN THIS YOU SEE REMEMBER ME WHEN I AM FAR AWAY'.
Details Cu, 35.8mm, 23.93g.

296 **Obv.** 'Dennis Keaton dear mother God Bless you Fare you well for Ever 1820'.
Rev. 'Mother dear wipe of thy tear With broken heart I'm confin here. With broken heart I'm sore Oppresd yet [hope] in Death. To find [A] rest'.
Details Cu, 35.9mm, 23.97g.

297 **Obv.** 'GEORGE YOUNGS NICHOLS FORGET.ME NOT.NORWICH'.
Rev. 'LOVE.LIBERTY and FRIENDSHIP' around a large crown.
Details Cu, 35.8mm, 24.24g, pierced with a square hole.

298 **Obv.** 'CL when this you see think on me'.
Rev. 'until I get my liberty WF 1830'.
Details Cu, 35.9mm, 23.87g.

295

296

297

298

299 **Obv.** 'ML when this you see think on me'.
 Rev. until I get my liberty WF 1830'.
 Details Cu, 35.8mm, 24.85g.

300 **Obv.** Original coin.
 Rev. Original coin.
 Edge 'H: NORMAN BORN 27 SEP: 1777'.
 Details Cu, 24.9mm, 9.30g.
 Host UK, 1/2d, 1772, edge raised and engraved.
 Ref. Dyer

301 **Obv.** 'RENTER WARDEN'.
 Rev. 'SEAL'.
 Details Cu, 27.8mm, 7.32g, pierced for suspension.
 Ref. Lloyd

302 **Obv.** 'RENTER WARDEN'.
 Rev. 'SILVER BRANCHES'.
 Details Cu, 28.2mm, 6.97g, pierced for suspension.
 Ref. Lloyd

299

300

301

302

303 **Obv.** 'Blunt. Operator for the Teeth and Bleeder Great Windmill Street near Brewer Street Golden Square'.
Rev. Smooth surface with a few scratches.
Details Cu, 27.4mm, 6.74g.

304 **Obv.** 'Blunt. Operator for the Teeth and Bleeder Great Windmill Street near the Haymarket London'.
Rev. Smooth surface.
Details Cu, 27.8mm, 7.48g.

305 **Obv.** 'Blunt. Operator for the Teeth and Bleeder Great Windmill Street near Brewer Street Golden Square'
Rev. Smooth surface.
Details Cu, 27.4mm, 7.03g.

306 **Obv.** 'HENRY SAVORY BORN 3 MAY 1786' around HS in ornate design. Whole design in relief, infilled with black Japanning.
Rev. Outer rim and legend removed. Central dimple from lathe centre used to remove outer rim and legend.
Details Cu, 35.9mm, 24.22g.
Host UK, 1d, 1797.

307 **Obv.** 'MARY SAVORY BORN 3 JUNE 1781', intertwined snaking legend 'THE NOBLEST ORNAMENT OF HUMANKIND, VIRTUE'S THE CHIEFEST BEAUTY OF THE MIND' around 'MS' with whole design in relief, infilled with black Japanning.
Rev. Original coin.
Details Cu, 35.8mm, 25.49g.
Host UK, 1d, 1797.

303 304

305

306

307

308 **Obv.** 'William Pritchett to Caroline
Hens age 20 1833', above two hearts
doubly pierced.
Rev. 'When this you se remember me
and bear me in your mind let all the
world say what they will don't prove to
me unkind'.
Details Cu, 35.8mm, 24.58g.

309 **Obv.** '[...] Small a loving heart is worth
it all Thos Dunn aged 38 Elizabeth
Dunn age 38', with a cup, pipe and
heart below.
Rev. 'Dear Wife Kindly take this gift of
mine. the gift I give and hope is thine
although I value it', with hatched area
below.
Details Cu, 35.7mm, 24.16g.

310 **Obv.** 'Willm Bower Chesterfield 1793'
with small decorative stars.
Rev. 'When this you see Remember
me *H*B*' with 'I*M' in exergue.
Details Cu, 33.6mm, 26.61g.
Host UK, 1d token, 1787–91.

311 **Obv.** 'J[...] Wood[...]ar Was
Transported For Life April 5 1834'.
Rev. Original coin with pricked
surface.
Details Cu, 34.0mm, 15.76g.
Host UK, 1d, 1806.
Ref. Dyer

308

309

310

311

312 **Obv.** 'WHEN THIS YOU SE
REMEMBER.ME.WHEN.I.AM.
FAR.AWAY', within crude wreath.
Rev. 'GA TO MA 1827', around a
double-pierced heart.
Details Cu, 35.9mm, 25.12g, pierced
for suspension.

313 **Obv.** 'T. curey When this You se
rmember me when I am Far awaY
G. Buros'
Rev. Original worn coin.
Details Cu, 35.9mm, 25.58g.
Host UK, 1d, 1797.

314 **Obv.** 'the 73 Ridgment the Sawsey
green as pitty a One as ever was
Seen we Beat them in the art of
Driling and allways'
Rev. 'game to Spend A Shilling.
Wm Fegen Transpoted 7 years Jany
6 1842'
Details Cu, 35.8mm, 23.9g.
Ref. Dyer

315 **Obv.** 'Peter Hart Aged 22 1833
transported for [7] years August 7
1833', leafy design.
Rev. 'When this you see rember me
& bear me in your mind let all the
world say wat they will dont prove
to me unkind'
Details Cu, 34.1mm, 16.08g, pierced
for suspension.
Ref. Dyer

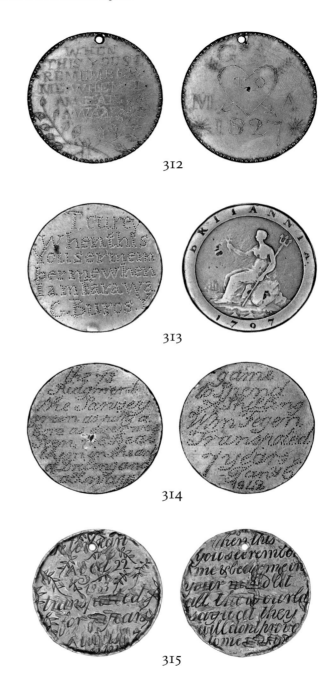

312

313

314

315

Index

Index of tokens

#172 233, *312*
#173 60, *316*
#174 *316*
#175 233, *316*
#176 17, **18**, 231, *316*
#177 *317*
#178 *317*
#179 *317*
#180 228, 314, *317*
#181 231, 315, *318*
#182 24, 38, **117**, 231, *318*
#183 63, 169, 230, 235, *318*
#184 *318*, 320
#185 57, 235, *319*
#186 *319*
#187 228, *319*
#188 *319*
#189 63, 321, *322*
#190 *322*
#191 74, 75, *322*
#192 163, 208, **211**, *322*
#193 *323*
#194 38, *323*
#195 *323*
#196 228, *323*
#197 *323*
#198 231, *324*
#199 *324*
#200 24, *324*
#201 *324*
#202 212, 216, *325*
#203 94, 95, 231, *325*
#204 23, 24, 77, 80, **81**, *325*
#205 **61**, 233, *325*
#206 *326*
#207 *326*

#208 *326*
#209 *326*
#210 55, *327*
#211 *327*
#212 *327*
#213 12, *327*
#214 231, *327*
#215 *328*
#216 55, *328*
#217 *328*
#218 *328*
#219 54, 235, *328*
#220 *329*
#221 *329*
#222 231, *329*
#223 233, *329*
#224 228, *329*
#225 50, *330*
#226 231, *330*
#227 60, 228, *330*
#228 *330*
#229 *331*
#230 228, *331*
#231 61, *331*
#232 63, *331*
#233 *332*
#234 228, 250, *332*
#235 175, **176**, 235, *332*
#236 222, *332*
#237 233, *333*
#238 233, *333*
#239 233, *333*
#240 *333*
#241 132, 142, 233, *334*
#242 231, 234, *334*
#243 *334*

#244 57, 228, *335*
#245 228, *335*
#246 235, *335*
#247 *335*
#248 50, 228, *336*
#249 *336*
#250 *336*
#251 *336*
#252 *337*
#253 *337*
#254 68, **170**, *337*
#255 233, *337*
#256 *337*
#257 235, *338*
#258 *338*
#259 *338*
#260 55, *338*
#261 *338*
#262 55, 233, *339*
#263 *339*
#264 *339*
#265 *339*
#266 *339*
#267 *340*
#268 **179**, 233, *340*
#269 **63**, *340*
#270 231, *340*
#271 *341*
#272 *341*
#273 *341*
#274 57, **58**, *341*
#275 *342*
#276 *342*
#277 39, **38**, **61**, *342*
#278 228, *342*
#279 *343*

#280 228, *343*
#281 231, *343*
#282 **39**, 40, 60, 233, *343*
#283 *344*
#284 61, **63**, *344*
#285 233, *344*
#286 235, *344*
#287 *345*
#288 228, *345*
#289 61, *345*, 346
#290 *345*
#291 *349*
#292 12, **13**, 61, *349*
#293 *349*
#294 228, *349*
#295 *350*
#296 347, *350*
#297 *350*
#298 *350*
#299 *351*
#300 55, 222, 228, *351*
#301 **16**, 235, *351*
#302 **16**, 235, *351*
#303 231, *352*
#304 231, *352*
#305 231, *352*
#306 228, *352*
#307 228, *352*
#308 *353*
#309 *353*
#310 231, *353*
#311 63, 231, *353*
#312 *354*
#313 *354*
#314 24, 61, 231, 348, *354*
#315 63, 231, *354*

A note on the Collection Highlights

Timothy Millett selected the Collection Highlights for their historical interest and visual impact. In many cases, it was possible to discover the circumstances in which specific coins were engraved and the histories of those named on them. Those details are captured in short notes accompanying an enlarged image. Unless attributed to a single author, these descriptions were produced collaboratively by Barbara Abbs, Timothy Millett and Sarah Lloyd.

Research on the Collection Highlights drew heavily on the resources listed below. Individual notes reference any significant additional sources of information.

Sources

Oxford English Dictionary Online
https://www.oed.com/

Oxford Dictionary of National Biography
https://www.oxforddnb.com/

The Digital Panopticon: Tracing London Convicts in Britain and Australia, 1780–1925
https://www.digitalpanopticon.org/ (which links to several commercial, subscription genealogical databases)

London Lives, 1690 to 1800
https://www.londonlives.org/

Old Bailey Proceedings online: The Proceedings of the Old Bailey, London's Central Criminal Court, 1674 to 1913
https://www.oldbaileyonline.org/

National Museum of Australia, Collection of Convict Love Tokens http://www.love-tokens.nma.gov.au/

Convict Records of Australia
https://convictrecords.com.au/

State Records and Archives, New South Wales, Convicts Index https://www.records.nsw.gov.au/archives/collections-and-research/guides-and-indexes/convicts-index

Libraries Tasmania
https://libraries.tas.gov.au/archive-heritage/guides-records

British History Online
https://www.british-history.ac.uk/

The National Archives; some of the following are available online via subscription genealogical databases: Prisons HO8; Letter Books HO9.

Lloyd's Register of Ships
https://hec.lrfoundation.org.uk/archive-library/lloyds-register-of-ships-online/

The British Newspaper Archive
https://www.britishnewspaperarchive.co.uk/

Photographic credits

All photos by Dave Cousins, copyright Timothy Millett, except p. 48: image courtesy Dix Noonan Webb Ltd; *p. 100:* photo Wiltshire Museum, Devises; *p. 100:* photo Dave Cousins; *p. 104, fig. 3:* British Museum, 1613421398; *fig. 4:* Jack Relph; *fig. 5:* Geoff Harris; *p. 110:* photo Jason McCarthy, National Museum of Australia; *p. 236:* photo Gary Oddie; *p. 157, fig. 5:* © Sir John Soane's Museum, London; *p. 159, fig. 6:* © Royal Academy of the Arts London; *p. 160, fig. 7:* London Metropolitan Archives

First published 2022

Text © the authors 2022

ISBN 978-1-911300-94-6

British Library Catalogue in Publishing Data

A CIP record of this publication is available from the British Library

Produced by Paul Holberton Publishing, London

paulholberton.com

Designed by Paul Sloman

Printed by Gomer Press, Llandysul

Front cover and frontispiece:
Tokens from Timothy Millett's collection. Photo Dave Cousins

Back cover:
Coin #254, obverse

3
Engraved Coins and the Circulating Medium

Graham Dyer

Quite understandably, Timothy Millett has acquired for his collection the engraved or stamped coins that for some reason have caught his eye. He has certainly developed an enthusiasm for convict tokens but perhaps on occasion he has also been attracted by the quality of the engraving, by the scurrilous nature of a political comment, or by the romantic sentiment that may underlie a message on a coin. But, whatever the motivation, it is easy to see why collecting them has become a personal passion and if, as a Royal Mint official of long standing I ought instinctively to condemn the defacement and mutilation of the circulating coinage, I confess that for the past few months I have taken pleasure from an enlarged photograph on the wall of my office of a group of Tim's coins.

A copper penny (#036, p. 51) on which William IV has been brutally traduced as 'The Idiot King' should not perhaps have amused me as much as it has, but from a professional point of view my interest has been aroused most of all by the coin

(#126), defaced by John Shield, who described himself as a dealer in coins as well as in tea and sugar – and I have written separately about this intriguing item elsewhere in this volume.

Having been collected in a way that has inevitably been somewhat random and unscientific, Tim's coins do not necessarily provide the most secure basis from which more general observations may be extracted. For instance, a numismatist would wish to determine how the host coins relate to what was available in circulation in the past three hundred years or so, that is to say, to explore how coins whose disfigurement includes a date may illuminate what was readily to hand in the circulating medium at different times. In this respect the silver coins in Tim's collection are unlikely to be particularly helpful since there are only thirty or so altogether and no more than twenty of these can be identified with certainty. Yet it is well known that silver coins were just as likely to be defaced as copper and Gary Oddie,

whose speciality is shillings, has over a comparable period amassed a larger collection of many hundred mutilated coins of that denomination. Nor, incidentally, was gold immune and I have just reminded myself that the Royal Mint Museum has a gold third-guinea, or seven-shilling piece, of 1802 with the letters 'J' and 'P' on the head of George III.

But in attempting to extract more from Tim's coins we are of course fortunate, as investigative numismatists, that from early in the reign of Charles II all coins in the United Kingdom have included the date of the year in which they were struck or sometimes, to be strictly accurate, a date very close to the year in which they were struck. Yet that date, where it can be seen on Tim's coins, is no more than a *terminus ante quem,* for coins can have a very extended life of active circulation, stretching over many decades, and the effects of normal wear and tear seem to have little impact on their acceptability in everyday transactions. Those of us with long memories, for instance, will recall how in the years immediately before decimalization it was not unusual to encounter in circulation pennies of Queen Victoria that were getting on for one hundred years old and whose well-worn condition in no way impeded their circulation.

Because the silver sample in Tim's collection is so small it is probably as well to deal with these coins first. Apart from a shilling of Edward VI (#154) and a stray sixpence of 1915 (#225), which looks to be an example of trench art from the First World War, the coins range in date from a crown of 1676 (#003, p. 6) to a sixpence of 1787 (#148), and represent the reigns of Charles II, William and Mary, William III, Anne, George II and George III.

Several, however, have been engraved or stamped with dates from the 1770s, 1780s and 1790s, perhaps fifty years or more after they first entered circulation, with pride of place going to the Charles II crown of 1676, which appears to have the date 1777 on the King's head. As such they occasion no real surprise, for they confirm what we know of the dilapidated state of the silver currency at the end of the eighteenth century – that after 1758, because of the high price of silver, virtually no new silver coins were issued from the Mint and the existing coins, dating back to the reign of Charles II and perhaps even beyond, were allowed to deteriorate. Some became little better than blank discs, and the situation was made worse by the infiltration of counterfeits and foreign coins. This placed a heavier burden on the use of copper and the balance was not redressed until the circulation of silver was fully restored by the reform of 1816/17 that followed the restoration of peace after the Battle of Waterloo.[1]

The 1787 sixpence of George III (#148), however, deserves a comment of its own because of the special circumstances in which the coin and associated shilling were issued, being intended, it seems, not for circulation but for the Bank of England to hand out sparingly as new coin to its customers at successive Christmases.[2] They generally turn up in unworn condition and there is an element of surprise, if only slight, to find one in Tim's collection. Its reference to the birth of Elizabeth Mitchell in 1780 actually pre-dates the coin and it is not the only specimen in Tim's collection where the graffiti is evidently commemorative in nature (#248 is another).

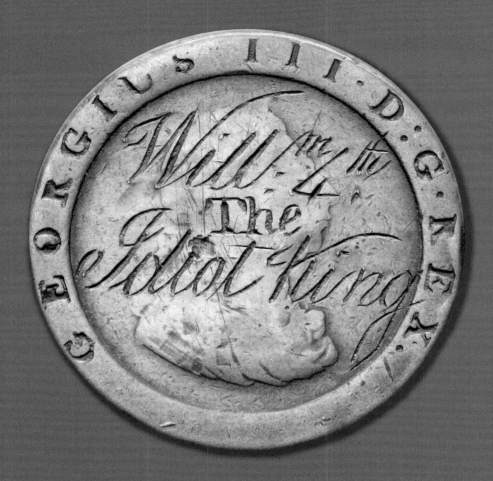

#036

William IV was frugal and modest in comparison with his predecessor, but his actions during the Reform Crisis of the 1830s positioned him as an obstacle to reform in a politically tense country. A variety of medals produced across his reign, including those that commemorated his death in 1837, declared: 'BY TRAMPLING ON LIBERTY I LOST THE REINS'. [KERRY LOVE]

Sources: https://www.britishmuseum.org/collection/object/C_M-9015 (1831); https://www.britishmuseum.org/collection/object/C_M-9289 (1837 Funeral coin).

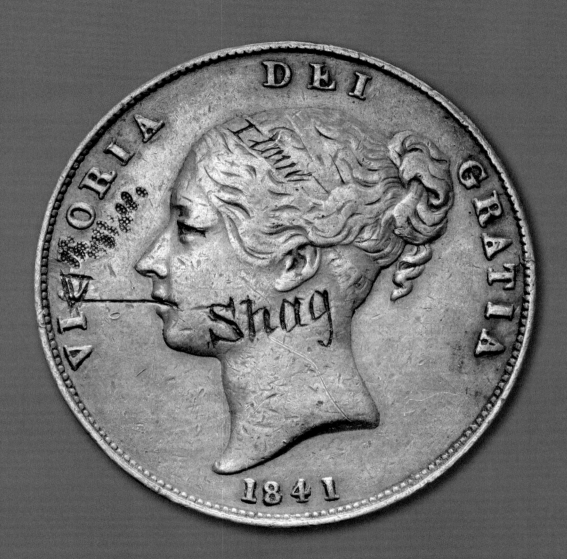

#047

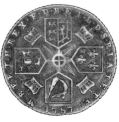

Coin #148

Putting silver to one side, nearly three hundred of Tim's coins – or roughly 90 percent of his collection – are copper. They therefore offer more scope for analysis and there is the great advantage of being able to make comparisons with James Gavin Scott's ground-breaking study *British Countermarks on Copper and Bronze Coins,* published by Spink and Son in 1975.[3] With commendable energy Gavin collected specimens wherever he could, consulted specialist collectors and dealers, and trawled through auction catalogues and past numismatic literature. Though he confined himself to copper and bronze, by the time of publication he had amassed a corpus, in greater or less detail, of well over 1700 British and Irish coins, to say nothing of foreign coins with British countermarks. And, particularly helpful in the present context, he deliberately restricted himself to coins that had been mutilated by tradesmen to serve as advertisements, as shop tickets, as pay and tool checks, and as store checks, thereby excluding the political, convict and love tokens that have been Tim's primary interest. There is, therefore, a real sense in which Tim's collection complements Gavin Scott's

study, and in which comparison between the two may be meaningful, for the motivation for Gavin Scott's coins is commercial while Tim's coins can be much more personal. If there is a downside, it is that such comparison is unfortunately hampered by the fact that a far greater proportion of Tim's coins have been reworked to an extent that makes it difficult or impossible to identify the host coin.

To begin at the beginning, official copper halfpennies and farthings were introduced in 1672 and we may perhaps conveniently think of a first phase of production that continued for the next one hundred years until 1775.[4] Within this period there were times when production was temporarily suspended and other times when the Mint would have been largely idle had it not been for the coinage of halfpennies and farthings, yet as late as the 1750s the Mint was inclined to look down its nose at copper, which it saw not so much as real money but as a substitute for proper coins. Neither it nor the Government gave copper the attention it deserved and the copper coinage became increasingly dogged by counterfeiting as villains took advantage of the disparity between the face value of the coins and the intrinsic value of the copper. In vain the Mint might complain, as in 1714, that 'the people are not nice & curious in taking good copper money',[5] and counterfeiting grew to an extent that today we would not consider possible, with the number of counterfeits estimated to be probably as great as the number of genuine coins. There was also the difficulty that copper did not circulate evenly and tended to accumulate among urban tradesmen, giving a false impression of surplus. Complaints of an excessive quantity in

circulation caused minting to be suspended in 1754, but it was resumed again in 1770 after London tradesmen petitioned for a new supply in order to throw counterfeits out of circulation. The Mint was not convinced that the one would follow from the other, but was not averse to a resumption 'for the Experiment of a Temporary relief to the Public'.[6]

The resumption was short-lived, coming to an end in 1775, and for the next twenty years there was to be no fresh minting of copper. In November 1787 the Mint was asked by a committee of the Privy Council to obtain and examine a sample of the coins in circulation, both genuine and counterfeit. Its report could hardly have been more damning: of the counterfeits, it found that only 8 percent had some tolerable resemblance to the genuine article, 43 percent were blatantly inferior, 12 percent were blanks and the balance was utter rubbish.[7] Well might the Mint deplore the ease with which 'the Public suffer themselves to be imposed on by the most bungling imitations' and it may be that among the unidentified pieces in Tim's collection there are examples of the 'trash' that the Mint so vehemently condemned. For his part, Gavin Scott certainly encountered a few counterfeits, chiefly halfpennies of George II and George III.

About thirty of Tim's copper coins, or one in ten, can be identified for certain as belonging to this early period from 1672 to 1775. All bear on the obverse the portrait of the reigning monarch and on the reverse the seated figure of Britannia, familiar enough to us now but so unusual at the time that the first coins of Charles II were said by Sir William Petty to have been hoarded for their beauty.[8] These thirty coins, however, may not tell

the full story since it seems very likely that among the unidentified host coins there are many others from this period, matching the approximate 10-gram weight and 30-millimetre diameter of the halfpenny.

Gavin Scott's lists, while they do not provide an exact count, suggest a similar proportion of one in ten and a further similarity is provided by the virtual absence of farthings. Leaving aside coin #219, which has been mutilated to such an extent that it might conceivably be either a halfpenny or a farthing, there are in fact no farthings among the thirty coins of this period identified in Tim's collection, while on the basis of weight and diameter the unidentified pieces likewise include no farthings of this period. No doubt their absence reflects in part the pattern of production, for the supply of farthings was consistently and intentionally outstripped by that of halfpennies. Thus, for instance, of nearly 90 million copper coins struck by the Mint between 1729 and 1754 only 10 million were farthings. And we may suppose that the opportunity provided by the greater availability of the halfpenny was reinforced by its larger size, which gave more enticing scope to the perpetrator of graffiti.

Tim's thirty coins span most reigns from Charles II to George III, with the exception of James II, whose omission can be explained by the fact that the only halfpennies and farthings of his brief reign were made of tin, not copper, and did not lend themselves to attractive engraving or stamping. The other exception is Queen Anne, and for the very good reason that no copper coins were issued during her reign. Two of Tim's coins are

from the original issue of Charles II, two belong to William and Mary, five to William III, two to George I, eight to George II and the remaining eleven to George III. This gives the expected eighteenth-century bias, also evident in Gavin Scott's lists, reflecting the scale of minting during the long reign of George II and the short but not insubstantial minting of 20 million halfpennies and 3 million farthings of George III between 1770 and 1775.

These coins, despite their increasing age, remained officially in circulation into the early years of the nineteenth century and may well have been used unofficially even later than this. Their longevity is plain to see among Tim's coins and is exemplified by the two halfpennies, both dated 1694, of William and Mary. Coin #262 has initials and the date 13 March 1742, while the other William and Mary halfpenny (#017, p. 56) has the words 'God Bless pc & Down with The Rump 1747', which perhaps conveyed its Jacobite message more immediately at the time than it does now. These were coins that evidently came conveniently to hand fifty years after they were struck, while an even hardier survivor is #155, a halfpenny of William III, that was just short of one hundred years old when it was abused by the London linen drapers Fassett & Addison in 1790. Also impressive in terms of its longevity is a halfpenny of George I, #216, which became a love token in the name of R. Brown in 1793, and similarly deserving of mention is #210, an early halfpenny of George II, which records the birth of James Maddison Bell in August 1795.[9]

A coin did not, however, have to be old to fall prey to the engravers and stampers. Coin #015, for instance, is a George III halfpenny of the 1770–1775 issue which appears to be a remembrance token from one Allen to another in 1774. A second of these halfpennies, #260, bears two names and the date 1775, while a third, #300, records a date of birth of September 1777. This last could, of course, have been defaced much later, but it deserves mention in any case for the clever way in which the information has been placed around the edge of the coin.

The necessary reform of the dilapidated copper currency was slow to come and in 1787 there was an eruption of private tokens, giving profit to their issuers as they contained much less than their face value of copper. At first these tokens were produced on an almost industrial scale by large manufacturers, some of them with a vested interest in the copper trade. This was followed by a second phase in the early to mid-1790s involving local tradesmen, whose myriad of small orders favoured the halfpenny. These token issues, some of them well made and with pleasing pictorial designs, were themselves adulterated by anonymous and lightweight pieces, but they evidently circulated quite freely and people were happy to accept them as coins, secure in the knowledge that they could be passed on to someone else.

These coins were not immune from defacement and no fewer than thirteen in Tim's collection can be confidently identified as late eighteenth-century tokens, a proportion that is not dissimilar to that reported by Gavin Scott. Where there is a difference it is that Gavin Scott's coins are predominantly halfpennies whereas ten of Tim's thirteen coins are pennies, favoured no doubt for their larger size. They are in fact pennies of the best

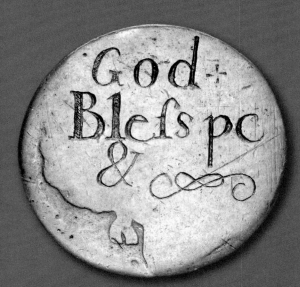 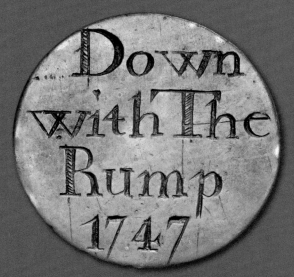

#017

The 'Rump' Parliament ordered the trial of **Charles I** in 1649. During the eighteenth century, 'Down with the Rump' was a common Jacobite slogan and toast. It expressed anti-Hanoverian feeling well into the 1740s and in the aftermath of the battle of Culloden (1745). The phrase survives on glassware, medals, ceramics and other objects, and is found frequently alongside blessings for Prince Charles. Studies of Jacobite material culture have relied heavily on sources connected with middle- or upper-class purchases, but the proliferation of the slogan across cheaper items like this token suggests a degree of ubiquity.

Sources: Neil Guthrie, *The Material Culture of the Jacobites*, Cambridge 2013, p. 124; jug: https://www.britishmuseum.org/collection/object/H_2004-1222-1; wine glass: https://www.lyonandturnbull.com/auction/lot/411-a-down-with-the-rump-jacobite-wine-glass/?lot=185570&sd=1

known type, issued in great quantity by the Parys Mines Company of Anglesey, showing the head of a druid and still instantly identifiable from the incuse inscription on the edge indicating where they were payable. Though it may be believed from the evidence of the Welsh antiquary Grant-Francis[10] that tokens could be found in circulation as late as the 1820s, the most recent date on Tim's specimens comes on **#274 (p. 58)**, which appears to celebrate the sixteenth birthday of Agnes Gorden in July 1797.

Salvation for the copper coinage was to come in the years after 1797, but not from the Royal Mint. Instead, the Treasury placed huge contracts with Matthew Boulton at his technically superior Soho Mint in Birmingham, beginning in 1797 with cartwheel pennies and twopences, the first time these two denominations had been officially struck in copper. These were followed in 1799 by halfpennies and farthings, and then between 1805 and 1807 by more halfpennies and farthings, and also by pennies, though these were not of the cartwheel type. There was to be another brief flurry of tokens around 1811 to 1815,[11] pennies as well as halfpennies, and represented in Tim's collection by two pennies, one of 1812 (#185) and the other 1813 (#244). But essentially, thanks to Boulton, the copper coinage had been placed on a sound footing, with well-struck coins that were at last in relatively plentiful supply and of a quality that made them much more difficult to counterfeit **(p. 48)**.

Boulton's production, measured against what had gone before, was enormous, amounting to no less than 75 million pennies, 170 million

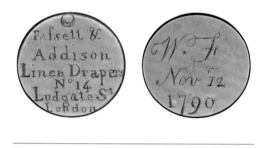

Coin #155

halfpennies and 10 million farthings, topped up with 720,000 of the cumbersome twopences.[12] It took time to digest, especially after silver coins began to circulate more freely following the reform of the silver coinage in 1816/17, and production of new copper did not resume until 1821, now by the Royal Mint and not by Soho. These post-Boulton coins initially struggled to enter circulation, and their supply was carefully controlled by a Treasury fearful of creating the inconvenience of a 'super-abundance' of copper.[13] By the end of 1856 the total production of post-Boulton copper had reached something like 40 million pennies, 60 million halfpennies and 85 million farthings. But if these figures seem substantial they are also misleading since they were boosted both by heavy demand from Ireland and by the issue of large quantities to territories overseas, with over 90 percent of the pennies and halfpennies of William IV, for instance, being sent abroad to countries like Canada and Ceylon.

Although in 1856 the copper coinage still had four years to run before, in December 1860, it began to be replaced by smaller and lighter bronze coins,

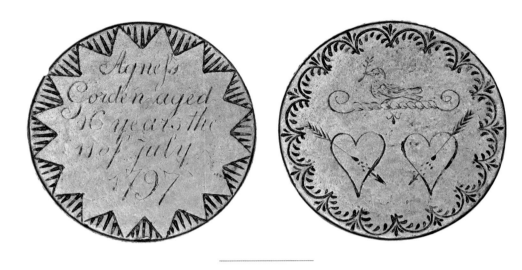

Coin #274

this is a good place to pause. Not only are none of Tim's copper coins as late as this, but thanks to Thomas Graham, Master of the Mint, we have at the beginning of 1857 a statistical snapshot of the copper circulation to provide a context for the coins in Tim's collection and also those in the lists compiled by Gavin Scott. Graham had been keen to make the case for the change-over to bronze and his survey, a means to that end, was simplicity itself. A temporary Mint clerk was charged with obtaining a quantity of £60 in copper coin from each of the four cities of London, Birmingham, Manchester and Glasgow, and bringing the coins back to the Mint to be examined and weighed. Such a sum may not sound a great deal but in fact it amounted to a very respectable total of some 86 thousand pennies, halfpennies and farthings. The methodology was almost certainly flawed, for the inclusion of rural areas would likely have given a slightly different result, but the survey remains full of interest.[14]

In broad terms it found that 32.9 percent of the sample consisted of pennies, 64.8 percent were halfpennies and 2.3 percent were farthings. That halfpennies should outnumber pennies by roughly two to one was very much in line with the quantities struck since 1797. Farthings, on the other hand, should have been ten times higher, at 25 percent, on the basis of the mintage figures and here was emphatic confirmation of the Mint's view that the farthing was a lazy coin that enjoyed a very restricted circulation bearing little relation to the numbers struck. The comparative absence of farthings from this period has its counterpart in Gavin Scott's lists, where they make up just 3 percent or so of the entries, while in Tim's collection there

is not a single farthing from 1799 to 1856. As for pennies and halfpennies, the lists compiled by Gavin Scott more or less reverse the proportions found in Graham's survey while Tim's pennies outnumber his halfpennies by around fifteen to one. This lack of correlation with the mintage figures and with Graham's survey leaves little doubt that the perpetrators of graffiti were likely to favour the largest available copper coin in order to give themselves the greatest space for meaningful messages or for attempts at artistic design.

If there was good news from Graham's survey it was that counterfeits, once the scourge of the copper coinage, had reduced to insignificant proportions. Nevertheless the survey, as he intended, gave proof of what was now the problem with the copper coinage – that so many of the coins were old and worn. Their flat surfaces had encouraged abuse and the practice of disfiguring them with advertisements had at last reached such a level that legal penalties were introduced by Act of Parliament in 1853. The worst offender was Edward Lloyd, who made such extensive use of the coinage to promote his newspapers that Gavin Scott was able to record around fifty different varieties of his handiwork.[15] Remarkably, a sixth of the coins in Graham's survey were reckoned to have been deliberately injured or defaced, and, with another sixth subsequently rejected by the Bank of England as worn out, Graham was able to claim that a third of the copper in circulation was unfit for use. This gave him the ammunition he needed to persuade Gladstone as Chancellor of the Exchequer that the copper coinage should be replaced by a lighter and more convenient coinage of bronze.

Despite the summarized form in which Graham published his results it is possible to identify the most important coin of all. This is the cartwheel penny of 1797, with its draped and laureate bust of George III on the obverse and a more obviously nautical Britannia on the reverse. Nearly 44 million of these famous pennies had been struck between 1797 and 1799, all dated 1797 and rendered distinctive not just by their large size but also by unusual raised rims with the inscription in incuse or sunken letters. Of the 86,000 coins in the survey, almost one in ten, or 8,120 to be precise, were cartwheel pennies, or 'ring pence' as they were described by Graham, and in terms of pennies alone one in four was a cartwheel. For the numismatist this can be something of a revelation, the familiarity of the date 1797 acting as a mental constraint that requires effort to get beyond and to recognize that, despite the date, their story belongs much more to the nineteenth century.

At the time, however, this convincing demonstration that the cartwheel penny had become the workhorse of the copper circulation would have caused no surprise. Their distinct 'aspect and structure', as a previous Master of the Mint, Sir John Herschel, had put it in 1853, made them quite unmistakable despite the wear and tear of over fifty years of constant use and he reckoned that they formed one-fifth of the total copper circulation. To some observers they had perhaps seemed even commoner, as William Miller of the Bank of England suggested that same year, 1853, when he said that 'you can hardly take three-pence but that you will receive one rimmed penny'.[16] Their proportion, however, would subsequently have

declined a little in the light of the very extensive issues of new copper between 1853 and 1856.

The prevalence of the cartwheel penny is immediately plain to see in Tim's collection, where there are as many as thirty coins, or roughly one in ten of the overall total, that have a cartwheel penny as their host. But the dominance of the cartwheel penny does not stop here. Some two-thirds of Tim's coins have been defaced to such an extent that no vestige of the design of the host coin can be seen and there can be no reliable visual identification. Yet there can be hope of identification in the case of the cartwheel penny, arising from the fact that the 36-millimetre diameter of a 1797 cartwheel is larger than that of the later copper pennies, either from Matthew Boulton or from the Royal Mint. And in fact no fewer than fifty of the unidentified copper hosts have a diameter that corresponds to that of the cartwheel penny; and they combine this with a weight that is also close to what it should be for a 1797 penny, though weight is less reliable than diameter because of the loss of metal from the wear and tear of circulation and then from the removal of metal by an engraver determined to produce an artistic design uncluttered by any remnant of what was on the host coin. It is not impossible that eighty or so of Tim's coins, more than a quarter of his entire collection, started life as a ubiquitous cartwheel penny. Lest this high proportion might make us wonder if Tim's method of acquisition – and in particular his enthusiasm for convict tokens – has in some way distorted the outcome, there is the matching evidence assembled by Gavin Scott, where the cartwheel penny features on well over 300 occasions in his lists, dwarfing every other coin

and accounting for nearly 20 percent of all the entries of defaced British coins.

The longevity of their availability is clearly evident from Tim's coins. Many of them, naturally enough, have graffiti that is virtually impossible to date, like the sentimental representation of love on #004 or the intriguing charm of the message on #205, where 'EH' thanks 'HW' for fastening her shoe string. But at least ten of the thirty coins that beyond all doubt are cartwheel pennies have graffiti that postdates 1820, by which time the coins were already over twenty years old. There are five with dates in the 1820s, beginning with the death of the three-year-old Emilia Hunt in May 1820 on #173, running through to the execution of the cheating banker Henry Fauntleroy in November 1824 on #034, and the birth of Matilda Rownsend in May 1826 on #227. Two coins belong, it seems, to the 1830s: #036 describes William IV as 'The Idiot King', while two sets of initials on #282 are accompanied by the date 1835. Two more cannot be earlier than the 1840s: #037 records against the date 1845 the pelting of Lord Mayor Gibbs with rotten eggs, while the critical 'Down with PRINCE Albert' on #039 must presumably postdate his marriage to Queen Victoria in February 1840. And, finally, there is #007, which, depending on how the date is interpreted at the end of 'The man who did this was born without a shirt 1840', may be the latest of all.

The fifty or so additional coins where the identification with the cartwheel penny rests on diameter, and to a lesser extent on weight, tell the same story of longevity. Perhaps as many as twenty, if the graffiti can be taken at face value, seem to postdate

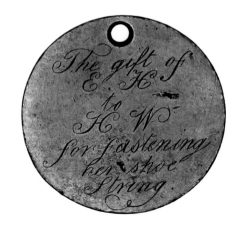

Coin #205

1820 and to run into the late 1830s and early 1840s. Thus, Edward Cowell, having been sentenced to seven years in July 1838, sent a suitably engraved #292 to his sister; #289 has a somewhat similar message to 'dear friends' in 1839, while #314 is generated by the transportation of William Fegen for seven years in January 1842. Longevity not only meant these coins were readily to hand in circulation, but the wear and tear of many years' use would have softened and smoothed the features of the designs and provided a more receptive surface for disfigurement.

In passing, it might be thought that the thickness of the cartwheel penny would operate against its suitability by making the coin difficult to pierce and therefore inhibit its wearing on a ribbon or a chain. But four of them have been successfully pierced and though two of these, #205 and #231, are as might be expected mementos of a personal

nature, the other two are impersonal and political, #074 with its uncompromising 'Down with the Catholics' and #277 with its wish that the fate of Henry Fauntleroy might befall 'all the Bilking East India Agents'.

In contrast to the penny, the companion cartwheel twopence of 1797, exactly the same design and format but larger in size and twice the weight, received no specific mention in the 1857 survey. It had been struck in very small numbers, amounting to no more than 720,000 pieces, and for this reason coupled with its cumbersome size it can have enjoyed only very limited circulation. To find one, #284 (p. 63), among Tim's coins, its reverse recording the birth of John Horn in 1788, was therefore a little unexpected. But in truth I should not have been as surprised as I was since there are two defaced specimens in the Royal Mint Museum and it features on nearly forty occasions in the lists compiled by Gavin Scott. Perhaps the mere fact of its unprecedented size gave it, for those seeking a coin to deface, impressive and unusual visibility.

I cannot, however, resist a final thought about the predominance of the cartwheel penny of 1797. While I concede, of course, that it was freely available over a long period of time, it disproportionately outnumbers the later pennies of 1806 and 1807 both in Tim's collection and in Gavin Scott's lists. I am therefore inclined to wonder if the coin enjoyed a particular attraction or fondness that made it even more likely to fall prey to the engravers and stampers in search of a keepsake. As a very young collector in the 1950s I can remember sensing its special appeal and this was cemented in

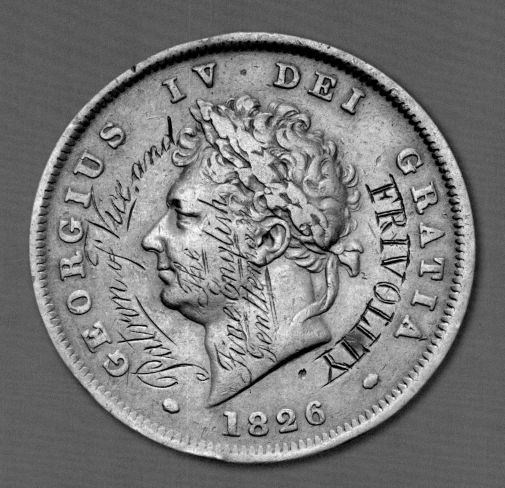

#048

Much satirized as Prince of Wales and then Prince Regent, **George IV** developed an early reputation for extravagance, gambling and immoral, womanizing behaviour. His attempt to divorce his wife, Princess Caroline of Brunswick, when he came to the throne in 1820 galvanized public criticism as the Queen's lost rights became associated with the people's lost rights. The King epitomized vice and irresponsible frivolity in a period when ideals of masculine behaviour shifted to focus on inner character and virtue. [KERRY LOVE]

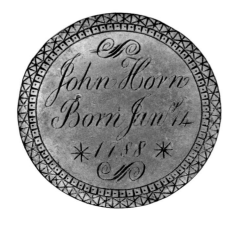

Coin #284

Coin #269

my mind by the sight of a worn cartwheel penny in the local museum at Colchester Castle that was said to have been used as a talisman for good luck. Above all, I can recall the comments of people at that time who would never have handled one and yet seemed able to refer to it in a way that was both familiar and affectionate.

The very large quantities of halfpennies and farthings of 1799 and of pennies, halfpennies and farthings of 1806 and 1807 are represented in Tim's collection but on a much smaller scale, amounting to no more than about twelve that can be reliably identified. They can be split more or less equally between pennies and halfpennies, with no farthings to be seen, and like the cartwheels they reflect the extended circulation enjoyed by Boulton's copper. For instance, the message of remembrance on #232, a penny of 1807, includes the date 1826; #269, a penny of 1806, records the

death of 'JT' in January 1829; while #311, another penny of 1806, is later still with its reference to a transportation for life in April 1834. It may be that among the unidentified copper host coins there are more of these Boulton coins, but probably just a handful or so at best. Only three of the unidentified coppers, for instance, have a diameter and weight compatible with the later pennies of 1806 and 1807: one of these, #183, is nicely engraved but lacks a date; #315 refers to the transportation of 22-year-old Peter Hart in 1833; and #189 was defaced in 1849 or thereabouts with the names of Robert and Sarah Adlam.

The post-Boulton coins of the period 1821 to 1860 are likewise distinctly scarce in Tim's collection. In fact there are only four, #047, #048, #050 and #125, consisting of a George IV halfpenny of 1826, George IV pennies of 1825 and 1826, and a Victorian penny of 1841. The presence of coins of

1825 and 1826 perhaps reflects the large issues to Ireland at that time to replace some of the existing Irish copper coinage, and the three coins of these dates are further linked by the same condemnation of George IV as the patron of 'vice and frivolity'. This same relative absence of the later copper is evident in Gavin Scott's lists, which show for George IV a slight bias in favour of coins of 1825 and 1826 and overall the customary slim representation of farthings.

The old copper, replaced by bronze in 1860, was allowed to circulate for a while longer but was eventually demonetized from 31 December 1869, which thus provides a *terminus post quem* of sorts for Tim's collection of copper coins.[17] Like the coins in Gavin Scott's lists, with which they provide a good match despite the contrasting motivation, they look on the whole to have been taken promiscuously from what was readily available in everyday circulation. And it seems clear that, though personal parsimony might have dictated otherwise, the larger-sized coins – the halfpenny in the eighteenth century and the penny in the nineteenth – were favoured for the greater scope they offered to those who wished to mutilate the coinage for commercial, political or personal reasons.

I am very grateful to Gary Oddie for his characteristically prompt and helpful comments on the first draft of this chapter, and I must also record my gratitude to Tim Millett for his fortitude in bringing a heavy cabinet of coins for me to see at the Reform Club on what turned out to be perhaps the worst day of 2018 for snow and ice in London.

1 For a general survey of the administration and output of the Royal Mint during the period covered by Timothy's coins see G.P. Dyer and P.P. Gaspar, 'Reform, the New Technology and Tower Hill, 1700–1966' in C.E. Challis (ed.), *A New History of the Royal Mint*, Cambridge 1992, pp. 398–606.
2 E.M. Kelly, *Spanish Dollars and Silver Tokens,* London 1976, p. 7.
3 James Gavin Scott, *British Countermarks on Copper and Bronze Coins,* London 1975.
4 The most useful description of the copper coinage remains C.W. Peck, *English Copper, Tin and Bronze Coins in the British Museum 1558–1958,* second edition, London 1964.
5 The National Archives (TNA) MINT 1/11, pp. 18–22.
6 TNA MINT 1/12, pp. 120–28.
7 Sir John Craig, *The Mint: A History of the London Mint from A.D. 287 to 1948,* Cambridge 1953, p. 253.
8 [William Petty], *Sir William Petty: His Quantulumcunque concerning Money,* London 1695, p. 8.
9 For the most recent account of the issue of these tokens, see David Wilmer Dykes, *Coinage and Currency in Eighteenth-Century Britain: The Provincial Coinage,* London 2011.
10 Col. Grant-Francis, *The Smelting of Copper in the Swansea District of South Wales, from the Time of Elizabeth to the Present Day,* second edition, London and Manchester 1881.
11 Paul and Bente Withers, *British Copper Tokens 1811–1820,* Llanfyllin 1999, is the standard reference for these tokens.
12 Boulton's output of copper coins for Britain and Ireland is summarised in *Return to the House of Commons,* no. 404 (1 August 1819).
13 Official references to the copper coinage of this period have been transcribed and collected in two box files, *COPPER 1672–1860,* in the Royal Mint Museum Library.
14 G.P. Dyer, 'Thomas Graham's Copper Survey of 1857', *British Numismatic Journal,* vol. 66, 1996, pp. 60–66.
15 Scott 1975, pp. 6–10, 26–28.
16 'Report from the Select Committee on Decimal Coinage', *Return to the House of Commons,* no. 851 (1 August 1853), pp. 49, 109.
17 The withdrawal and demonetization of copper coins is summarized in the *First Annual Report of the Deputy Master of the Mint 1870,* London 1871, pp. 26–27.

4

John Shield

Coin Dealer

Graham Dyer

One of the most intriguing coins in Timothy Millett's collection is #126, defaced in the name of John Shield junior. On one side it reads 'John Shield junr. Dealer in Tea Sugar and Coins', and on the other 'The best price given for Guineas. NB Politics taught'. The words have completely replaced the designs of the host coin but the weight of 7.88 grams and diameter of 27 millimetres suggest that it was originally a halfpenny of the seventeenth or eighteenth century.

Shield's unexpected role as a teacher of politics is probably worth a note of its own, but for a numismatist it is his coin dealing that is of greater interest. It needs to be said at the start that the name of John Shield is not familiar to modern collectors and is not to be found in the treasure trove that is Harry Manville's *Biographical Dictionary of British and Irish Numismatics*.[1] Plainly, if he operated in the eighteenth or nineteenth century, he was not a dealer with the range and stature of Richard Miles or Matthew Young or the slightly later William Till. Perhaps his interest in coins had not been

sustained long enough to make an impact, similar to one 'Bellamy in the Poultry' in London who we are told by the collector Sarah Sophia Banks had by 1799 given up selling coins to become a cutler.[2] But much more likely, in the modern sense of buying and selling coins for collectors, he may not have been a coin dealer at all.

The emphasis on guineas in fact prompts the thought that Shield may simply have been a trader who purchased at a price those troublesome guineas that by wear and tear, fair means or foul, had been reduced below the legal tender limit – the least current weight – of 5 pennyweight 8 grains, imposed during the extensive recoinage of light guineas in the 1770s.[3] Strictly speaking, when guineas fell to this point they could not be passed on at face value but had to be treated as gold bullion and, ideally, cut with shears to prevent further circulation. For someone left holding such a light guinea the inconvenience could to an extent be mitigated by Shield or others like him taking it off their hands as gold bullion, less of course a

#126
———

consideration for their trouble. This had the potential to be a competitive business, hence Shield's claim to give the best price.

Examples of this activity are to be found in Irish newspapers of 1787, at a time when efforts were being made by the banking community to root out light gold in England, Scotland and Ireland.[4] The *Dublin Evening Post* of 7 June 1787, for instance, contains an advertisement from C. Jenkins of Dame Street, claiming to give the highest price in Dublin for light gold and, to generate confidence, he undertook to cut the light coins in the presence of the seller to put 'an effectual stop to their further circulation'. Similar advertisements were placed at that time by Nicholas Le Favre of Grafton Street and Henry Whitestone of Dame Street, both also claiming to offer the best deal. In August 1787 they were joined by the Bank of Ireland, which opened a special office in Boot Lane at the rear of the bank and promised to give the 'utmost Value' for guineas under 5 pennyweight 8 grains and half-guineas under 2 pennyweight 16 grains.

Shield does not appear in a contemporary Dublin trade directory and it seems that we must look elsewhere for his location, no doubt in an urban centre such as London, Birmingham, Manchester or Glasgow. As for date, the period of the gold recoinage of the 1770s and the years immediately afterwards, when the circulation of light gold was discouraged by the use of accurate coin weights, looks to be right. A date later than that is unlikely since guineas quickly disappeared from active circulation after the Bank of England was directed to suspend cash payments in February 1797, and with their place taken by banknotes there would have been little or no business for people like Shield.[5]

Newspaper advertisements were not cheap and Shield may perhaps have found it more cost effective to engrave a coin or two. He cannot have done it in quantity, for no specimen had come the way of Gavin Scott when he published his *British Countermarks on Copper and Bronze Coins* in 1975.[6] And with no coin scales or weights having been reported bearing the name of John Shield, coin #126 may prove to be Shield's only claim to numismatic immortality.[7]

1 Harrington E. Manville, *Biographical Dictionary of British and Irish Numismatics*, London 2009.
2 Manuscript note by Sarah Sophia Banks in the Royal Mint Museum Library.
3 For the most recent account of the recoinage, see Kevin Clancy, 'The Arrival of the Gold Standard', *British Numismatic Journal*, vol. 89, 2019, pp. 141–48.
4 See, for instance, F.G. Hall, *The Bank of Ireland 1783–1946*, Dublin and Oxford 1949, pp. 74–75.
5 G.P. Dyer, 'The Currency Crisis of 1797', *British Numismatic Journal*, vol. 72, 2002, pp. 135–42.
6 James Gavin Scott, *British Countermarks on Copper and Bronze Coins*, London 1975.
7 The standard work on the subject of coin scales and weights is Paul and Bente Withers, *British Coin-Weights*, Llanfyllin 1993, and they have been kind enough to confirm that they are not aware of the name of John Shield in this connection.

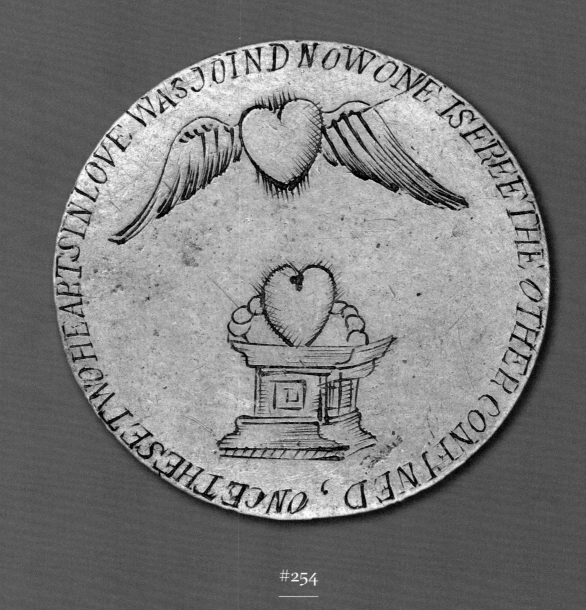

THESE TWO HEARTS IN LOVE WAS JOIND NOW ONE IS FREE THE OTHER CONFINED, ONCE

#254

Part two

Love and Memory

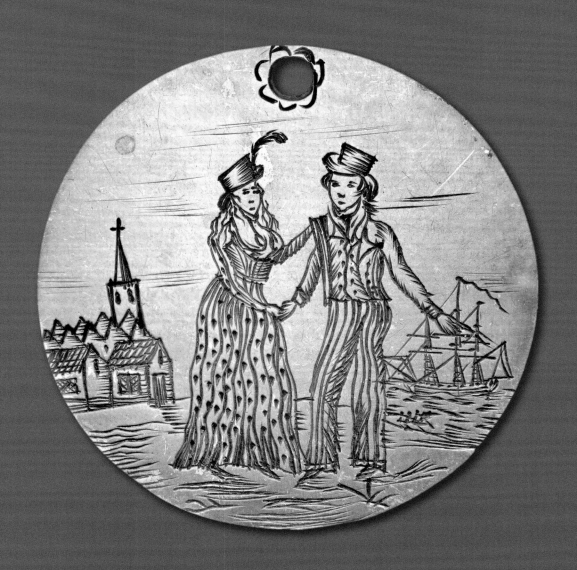

#018

5

The Sailor's Farewell

Maritime Culture

Hamish Maxwell-Stewart

Many love tokens depict a sailor leaving a grieving family, or bear phrases such as 'The Sailor's Departure'. These tokens are a visible reminder of the dangers of life at sea in the age of sail. They form part of a wider collection of objects designed to be presented as a promise of safe return or perhaps to ensure that those lost at sea were not lost to memory. From the mid-eighteenth century onwards, several British potteries produced wares illustrated with similar motifs. Descriptions of prison and convict tattoos also reveal that some working-class Britons chose to have their bodies decorated with memorials marking an overseas departure. This chapter will place love tokens illustrated with the 'sailor's farewell' and related designs within the context of other objects and practices designed to supply the market for sailor's gifts and ward against the dangers associated with oceanic travel.

The idea that a physical object can act as a place-holder for memory has a long history. As the 1856 publication *Elegant Arts for Ladies* put it, 'Hair, that most imperishable of all the component parts of our mortal bodies, has always been regarded as a cherished memorial of the absent or lost'.[1] Hair could be woven into jewellery – earrings and broaches fashioned from hair (or perhaps the hair of two lovers entwined) were particularly common in the nineteenth century. A lock of hair could also be contained in a locket, an object designed to be touched while protecting its fragile contents.[2]

Miniature portraits, painted initially on vellum and then later on ivory, served a similar purpose. These first became common in royal courts in the sixteenth century. Miniatures could be openly displayed or discretely concealed – a necessity in the case of clandestine love affairs. Edward, First Lord Herbert of Cherbury, a fashionable court figure in the early seventeenth century, nearly lost his life on account of such a portrait. When Sir John Ayres discovered Cherbury's likeness in his wife's possession, he accosted his rival in the street,

severely wounding him.[3] The tale is indicative of the power associated with the act of giving. As the French sociologist Marcel Mauss put it: 'To make a gift of something is to make a present of some part of oneself'.[4] As Mauss observed, the value of the gift lies in its emotional as well as its material worth. While it is true that sometimes its value is wholly emotional, expense can imply emotional investment. This is especially true of élite exchange.

By the eighteenth century, artists specializing in miniature portraits were established in London and other fashionable regional centres. The objects of memory that could be commissioned from such individuals had advantages over locks of hair in that they could contain short written messages, and yet were still small enough to be hung around a neck on a ribbon or in other ways kept close to the person. For high-status women they became expected accoutrements. It was said that by the 1770s the miniature portrait had become an 'ornament necessary' to any woman with a pretence to a 'Station in Life'.[5]

Lockets and miniature portraits were bespoke items. There were other, cheaper ways of fashioning keepsakes. One of these was a love token – a coin whose surface had been polished and re-engraved with a personal message. In this case it was the time invested in the creation of the object, rather than the expense of acquiring it, that gave emotional weight to the act of giving. A coin, a mechanism of financial exchange repurposed to memorialize a private promise, could be pierced and worn around a neck or otherwise kept safe. Like portraits, tokens could form part of complex exchanges that included the giving of locks of

hair and letters and, on occasion, the acquisition of tattoos.[6]

They could even be engraved with likenesses, a couple hand-in-hand being particularly common. In contrast to jewellery and portraits, however, the making (or acquisition) of a token was an act accessible to a wide range of the population. While it was necessary for the recipient to have some ability to read, the repeated use of a small range of stock phrases lowered literacy requirements. Many tokens bear the phrase 'When this you see', for example. Even those with limited reading skills might recognize these words and know the sentiments invested in the item into which they were cut.

Like other objects of memory, love tokens were commissioned by those about to be separated. The services of miniature portrait painters were particularly sought after by naval and military officers with orders to embark for overseas service. Such objects were gifted alongside promises of reunion, or perhaps in the hope that the giver would not be expunged from memory once they had sailed over the horizon. Just over sixteen percent of tokens in the Millett collection make reference to a farewell, departure or some other moment when lovers would be separated. Others bearing images of three-master ships, sloops and other vessels probably allude to similar circumstances. Some carry images of a sailor bidding farewell to a wife, relative or lover (#018, p. 70). Floral decoration, especially depictions of forget-me-nots, were also common embellishments.

Many of these tokens were presented as gifts by convicted criminals. The words 'When this you

see', for example, can be found on over a quarter of known tokens fashioned or commissioned by convicts sentenced to transportation.[7] The same message can occasionally be found tattooed on both male and female convict bodies, suggesting that this form of exchange was not restricted to gifts provided by men to women.[8] Some nineteenth-century commentators noted the connection between the verse and mementos left behind by those sent overseas for 'their country's good'. Thus, William Martin, who served as a surgeon-superintendent on a convict voyage to Australia in 1832, regaled dinner parties with stories of the signs and symbols adopted by criminal gangs. The felons entrusted to his care, he claimed, had revealed that initiates to the Society of Forty Thieves (a London criminal organization for adolescent thieves), were presented with 'a badge of brotherhood'. This 'medal' was engraved with the words 'When this you see, remember me, & bear me in yr mind. Let all the world say what they will, don't prove to me unkind.'[9]

Newspaper accounts made similar connections. In a complex case described in the *Morning Chronicle* in 1829, the prisoner was found to have a 'love token' made of copper, 'about the size of a two-penny piece', with this verse 'neatly cut upon it with a very fine punch'.[10] The *Morning Post* reported another case where a pair of suspected pickpockets found loitering outside the opera house were sentenced to two months hard labour in the House of Correction when one was found to have a similar token in his possession.[11] Another was discovered on the person of a young woman arrested for stealing lace from a silk mercer in Oxford Street in 1837. It turned out that the token had been given to her by a former lover who had been transported five years previously. When she was searched at the station-house, a lock of his hair 'wrapped up in a piece of white scented paper' was also discovered 'concealed in her bosom'. She was committed for trial by the magistrate who told her that 'in all probability she would soon have an opportunity of seeing her poetical true-love in a far distant country'.[12] Travellers' reports of the new 'thief colony' even reported that 'When this you see' was engraved on the tombstones of deceased former convicts.[13]

The notion that criminals had a set of counter values distinct from the norms of society became widespread during the 1820s panic over rising crime rates. Where historians note rapid and uncontrolled urbanization, high levels of unemployment and high prices, contemporaries pointed the finger of blame at the 'undeserving poor'. A desire to identify criminal traits led to much speculation about the nature of criminal associations.[14] The idea that members of criminal organizations carried medallions 'coined' by ingenious underworld artists took hold in middle-class imaginations. These badges of membership consisted of penny-pieces, 'the ordinary impressions on which were filed off', and in their place the words 'When this you see Remember me When I am far away…' added.[15]

Despite the fears of nineteenth-century moral entrepreneurs, there is much evidence to suggest that the verse 'When this you see' was in popular circulation as a mnemonic device long before it was co-opted by those condemned to a life in exile

by British and Irish courts. Tin-glazed earthenware mugs and tankards inscribed with the phrase bear dates as early as 1647.[16] In Staffordshire pottery towns even tombstones were sometimes fashioned out of glazed earthenware. One example dated 1865 is inscribed 'When this U C remember mee' – proof that this was a device employed in cemeteries other than those located in far-flung penal colonies.[17]

The same verse (or variants of it) can be found on many love tokens that appear not to be the work of convicted felons. A token in the Millett collection with the text 'Mr JOHN LANE AND Mrs LANE' is engraved with an image of a respectably attired man and woman both with glasses in hand sitting on high-backed chairs at a round pedestal table with bowl. On the reverse the words 'WHEN THIS YOU SEE PRAY THINK ON ME 1780' encircle a central image of a crown and two hearts pierced with darts (#107, p. 193). Another has the words 'When This You See, Then Think of Mee' inscribed around an ornate 'EH' monogram, and on the reverse the phrase 'My Heart With The, Shall Ever Bee 1778' (#117, p. 76). Court records reveal that the probability that a sentence to transportation inspired the fashioning of either of these tokens is vanishingly slim. After the outbreak of the American Revolutionary War in 1775, the trans-Atlantic trade in convicted prisoners was brought to an abrupt halt. Courts reacted accordingly. Not one single convicted prisoner was sentenced to transportation in London's Old Bailey in the years 1777–80. Regional circuit courts followed suit. It was only following the ill-fated decision to deport convicted felons to West Africa in the early 1780s that transportation was reintroduced as a sentencing option.[18]

Even the words 'Let all the world say what they will', suggesting disapprobation following the commission of some transgressive act, turns out not to be restricted to tokens fashioned by convicts. John White, for example, commissioned a token engraved with this verse to celebrate his marriage to Catherine Elizabeth Fraser at St Leonards, Shoreditch, on 11 April 1829 (#191).[19] The phrase was also in circulation long before the First Fleet was dispatched to Botany Bay. It was deployed by Bishop Hoadly in a 1731 letter that was later held up as an exemplar of elegant writing.[20] From there it made its way on to a number of other objects including tea pots and rolling pins.[21]

At the same time as miniature portraits became essential accoutrements for wealthy women, developments in mass production techniques helped to bring other objects of memory within the reach of the less well-off. In 1761 Josiah Wedgwood entered into an agreement with the Liverpool printer John Sadler. Sadler had recently invented a process for transfer printing directly on to the surface of tin-glazed tiles. He adapted the technique so that it could also be applied to creamware pottery supplied by Wedgwood. The process involved applying metallic-oxide ink to an engraved copper plate and then transferring the design to paper, which was then pressed on to a glazed ceramic surface while the ink was still wet.[22] Transfer printing drastically reduced the costs of production for decorated items. Sadler claimed that he could print more tiles in six hours 'than one hundred skilled pot painters could have

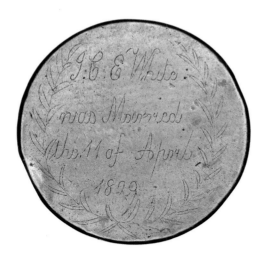
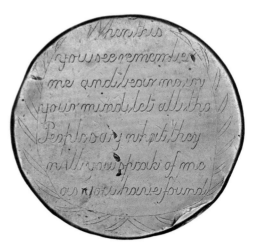

Coin #191

painted'. The lowering of production costs opened up new markets.[23]

Most of the designs selected to supply the market for cheaper wares drew on existing genre prints. Eliminating the need to commission new designs was an effective way of further cutting costs, although an engraver had to be employed to fashion plates for each recycled image. While prints based on Boucher paintings might be used on items designed for middle-class tables, more popular scenes were reproduced on tiles and other mass-produced wares. Amongst the works repurposed by Sadler were images of popular actors and maritime scenes. These included five 'sailor's farewell' and 'sailor's return' designs.[24] Two of these were based on a pair of prints first published by Thomas Booth in 1744.[25]

The first of these prints depicts a modestly dressed sailor bidding his lover farewell before embarking for the South Seas with Anson in 1740. Anson and his crew returned to a rapturous welcome in 1744. The capture of the *Acapulco* galleon laden with 34.5 tonnes of silver made the survivors of this voyage wealthy. A seaman's share of the first instalment of the prize money amounted to £171, the equivalent of twelve years' wages.[26] In the second print, based on a painting by Louis Philippe Boitard, a now expensively dressed sailor drops a pocket watch into his lover's outstretched apron filled with coin **(fig. 1)**.[27]

Sadler & Green tiles **(fig. 2)** with these designs found a market in the transatlantic homes of those who had profited from maritime commerce. Many were exported to the American colonies where they

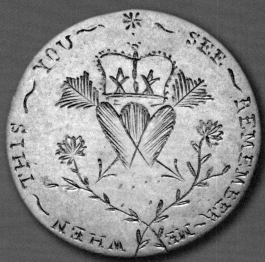

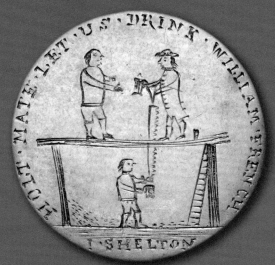

#113

#117

were commonly used to line hearths.[28] Following the partnership with Wedgwood, sailor's farewell and return designs were transfer-printed on to creamware plates and other ceramic vessels. These had more versatile uses as gifts or were further adapted to commemorate specific events.

From the 1760s Wedgwood transfer-printed scenes of sailors leaving wives or lovers were replete with verses including 'When this you see'.[29] These were reproduced on creamware pint mugs, punch bowls and jugs. The same transfer prints were used again and again, often by different potteries who had either acquired the original engraved plates or copied them. They also had their parallels in existing elite practices and the East India trade. Porcelain punch bowls and tea pots, hand-painted by Chinese artists in Canton for the European export market during the Qianlong period (1736–95), reproduced images from Booth's 1744 prints. On one side a sailor dressed in slops holds his lover by the waist while pointing to a ship. On the other, the couple are happily reunited. The returned sailor is fashionably dressed, has a walking stick tucked neatly under his arm, and is in the act of dropping a watch into the coin-laden apron of his lover (fig. 3).[30] Capitalizing on the fame of Anson's voyage, these objects made allegorical reference both to the dangers and the potential rewards of service with 'John Company'.

Oceanic travel in the age of sail was notoriously dangerous. Sailors lived in particular fear of being driven on to a lee shore, and those who sailed the sea for a living sometimes chose to adorn their arms with protective words and symbols, pricked out in ink or gunpowder in order to ward off such a fate. As one such verse had it, 'From, rocks, hills and sands and barren lands, kind fortune set me free'.[31] Others tattooed themselves with anchors. There is perhaps no trope more associated with a sailor than an anchor emblazoned, Popeye-style, on the arm. In Arthur Conan Doyle's *Study in Scarlet*, Holmes impressed Watson with his ability to identify a former marine, in part because of the 'great blue anchor on the back of the fellow's hand'. As Holmes explained, while the man's bearing indicated former military service, his tattoo 'smacked of the sea'.[32] The symbol is as much biblical, however, as it is nautical. Its frequent appearance next to the word HOPE is in reference to Hebrews 6:19: 'which hope we have as an anchor of the soul, both sure and steadfast…'. Like their tattooed counterparts, many love tokens were produced with images of Hope leaning on an anchor, her watchful gaze protecting a departing ship (#204, p. 80). Survivor bias could give the illusion that such talismanic devices inoculated the wearer from the outrageous twists of fortune. Whereas the limbs of the old sailor were exposed to view, failed designs punctured into the decomposed flesh of those lost at sea were not.

Yet those in peril at sea were in danger of much more than just being driven by a gale on to a jagged and unforgiving shoreline. Even when not in action, a ship was a dangerous place. Of those who sailed with Anson in 1740, four died in action and more than 1,300 from disease.[33] In the years 1778–1806 a staggering nineteen percent of the strength of the Royal Navy was sent to hospital each year, mostly for non-battle related injuries.[34] The Naval toast beloved of midshipmen and lieutenants

fig. 1 Detail from T. Booth, *Sailor's Return* (1744). British Museum, 1871,1209.2744

fig. 2 Detail from Sadler & Green tin-glazed earthenware tile, transfer-printed, Liverpool, 1758–61.V&A, c.583–1922

eager for the opportunity for promotion was 'To a bloody war and a sickly season'.[35] The risk from the sickly season was far greater, however, than that from the bloody war.

Deaths from disease were usually more common at the start and end of a voyage. Inadequate pre-voyage screening often meant that passengers and crew brought infections onboard with them. Contagious diseases could spread rapidly in the confined spaces of a vessel. Typhus, dysentery, smallpox, measles, pleurisy and influenza were all common killers at sea. Unlike on land, it was not possible for the healthy to isolate themselves from the sick. As a result, infections at sea were often less discriminate than on shore. Fevers, however, tended to burn out as the pool of those who had not previously been infected reduced. While the risk of contagious disease declined as a voyage

fig. 3 Detail from Qianlong period porcelain punch bowl made for European Market. Author's collection

progressed, other health risks increased. As the contents of casks turned bad, the probability of food poisoning grew. Reduced nutritional intake could also weaken immune systems.

Scurvy, a multi-system disorder resulting from reductions in vitamin C intake posed a particular threat for those who embarked on long oceanic voyages. A peculiar aspect of this deficiency disease is the mortality rate amongst those who, though afflicted with swollen gums and other outward signs of the disease, appeared otherwise stable. Many of those who died on Anson's 1740–44 voyage 'ate and drank heartily, were cheerful, and talked with much seeming vigour' shortly before they expired.[36] While stopping to resupply reduced the risks associated with deficiency diseases, it increased the risk of introducing fresh contagions.

The risk of death for passengers and crew on Dutch East India company vessels sailing in the 1730s to the East Indies was over 12.5 times that for young adults on land.[37] While death rates at sea fell in the period 1700–1850, those who stepped on board a vessel continued to be at greater risk of death than those who remained on land. The probability that a convict bound for the Australian penal colonies in the years 1817–53 would die at sea was double that on land. It is perhaps no surprise that free migrants were warned that a voyage to the Antipodes would be a 'terrible undertaking'.[38] Those in the tropics faced even greater dangers. In the 1830s British troops in Bengal died at a rate that was 4.7 times greater than those in barracks in the British Isles.[39]

Despite the dangers, Britons took to the sea in ever increasing numbers. An estimated 108,000 English, Welsh and Scottish migrants departed for the Thirteen Colonies in the period 1700–75.[40] Departure rates increased substantially in the nineteenth century. Some 630,000 passengers from Britain and Ireland disembarked in United States ports between 1820 and 1845. Others migrated to Canada, the Cape Colony and Australia.[41] The maritime labour force also increased substantially. During the period 1789–92 there were over 108,000 seamen employed annually in the Navy and merchant marine. At the height of the Napoleonic Wars this figure rose to just under 246,000 before falling back to an annual average of 152,000 between 1816 and 1828.[42]

As the numbers who took to the sea increased, so too did the market for presents that might be exchanged as a promise of a safe and prosperous

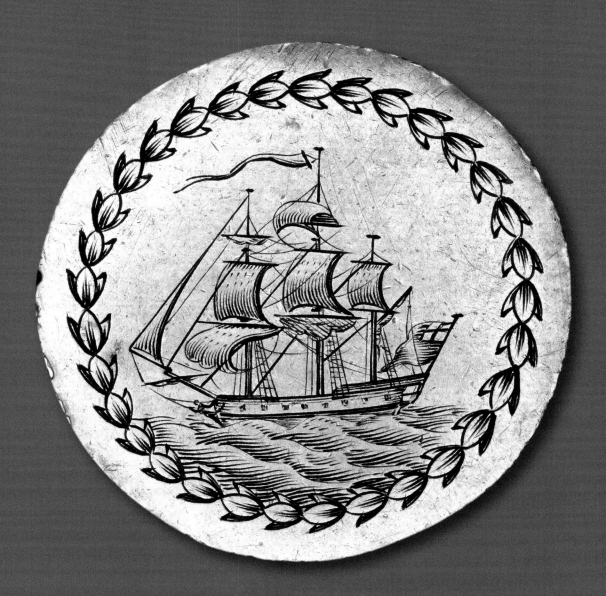

#204
———

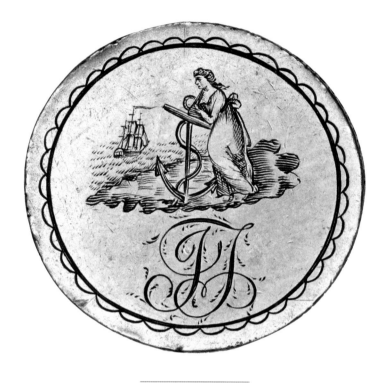

Coin #204 (obverse)

return. It was not just Wedgwood who cashed in on this growing opportunity. The radical pamphleteer Thomas Spence dealt in tokens in the years 1794–96. While many of those he produced for sale in his London shop bore political messages, some were also produced for his brother's business. Jeremiah Spence ran a shop in Newcastle that supplied slop clothing to seaman.[43] A die commissioned by Thomas inscribed with the words 'WHEN THIS YOU SEE REMEMBER ME' encircling a crown and anchor and two hearts was probably intended for sale to Jeremiah's nautical clients (fig. 4).[44] These readymade love tokens were presumably designed to be given away as gifts by those about to embark on a voyage.

After 1800, industrial practices further reduced manufacturing costs. During the first half of the nineteenth century, Sunderland potteries mass-produced jugs and tankards decorated with various transfer prints of the sailor's farewell. A feature of these wares was their use of lustre. Gilding had long been established as a technique

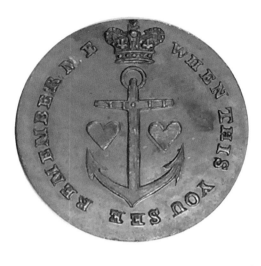

fig. 4 A token from the author's collection

for decorating ceramics but, with gold applied to each item and burnished by hand, it is a labour-intensive process, and only the very wealthy could acquire the resultant vessels. In 1805 Wedgwood developed a technique that utilized small amounts of gold dissolved in acid and applied in thin layers to glazed ceramic wares with a brush or by dipping. Several Sunderland potteries adapted the process to produce a 'splash lustre' – a refined version of Wedgwood's technique where small drops of oil were applied prior to firing to give the finished piece a mottled effect.[45]

Sunderland was a centre of the British coal trade and therefore an important maritime hub. Lustreware jugs, punchbowls and tankards furnished the market for objects of memory in part because these low cost, eye-catching ceramics were functional. Each time a tankard or jug was used, the message transfer-printed on the lustre-emblazoned vessel reminded the user of the giver and their promised return. Other objects functioned in the same way, including rolling pins made at the Nailsea glassworks near Bristol. These were printed with maritime designs and the 'When this you see…' verse. Such wares remained popular until the mid-century. New production runs were commissioned after the outbreak of the Crimean War, for example – an attempt to cash in on both patriotic fervour and the upturn in demand for gifts amongst departing sailors and soldiers. Thereafter sales declined as photography techniques improved in the second half of the nineteenth century. The advent of the camera effectively brought the miniature portrait, the departing gift

of choice for well-heeled late eighteenth-century officers, within the means of those who were not so well off. When servicemen departed for future wars, they left a likeness of themselves for loved ones to place on the mantlepiece, rather than a generic picture of a departing sailor and his lover printed on a jug or rolling pin.

Keepsakes and promises of reunion engraved or punched into coins became popular in an age when manufacturing techniques enabled the mass production of articles designed to be given as departing presents. While the potteries in particular responded to the rise in demand for objects of memory, the number of bespoke items also increased, including love tokens specifically crafted to commemorate a departure. As a cross-class phenomenon, it is particularly notable that hand-fashioned and mass-produced objects of memory share the same limited range of verses and images – including the sailor's farewell. Both were fashioned to guard against the dangers associated with oceanic travel. It is no coincidence that this was also a time when ever larger numbers of individuals either worked in maritime industries or found themselves in peril on the sea as passengers. Love tokens provided travellers who lacked the means or resources to acquire more expensive manufactured objects an opportunity to fashion a personalized object of memory. This probably explains why so many recorded examples can be linked to those condemned to a social death via a sentence of exile to a penal colony. The practice, however, was not limited to social outcasts despite the claims to the contrary asserted by some nineteenth-century observers of criminal practices. For many Britons, a hand-engraved object conveyed a greater emotional investment than a purchased item.

As literacy levels increased and the dangers of oceanic travel subsided, the custom of fashioning a love token as a promise of return became less marked. While tokens continued to be produced after the mid-nineteenth century, with many examples dating from the First World War, a photograph served as a more effective means of keeping a memory alive. Postage systems and trans-continental telegraph wires also provided ways of keeping in touch, further reducing the need for talismanic devices promising a safe return.

1 *Elegant Arts for Ladies*, London 1856, pp. 3–4.

2 Geoffrey Batchen, *Forget Me Not: Photography & Remembrance*, New York 2004, p. 32.

3 Edmund Lodge, *Portraits of Illustrious Personages of Great Britain*, London 1835, Chapter 13, p. 3.

4 Marcel Mauss, *The Gift: The Form and Reason for Exchange in Archaic Societies* (1950), trans. W.D. Halls, London 1989, p. 12.

5 Marcia Pointon, '"Surrounded with Brilliants": Miniature Portraits in Eighteenth-Century England', *The Art Bulletin*, vol. 83, no. 1, 2001, pp. 51–55.

6 Hamish Maxwell-Stewart, Paul Donnelly and Timothy Millett, 'Dr Martin and the Forty Thieves' in Lucy Frost and Hamish Maxwell-Stewart (eds.), *Chain Letters: Narrating Convict Lives*, Melbourne 2001, p. 187; Sally Holloway, *The Game of Love in Georgian England: Courtship, Emotions and Material Culture*, Oxford 2019, pp. 69–92.

7 Timothy Millett and Peter Lane, 'Known Convict Love Tokens' in Michele Field and Timothy Millett (eds.), *Convict Love Tokens: The Leaden Hearts the Convicts Left Behind*, Kent Town, South Australia 1998, pp. 75–114.

8 Hamish Maxwell-Stewart and James Bradley, 'Convict Tattoos: Tales of Freedom and Coercion' in Field and Millett 1998, pp. 47–52.

9 'Journal of George Washington Walker', Mitchell Library, State Library of New South Wales, B708-1, pp. 210–14.

10 'POLICE', *Morning Chronicle*, 28 April 1829.

11 'POLICE INTELLIGENCE', *Morning Post*, 25 August 1824.

12 'POLICE', *London Dispatch*, 28 May 1837.

13 'LITERARY VARIETIES', *Bristol Mercury*, 26 July 1845.

14 *The Examiner*, 25 November 1827.

15 *Morning Chronicle*, 25 August 1824.

16 Alexandra Walsham, 'Domesticating the Reformation: Material Culture, Memory, and Confessional Identity in Early Modern England', *Renaissance Quarterly*, vol. LXIX, no. 2, 2016, p. 574.

17 G. and R.E. Wolliscroft Rhead, *Staffordshire and Potters*, London 1906, p. 129.

18 Emma Christopher and Hamish Maxwell-Stewart, 'Convict Transportation in Global Context *c.*1700-1788' in Alison Bashford and Stuart McIntyre (eds.), *Cambridge History of Australia*, vol. 1, Cambridge 2013, pp. 74–78.

19 Marriage Register, St Leonard, Shoreditch, Hackney, England, London Metropolitan Archives; London, England; Reference Number: DL/T/069/040, no. 438, p. 146. *London, England, Church of England Marriages and Banns 1754–1932*, www.ancestry.com/ (accessed 11 December 2019).

20 Vicesimus Knox, *Elegant Epistles: Being a Copious Selection of Instructive, Moral and Entertaining Letters, From the Most Eminent Epistolary Writers,* London, vol. IV, part 1, 1812, p. 110.

21 White glazed earthenware rolling pin, National Maritime Museum, Greenwich, London, AAA6231.

22 Maxine Berg, *Luxury and Pleasure in Eighteenth-Century Britain*, Oxford 2005, p. 136.

23 Brian Dolan, *Josiah Wedgwood: Entrepreneur to the Enlightenment*, Bury St Edmunds 2004, pp. 83–84.

24 John Hodgkin, 'Transfer Printing on Pottery. Part II – A Catalogue of Liverpool Tiles', *Burlington Magazine*, vol. VI, no. 22, 1905, p. 325.

25 Bernard Watney, 'Engravings as the Origin of Designs and Decorations for English Eighteenth-Century Ceramics', *Burlington Magazine,* vol. CVIII, no. 761, 1966, pp. 407, 409.

26 Glyndwr Williams, *The Great South Sea: English Voyages and Encounters 1570–1750*, New Haven 1997, p. 246.

27 J. Booth, *Sailor's Return* (1744), British Museum, 1871,1209.2744.

28 Marshall B. Davidson, 'American House-Warming', *The Metropolitan Museum of Art Bulletin*, vol. III, no. 7, 1945, p. 179.

29 Sarah Richards, *Eighteenth-Century Ceramics: Products for a Civilised Society*, Manchester 1999, pp. 53–54.

30 Author's collection.

31 Description of John Popjoy's tattoo, transported on the *Larkins* to New South Wales, Tasmanian Archive, CSO/1/416/9354.

32 Arthur Conan Doyle, *A Study in Scarlet and a Sign of the Four*, Ware 2004, p. 18.

33 Williams 1997, p. 246.

34 Zachary B. Friedenberg, *Medicine Under Sail*, Annapolis 2002, pp. 40–41.

35 'The Navy' in Susan Ratcliffe (ed.), *Oxford Essential Quotations*, 4th edition, Oxford 2016.

36 George Anson, *A Voyage Round the World in the Years 1740, 41, 42, 43, 44*, London 1853, p. 44; Roger W. Byard

and Hamish Maxwell-Stewart, 'Scurvy – Characteristic Features and Forensic Issues', *American Journal of Forensic Medical Pathology*, vol. XL, no. 1, 2019, pp. 43–46.

37 James C. Riley, 'Mortality on Long-Distance Voyages in the Eighteenth-Century', *The Journal of Economic History,* vol. XIV, no. 3, 1981, p. 655.

38 Rebecca Kippen and Hamish Maxwell-Stewart, 'Sickness and Death on Convict Voyages to Australia' in P. Baskerville and K. Inwood (eds.), *Lives in Transition: Longitudinal Research in Historical Perspective*, Toronto 2015, pp. 43–70.

39 Philip D. Curtin, *Death By Migration: Europe's Encounter with the Tropical World in the Nineteenth Century*, Cambridge 1989, pp. 7–8.

40 Aaron Fogleman, 'Migrations to the Thirteen British North American Colonies, 1700–1775, New Estimates', *The Journal of Interdisciplinary History*, vol. XXII, no. 4, 1992, pp. 691–709.

41 Charlotte J. Erickson, 'Emigration form the British Isles to the USA in 1841', *Population Studies*, vol. XLIII, 1989, p. 347.

42 David J. Starkey, 'Quantifying British Seafarers, 1789–1828' in Richard Gorski (ed.), *Maritime Labour: Contributions to the History of Work at Sea*, Amsterdam 2007, p. 100.

43 P.M. Ashraf, *The Life and Times of Thomas Spence*, Newcastle 1983, pp. 191–92.

44 Author's collection.

45 Michael Gibson, *19th Century Lustreware*, Woodbridge 1999, pp. 14–15.

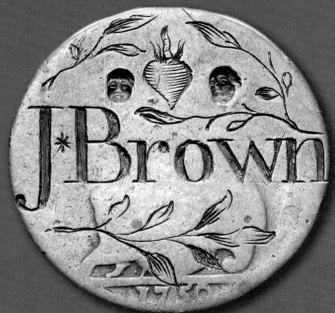

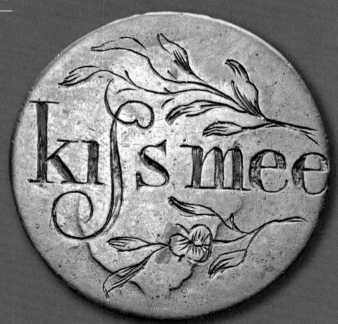

6

'Kiss Mee'

Coins, Love and Matrimony

Sally Holloway

Since at least the sixteenth century, courting men and women had exchanged bent, bowed and broken coins in order to make marriage contracts.[1] In his memoir, the Somerset husbandman John Cannon (1684–1743) recounted how he bound himself to his uncle's maidservant Mary Rose (d. 1728) in 1706 by exchanging a written contract and breaking a silver shilling in two:

> [W]e made our Witness neither to transgress or forsake each other till death & further promising Matrimony as soon as God would please to vouchsafe a favourable opportunity & for confirmation thereof we bow'd & broke in pieces an English Shilling & I kept one part & Mary the other & she made two bags and sew'd this Contract & piece of Silver in one for herself and ye other for me never to be opened till we had Consummated Matrimony.[2]

Following the exchange they were considered married before God (if not yet in law), and were known locally as 'Man & Wife wanting ye Ceremony of Marriage'. Unfortunately, this was as far as their relationship progressed, with John opting to marry someone else rather than solemnizing this union.[3] A similar ritual is brought to life in Joseph Addison's tale *The Adventures of a Shilling* (1710), told from the perspective of the shilling itself. The coin recounts how a milkmaid 'bent me, and gave me to her sweet-heart', alongside the declaration "*To my love and from my love*". In Addison's story, the couple went on to consecrate their marriage several days later.[4] For others, a silver sixpence proved equally effective in securing a contract, with the hero of the opera *The Country-Wedding* (1729) recalling how 'we love [one another], and as a Token, / A crooked Sixpence was between us broken'.[5] The breaking and bending of such coins remained an important material ritual in contracting marriage through the first half of the eighteenth century.

The nature of coins as tokens changed following the Hardwicke Marriage Act of 1753, which required a valid marriage to take place in church in a single

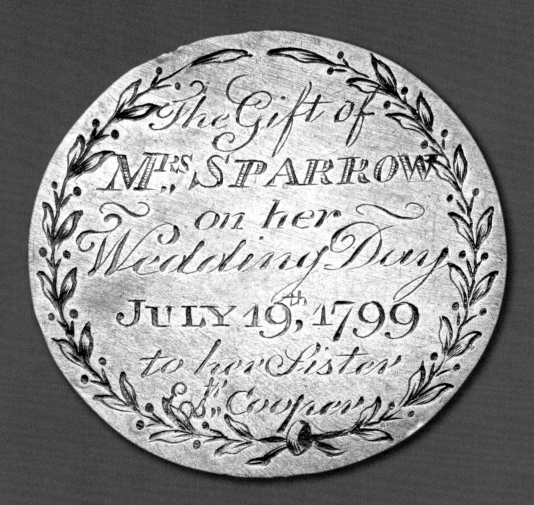

The Gift of
Mʳˢ SPARROW
on her
Wedding Day
JULY 19ᵗʰ, 1799
to her Sister
Eᵗʰ Cooper

#120

———

Mary Cooper married Stephen Sparrow on 19 July 1799 at
Christchurch with St Mary and St Stephen, Spitalfields, Tower
Hamlets. He came from Chesterton in Cambridge, she from
the parish. Witnesses were Elizabeth Smith and Diana Guppy.
This was the only Sparrow married on this day.

legal event. As marriage contracts were no longer enforceable in the church courts, coins lost their legal significance to become primarily affective gifts. Due to their longstanding association with betrothal and marriage, silver shillings still made apt wedding gifts between family members, alongside traditional love tokens such as ribbons and gloves typically presented by couples to their guests.[6]

Newly married Mrs Sparrow gave an engraved shilling to her sister Esther Cooper to mark her wedding day on 19th July 1799 (#120). The coin both memorialized the sisters' bond as Mrs Sparrow left to establish a new household and family unit – denoted by her new name engraved on the coin – and may also have functioned as a lucky token for Esther's own nuptials. The text is encircled by a wreath of myrtle threaded through a wedding ring, symbolizing sensual love, marital happiness, harmony and longevity.[7]

'Crooked' coins were harnessed as amulets by suitors and spouses hoping to bring their relationships good fortune. The physical alteration of these coins activated them as lucky objects, changing their value from an economic to a superstitious or magical currency.[8] Lucky 'benders' were made by bending coins into an 'S' shape, most often a sixpence due to the greater malleability of silver.[9] The distinctive shape of benders made them easily distinguishable, so they could quickly be reached for in a pocket to hold or rub as desired. If returned to its original state, this indicated that a coin's lucky properties had come to an end. As the young Helen Harcourt discovered in Mrs Yeates's novel *Eliza*, her sixpence had straightened out following her lover Timothy's desertion:

he gave me a crooked sixpence the last time we parted at the bun-house, at Lyncum – I have never liked buns since; the very sight of a brown bun, put's [*sic*] me in mind of *Timothy's* inconstancy; the very crooked sixpence, which was as crooked a one as ever I saw, some how or other, how I never knew, was quite flat when I took it out of my pocket to throw it away, when I heard that the false hearted man was married to *Betty*, the chandler's nurse.[10]

Lucky tokens such as silver coins, medals and foreign currency were carried around in pockets in this manner, and stored in special silk or net purses, lending them the name 'pocket-pieces'. They were commonly modified in some way in order to secure their amuletic properties, including hammering them with notches or engraving them with the name or initials of the giver.[11]

Engraved pennies and halfpennies made particularly popular gifts between plebeian couples, since they were widely available (and frequently counterfeit), inexpensive, portable, durable, and easy to personalize given their soft copper and larger size. Women carried them around in their pockets alongside courtship gifts such as ribbons and locks of hair, and material proof of marriage such as wedding certificates.[12] Coins were also punched with holes to hang from ribbons around women's necks, enabling them to remain literally in touch with loved ones during periods of absence.

Coin #165, which probably originated as a copper halfpenny, has a small circle stamped out at the top; the obverse is engraved with the phrase

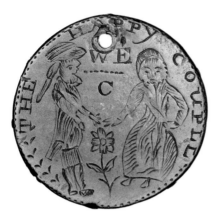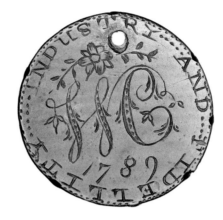

Coin #165

'THE HAPPY COUPLE', below which a man and woman reach to clasp hands in evocation of their marriage. The initials 'W E' above the letter 'C' likely reference the bride's new identity ('W C'), as she married 'H C' inscribed on the reverse. The motto 'INDUSTRY AND FIDELLITY' references the ideal match, one that was at once industrious, productive, faithful and loving (#165).

In embodying the couple's hopes, and their new roles as husband and wife, the coin symbolically made a marriage as it was physically carried against the owner's body (#093, p. 86).

The ritualized process of turning a coin over in the palm of a hand, running a finger over its surface, holding it to the lips to kiss and between the teeth to taste worked to foster feelings of love. The associated mottoes such as 'Kiss Me', 'When You See This Blow Me a Kiss', 'When This You See Think of Me' and 'Forget Me Not' reveal the purpose of coins as tactile reminders of a loved

one, and a material prompt to reflect on them in absentia. Such mottoes are far from unique and appear on a wide range of related love tokens such as patch boxes, perfume bottles, posy rings, rolling pins, snuff boxes and stay busks, clearly situating coins among the material culture of love more broadly. Coin #093, a re-used copper half-penny, was created or commissioned by J. Brown as an emblem of his love, with a burning heart situated above his name, denoting the intensity of his passion. Either side of the heart sit two faces representing Brown and his beloved. The reverse of the coin exhorts the recipient to 'kiss mee', with the letter 's' carved to resemble a heart or pair of pursed lips. It both operates as a metonymic object, embodying the giver himself, and invokes the widespread ritual of kissing love tokens to strengthen an emotional bond.[13]

The eighteenth century witnessed a new celebration of romantic love before marriage, with a

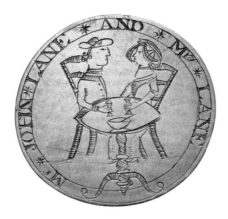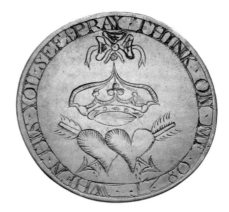

Coin #107

loving match seen as a key route to lasting happi-
ness. The copper halfpenny #107 acts as a material
expression of the marriage of Mr and Mrs Lane,
who are depicted on one side drinking together at
a tea table, invoking the happy domesticity of their
family home. They sit facing each other and meet
one another's gaze directly, representing the union
between their two hearts. The reverse features a
true lover's knot symbolizing marriage, popu-
larly known as 'tying the knot'.[14] Suspended from
the knot is a crown atop two bleeding hearts shot
through by arrows. This combination of symbols
sanctifies the couple's marriage, underscoring the
sacred status of their union. It can also be found
on other coins made to celebrate a marriage (such
as #128), suggesting that it was made to a standard
professional design. By exchanging this small but
enduring token, the couple created a tangible
object which anchored their loving marriage in the
material world.

Coins made eminently suitable tokens of
courtship, betrothal and marriage as they could
be modified by individuals in diverse ways,
whether bent, hammered with notches, broken
into pieces or engraved with amorous mottoes.
When smoothed to a blank surface, a shilling,
penny or halfpenny could facilitate a whole
symbolic language of love told through burning
or wounded hearts, crowns, rings, true lover's
knots and blossoming flowers. The ways in which
these coins were subsequently worn, handled and
stored provides further valuable clues for histo-
rians about their affective meaning, as they were
saved in specially made bags, worn against the
skin, and touched, tasted and kissed in order to
elicit feelings of love. The very durability of coins
helped to give relationships a sense of permanence
and to provide a lasting means of memorializing a
romantic bond, years or even centuries after it was
first formed.

I am grateful to Tim Hitchcock, Sarah Lloyd and Bridget Millmore for sharing invaluable feedback on versions of this chapter.

1 David Cressy, *Birth, Marriage and Death: Ritual, Religion, and the Life-Cycle in Tudor and Stuart England*, Oxford 1997, pp. 259, 263–66; Laura Gowing, *Domestic Dangers: Women, Words, and Sex in Early Modern London*, Oxford 1996, pp. 159–60; Bridget Millmore, 'Love Tokens: Engraved Coins, Emotions and the Poor 1700–1856', unpublished PhD thesis, University of Brighton 2015, pp. 42–45; Diana O'Hara, *Courtship and Constraint: Rethinking the Making of Marriage in Tudor England*, Manchester 2000, pp. 84–88.

2 John Cannon, 'Memoirs: of the: Birth Education Life and Death of: Mr: John Cannon Sometime Officer of the Excise and Writing Master at Mere Glastenbury & West Lydford in the County of Somersett', 1684–1743, Somerset Archive and Records Service, DD/SAS C/1193/4, f. 64.

3 Cannon, 'Memoirs', ff. 57, 126.

4 Joseph Addison, *The Tatler*, no. 249, 11 November 1710, p. 211.

5 *The Country-Wedding, And Skimington: An Opera*, London 1729, Air III, p. 4.

6 See Cressy 1997, pp. 362–63; Felicity Heal, *The Power of Gifts: Gift-Exchange in Early Modern England*, Oxford 2014, pp. 65–66; R.A. Houston, *Bride Ales and Penny Weddings: Recreations, Reciprocity, and Regions in Britain from the Sixteenth to the Nineteenth Century*, Oxford 2014, pp. 60, 82.

7 Jack Tresidder (ed.), *The Complete Dictionary of Symbols in Myth, Art and Literature*, London 2004, p. 332. For a further example see #090.

8 Paul Donnelly, '"A Bracelet of Bright Haire": Memory and Tokens of Love' in Michele Field and Timothy Millett (eds.), *Convict Love Tokens: The Leaden Hearts the Convicts Left Behind*, Kent Town, South Australia 1998, p. 58; 'Coins' in Jacqueline Simpson and Stephen Roud (eds.), *A Dictionary of English Folklore*, Oxford 2000; Iona Opie and Moira Tatem (eds.), *A Dictionary of Superstitions*, Oxford 2005, p. 357; Owen Davies and Timothy Easton, 'Cunning Folk and the Production of Magical Artefacts' in Ronald Hutton (ed.), *Physical Evidence for Ritual Acts, Sorcery and Witchcraft in Christian Britain: A Feeling for Magic*, New York 2015, pp. 209–31 at 215.

9 Bridget Millmore, '"An Heart that can Feel for Another": Love Tokens and the Icon of the Heart in Eighteenth-Century Britain' in Katie Barclay and Bronwyn Reddan (eds.), *The Feeling Heart in Medieval and Early Modern Europe: Meaning, Embodiment, and Making*, Berlin 2019, pp. 203–19.

10 Mrs Yeates, *Eliza, A Novel: In Two Volumes*, Lambeth 1800, vol. 2, p. 46.

11 See 'pocket-piece, n.', *Oxford English Dictionary Online*, www.oed.com/view/Entry/146418 (accessed 2 May 2020).

12 Barbara Burman and Ariane Fennetaux, *The Pocket: A Hidden History of Women's Lives, 1660–1900*, New Haven and London 2019, pp. 197–203; Katie Barclay, 'Doing the Paperwork: The Emotional World of Wedding Certificates', *Cultural and Social History*, vol. 17, no. 3, 2020, pp. 315–32.

13 Sally Holloway, *The Game of Love in Georgian England: Courtship, Emotions, and Material Culture*, Oxford 2019, pp. 69–92.

14 Matthew Prior, *Poems on Several Occasions*, London 1718, p. 331: 'So to the Priest their Case They tell: / He ties the Knot; and all goes well'.

7

'In Remembrance of the Bloody Fact'

Coins, Public Execution and the Gibbet in Hanoverian England

Steve Poole

Pocket-pieces commemorating public execution are comparatively rare. Unlike tokens celebrating love, friendship and family, achievement, or ideology, hanging tokens have few positive messages to communicate and do not presume a personal connection. To own one is to be reminded of traumatic events or, perhaps more positively, of the triumph of justice and the necessity of deterrence. Most, we can assume, were designed and cast for sale as souvenirs of a particularly notorious crime; one was struck in 1692, for example, to mark the execution of the French Jacobite agent Barthold Granval, for the attempted assassination of William III. Granval was hanged, drawn and quartered for his trouble and so the lavishly illustrated professionally produced coin might serve as an official memento of the King's providential escape and the failure of Jacobite conspiracy in a foreign court.[1] The execution of Jacobite rebels in Britain after the Battle of Culloden in 1746 caused further coins to be struck, this time featuring one prisoner dangling from a gallows and another two praying for mercy as they wait their turn, beneath the inscription, 'More Rebels A Coming'.[2] These were representations of a resilient protestant State, however, and not a conscious attempt to memorialize the guilty. The few that did so include coins marking the execution of the East Anglian murderer James Bloomfield Rush in 1849, and the London fraudster Henry Fauntleroy in 1824. While we know coins such as these were in circulation, we know

little of the circumstances of their manufacture, of their production and design, or the motivation of those who purchased them. This essay focuses on an exceptional and entirely unique coin in the Millett collection (#203, facing).

One of several individually struck by the same hand, it commemorates a noteworthy murder and an execution, but is too roughly designed and cast to have been intended for public sale. More remarkably still, we know not only the intention of the designer and the identity of the engraver, but the people to whom the coins were presented. It is a pocket-piece with a remarkable story to tell.

On a bitterly cold January morning in 1768, high on the downs beside the road between Salisbury and Blandford, a grim discovery was made in a chalk pit. It was the body of a man, partly covered in snow; the victim, without a doubt, of a brutal assault. His skull was fractured, there were deep stab wounds to his chest and abdomen, and his right hand was badly cut, perhaps in self-defence. How long he had lain there undetected and undisturbed, it was hard to say. Deep snow had clung to the Wiltshire uplands for the past month, leaving many of the county's chalk roads impassable to carriages and treacherous to anyone heading out on foot. News of accidental deaths and providential escapes had been circulating in the local press for three weeks and, by the end of the month, the city of Salisbury had given relief to more than 3,000 people. By all accounts, the winter of 1767–68 was extraordinarily harsh, and the snow stayed heavy on the ground until the end of the month. It was the thaw then that revealed the body in the chalk pit.[3]

The most likely cause of death was the sharp knife found discarded a short distance away, and some large flints left lying beside his head, but the time it had taken for the melting snow to reveal the body fed speculation that he had been murdered several weeks earlier and that the perpetrator was long gone. Two miles down the road in Salisbury, however, memories were quickly jogged. The dead man was recognized as a Jewish pedlar who tramped into Salisbury with a box of trinkets shortly after Christmas, stopped for a night at the Running Horse tavern, and left in the morning by the Blandford road just as the snow was beginning to fall. His name was Wolf Myers. This prompted further memory. A few hours after the pedlar's departure, some excitement had been caused by the arrival of a carrier who had picked up a wounded sailor on the Blandford Road and taken him to the city's new infirmary for treatment. The sailor said his name was John Curtis; that he had been walking to Salisbury from Plymouth when he was attacked by a lone highwayman, who stabbed him in the side with a cutlass, threw him to the ground, dislocating his shoulder, and robbed him of 20 guineas in cash. According to Curtis, the highwayman made for the fork in the road leading to Shaftesbury and galloped off. He gave a detailed description of his assailant to a Salisbury magistrate, and a reward notice was published, but the highwayman was never found. Curtis had had his wounds attended to in the infirmary, then left the following morning on the Gosport coach, 'with his box on his back'.[4]

The discovery of Myers's body caused an immediate reappraisal of Curtis's identity, the box he

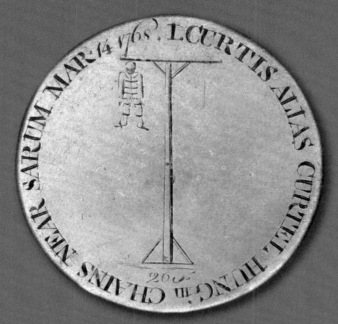

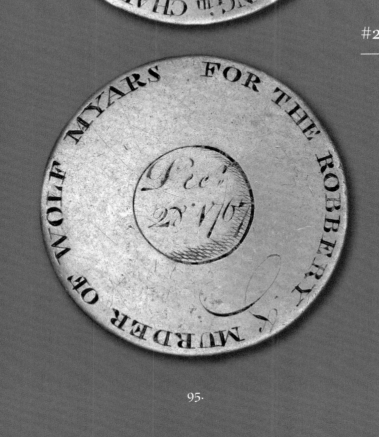

#203

was carrying, and the cause of his injuries. A coroner's inquest was convened, the sailor's guilt concluded, and a warrant sent down to the magistrates of Gosport and Portsmouth for his immediate arrest.[5] Curtis was soon found amongst the crew of a man-of-war in the harbour. He was taken up, his lodgings searched and some incriminating evidence discovered, the most telling of which was a trinket box containing 'wares such as the Jews normally carry'.[6] There was also a watch, assumed to have been stolen from Myers and some sticks of dried rhubarb, a common ingredient in Jewish cooking often carried by Jewish pedlars. A handbill was also found, identical to one in the dead man's coat pocket, advertising the business of Jacob Cohen, a Jewish silverware dealer from Frome, together with a letter in Curtis's hand asking the Gosport magistrate Edward Bedford to help him recover his alleged losses at the hands of the highwayman, but clearly never sent.[7] An audience with Bedford was granted nevertheless, because the Justice of the Peace questioned Curtis three times over the next eight days in Gosport Bridewell.

Bedford pushed Curtis for a confession but the sailor steadfastly denied both the murder and the robbery. The trinket box was his, he insisted, and he had been trading its contents to earn a living while his ship made ready to sail. Bedford reminded him of the consequence of going out of the world 'with a lie in his mouth' and assured him he had reliable witnesses ready to testify in court. This was an exaggeration. Bedford's key witness was to be Jacob Cohen, the Frome dealer who had sold Myers his pedlar's box and its contents. Cohen was to confirm the origin and ownership of the box so that Curtis's guilt for the robbery, at least, would be proven. But Cohen failed to show.[8]

One week after his arrival in the Bridewell, Curtis turned to self-harm, first beginning a hunger strike, as 'he would sooner starve himself to death than be hanged wrongfully', then 'falling into a fit' so that a surgeon was required to bleed him. As soon as the surgeon was gone, Curtis reopened the wound and allowed it to bleed freely, losing enough blood to cause Bedford to put him on suicide watch before ordering his removal to the county gaol at Winchester.[9] By the time Curtis came to court at Salisbury in March, Cohen's continuing failure to testify had led to the dropping of the robbery charge, and there was no real evidence to convict Curtis of the murder. Further attempts to gather witnesses were certainly ongoing, however, partly through negotiation with some prominent members of Portsmouth and Gosport's Jewish community. The most industrious of these was Abraham Woolf, founder and leaseholder of Portsmouth's first synagogue, and a man 'generally regarded as the leading spirit' of the community. Portsmouth was home to one of the fastest growing Jewish communities in England at this time, and it was set to become the third largest by 1841.[10] Woolf was present at Bedford's examination of Curtis at Gosport, questioning his knowledge,

in regard to the weights found in the (pedlar's) box but he knew the weight of very few of them, their names, or how many of the small ones made an ounce. He did not know the name of rhubarb, which was found in the box, nor the use or value of it, or the silver buckles, spoons,

or any of the toys, neither could he tell the name of either of the wheels or movements in a watch, which the Jew showed him.

Woolf travelled up to Salisbury when the trial began in the hope of testifying, but he was not called.[11]

Despite the inconclusive nature of the evidence, Curtis was convicted after a four-hour trial. He was sentenced to be hanged, not in the usual place just outside the city at Fisherton but on Harnham Hill, where Myers's body was found. Moreover, his corpse was ordered afterwards to be 'hung in chains' in the same place on a pole 26 feet high. This was known as 'gibbeting'. Felons executed for homicide had been forbidden Christian burial since the passing of the Murder Act in 1752, which stipulated 'that some further terror or peculiar mark of infamy be added to the punishment'.[12] In practice, this meant the bodies of murderers would either be sent to the surgeons for public dissection and anatomization or brushed with tar or tallow as a preservative, encased in an iron frame and hoisted up to slowly decompose as a deterrent to passers-by. Conscious perhaps that the conviction did not sit well with Curtis's continuing protestations of innocence, renewed efforts were made by a number of visitors to the condemned cell, including two clergymen, to persuade him to confess and repent. He would not co-operate. His case, he said, was no different to Richard Coleman's, who had been wrongfully hanged on Kennington Common in Surrey in 1749 for the rape and murder of a woman called Sarah Green. Coleman had been convicted on the mistaken evidence of the mortally wounded victim and

several witnesses, but like Curtis, he denied it to the last. Two years later, Coleman was exonerated when three men were committed for Green's death on stronger evidence. One of them turned King's evidence against the other two, who were both hanged.[13]

As doubts lingered over the safety of the conviction, Curtis was granted a five-day stay of execution. But there was to be no reprieve and on 14 March he was taken up the hill, surrounded by a crowd of spectators, to be hanged on a gallows precisely erected 'in a conspicuous part of Lower Birn Beck Field in Britford within view of the roads from Salisbury to Blandford Forum and Shaftesbury'.[14] One final attempt was made to draw a confession. Curtis was made to look down into the chalk pit in which Myers's body was found and asked 'if he remembered the place, to which he said no, and 'tho ardently pressed to confess the crime for which he was instantly going to suffer, he denied it to the last'. He then handed a written statement to a man he knew in the crowd, ensuring his denials became a matter of public record, and to counter any fictitious 'last dying speeches and confessions' that might be circulating. Sure enough, it was reproduced in the national press. 'I am not guilty', he reiterated.[15]

That some inauthentic gallows speeches were also in circulation is quite possible if the *Salisbury Journal* is to be believed. According to that paper, Abraham Woolf had not gone home after the trial but stayed for the hanging and 'distributed several quires of dying speeches amongst the populace at different places'. Woolf was stung by the inference that he had only come to Salisbury

to hawk doggerel verse around the streets and complained to the paper that it had caused him to be 'amongst some unthinking people, much injured in his reputation and business'.[16] It was not the first time in recent months Woolf had taken steps to defend his character from defamation. In fact, this was his second foray into the law courts in a year. The previous February he had taken another man from Portsmouth to the Court of Common Pleas in London's Guildhall for 'speaking scandalous and defamatory words' of him. He won, pocketing damages of £30 in the process.[17] Now, several weeks after Curtis's trial, the *Journal* admitted a 'mistake' in its reporting of Woolf's interventions at Salisbury and the Prison Ordinary, Vanderplank, tried to put the matter straight. Woolf, and several other 'gentlemen from Portsmouth' had come to Salisbury for no other reason than to give evidence against Curtis in court, said Vanderplank. They had not been called because the evidence was strong enough without them and in any case 'the public in general firmly believe him to have been the murderer'. Far from deserving censure, Woolf should be 'highly commended for the trouble and expense he put himself to in attending the trial of so inhuman and barbarous a villain'. At Woolf's instigation moreover, Vanderplank went further. He had spent many hours sitting with Curtis as he awaited execution, he said, and the prisoner had finally admitted that although he had not struck the fatal blow, he 'had been present' at Myers's murder. Vanderplank thought it as good as a confession, 'as it was proved he had no company with him on the road'.

Woolf had certainly invested a great deal of energy on Myers's behalf. It was he who ordered and paid for a series of commemorative coins to be struck to mark Curtis's execution and organized their distribution. He 'made a present of a pocket-piece, in copper, to the under-sheriff, Mr Salmon, after the execution, on the spot, likewise to several Gentlemen of the city, and to several other Gentlemen who had exerted themselves in the apprehending of the murderer, in remembrance of the bloody fact'. The engraver was Isaac Levy, a Jewish silversmith at Salisbury and possibly the son of Woolf's co-leaseholder at the Portsmouth synagogue, the master engraver Benjamin Levy (fig. 1).[18]

These pocket-pieces are unique. In their rough and unsophisticated design, they are unlike any other known tokens memorializing public punishment events. The number of them is unknown, but at least thirteen have survived, each one individually engraved by hand on a smoothed coin.[19] On one side of all of them, a rough circle, sometimes with minimal hatching to indicate depth, represents the chalk pit in which Myers was found, surrounded by simple commemorative lettering to record the date of the murder and (in some cases) the robbery too.

On the other side, however, two different designs have been produced. Nine depict Curtis in crude manikin form, suspended from the gibbet pole in his iron cage, with additional lettering recording his name, the date of his death and that he was 'hung in chains near Sarum' on a pole 26 feet high. The other four are quite different. These are engraved with a rough picture map of the point at which the Blandford and Shaftesbury roads

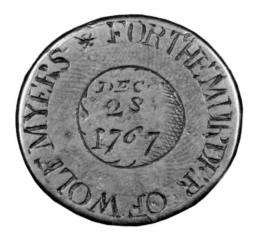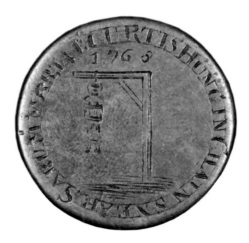

fig. 1 One of two Wolf Myers coins now in the
collections of the Wiltshire Museum, Devizes,
2004/34. Reproduced with kind permission

diverge, close to the summit of Harnham Hill. At
the top we see Curtis and his gibbet pole. To the
left, and close to the Blandford road, we see the
chalk pit and a barn, while to the right we see
Salisbury Cathedral, a landmark visible from the
top of the hill (fig. 2).

There are very few known coins with which
these pieces may be usefully compared. One
example in the Millett collection marks the trial
and execution in London of the banker Henry
Fauntleroy for forgery in 1824 (#034, p. 103).

At least four coins were made in commemora-
tion of this event, all individually engraved. Each
coin uses just one side of a Georgian penny and
content is restricted to a few encircling lines of
text in flowing script, except one which includes a

central illustration of a hanged man in tails.[20] The
similarity of the language and the handwriting in
all four suggests the work of a single hand. The
most explicit reads, 'Fauntleroy, the robber of
widows and orphans, hanged at Newgate 1824.
Such be the fate of all bilking bankers and agents',
while the other three state simply, or with minimal
variations, 'The fate of Fauntleroy to all insolvent,
bilking bankers and agents' (#049, p. 103).

Unlike the Curtis coins, the identity of their
maker is unknown and one can only guess at the
means by which they were circulated. Although
execution for forgery was not uncommon and the
numbers of people sentenced to death for it had
been escalating in the early part of the nineteenth
century, Fauntleroy was not a typical victim of the

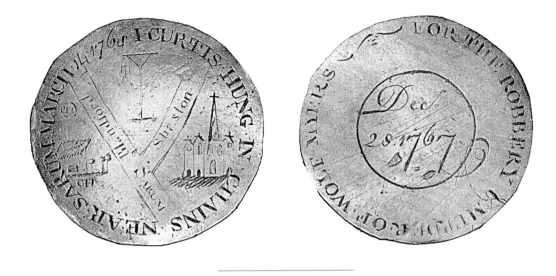

fig. 2 Private collection

Newgate gallows. To all outward appearances, he was a respectable middle-class partner in London's Berners Street Bank. However, for ten years he had been defrauding customers by forging powers of attorney and slowly milking them. By the time of his arrest, Fauntleroy may have embezzled at least £360,000. Intense public interest in his case centred on a recognized anomaly. Forgery was broadly understood to be a white-collar crime, and yet the perpetrators most likely to find themselves on trial for it tended to come, like the majority of all defendants at the Old Bailey, from humbler backgrounds. It was felt not only that the wealthy and influential were substantially evading justice but that their crimes were more inexcusable because they were relatively unnecessary. Since it was also understood that convicted forgers invariably went

to the gallows without clemency, any reprieve for a man of Fauntleroy's standing would smack of class favouritism. But by 1824, amidst a general feeling that the Bank of England exerted far too much influence in securing capital convictions, the high number sent for hanging had become a cause for concern. Further controversy was aroused by Fauntleroy's defence that he had been forced into embezzlement to safeguard the business of his own bank because the Bank of England had refused to extend him sufficient credit.[21]

Popular opinion over Fauntleroy's fate was sharply divided. Given his 'good character' and respectable background, there was some clamour in polite circles for a reprieve. 'Every effort was used to obtain commutation of the sentence', recalled one newspaper 65 years later. 'His case

was twice argued before the judges on points of law... followed by appeals to the Home Secretary, and all possible political interest was brought to bear, but without success'.[22] As *Bell's Life in London* put it at the time,

> In the appalling dispensations of justice, there shall appear no reason for the prevalence of an opinion, that any possible distinction can be made between the high and the low when brought to the bar of their country. There is indeed a moral example expected from persons of rank and wealth which it would be impolitic to weaken.[23]

The Fauntleroy case was certainly sensational, in a year already marked for notoriety by the much-discussed trial and execution of John Thurtell for murder. Both trials exposed moral scandal, financial fraud and corruption, although in Thurtell's case it was against the plebeian background of underworld gambling and prize fighting rather than high-society banking. This juxtapositioning did no favours to Fauntleroy, who was 'daily annoyed by seeing the unfounded slanders propagated respecting him in the public prints and he was dreadfully distressed and nervous on finding his name frequently associated with that of the cold-blooded murderer Thurtell'.[24] The Fauntleroy coins express plebeian satisfaction that a man who could turn 'robber of widows and orphans' with a simple stroke of his pen should be brought to justice. And their stark warning to 'bilking bankers' everywhere was not without impact, for they were called to mind in the popular press some forty years later.[25]

But few other victims of the gallows were memorialized in this way. Coins were circulated for sale to mark the execution of the murderer James Blomfield Rush at Norwich in 1849, but these were professionally struck in brass rather than scratched into existing coinage. These were collectors' pieces, and like William Corder, the 'red barn murderer', Rush also inspired the production of a set of commemorative Staffordshire pottery figurines. The turning of notoriety into the mass-production of collectable curiosities played a central role in the afterlife of both these killings, but this only highlights the essential difference between them and the case of Curtis and Myers.[26] Abraham Woolf was not creating dark souvenirs for general sale but personalized mementos for individuals who played a part in bringing Curtis to the gallows. Indeed, the example in the British Museum has been drilled through with a small hole at the top, presumably so that it could be worn around the neck of the owner (fig. 3). Moreover, the use of picture maps on at least four of them suggests Woolf's principal interest was in the assignment of spatial association as much as the recording of justice. Each coin locates the gibbet site in relation to its wider landscape (figs. 4 and 5).

Key dates in the narrative are added to each of the coins: the murder (28 December 1767), the discovery of the body (25 January 1768), and the date of Curtis's execution (14 March 1768). All four of the map coins define the landscape with reference to the same key features (gallows, pit, barn and cathedral), and two add a milestone to mark the fork in the road. The cathedral's architecture is inconsistent and emblematic rather

than representational and the significance of the equally variable 'barn', a feature that plays no part in the recognized narrative of events, is now a mystery. Woolf's mapping of Harnham Hill critically changes its associative identity from simply the high road to Salisbury to a site of suffering and retribution. At the time of Curtis's execution, detailed and reliable maps of Wiltshire were still hard to find. There had been no fully surveyed cartography since the pioneering work of John Speed a century and a half earlier, and the first mapping to replace it would not appear until the publication of Andrews and Dury's map of the county in 1773. In a sense then, Woolf's map coins were not so much an attempt to reinterpret the cartography for contemporary use but to establish it. Curtis's gibbet is clearly marked by Andrews and Dury (fig. 6).

Curtis, it will be recalled, was asked pointedly whether he could 'remember the place' as the execution procession marched him to the chalk pit and gallows. 'Remembering' the place was as much about *defining* it as a crime scene as recalling any of its other possible meanings and associations, especially given a landscape now to be permanently inscribed by a 26-foot gibbet pole (fig. 7).

As the geographer Doreen Massey has noted, such redescriptions of the landscape tend to make it 'temporal and not just spatial; as set in time as well as space.… The identity of places is very much bound up with the histories which are told of them, how those histories are told, and which histories turn out to be dominant.'[27]

To understand the Curtis/Myers tokens fully, we must also understand the practice of hanging felons at the scene of their crime.[28] Although sentence of death would be passed by the trial judge on conviction by the jury, arrangements for the time and place of an execution and whether to gibbet or anatomize the criminal body were normally the responsibility of the county sheriff. Generally, the customary place was close to the boundaries of the county town and a short distance from the gaol. But occasionally, to maximize impact, he might order an execution elsewhere. Taking convicts back to the place where the crime was committed transformed the execution process from a standardized ritual in a customary place associated predominantly with public punishment, to a one-off performance, delivered in a series of theatrical scenes against a familiar backdrop. Crowds were often far greater than at the 'usual place', and often considered better behaved as well, perhaps because the mystique of the ritual had not been weakened by over-familiarity.

In these circumstances, dramatic last-minute confessions were often hoped for by the prompting of associative memory. As the *Morning Chronicle* put it, reporting the execution of two men for murder at Godalming in 1818, it was fitting that 'the neighbourhood which had been alarmed and horror-struck at the atrocity of their crime, should likewise witness their punishment and hear their confession, if disposed to make any'.[29] And sometimes it worked. John Ogleby, hanged for a murder in a village near Sevenoaks in Kent in 1750, was 'much surprised by the sight of the gibbet and of several thousand people… he stood up in the cart and desired all people would pray for him and the poor man he had killed, and confessed the fact

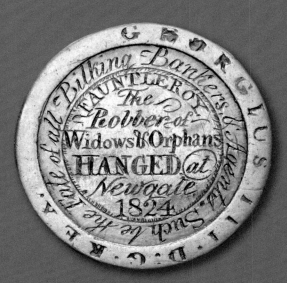
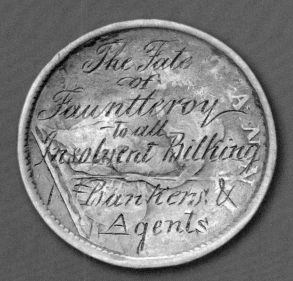

#034, #049

Henry Fauntleroy (1784–1824) joined the family firm of Marsh, Sibbald & Co., bankers in Berners Street, London, and became a partner in 1807. The bank over-stretched its resources on speculative building contracts in Marylebone. Fauntleroy spent lavishly on high living, property investments and a personal conviction that he bore an affinity and physical resemblance to Napoleon. By 1815 the bank was in danger of collapse. For the next ten years, Fauntleroy forged powers of attorney, stealing from trust funds and embezzling stock to a value of £360,000. He was arrested in 1824 when his forgeries first came to light. The case became a press *cause célèbre*. Fauntleroy admitted his guilt, but the Old Bailey jury was unpersuaded by his claim that he had acted only to keep the bank solvent. He was sentenced to death and, after two failed appeals, was hanged at Newgate Prison, on 30 November 1824, when a crowd estimated to be 100,000-strong turned up to watch.

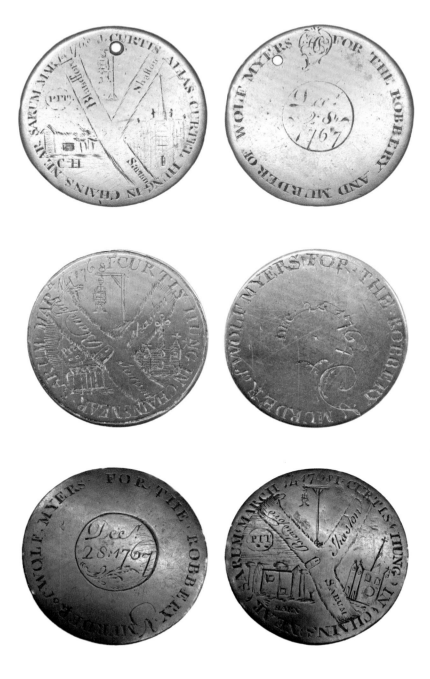

fig. 3 British Museum,
1613421398

fig. 4 Courtesy
Jack Relph

fig. 5 Courtesy
Geoff Harris

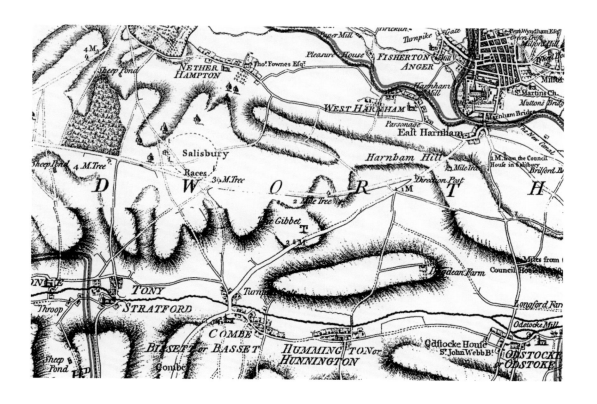

fig. 6 *Andrews's and Dury's Map of Wiltshire 1773, a reduced facsimile* (Wiltshire Record Society, 1968) showing Curtis's gibbet. With thanks to John Chandler for his assistance

which till that time he had denied'.[30] John Walford was another. Taken back to his home village of Over Stowey in 1789 to be hanged and gibbeted for the murder of his wife, Walford like Curtis was confronted with the crime scene. 'On the way to the gallows they drove to the very spot where he committed the murder,' recounted Tom Poole.

'The horses stopped. He looked over the side of the cart and said, Drive a little further. Now, said he, I see it.'[31] William Keeley, hanged for murder on a hill outside Chipping Camden in 1772, 'persisted in denying the fact in the most solemn manner until he came within sight of the spot where he committed the murder. He could then hold out no

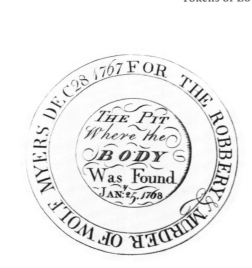

fig. 7 Line drawing of a coin in the Salisbury Museum collections, in which the chalk pit from which Myers's body was retrieved is the principal feature. Reproduced in Miss Child, *The Spinster at Home in the Close of Salisbury. No Fable. Together with Tales and Ballads,* Salisbury 1844, pp. 195–204

longer, but confessed.'[32] Perhaps the most performative of these confessional moments was that of John Plackett in 1762. Hanged for robbery in the countryside near Islington, 'he loudly spoke a confession of the fact for which he suffered, and two other facts, all committed within sight of the spot where he suffered. There, said he, in that field (pointing to the place), I robbed the gentleman, myself alone, for which I die. And there (pointing to Goswell Street Road), I robbed a woman of a trifle of money but did not hurt her. This was the first I ever did. And there (pointing near the same place) I robbed a man of a small sum but did not abuse or ill-treat him.'[33]

In contrast to the often hurried twice-yearly executions at the usual place, crime scene hangings impressed themselves upon local memory by familial and situated poignancy. At Chipping Camden, William Keeley's mother and father 'met him on the road not far from the place of execution', it was reported, 'and the scene of their parting was very affecting'.[34] Such pathos, it was hoped, would produce an equally profound effect on the watching crowd. Those who came to see Robert Watkins hanged at Purton Stoke in Wiltshire fell into 'a fearful and breathless anxiety, a solemn stillness, and a deep expression of melancholy thought' as they waited. 'Near to the fatal spot, the cart passed his wretched mother, he looked steadfastly at her for some moments and with a gentle inclination of head and great expression of feature, seemed to take an eternal farewell of her.'[35] Indulgent Sheriffs might let scenes like these play out for several hours for there was no need to hurry. Richard Randall, hanged at Totterdown near Bristol in 1783, 'remained under the fatal tree for two or three hours and a considerable part of the time with the rope fixt for launching him into eternity' before finally signalling for the cart to pull away.[36] Crowds had plenty of opportunity for reflection, as they measured crime and punishment against familiarity and locale. Watching the fatal return to the small village of Kenn in Somerset of three young men condemned to death for incendiarism, stirred painful reflections for the Methodist minister John Leifchild. 'What occasion had these men for deep sorrow and regret when brought for the last time to witness scenes familiar to them from their infancy?' he wondered. 'How often may

they have paced this very spot in the innocence of childhood!'[37]

Curtis had no familial connection with the place chosen for his execution, but the extraordinary manner of his death was designed nevertheless to leave its mark on local memory. Besides Woolf's engraved pocket-pieces, the gibbet itself became a marked feature on Andrews's and Dury's map of Wiltshire, first published five years later, in 1773, and the case was committed to a lengthy doggerel in 1844, with key moments in the narrative duly remembered:

Then the murderer's conducted all round the
 drear pit
And the Sheriff exacts that he look into it
From the cart where in agonised state he
 doth sit
Ah! Will he not madden or fall in a fit?
As he once more perforce approaches
 that spot
Where his victim he left to stiffen and rot!
He's then pressed to confess while yet there's
 still time
But denies the commission of murder's
 fell crime...[38]

In presenting his pocket-pieces to specific individuals, Woolf clearly had no interest in their wider circulation. They are story-telling devices trapping time and place, nailing remembrance of past trauma and mapping a landscape of loss.

The High Sheriff of Somerset did something similar after the hanging of the Kenn incendiaries in 1830, cutting the silver buttons from his tunic and handing them to the principal tenant famers of the district who made up his Javelin men for the day. The buttons were passed down through the recipients' families as tokens of memory, several of them emerging once more at a Clevedon charity auction in 1941, their meaning and provenance not yet lost to local knowledge.[39] In our own world, where roads are frequently reinterpreted through the placing of unofficial memorials at fatal accident sites, we may perhaps re-read Woolf's coin-maps in the light of what Karen Till and Julian Jonker have termed the 'haunted archaeologies' or 'spectral traces' of traumatic pasts in the present; the more so, indeed, since gibbeting sites have long been associated with hauntings. In proposing an alternative cartography, Woolf's tokens remind us that landscape cannot be reduced or tied to a fixed moment of becoming and that autonomous reading may not be suffocated by a neutral hierarchy of signs introduced by the Ordnance Survey. 'Landscapes refuse to be disciplined,' wrote Barbara Bender. 'They make a mockery of the oppositions that we create between time [history] and space [geography] and between nature [science] and culture [social anthropology].'[40]

1 *The History of England, Faithfully Extracted from Authentick Records, Approved Manuscripts and the Most Celebrated Histories of This Kingdom*, vol. II, London 1715, p. 371. See also *The Art of Assassinating Kings, Taught Lewis XIV and James II by the Jesuites*, London 1695, p. 11.

2 Noted in J.R.S. Whiting, *Commemorative Medals: A Medallic History of Britain from Tudor Times to the Present Day*, Newton Abbot 1972, p. 130.

3 *Salisbury and Winchester Journal*, 4, 11 and 18 January 1768.

4 *Salisbury and Winchester Journal*, 25 January 1768; *Scots Magazine*, 1 February 1768; *Public Advertiser*, 6 January 1768.

5 Myers's body was sent to London after the inquest where, presumably, he had relatives. Wiltshire and Swindon History Centre, Britford General Register, 1712–1812, 499/6.

6 *Oxford Journal*, 6 February 1768.

7 On Jewish rhubarb pedlars, see interviews recorded with London street vendors by Henry Mayhew in the following century. 'All de rhubarb-sellers was Jews', he was assured by a Moroccan Jew who had been making a living selling it for decades: Henry Mayhew, *London Labour and the London Poor: The London Street Folk*, vol. I, London 1861, p. 453; *Oxford Journal*, 6 February 1768.

8 *Derby Mercury*, 19 February 1768.

9 *Derby Mercury*, 19 February 1768.

10 I.S. Miesels, 'The Jewish Congregation of Portsmouth (1766–1842)', *Transactions of the Jewish Historical Society of England*, vol. VI, 1910, pp. 111–27; Cecil Roth, 'The Portsmouth Community and its Historical Background', *Transactions of the Jewish Historical Society of England*, vol. XIII, 1935, pp. 170–76; Eugene Newman, 'Some New Facts about the Portsmouth Jewish community', *Transactions of the Jewish Historical Society of England*, vol. XVII, 1952, p. 258. See also Tony Kushner, 'A Tale of Two Port Jewish Communities: Southampton and Portsmouth Compared' in David Cesarani (ed.), *Port Jews: Jewish Communities in Cosmopolitan Maritime Trading Centres, 1550–1950*, second edition, London 2013, pp. 87–111.

11 *Salisbury and Winchester Journal*, 8 February, 21 March 1768.

12 25 Geo II c.37, *An Act for Better Preventing the Horrid Crime of Murder*.

13 William Wilson, *Solemn Declaration of Richard Coleman who was Executed on Kennington Common… for the Murder of Sarah Green, Widow*, London 1749; *Lloyds Evening Post*, 14 March 1768. Coleman's case was a well-known miscarriage of justice and Curtis may have been familiar with it from its appearance in several popular publications, including the *Newgate Calendar*, the *Proceedings of the Old Bailey*, which covered the second trial, and the *Gentleman's Magazine*, vol. XXI, 1751, p. 377, and also in the rather more sensational and very recently published *The Cries of Blood, or The Juryman's Monitor*, London 1767, p. 69. Indeed, the case was cited by the notorious nineteenth-century murderer John Thurtell in his trial defence in 1824: *The Trial of John Thurtell and Joseph Hunt for the Murder of Mr William Weare…*, London 1824, p. 44.

14 The National Archives, Assizes: Western Circuit: Gaol Books, ASSI 23/7, entry dated 9 March 1768; R.F. Hunnisett (ed.), *Wiltshire Coroners' Bills, 1752–1796*, Wiltshire Record Society, vol. XXXVI, Devizes 1981, p. 149.

15 *Lloyd's Evening Post*, 23 March 1768.

16 *Salisbury and Winchester Journal*, 2 May 1768.

17 *Newcastle Chronicle*, 7 March 1767.

18 *Salisbury and Winchester Journal*, 21 March, 2 May 1768. Benjamin certainly had a son, Isaac, who also practised as an engraver.

19 The majority are in private collections but two may be seen in the numismatic collections at Devizes Museum, two more at Salisbury Museum and another in the British Museum, London. For the latter two see Whiting 1972, p. 141.

20 Coin sold at auction in 2009, http://www.londoncoins.co.uk/?page=Pastresults&auc=126&searchlot=718&searchtype=2 (accessed 17 November 2020).

21 Sara Malton, 'Forgery, Fiscal Trauma and the Fauntleroy Case', *European Romantic Review*, vol. XVIII, no. 3, 2007, pp. 401–15.

22 *Sporting Times*, 8 May 1889.

23 *Bell's Life in London*, 28 November 1824. For the case against Fauntleroy's execution, see for example, *Blood for Gold or Death for Forgery, Proved to be Inexpedient, Unjust and Unscriptural, Suggested by the Recent Execution of Mr Fauntleroy*, London 1824.

24 *Pierce Egan's Account of the Trial of Mr Fauntleroy for Forgery*, London 1824.

25 James Gregory, *Victorians Against the Gallows: Capital*

Punishment and the Abolitionist Movement in Nineteenth Century Britain, London 2012, p. 103, citing the *Railway News* in 1864.

26 For a Rush commemorative coin in the collections of the Ashmolean Museum, see http://www.jermy.org/photos/rushmedal1.html (accessed 17 November 2020). For comparison with the souvenir industry surrounding Corder, see Shane McCorristine, *William Corder and the Red Barn Murder: Journeys of the Criminal Body*, Basingstoke 2014.

27 Doreen Massey, 'Places and Their Pasts', *History Workshop Journal*, vol. xxxix, no. 1, 1995, p. 186.

28 I have written about crime scene execution in detail in 'For the Benefit of Example: Crime-Scene Executions in England, 1720–1830', in R. Ward (ed.), *A Global History of Execution and the Criminal Corpse*, Basingstoke 2015, pp. 71–101.

29 *Morning Chronicle*, 15 August 1818.

30 *Penny London Post*, 31 August 1750.

31 As cited in H. Sandford, *Thomas Poole and His Friends*, vol. 2, London 1888, pp. 235–37.

32 *Bath Journal*, 31 August 1772.

33 *God's Revenge Against Murder; Or, the Genuine History of the Life, Trial, and last Dying Words of … John Plackett, for a Highway Robbery on Jacob Faye, a Danish Young Gentleman, near the City Road, for which he was Executed, and afterwards Hung in Chains on Finchley Common*, London 1762.

34 *Bath Journal*, 31 August 1772.

35 Ethel Richardson, *The Story of Purton*, Bristol 1919, pp. 83–85; *Salisbury Journal*, 3 August 1819.

36 *Felix Farley's Bristol Journal*, 10 April 1784.

37 Rev. J. Leifchild, D.D., *Remarkable Facts Illustrative and Confirmatory of Different Portions of Holy Scripture*, London 1867, p. 222. For this event, see Steve Poole, 'A Lasting and Salutary Warning: Incendiarism, Rural Order and England's Last Scene of Crime Execution', *Rural History*, vol. xix, no. 2, 2008, pp. 163–77.

38 F. Child, *The Spinster at Home in the Close at Salisbury: No Fable, Together with Tales and Ballads*, Salisbury 1844.

39 *Clevedon Mercury*, 13 December 1941.

40 See Julian Jonker and Karen E. Till, 'Mapping and Excavating Spectral Traces in Post-Apartheid Cape Town', *Memory Studies*, vol. ii, no. 3, 2009, pp. 303–35. For Bender, see Doreen Massey, 'Landscape as a Provocation: Reflections on Moving Mountains', *Journal of Material Culture*, vol. xi, no. 33, 2006, p. 34. See also the exhibition catalogue, Karen E. Till (ed.), *Mapping Spectral Traces*, Blacksburg VA, 2010.

Convict love token from R. Hoklay, 1834

8

'As You Find Me'

Tokens, Memory and Family History

Sophie Jensen

Over the past decade, The National Museum of Australia [NMA] has worked with Timothy Millett's earlier collection of convict tokens. In this essay Sophie Jensen demonstrates how knowledge of such objects expands through the research and personal connections that wider audiences bring to them. In sketching this potential, she also outlines an agenda and rationale for future collaborations across numismatics, social history and heritage.

Richard Oakley's convict token is a tiny object.[1] Carved on the obverse of a cartwheel penny, it is not as elaborate as many. Only a single face has been engraved with a simple set of formulaic words, the only image a small flowerpot decorated with two sparse sprigs. This particular token is closely associated with two others in the NMA collection: those made for convicts Richard Turner and Henry Rye. All three were sentenced at the Sandwich Gaol Delivery in August 1834. Oakley's offence was listed as 'breaking into a counting house and stealing – and larceny.' He received 14 years as did Henry Rye. Turner was acquitted after evidence was admitted. The style of lettering and wording on the three tokens is virtually identical, although each dedicates his token to his own loved one, Oakley to 'Ch[a]llott', Turner to 'mother'[2] and Rye to 'William'.[3] Oakley was transported to New South Wales, departing on the *Mary Ann* on 6 July 1835; Rye left for Hobart on the *Norfolk* on 12 May 1835.

While Oakley sailed to a new life in New South Wales, his token remained, presumably with Charlotte, in England. Many years later it came

into Timothy Millett's collection before making its own journey to Australia when the collection was purchased by the NMA, along with 307 others, in 2008. The NMA currently holds 315 of these precious and intriguing items, ranging in date from the earliest years of transportation up to 1856. It is the largest holding of convict tokens in Australia and one of the highlights of the National Historical Collection.

Convict tokens are items of endless fascination and wonder to visitors to the Museum. Since their purchase in 2008 large portions of the collection have been on display within the Museum's permanent exhibitions. Tokens are also regularly lent for exhibition in institutions across the country and internationally. The entire collection has been digitized and is made available through the Museum's website. Users are able to search the collection, view high-resolution images of both faces, read transcriptions of the inscriptions as well as comment on the tokens and interact with other researchers and visitors through a discussion forum.[4] Short biographies of known individuals are also included where possible. Although the collection is popular amongst the broad Museum audience, the group that has engaged most deeply with, and recognized the potential of, these items is family historians.

The reasons for family historians' intense interest in discovering their convict past have been the focus of analysis and speculation. The undoubted value that family historians can provide for the relatively unfashionable area of Australian colonial history has also become better appreciated.[5] In our libraries and archives family historians have discovered the 'treasures' of the convict system: the official records through which convicts were tracked and managed. These documents are now available at the click of a button through numerous sites that provide researchers with all the tools that they require to trace an ancestor from sentencing and then on through an entire convict career.[6] Using these sources, family historians have been able to document their ancestors' lives as they intersected with bodies of authority and control.

Alongside growing interest in discovering and documenting convict lives there has been a corresponding fascination with the physical traces that remain. Historic sites associated with Australia's convict past have become popular places of interpretation, exploration and visitation. The remnants of convict settlements and institutions provide a vivid glimpse into the landscape in which convicts existed. The material culture of convict life is, however, comparatively sparse. Items are predominantly impersonal in nature – archaeological finds, standard issue uniforms, clothing and equipment, products of labour such as bricks, roads and bridges. It is in the context of these remains that the significance of convict tokens can be appreciated.

The tokens often (but not always) provide a name, a date and sometimes an age or a length of sentence. These tiny but key pieces of information allow us to tie tokens to archival records and official documents. The additional marks, messages, images, sentiment and stories then add

a dimension that is unlike any other survival of convict material culture. Individually, the tokens are undoubtedly moving and highly evocative. Each one speaks directly to a specific convict's story. What the tokens provide that is unique is not only a direct connection, but an intimate connection, to an individual convict's inner, or emotional, life. Tokens remind us of relationships that would soon be torn apart.

In her analysis of the overlap between museums and biographies, Kate Hill asks 'how far we can interact with the materiality of the museum to develop our relationship with others, alive or dead, and whether objects can be active agents in those relationships'.[7] At the time of their giving, convict tokens provided a link, a connection between convicts and their wives, husbands, sisters, brothers, children, friends and loved ones of all descriptions. In their new Museum environment these same objects have indeed become active agents, providing a link for family historians and researchers seeking to re-establish connections and relationships, physically and emotionally, that have been long lost.

Since arriving at the NMA the Millett collection of convict tokens has been accessed by family researchers who, having discovered that 'their' convict was among those represented in the collection, wish to come and see, and perhaps even hold, the token that was produced by, or for, their ancestor.

It is impossible to know what an individual may have felt upon receiving a gift of a small token, a memento, a keepsake from a loved one from whom they were to be separated. In truth each token would have inspired its own set of reactions, each unique to the circumstance of the giver and receiver. As we, curators of the NMA collection, hand a token to a descendant, it is a different type of gift – a gift of a physical, visceral connection to the past. Tokens that were born of separation have become objects of reconnection.

In April 2015, Brian Oakley visited the Museum's repository in order to hold the token made for Richard Oakley, his great grandfather. This tiny, rather plain token nonetheless provoked a powerful and complex experience. As Brian describes:

> I was holding my great grandfather's love token and the overwhelming feeling of connection I had to the very person who was responsible for my life, my father, grandfather, my children and grandchildren's lives and especially being an Australian. I was totally overcome in the moment and was moved to tears. I wanted him to feel from me the legacy he left with the wonderful family he and my great grandmother created.[8]

Each convict token speaks to unique experiences and relationships. The collection as a whole is creating something equally enlightening. Together the tokens weave a powerful and moving story that will take us in new directions as this intriguing work of facilitating connections and relationships continues. The tokens are generating a collection of convict biographies that may yet enable the Museum to piece together a richer piece of work – a

collective biography that will not only illuminate convict lives from a new perspective but will also tie this to the lives and experiences of the individuals and families that came after.

When museums and biographies come together, we get relationships: between people, between people and things, and between people and buildings. Museums and biographies in combination highlight questions around how we know and communicate the past, and to what extent our own selves are separate from both other selves and the 'object' world. They prompt us to ask how far we can develop our relationship with others, alive or dead, through the materiality of the museum, where objects become active agents in the process.

1 http://www.love-tokens.nma.gov.au/tokens/ 2008.0039.0155 (accessed 14 January 2021).

2 Dear mother / when this you see / Remember me / and bear me in your / mind let all the ** / world say what / thay will speak of / as you find / R. * Turner 1834.

3 Dear WILLIA / M Wen this you / see re[me]ber me [&] / ** bear it in you Min / d*let all the world* / say what / thay will / speak of me as / you finD*H*rye / 18 34.

4 http://www.love-tokens.nma.gov.au/ (accessed 14 January 2021).

5 Tanya Evans, 'Secrets and Lies: The Radical Potential of Family History', *History Workshop Journal*, no. 71, 2011, pp. 49–73 (p. 52).

6 Graeme Davison, 'Speed Relating: Family history in a Digital Age', *History Australia*, vol. VI, no. 2, 2009, pp. 43.1–43.10 (p. 43.2).

7 Kate Hill (ed.), *Museums and Biographies: Stories, Objects, Identities*, Woodbridge 2012, p. 1.

8 Brian Oakley, email to Sophie Jensen, 19 October 2020.

9

William Kelly and Thomas Spicer

Shared Stories, Reunited Coins

Timothy Millett

In *Convict Love Tokens* (1998), I first argued that there was in Newgate prison an engraver, presumably an inmate, who produced love tokens to order in the years 1817 and 1818. I had found four coins, which shared distinctive characteristics.

One of the four coins was for seventeen-year-old Thomas Spicer, sentenced to death for passing a forged banknote. At the time I didn't follow the story beyond the basic details. I had discovered that he had been reprieved and transported to New South Wales. I supposed then that his reprieve had been due to his youth.

The Newgate group were always on my radar when viewing auction lots or attending coin fairs. Other examples appeared in the following years. One was for a William Kelly.

Initially I didn't make the link. William Kelly was a fifteen-year-old London-Irish boy. He was

Thomas Spicer's co-defendant in the forgery trial. When I acquired the Kelly coin, the two pieces came together for the first time since they had been engraved in Newgate.

During the years that followed, the shared histories of William Kelly and Thomas Spicer have been uncovered. They are electrifying. The police corruption implicated in their convictions, their death sentences, detention in Newgate Prison, and the remarkable circumstances that led to their sentences being commuted to transportation, make a compelling story, as do their very different fates in New South Wales.

George Dibley, a descendent of Thomas Spicer, recovered the narrative that follows. He was stimulated to research the life of his paternal great grandmother, Laura Spicer, by his mother's many vivid stories about the trials and catastrophes of

fig. 1 Thomas Spicer.
Drawing by Nick Griffiths

her grandmother's life. Thomas Spicer the convict, and the terrible fate that befell Laura's mother Bridget and Laura and her siblings, were not part of those stories. They have only been discovered through his ongoing research in recent years.[1]

•

On the evening of Wednesday 26 November 1817, Thomas Spicer, a warehouseman, and William Kelly, an errand boy, were arrested for passing a counterfeit £5 note. They had presented the note at a pork-butcher's shop and succeeded in changing it for five £1 notes. They were arrested shortly after they left the shop and transferred to Newgate Prison where they awaited trial. This took place on Wednesday 14 January 1818 at the Old Bailey. Both boys were found guilty and on Saturday 17 January 1818 they were sentenced to death by hanging. The date of execution was set for 25 February.

The relative youth of the boys might have been seen as a mitigating circumstance but there was plenty of recent precedent to indicate that the authorities, and particularly the Bank of England, took a hard line against those who passed forged notes.

•

In his *Facts Relating to the Punishment of Death in the Metropolis* (1831), Edward Gibbon Wakefield describes the highly stage-managed

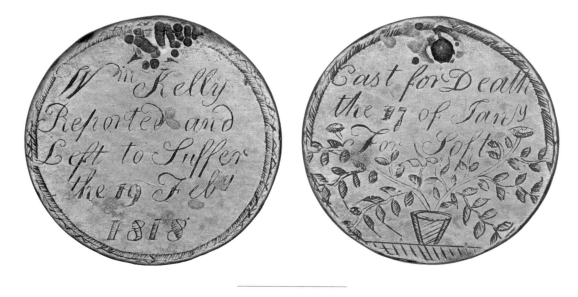

Coin #182

performances that took place within the chapel of Newgate prison:

> In the midst of the chapel is a large pew, painted black, which is called the Condemned Pew. Those who sit in it are visible to the whole congregation, and more so to the Ordinary [clergyman], whose desk and pulpit front the centre of the condemned pew, within a couple of yards of it … The Sunday preceding the execution, there is a grand ceremony, usually called the 'condemned sermon' which is of course made for the occasion.

On Sunday 15 February 1818, just ten days before their own scheduled executions, William Kelly and Thomas Spicer attended the 'condemned sermon'. The terrible fate of the condemned prisoners seated before them was to play an important role in their own destinies.

A gruesome theatrical feature of the service is that an open coffin is set up within the condemned pew, in the well of the chapel. It is flanked by the condemned prisoners, on this particular Sunday, two men soberly dressed and two women in black with white caps. At his desk is the Ordinary, the Rev. Horace Cotton, a 'robust, rosy, well fed unctuous individual whose condemned sermons were more terrific than any of his predecessor's'. His chosen text is from the Book of Job: 'Oh pity me, oh ye, oh pity me my friends for God has touched me'.

fig. 2 Newgate chapel, aquatint, 1809, published
by R. Ackerman after A.C. Pugin

The four prisoners he addresses are Charlotte
Newman, Mary Ann James, William Hatchman and
John Attel. Three are condemned for forgery.

It has been a while since women were hanged at
Newgate and there is considerable public interest.
All the pews on the ground floor are full and the
galleries are crowded. In addition to the prisoners,
whose attendance is compulsory, a congregation
has paid to witness the spectacle.

What are the emotions of William and Thomas
as they witness the ceremony? They may still
nourish some hope. All capital sentences are
reviewed and respited or confirmed by the Prince
Regent in Privy Council. The decision on their case
is still to be received.

Early on the morning of Wednesday 18 Febr-
uary, the four condemned prisoners are hanged.
A ceremonial attached to executions starts at

midnight the night before when the sexton of St Sepulchre's Church, close to the prison, walks to Newgate carrying a handbell, which he rings outside the condemned cells, reciting verses urging those within to prepare themselves for death. The church bells toll at 8am to herald the preparation of the prisoners for the scaffold. The Rev. Cotton conducts the religious aspect of the ceremony and signals the hangman to action. 'In the midst of life we are in death', he intones. The prisoners drop. In this case, the hangman has misplaced the ropes, and death is slow. There is intense unease amongst the large crowd and noisy outbursts of disgust.

John Cam Hobhouse records in his diary on 23 February that the hangman had been drunk. The apparent convulsions of the condemned, which so outraged the crowd, were caused by the hangman working below the scaffold, pulling on the feet of victims to hasten their end.

•

The Recorder of London was charged with bringing to Newgate the decisions of the Privy Council on each capital sentence. The Privy Council was a form of appeal, though without formal processes of representation. It provided an opportunity for the Prince Regent, and through him the government of the day, either to show clemency or to send sterner messages about criminal behaviour and public safety. Condemned prisoners waited four-to-six weeks in cells separate from other prisoners and sat together in the condemned pew at the daily chapel services. Everyone knew when the Recorder was due at the

prison and the atmosphere of tension would have been overwhelming.

On Thursday 19 February, the Recorder reported that William and Thomas were confirmed to hang on the 25th along with the Rawlinson brothers, William (21) and John (19), convicted of theft from a boat.

John Lucas, a 26-year-old shoemaker, charged with stealing a large quantity of carpet, had been tried on 14 January, found guilty and sentenced to death on 17 January. The Recorder's Report contained respite for Lucas, whose sentence was commuted to twenty-one years' transportation.

The Recorder's Report was to all intents the final decision on the boys' lives. It is at this point that they sought out the Newgate engraver and commissioned their convict coins. Three survive, two for Thomas Spicer and one for William Kelly. Each records two events: on one side, 'Cast for Death', with the date of their sentencing; on the other, 'Reported and Left to Suffer the 19 Feby 1818'. Their crime, 'for soft' (a slang contraction of the formal charge 'setting it forth'), is engraved on Kelly's coin, but on only one of Spicer's two coins.

•

On Friday 20 February, the day after the Recorder delivered his report, Alderman Matthew Wood, MP for the City of London, visits Newgate with his House of Commons Committee to investigate the state of the prison. Wood was a well-known radical politician, who had taken a prominent role in the suppression of the Newgate Riot of 1816.

An agitated John Lucas insists on speaking to Wood, reporting that two boys who are to be

hanged in a few days had been induced to commit the crime so that others might collect the Bank of England's 'blood money' reward.

Thomas Limbrick was the arresting officer; a Newgate prisoner called Parsons is his nephew. Lucas tells Wood that Parsons had told him that his uncle had conspired with a local crook, Charles Finney, who had set up Kelly and Spicer to pass the counterfeit note. Limbrick had made the arrests and in return, the pair had shared the £30 reward.

The Committee hears evidence first from William Kelly. He confirms that he had started working for Finney about three months before his arrest. He was at that stage destitute. Finney, ostensibly a costermonger, recruited him to help in his business, buying him new clothes to make his appearance 'respectable'. It was not long before Finney involved him in the passing of low-value counterfeit notes. For this, William received a small reward. Shortly before the crime for which they had been convicted, he had agreed to Finney's request that they move up to bigger value notes. It was at this point that Thomas Spicer was recruited.

Spicer states that he only became involved through Finney's persuasion and confirms to the Committee that this had been his first time out with a counterfeit note.

A very reluctant Parsons confirms the relationship between his uncle and Finney. He tells the Committee that the day before the arrest the two of them had breakfasted together and then gone off in a chaise.

Finney had been a plasterer and used his knowledge of the area and its local businesses to plan the crime. Finney set up Kelly with a plasterer's flannel jacket, white apron and a paper hat. This would be his cover for passing the notes. Finney kept a bucket of liquid plaster and a brush at home, which he sprayed over Kelly before an outing. Knowing the names of local businesses, he was able to send him into shops around St Giles and Seven Dials, claiming to be doing plastering work locally. This was one of the most notorious parts of London, an Irish ghetto known as the 'Rookery', 'Little Dublin' or 'The Holy Land'.

The crime for which the two were arrested was at the pork-butcher's shop of James Braidey at 73 St Martins Lane. Kelly told Braidey that he was doing work for Henry Crease nearby in Long Acre. Braidey knew Crease as a customer, and readily changed the £5 note into five £1 notes.

When the boys left the shop, Finney signalled to Limbrick who, with Constable Smith, followed the boys as far as King Street, Seven Dials, where they were taken. Limbrick came up behind Kelly who was walking beside Finney and seized him. He directed Smith toward Spicer, calling for him to 'go forward and nipper him'. Finney was allowed to look on and then walk off.

Kelly's father, attending the Committee hearings at Newgate, indignantly accuses Finney of 'selling his son like a bullock'.

The press takes a close interest in the evidence disclosed to Wood's Committee. The 'Blood Money Plot', as the papers call it, opens a discussion of hanging as a disproportionately severe penalty for forgery.

Sherwin's Political Register, a popular radical journal, takes up the case. It characterizes the crime

as 'a petty fraud upon a gang of swindlers', and concludes that such a travesty of justice makes a mockery of the British legal system, which is accustomed to holding itself up to the 'envy and admiration of the World'.

On its second day of collecting evidence, the Committee hears from Constable Smith, who arrested Spicer. He tells the Committee 'that he has had him [Spicer] once in custody for an assault but never knew him to be a flasher [criminal]'. William Sutton, the keeper of the White Hart in Drury Lane is also interviewed. He considers Spicer 'a remarkably well-behaved young man' and has 'heard that Kelly's friends were very respectable, but he did not know them. Kelly always appeared to him a very well-behaved young man.'

Convinced by the evidence, Alderman Wood applies on the boys' behalf to the Home Secretary, Lord Sidmouth, for a reprieve of the death sentences. The response was prompt – 'the case has received the consideration of the Council, who were of the opinion that the sentence of the law should be put into force.'

But Wood is tenacious and draws in other reformers who take an interest in the case. One of these is Samuel Hoare, the Quaker banker who is Chairman of the 'Society for the Improvement of Prison Discipline and for the Reclamation of Juvenile Offenders.'

•

Hoare and other members of his committee already have a meeting arranged with Sidmouth on Saturday 21 February to discuss their proposal for a new prison for young offenders. They take the opportunity to make representations on William's and Thomas's part. Sidmouth asks them to wait on the Solicitor-General who will hear their arguments in detail. The case is put by Committee member Thomas Fowell Buxton, the brother-in-law of Elizabeth Fry, who has a reputation for persuasive eloquence.

Hoare follows up with a letter to Sidmouth. He drives home the youth of the boys and the evidence of their entrapment. 'No doubt can be entertained that these offenders were instruments in the hands of others; they were betrayed before the offence was committed to the police officer, that the crime might have been prevented but it was allowed to have been committed; and the most guilty have evaded justice.' He goes on to point out William Kelly's disadvantage. 'He was borne in Vice – nursed in depravity – tutored in crime', and 'is the son of Daniel Kelly, who kept a most notorious house in Rose Street, Covent Garden and is a most abandoned character'. Hoare poses a rhetorical challenge to Sidmouth, 'is [Kelly] to be sent to that Tribunal of his God, alleging that the Country which gave him his birth, gave him no chance of virtue, no opportunity for repentance?'

His final argument appeals to public order. Less than a week previously, the botched hangings of two women and two men had caused considerable disquiet. Hoare asks Sidmouth what the effect might be on the standing of the Law in the eyes of the public, if similar problems were to arise in the hanging of boys of fifteen and seventeen. The letter concludes: 'Public interest requires not the sacrifice of the lives of two youths who are not yet in the very spring of their existence and if spared

may live in another country to make atonement for their offences. If they should be objects of pity and commiseration, surely some disgust may be excited against the enforcement of the Laws which to be beneficial must have their foundation in the hearts and feelings of his Majesty's subjects'.

•

While efforts are made through various avenues of influence to secure a respite of the death sentences for Kelly and Spicer, at Newgate Prison arrangements are put in place in the usual way for their executions, scheduled for Wednesday 25 February. On Sunday 22 February, the condemned sermon is preached by the Rev. Cotton. William Kelly, a fair-haired boy, sits in the condemned pew, his grey eyes fixed on the open coffin. Thomas Spicer sits next to him, he is taller, 'slim-made' with brown hair and hazel eyes. The Rawlinson brothers, William and John, sit on the other side of the coffin.

'The sermon of this day ... must produce a striking effect at the moment of its delivery. For a while the preacher addresses himself to the congregation at large ... At length the Ordinary pauses; and then, in a deep tone which, though hardly a whisper, is audible to all, says – "Now to you, my poor fellow-mortals, who are about to suffer the last penalty of the law"... in the same solemn tone, he talks for about ten minutes of crimes, punishments, bonds, shame, ignominy, sorrow, sufferings wretchedness, pangs, childless parents, widows and helpless orphans, broken and contrite hearts, and death ... for the benefit of society.'

•

On Monday 23 February, with barely a full day before the scheduled hangings, the authorities at Newgate receive notification that Kelly's and Spicer's sentences have been 'respited for a week' to allow further consideration of the case. They will now be hanged on Wednesday 4 March.

John Cam Hobhouse, who later that year became an MP, records a visit to Newgate on 23 February to hear the evidence presented to Wood's Committee: 'it appeared to me that they [Kelly and Spicer] were decidedly drawn in by one Finney, who in combination with Limbrick, an officer, got the blood money for their conviction'.

•

At midnight the sexton rings his bell once again outside the condemned cells. At 8am on Wednesday 25 February, St Sepulchre's bell tolls to signal the preparation of the prisoners whom the hangman will 'launch into eternity' that morning. The Rev. Cotton accompanies brothers William and John Rawlinson to the scaffold, where they are pinioned and blind-folded while he recites from the burial service of the Book of Common Prayer. Their deaths are without incident. In the condemned cells, William Kelly and Thomas Spicer also hear the bells that may yet toll for them on 4 March.

On Monday 2 March 1818, the Keeper of Newgate is advised that their capital convictions are 'respited during pleasure'. Later their sentences are commuted. As a first offender, Thomas is sentenced to fourteen years' transportation. For William, who confessed to passing false notes for Charles Finney over three months and has

two additional convictions for October 1817, the sentence is twenty-one years' transportation.

William and Thomas are kept at Newgate until 9 April 1818 when they are transferred to the hulk *Retribution*, moored in the Thames. *Retribution* held over 500 prisoners in bleak and insanitary conditions. The death rate among prisoners was high.

Finally, on 29 June 1818 they are transferred to the *Morley* at anchor in The Downs where the vessel awaits a fair wind. On 18 July 1818, Thomas Spicer and William Kelly set sail on their non-stop voyage to Port Jackson, Australia. There are 164 male convicts aboard and the journey takes 3 months and 21 days.

The *Morley* arrives in Sydney on 7 November 1818. Spicer, older, more strongly built and with a less tarnished background than Kelly, is assigned as labour to Robert Lowe, a progressive free settler with capital. It is possible that Lowe knew of Thomas's case and sought him out; his family were also from Clerkenwell and Robert's father had connections with Hoare and other Quaker reformers.

Spicer takes his opportunities and progresses quickly on the Lowe estates, becoming a highly valued employee and given huge responsibilities. By the 1830s he is buying his own land in Mudgee, 260km south of Sydney. He became a prominent member of the community. He buys a further 993 acres of good alluvial land in a place still known today as Spicers Creek.

Later in life he forms a de facto marriage with a younger woman, Bridget Maher, an assisted immigrant from Clonmel in Ireland, with whom he has eight children. The upward trajectory of his life is confirmed when gold is discovered at Spicers Creek and he makes a considerable sum letting out plots for £1 per month. According to local newspapers, 'some five hundred, including Chinamen, have obtained licences'.

On 17 January 1862, 44 years after he and William Kelly were sentenced to death at the Old Bailey, his 'mettlesome' horse runs him into a tree. He dies without a will and as he is not married to his children's mother, neither she nor the children are deemed to have any legitimate claim on his estate. The seven surviving children are all under nine years old, the youngest four are pairs of twins aged three and eighteen months. They and their mother are evicted from their home with no means of support. The two oldest children are taken in by locals. The rest are sent to the Catholic Orphanage at Parramatta, where two die. Their mother Bridget becomes a vagrant and, a few years after Thomas's death, drowns in the Cudgegong River at Stoney Pinch, south of Mudgee. Thomas Spicer's estate is sold up and after debts are settled, over £9000 ($2 million today), is forfeit to the government of New South Wales.

William Kelly's life takes a different path. He is Catholic and Irish, at a time when prejudice is widespread, and known to be from a criminal background. Lightly built and with no trade skills, he is not selected by a free settler. The conclusion of the Napoleonic Wars, with the return of poverty-stricken discharged soldiers and fears of a crime wave, had swelled the number of transportees arriving in the colony. Eventually Kelly is assigned to the Emu Plains Agricultural Establishment on

the Nepean River about 58km west of Sydney. This is a 'make-work' government scheme to increase the colony's food security and absorb surplus labour. Here teams of men, housed in basic huts and sleeping on the mattress they had carried from the convict transport ships, work to clear the forest from an area of fertile river flats ready for ploughing and planting. It is heavy and dangerous work.

It is here that William Kelly is crushed to death by a falling tree stump on 3 May 1822 at the age of 19. He is buried in an unmarked grave in the overgrown cemetery of a town planned but never built. The year 2022 marks the two hundredth anniversary of his death.

1 In piecing together this story, Lynne Robinson has contributed her research on Thomas Spicer's rise from assigned convict servant to wealth and local prominence, and particularly on the fate of Spicer's de facto wife Bridget Maher and her children. Peter Mara, a great-great grandson of Mary Wall, elder sister of Bridget Maher, is a family historian whose forebears, convict and free, settled in the Mudgee district. Among the lives he has traced is the first child of William and Mary Wall, born in New South Wales and baptized 'Spicer Jeremiah Wall'. That name was a tribute to Thomas Spicer, a successful farmer more than twenty years in the colony, who had probably helped the young Irish immigrants William, Mary and Bridget settle in a strange land.

Note on sources

Public interest in what many newspapers dubbed the 'Blood Money Plot' was high, with detailed reports covering the Wood Committee's hearing and subsequent developments. Quotations in this chapter are drawn principally from *Sherwin's Political Register*, 23 February 1818; *St James Chronicle*, 24 February 1818; *Baldwin's London Weekly Journal*, 28 February 1818. Other sources include *The News* (London), 1 March 1818; *British Press*, 28 March 1818; *Champion* (London), 16 March 1818; *Observer* (London), 2 March 1818; *The Northern Star or Yorkshire Gazette*, February–March 1818; *The Statesman* (London), 20 March 1818.

Australian Newspapers (https://trove.nla.gov.au/newspaper) covered the Gold Rush at Spicers Creek, the death of Thomas Spicer and the sale of his considerable estate

All details of trials, charges, respites, embarkation and physical descriptions are drawn from the *Digital Panopticon* https://www.digitalpanopticon.org/

'The Diary of John Cam Hobhouse', February 1818, https://petercochran.wordpress.com/hobhouses-diary/

The Life of William Allen: with Selections from his Correspondence, vol. 1, Philadelphia 1847

John Thomas Bigge, *Report of the Commissioner of Inquiry into the State of the Colony of New South Wales* (1822) https://collection.sl.nsw.gov.au/record/74vv5PX8qd43

Naomi Clifford, 'Horace Cotton: The Extraordinary Ordinary of Newgate' and 'Charlotte Newman and Mary Anne James', www.naomiclifford.com (accessed 10 March 2022)

The National Archives, PRO 30/45/1/20ff.395-399, 'Letter to the Home Secretary Viscount Sidmouth from Samuel Hoare, jun., 21 February 1818'

Part three

Politics

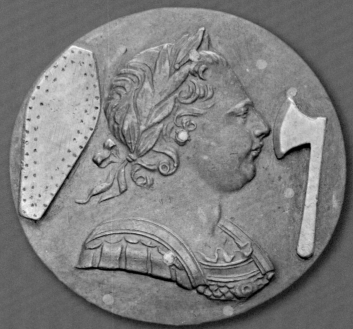

#025

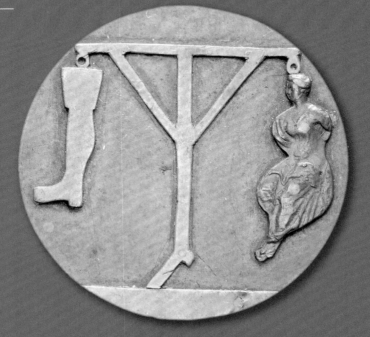

10

The Material Culture of Plebeian Politics

1760–1850

Katrina Navickas

Political culture in the Georgian era was a lively and constantly flowing series of ideas and personalities. It was a visual culture. Politicians and the monarchy were mocked or questioned in satirical cartoons, posters, handbills and theatrical displays of symbols during carnivalesque rituals accompanying election hustings.[1] It was a participatory culture. Despite most of the British population not being entitled to vote, non-electors could and did take part in the process of questioning, or rather haranguing, politicians.[2] It was the politics of the street as much as in parliament. It was a material culture, with a wide range of objects used as part of the display and the theatre of elections. From the 1760s onwards, it evolved into a mass popular and increasingly plebeian or working-class movement for reform of the parliamentary system, calling for an end to corruption in parliament. Inspired by the

American and French revolutions of the late eighteenth century, the call increasingly came for the franchise for all men.

This chapter examines the place of engraved coins and tokens in eighteenth-century popular politics. Clothing, pottery, jewellery, banners, monuments and other material items were replete with all kinds of political symbols and slogans during this period, engaging all classes in elections and social movements. They were vital ingredients in the public sphere of debate and campaigning.[3] Yet, with the exception of studies of the tokens of Thomas Spence in the 1790s, there has been little interest or indeed awareness of coins and tokens engraved with political slogans.[4] As the items in Timothy Millett's collection illustrate, however, engraved coins and tokens were as much part of this rich political culture as other types of material

item. This chapter examines how coins can be seen within similar channels of communication and propaganda as other material items in the history of popular agitation for change in the parliamentary system.

We should see the coins and tokens in two ways. First, they were a particular form of political communication specific to the medium, a distinctive form of individual expression unique to the material form of engraved metal. Second, they operated within the wider language of material popular politics that included pottery, graffiti, mummery and other items and rituals common to electoral culture and familiar to the general population as well as to the political elite. As the other essays in this volume demonstrate, engraved coins and tokens were a vital form of expression for many who did not have a voice in other arenas: the poor, the plebeian, the criminal, women and other non-elites. Political tokens nevertheless operate in a different channel from other types such as love tokens, in part because they often operated as a form of communication within an environment of suppression. And unlike convict tokens, they remained predominantly anonymous.

Such items were made and circulated within the spaces of politics. They were meant to be shared, touched and moved from place to place. Older studies of material culture in the eighteenth century focused on consumption, identifying this period as an age of consumers who displayed their increased wealth by accumulating luxury goods from domestic and imperial markets.[5] Then historians became more interested in what such objects represented and symbolized as cultural items, how

personal identities and class were communicated through things.[6] Whatever the approach, the dominant focus of eighteenth-century material culture studies has been on domestic objects and personal possessions associated with the body and with the home. Frank Trentmann has termed these 'soft' material objects, as opposed to under-researched 'hard' items, such as metal and stone used out-of-doors or in the context of work.[7] Histories of the emotions have amplified that trend. There has been growing appreciation of the role of love tokens in shaping relationships, and histories of crime and migration have also begun to pick up on convict tokens as a vivid source for the dispossessed.[8] Although social historians have moved beyond the luxuries of the upper and middle classes to examine more plebeian items, including objects left with babies delivered to London's Foundling Hospital, the emphasis nevertheless has remained domestic and personal.[9]

This chapter proposes that objects do more than represent meanings; they are integral parts of people's bodily and physical experiences and of their interactions with the material environment. In Trentmann's words, 'things … recruit us into politics as much as we recruit them'.[10] The following discussion therefore explores networks and relationships between people and objects. Locating modified coins and objects within the environments in which they circulated makes them much more than an expression of political symbolism directed from above or below, but rather agents of exchange and interaction.

The eighteenth century was an age of satire, necessitated by censorship. Political opponents of

Sir Robert Walpole's premiership in the 1720s and 1730s faced the threat of being sued for seditious libel.[11] A legacy of suspicion continued through the suppression of Jacobitism from the 1710s to the 1740s. Under the 'rage of party' period of political instability that accompanied the first decade of George III's reign in the 1760s, critiques of government were widespread, and it is then that we see the emergence of specifically political slogans on tokens and coins, at least on those that survive in current collections. Lord Bute, the King's tutor, favourite and later Prime Minister, was the lightning conductor of popular political criticism.[12] Freedom of speech was tested but was less of a concern for suppression in the 1770s and 1780s during the American revolutionary period and domestic calls for parliamentary reform raised by the Association movement. But censorship returned during the French Revolutionary decades with a series of legislation against seditious libel and writings that reformers and radicals termed William Pitt the Younger's 'reign of terror' in the 1790s.[13] Although most critics of government and advocates for parliamentary reform remained patriotic and broadly supportive of the Hanoverian monarchy when threatened by French invasion, there was nevertheless an undercurrent of discontent against the personal rule of George III, and more especially against the Prince Regent, for going beyond the constraints that the constitutional system was intended to maintain on royal power. A thread of regicidal ideas was apparent among the republican elements of popular radicalism.[14]

The hidden material culture of politics had its precursors in seventeenth-century loyalist motifs and Jacobite propaganda and memorabilia.[15] A whole wealth of Jacobite items exists, ranging from tartan ribbons to engraved drinking vessels, lockets and other items that formed part of the underground and exile networks of supporters of the Stuart monarchy. Some were commemorative of the Stuart kings and princes and of Jacobite battles lost and won, while other items, such as engraved glasses, formed – much like Masonic and other associations with closed membership – integral elements of rituals in dinners and other events to maintain solidarity in a period of repression.[16]

There was an important difference between Jacobite items and the engraved tokens we see later in the eighteenth century. Jacobite material culture was generally made up of elite or middle-class objects, usually produced specifically for the purpose of communicating Jacobite sentiments and facilitating networks of association. Engraved coins by contrast were accessible to, and made by, lower classes, including the illiterate, judging by some of the markings. They were not necessarily designed for any specific ritual or occasion. Although Jacobitism was not a monolithic movement and did not have a coherent ideology, it had at least one definable goal in the restoration of the Stuarts.[17] The political movements that followed later in the eighteenth century did not have consistent goals that could be neatly expressed through a clear aesthetic. Engraved tokens do not appear to have been a major part of Jacobite material culture (see for example #017, p. 56).[18] Political tokens survive mainly from the 1760s onwards in the collections. This chronology reflects a distinct shift in the form and nature of popular political

movements in this period, from specific causes and more elite membership towards more democratic mass politics.[19]

'Wilkes and Liberty'

The slogan 'Wilkes and Liberty' rallied the first major plebeian political movement calling for reform of the parliamentary system in the eighteenth century. The supporters of John Wilkes, the renegade politician and libertine, were inventive and successful in their use of propaganda, combining symbolism with mass production on a scale not seen before for an individual politician. In 1763, William Hogarth, a long-time critic of Wilkes, produced his infamous caricature defaming Wilkes's character. Hogarth's caricature appeared a couple of weeks after the publication of number 45 of Wilkes's newspaper the *North Briton* on 23 April 1763, which denounced Lord Bute and directly criticized George III, resulting in Wilkes's arrest and imprisonment in the Tower of London.[20] Yet the Wilkite movement were able to appropriate the distinctive portrayal of their leader and use it in clever ways against Hogarth, plagiarizing the image across thousands of items of pottery, now easily transfer-printed or painted at low cost. The crude deportment of Wilkes and the accompanying slogan 'Wilkes and Liberty' were a clever inversion of Hogarth's intentions, appealing to the lower and middle classes with an image of the politician as straightforward in defence of Englishness and the liberties of the subject.[21] The survival of so many Wilkes punch bowls in museums across England, for example, indicates how ubiquitous

these items were.[22] Another key feature of the Wilkite movement was its attack on Lord Bute and its slurs on the Scots. Anti-Scottishness threaded through much political agitation in England in the mid-eighteenth century. Bute's Scottishness allowed critics to tar him with the suspicion of Jacobitism as a potential threat behind the scenes of the Hanoverian monarchy. Attacking Bute and his alleged manipulation of George III through the *North Briton* (itself a sardonic reference to Scotland), Wilkes exploited this undertone with great success, promoting an English liberty and denigrating the Scots (#241).

The '45' became the shorthand symbol for anti-Scottishness, and it later represented both Wilkes's admittedly incoherent programme, and a marked reminder of the Hanoverian victory against the Jacobites in 1745. But '45' became something else – chalked on walls, carved backwards into the soles of shoes so that it appeared imprinted on the mud of the streets, turned into elaborate brooches and other adornments for the middle classes to show their discontent at the political system.[23] Therefore, the Wilkite movement involved both traditional forms of political communications common to local electoral cultures, while also spearheading new types of mass politics involving new tools of consumerism on a national scale. Crucially, engraving existing coins and tokens was an accessible craft and enabled popular agency. It did not require someone to produce the propaganda ready-made.

One of the most striking coins in Millett's collection was minted between 1770 and 1775, and defaced sometime thereafter. It shows a

Coin #241

double gibbet, with a boot hanging on the left and Britannia hanging on the right (#025, p. 128). This marked a subversion of the scales of justice that Britannia is usually pictured with. The boot refers to Lord Bute and indicates the longevity of the symbol shorthand sometime after George III had distanced himself from his former favourite. On the obverse, the portrait of George III is defaced with a coffin to the left and an axe to the right. The politics of regicide are vividly indicated in the piece. Whether this was a modification done as propaganda by a supporter of Wilkes or an expression of discontent only indirectly connected with the movement, using symbols in the vernacular aesthetic, is of course impossible to determine. But it nevertheless reflected the potency of the action as well as the symbolism. The symbols of state – the constitutional monarchy, as established by the Glorious Revolution and the Bill of Rights between 1688 and 1690, the Church of England, and the 1707 Union with Scotland – were at stake.

Expressed on the coin of the realm, the head of the monarch was the definitive symbol of sovereignty: indeed, archaeologists look for the monarch or emperor's head in coins from antiquity as key evidence for who was in power and the boundaries of their realm.[24] Hence the common language of national symbols was the one to draw from in defacing and engraving coins as political statements. This was different from 'coining', a form of counterfeiting which was generally done for profit and was an offence punishable by death – notably the Calderdale coiners who met that fate for clipping the edges from coins on a semi-industrial scale in West Yorkshire in the 1760s.[25] Depicting Britannia hanged on a gibbet was a subversion of the dominant symbolism that sought to inculcate a united Britishness. Drawing an axe and coffin alongside the King's head was both a regicidal threat and a symbolic exertion of agency over these national symbols. Debates over the role of the monarch since the Civil War and the Glorious Revolution had not yet been resolved.

Symbols engraved on coins and tokens illustrate a multitude of jumbled aims, adherents, ideas and chronologies – and most cannot even be classed as a movement at all. They perhaps can be classed as a form of 'meta-movement' in the same way as later popular subaltern and working-class movements, notably General Ludd and the Luddite machine-breakers in 1811–13 and Captain Swing in the early 1830s. In his study of the Captain Swing agricultural rioters, Peter Jones defined a meta-movement as 'composed of a series of interrelated incidents and events that occurred across a broad canvas (in this case, nationwide), yet which were individually

defined by an intense localism and an active rejection of anything resembling a guiding principle or unifying set of demands'.[26] Such meta-movements required, or were sustained by, using an anonymous eponym as much as by the personality of the leadership. So the mythical characters of General Ludd or Captain Swing were appended as signatories to threatening letters to landowners and politicians. This practice enabled what was in fact a geographically fragmented movement to give the impression of being more united and organized than it was in reality. That feature was similarly sustained by tokens as political communication. This is not to argue that such social campaigns were pre-political or backward looking in their worldview. On the contrary, engravings and similar expressions of discontent such as graffiti were dynamic, responsive to contemporary concerns, and modern in their immediacy and relevance.[27]

In the case of pro-Wilkes coins, the leader of the movement was almost irrelevant. It was the act of inscribing what in effect was in our terms akin to a political meme that connected the inscriber to a feeling of participation in a wider movement or protest. The purpose was to share and circulate it either to spread the message or conversely to annoy its opponents or, in the case of Spencean tokens in the 1790s, to keep it as a collectible.

As Jacobite code developed its own parallel culture of communication, political and social commentary got snappier, abbreviated and more precise. Clever symbols and phrases – the shorter the better – became a quick and easy way to cut through the efflorescence of tracts, newspapers and large quantities of other print that formed this age of debate. In referring to Bute, the King's favourite and enemy of Wilkes, 'No B—' not only tried to evade the laws of libel but also got to the point much quicker than a philosophical treatise. The em-dash formed a point of emphasis as much as a form of evasion. In print, but especially on metal, one can imagine the inscriber engaging in physical effort to hammer in the slogans and symbols in defiance. This was not merely textual and symbolic propaganda, it was physical and material.

The 1790s and varieties of patriotism

The new one- and two-pence copper coins, produced by Matthew Boulton's Soho Mint from 1797, coincide with a greater range of politically modified items. As studies of convict love tokens have demonstrated, the heavy and large copper pennies became the surface of choice for plebeian engravers of all types of message.[28] Millett's collection contains several coins that reveal how the position of the monarchy in the constitution and in British identity was at stake during the tumultuous period of the French Revolution and Napoleonic Wars.

Popular loyalism or 'vulgar conservatism' against the French Revolution and domestic radicals in Britain was widespread during the 1790s.[29] One coin in the collection shows a man hanging from a gibbet, with 'Tom Paine' engraved above it (#019, p. 136). Thomas Paine, author of *The Rights of Man* (1791–92), was identified by William Pitt the Younger's government as the number one enemy of the constitution.[30]

There are few other loyalist tokens in the collection but this may be because elite and middle-class

loyalist associations produced their own forms of propaganda, including tokens and medals accompanying the formation of volunteer regiments, that were designed to be distributed free or at low cost to the general population.[31] Coin #019 may have been a copy of the more widely circulated loyalist token 'End of Paine', which also showed a gibbet hanging.

The best-known radical coinage of the 1790s was the work of Thomas Spence, the Newcastle writer and republican propagandist. Spence produced a huge number of his own tokens, many of which were to commemorate the 1794 Treason Trials, in which the London Corresponding Society (LCS) radicals John Horne Tooke, Thomas Hardy and others were tried and acquitted for sedition.[32] Spence commemorated their acquittals with a counter-token, 'End of Pit', depicting the prime minister hanged. Supporters of the acquitted radicals claimed that the trials were a gross extension of private parliamentary privilege and that Pitt himself and his ministers should be tried and hanged for treason. In the *Morning Chronicle* of 26 December 1794, for example, the poet Samuel Taylor Coleridge published a sonnet to Pitt, declaring that it was in the interest of Justice that Pitt should die.[33] Engraved coins with similar messages, however, were different from Spence's propagandist ready-made items. One railed against Pitt's plans from 1797 to increase taxation, with 'No Triple Tax' and 'Pitts Deserts' engraved above a man on the gallows (#111, p. 137).

A William III sixpence that reads 'Damn Tooke TD' may be a loyalist reference to the Treason Trials (#026). Visions of capital justice were in

some sense theoretical constitutionalist reasoning that were never intended to be implemented, but they reflect the multi-layered debates that the government's suppression of free speech entailed. Political and legal questions raised by the Glorious Revolution of 1688 about the powers of monarch and prime minister remained unsettled over a century later.

Material forms of propaganda were meant to be spatial. Much like graffiti (such as '45' chalked on a door), anonymous slogans were intended to be seen by opponents as well as potential supporters. Their purpose was to build a meta-movement by visual means, to make their presence known across a space. But even more than graffiti, which claimed a static space on walls and doors, tokens were not fixed. This was an age of flows and communications, when turnpikes and later canal-building improved journey times and the experience of travel. Historians have disagreed over how widely Spence's tokens circulated across the country.[34] The survival of so many well-worn Spencean medalets commemorating the LCS leaders and the Treason Trials indicates that they were designed for general circulation, but this does not necessarily mean that they were used as propaganda; rather, they may have been just a solution to the prior shortages of low denomination specie. On the other hand, the more propagandistic types of Spencean token, the halfpenny and farthing coins stamped with caricatures and political messages, are generally found in almost mint condition, indicating that they were always intended or treated as collectors' pieces.[35] Many of the items in this collection are by contrast worn to some extent, though we cannot know their

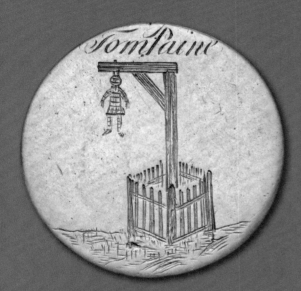

#019

Revolutionary events in France stirred mixed responses across the Channel. Loyalist crowds took to burning **Thomas Paine**, author of the *Rights of Man* (1791), in effigy. Depictions across various media, including the token coinage, reproduced Paine as a hanged man. One 1793 example in the British Museum pushes the message of the gibbet home with loyalist puns: 'The end of pain' and 'The Wrongs of Man'. The reverse of coin #019 is a pretty but politically innocuous floral design by contrast. [KERRY LOVE]

Sources: https://www.britishmuseum.org/collection/object/C_SSB-193-160-1 (token); Mark Philp, *Reforming Ideas in Britain: Politics and Language in the Shadow of the French Revolution, 1789–1815*, Cambridge 2013.

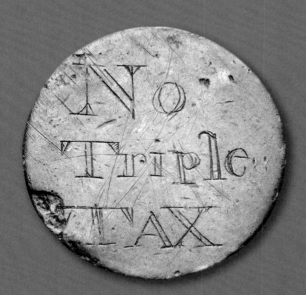
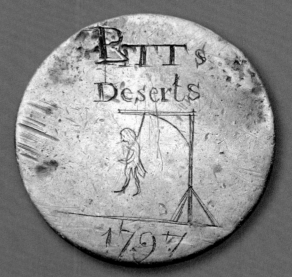

#111
————

The 'triple assessment tax', authorized after considerable opposition by Parliament in January 1798, was the latest in (the younger) **William Pitt**'s attempts to address Britain's debt crisis, which was long-standing and exacerbated by the wars against revolutionary France (from 1793 onwards). The measure tripled the rate of existing assessed taxes and was intended to raise approximately £7 million. By 1799, its failure to deliver had pushed the Prime Minister into replacing the triple tax with income tax levied on incomes above £60 on a sliding scale between 5% and 10%. These closing years of the century were marked by poor harvests, dearth, hardship and unrest. Depictions of Pitt hanging from the gallows are seen across the token coinage, including one issued in 1796 by Thomas Spence engraved 'End of P T', which may have inspired this one (British Museum Object Number T.6819). [KERRY LOVE]

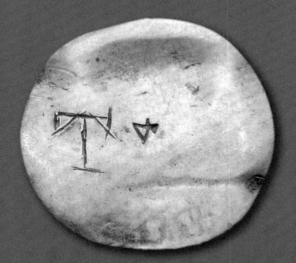 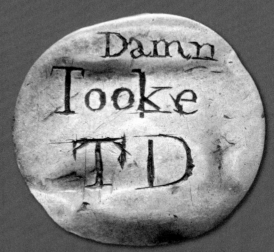

#026

John Horne Tooke (1736–1812), radical politician, canvassed for John Wilkes in the Middlesex elections of 1768 and launched the Society of Gentleman Supporters of the Bill of Rights in 1769 to fund Wilkes, although they fell out in 1771. He supported the American revolutionaries in the War of Independence and was imprisoned for libel in 1777. Active in Major John Cartwright's Society for Constitutional Information, he went on to promote Paine's *Rights of Man* in 1791 and the cause of political reform thorough the London Corresponding Society and other organizations. By 1794 the government had become increasingly repressive and suspicious of radical views. Horne Tooke was arrested and tried for treason alongside Thomas Hardy and John Thelwall. The jury returned a 'not guilty' verdict and now Horne Tooke's political views became less overtly radical. The acquittals were celebrated on commemorative medals, but this coin comes from the loyalist side of politics. [KERRY LOVE]

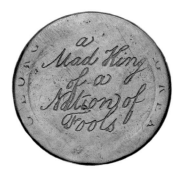

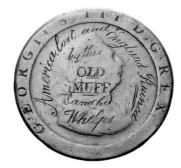

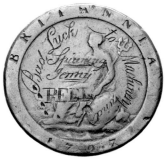

Coin #072

Coin #042

journeys through over two hundred years or more of their existence.

Apart from Spencean tokens, however, few other radical engraved coins from the 1790s survive. Why? John Barrell notes that the radical societies of the 1790s did not obviously copy the Wilkites in conveying meanings and spreading ideas by visual and material means.[36] Rather, radicals channelled their efforts into debates and political pamphlets to create an alternative political public sphere through text and speech. Like their successors, the Hampden Clubs in the 1810s and the Chartists in the 1830s and 1840s, they sought to portray their respectability to vote and therefore did not wish generally to enter into what they saw as the more base or corrupt world of electoral satire and humorous propaganda.[37] Yet the practice of inscribing other types of oppositional political slogans on coins continued, and provided a voice for those not formally part of the organized democratic movements. Just as anonymous threatening letters provided an individual yet collective outlet

for discontent during the Luddite and Captain Swing agitations directed towards aristocratic landlords and the government, so defaced coins allowed a more disparate and anti-monarchical outlet in British society.

The other predominant type of political slogans on 1797 pennies surviving in Millett's collection are anti-royal. The illness of George III, which incapacitated him between 1788 and 1789, and then permanently from 1810 until his death in 1820, led to the Regency crisis, during which debates were raised in parliament about limiting the powers of the much-hated Prince Regent. One coin is inscribed 'A Mad King of a Nation of Fools' (#072). The trope of the mad king is repeated on #036: 'William 4th The Idiot King' for William IV (1830–37). The derogative use of the term 'whelps' to describe George III's children originated in Jacobite critiques of George I and his son, and continued into this era: 'America lost and England Ruined by this OLD MUFF and his Whelps' (#042).[38] Most of the criticism was centred on corruption and the Civil List, reflecting common

 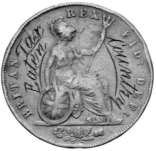

Coin #125 Coin #039

critiques expressed by the 'Mountain' faction of the Whigs and in the radical press, such as William Cobbett's *Political Register*.[39] There are several coins in the collection engraved with the same tropes, although from later in the nineteenth century.

In 1833 and 1834, Parliament debated the annuity paid to Prince Leopold, a German aristocrat, ever since his marriage to the ill-fated daughter of George IV in 1816.[40] This controversy was reflected on coins: 'The Patron of Vice and Frivolity, £50,000 a Year to a German Whelp Leopold' (#050); 'The Patron of Vice and Frivolity. Tax Eaten Country' (#125); and 'To Perpetuate Royalty £50,000 a Year to a German RIP Leopold' (#038). The theme appears to be widely reproduced, given another halfpenny more recently acquired by Millett inscribed with '£50,000 a year to a German Whelp, LEOPOLD, Flare UP, John Bull'. The image of Britannia is erased though her name survives around the top. British (or rather, English) patriotism could combine an anti-continental xenophobia with critique of government corruption. 'Down with Prince Albert' continued the generic sloganry into the Victorian era (#039).

We should not take these as evidence of widespread anti-monarchical sentiment in the population. There was no sustained or mass movement for republicanism in Britain, with only the Irish revolutionaries and campaigners for repeal of the 1801 Union taking action against Hanoverian rule and the idea of monarchy in general.[41] Rather, the monarchy as represented on coins was an obvious target for broader and more inchoate discontent, easily transferred on to the symbols of state but never translated into practice. Inscribing coins and tokens with symbols and slogans was an individual act, responsive to the material form and use of the items in particular moments of political tension and unrest. They gave a voice to the unrepresented as well as amplifying broader campaigns for reform. They were not meant to be programmatic or part of a coherent movement or agenda, and like anonymous letters, they could be the 'voice of a crank' as much as a well thought-out piece of protest.[42] Yet

such engraved coins should not be regarded as less sophisticated or remote contributions to popular politics, but as individual expressions of sentiment or anger that were integral to the participatory debates that consumed eighteenth- and nineteenth-century Britain. Together with a wider print and newspaper culture, and the emergence of the 'mass platform' protests of the early democracy movement, even the smallest acts of individual resistance to established regimes – from anonymous letters to engraved or defaced coins and tokens – could serve to channel oppositional expression of all kinds.

1 M. Dorothy George, *English Political Caricature: A Study of Opinion and Propaganda*, Oxford 1959, 2 vols.

2 Frank O'Gorman, *Voters, Patrons, and Parties: The Unreformed Electoral System of Hanoverian England 1734–1832*, Oxford 1989.

3 Frank Trentmann, 'Materiality in the Future of History: Things, Practices and Politics', *Journal of British Studies*, vol. XLVIII, no. 2, 2009, p. 299; James Epstein, *Radical Expression: Political Language, Ritual, and Symbol in England, 1790–1850*, Oxford 1994; James Epstein, 'Understanding the Cap of Liberty: Symbolic Practice and Social Conflict in early Nineteenth Century England', *Past & Present*, vol. CXXII, 1989; Katrina Navickas, 'That Sash will Hang You: Political Clothing and Adornment in England, 1780– 1840', *Journal of British Studies*, vol. XLIX, no. 3, 2010, pp. 540–65.

4 John Barrell, 'Radicalism, Visual Culture and Spectacle in the 1790s', *Erudit: Romanticism on the Net*, vol. XLVI, 2007, pp. 12, 15.

5 Neil McKendrick, John Brewer and J.H. Plumb, *The Birth of a Consumer Society: The Commercialization of Eighteenth-century England*, London 1982.

6 Victoria Bonnell and Lynn Hunt (eds.), *Beyond the Cultural Turn: New Directions in the Study of Society and Culture*, Berkeley 1999; Trentmann 2009, p. 288; Maxine Berg and Helen Clifford (eds.), *Consumers and Luxury: Consumer Culture in Europe 1650–1850*, Manchester 1999; John Styles and Amanda Vickery, *Gender, Taste, and Material Culture in Britain and North America, 1700–1830*, New Haven 2006.

7 Trentmann 2009, p. 287.

8 Sally Holloway, *The Game of Love in Georgian England: Courtship, Emotions and Material Culture*, Oxford 2019; Michele Field and Timothy Millett (eds.), *Convict Love Tokens: The Leaden Hearts the Convicts Left Behind*, Kent Town, South Australia 1998.

9 Ruth Mather, 'The Home-Making of the English Working Class: Radical Politics and Domestic Life in Late-Georgian England, c.1790–1820', unpublished PhD thesis, Queen Mary's University, 2017; John Styles, *Threads of Feeling: The London Foundling Hospital's Textile Tokens 1740–1770*, London 2010.

10 Trentmann 2009, p. 300.

11 Bertrand Goldgar, *Walpole and the Wits: The Relation of Politics to Literature, 1722–1742*, Lincoln NE 1976.

12 Peter Thomas, *George III: King and Politicians, 1760–1770*, Manchester 2002.

13 Albert Goodwin, *The Friends of Liberty: The English*

Democratic Movement in the Age of the French Revolution, London 1979.

14 John Barrell, *Imagining the King's Death: Figurative Treason, Fantasies of Regicide, 1793–1796*, Oxford 2000, p. 114; Steve Poole, *The Politics of Regicide in England, 1760–1850: Troublesome Subjects*, Manchester 2000.

15 Angela McShane, 'Subjects and Objects: Material Expressions of Love and Loyalty in Seventeenth-century England', *Journal of British Studies*, vol. XLVIII, 2009, pp. 871–86.

16 Neil Guthrie, *The Material Culture of the Jacobites*, Cambridge 2013; Murray Pittock, 'Treacherous Objects: towards a theory of Jacobite Material Culture', *Journal for Eighteenth-Century Studies*, vol. XXXIV, no. 1, 2011, p. 38; Murray Pittock, *Material Culture and Sedition, 1688–1760: Treacherous Objects, Secret Places*, Basingstoke 2013.

17 Guthrie 2013, p. 4.

18 See coin #017 as an example of the engraved Jacobite slogan, 'Down with the Rump'.

19 The slogan of the London Corresponding Society of the 1790s, although there are few if any specifically engraved tokens associated with the group.

20 Amelia Rauser, 'Embodied Liberty: Why Hogarth's Caricature of John Wilkes Backfired', in Bernadette Fort and Angela Rosenthal (eds.), *The Other Hogarth: Aesthetics of Difference*, Princeton NJ 2001, pp. 252–53.

21 Rauser 2001, pp. 242, 248 and 252.

22 Thomas Whitfield, 'Liberty, Property, Materiality: An Historical Archaeology of Later-Eighteenth-Century Protest and Resistance in North East England, 1763–1814', unpublished PhD thesis, University of Newcastle 2020, appendix 1.

23 British Museum, OA.377, '45' brooch, 1763. See coin #241.

24 Rory Naismith, 'The Social Significance of Monetization in the Early Middle Ages', *Past & Present*, vol. CCXXIII, 2014, pp. 3–39.

25 Henry Ling Roth, *The Yorkshire Coiners, 1767–1783*, Halifax 1906.

26 Katrina Navickas, 'The Search for General Ludd: The Mythology of Luddism', *Social History*, vol. XXX, no. 3, 2005, pp. 281–95; Peter Jones, 'Finding Captain Swing: Protest, Parish Relations, and the State of the Public Mind in 1830', *International Journal of Social History*, vol. LIV, 2009, p. 434.

27 Katrina Navickas, 'Thirdspace? Historians and the Spatial Turn, with a Case Study of Political Graffiti in Late Eighteenth- and Early Nineteenth-Century England' in Sam Griffiths and Alexander von Lunen (eds.), *Spatial Cultures: Towards a New Social Morphology of Cities Past and Present*, London 2016.

28 Claire Tindall, Ainslie Greiner and David Hallam, 'Harnessing the Powers of Elemental Analysis to Determine the Manufacture and Use of Convict Love Tokens – A Case Study', *Bulletin of the Australian Institute for the Conservation of Cultural Material*, vol. XXXVI, no. 1, 2015, p. 45.

29 Mark Philp, 'Vulgar Conservatism, 1792–3', *English Historical Review*, vol. CX, no. 435, 1995, pp. 42–65.

30 Barrell 2007, p. 12.

31 Katrina Navickas, 'The Spirit of Loyalty' in Allan Blackstock and Frank O'Gorman (eds.), *Loyalism and the Formation of the British World, 1775–1914*, Woodbridge 2014, p. 59.

32 Barrell 2007, p. 15; R.C. Bell, *Political and Commemorative Pieces Simulating Tradesmen's Tokens, 1770–1802*, second edition, Felixstowe 1988.

33 Barrell 2000, p. 415; *Morning Chronicle*, 23 December 1794; Marcus Wood, *Radical Satire and Print Culture, 1790–1832*, Oxford 1994, p. 81.

34 Wood 1994.

35 Barrell 2007, p. 20.

36 Barrell 2007, p. 12.

37 Matthew Roberts, *Chartism, Commemoration and the Cult of the Radical Hero*, Abingdon 2020.

38 'Geordie Whelp's Testament' in Charles Mackay (ed.), *The Jacobite Songs and Ballads of Scotland from 1688 to 1746*, London 1861, p. 133; Andreas Gestrich and Michael Schaich (eds.), *The Hanoverian Succession: Dynastic Politics and Monarchical Culture*, Farnham 2015, p. 166.

39 Philip Harling, *The Waning of 'Old Corruption': The Politics of Economical Reform in Britain, 1779–1846*, Oxford 1996.

40 Hansard, House of Commons, 21 February 1833, vol. XV, cc1077–9, and 11 February 1834, vol. XXI, cc213–27, https://api.parliament.uk/historic-hansard/commons/.

41 Poole 2000, p. 96.

42 E.P. Thompson, 'The Crime of Anonymity' in Douglas Hay, Peter Linebaugh, John Rule, E.P. Thompson and Cal Winslow (eds.), *Albion's Fatal Tree*, reprinted London 1988, pp. 273–74.

11
The Temple Bar Token
A Portal to London's Radical Past

Joseph Cozens

The Temple Bar token is distinctive for the quality of its workmanship and the quantity of historical information which it conveys (#015, p. 144). The viewer is confronted by a beheading, carried out before Temple Bar, the ceremonial gateway that marked the western limits of the City of London.[1] This imagery is evocative of the failed Jacobite Rebellion of 1745 and the 120 state executions that ensued in the years after the Battle of Culloden.[2] Yet the dedication 'E Allen to Th[s] Allen', and the date of 1774, invoke a later period and a different kind of oppositional politics. This case study decodes the symbolism of this defaced halfpenny and considers its historical significance as a political token. It argues that the coin was intended to preserve and communicate the Wilkite sympathies of Thomas Allen, the coin's original owner. The chapter first examines the connection between Temple Bar and two executed Jacobite rebels. It then reconstructs the biography of Thomas Allen

and his support for John Wilkes. The final part analyses the role of mock executions within Wilkite counter-ritual and visual satire.

Temple Bar

The engraver of this token draws knowingly on Temple Bar as an historic site of public punishment. Although no eighteenth-century executions took place there, the decapitated heads of traitors were periodically displayed above the ceremonial archway, designed by Christopher Wren in 1670. In the aftermath of the '45, for example, two notable Jacobite leaders, Francis Townley and George Fletcher, suffered this fate. Both men were northern Englishmen who served as officers in the rebel army of Charles Edward Stuart. Having taken up arms against the Crown, Townley and Fletcher were tried and convicted of treason, and executed at Kennington Common on 30 July 1746. After

#015

———

being hanged for 'six minutes', cut down while 'still breathing', and decapitated in the pouring rain, their severed heads were 'affixed on two Poles' above Temple Bar in plain view of those passing along Fleet Street and the Strand (**fig. 1**).[3]

For several weeks in August 1746, spectators stood 'gazing up' at the new additions to Temple Bar while enterprising businessmen capitalized on the market for dark tourism by charging customers to view the gurning faces through a telescope.[4] Printmakers and political journalists stoked the public's interest by giving voice to the rebel heads in published 'dialogues' and 'conversations'.[5] However, in March 1772 both of the 'grinning ornaments' – now in a state of considerable decay – were blown down in high winds, to the shock of pedestrians passing below. Public executions, particularly those accompanied by post-mortem punishments such as hanging in chains, gibbetting, or, in this case, the placing of heads on poles, were long-lasting events which lingered for generations in popular memory.[6] Any contemporary Londoner who looked at the Temple Bar token would have instantly recognized the ignominious punishment that the coin's engraver has sought to depict.

Given its sombre tone, it is possible to read this engraved coin as a pro-Jacobite token. The remains of Townley and Fletcher certainly attracted the attentions of political sympathizers, who, on at least one occasion, attempted to retrieve the rebel heads and return them to the custody of their families.[7] Seen in this tradition, the Temple Bar token could be viewed as a kind of Jacobite *memento mori*. However, the provenance of the

halfpenny, which dates from the 1770s, and the dedication ('Th[s] Allen 1774'), warn us against this interpretation.

Thomas Allen

The token's original owner appears to have been Thomas Allen (1705–1792), a substantial master brewer, who resided on Burr Street in the parish of St John's Wapping.[8] Allen ran his brewing operation from premises in Meeting House Yard, near Nightingale Lane, where he also provided a venue for his fellow-Congregationalists to worship.[9] Far from being a Jacobite sympathizer, poll books reveal that, like many men of commerce in London's East End, Allen was a staunch supporter of John Wilkes.[10] In the general election year of 1768, as a freeman of the City of London and as an elector of Middlesex, Allen cast his vote for Wilkes in two separate elections.[11] The political token may well have been a gift, given to Allen by his son Edward, a publican from Hoxton, to celebrate the apogee of Wilkes's political career in 1774.[12]

In December 1774, after a long period of exclusion from Parliament, Wilkes finally took up his seat as MP for Middlesex. During his turbulent political career, Wilkes gained considerable popularity among the middling and lower ranks of Londoners. Men like Allen, who were wealthy but certainly not part of the established political elite, were drawn to the banner of 'Wilkes and Liberty' for several reasons. Firstly, Wilkes cultivated a self-image that was brazenly defiant of authority and that was hostile to the malign political forces of oligarchy and corruption.[13] Secondly, Wilkes was

A Crown or a Grave

TOWNLEY

FLETCHER

Executed at Kennington Common July 30.
Exposed on Temple Barr,
Aug.ᵗ 2ᵈ 1746.

146.

among the first to utilize commercialized political techniques to reach his middle-class supporters. Portraits of Wilkes – the emblem of 'English liberty' – were widely reproduced on mugs and pots for his followers to purchase.[14] Thirdly, Wilkes made considerable political capital by tapping into the burgeoning culture of English nationalism. He frequently characterized his political enemy the Scotsman John Stuart 3rd Earl of Bute as a dangerous interloper. In the pages of *North Britain*, for example, Wilkes represented Bute as a royal favourite who had monopolized place-holding in the interests of his native Scotland. Moreover, Wilkes accused Bute of being a crypto-Jacobite intent on re-establishing Stuart autocracy.[15]

Wilkite symbolism and counter-ritual

The 'militant chauvinism' found in Wilkes's writing was readily translated into London's street politics through Wilkite symbolism and counter-ritual.[16] For example, Prime Minister Bute was often represented as a 'Jack Boot', a symbol of Stuart/Catholic autocracy. The boot emblem appears repeatedly in contemporary prints and was usually paired with a petticoat, a stand-in for the Princess Dowager (1719–1772), with whom Bute was said to be having an affair. These symbolic representations were also harnessed during Wilkite demonstrations. In December 1763, after Parliament ordered the 45th

fig. 1 British Museum Satires 2799, Executed at Kennington Common (1746). © The Trustees of the British Museum. All rights reserved

edition of *North Briton* to be ceremonially burned at the Royal Exchange, supporters of Wilkes staged a counter-demonstration at Temple Bar, where 'a large Jack-boot stuffed with straw was burnt in effigy' amidst the cheers of a large crowd.[17] Similarly, during the Mansion House Riots of May 1768, the Wilkite 'mob' goaded the loyalist Lord Mayor Thomas Harley by parading a boot and petticoat suspended on a wooden gibbet.[18] On this occasion, the Wilkites had their standard confiscated by the authorities. However, one coin in the Millett collection preserves, in physical form, the symbols of Wilkite opposition (#025, p. 128).

As the use of the gibbet, the axe, and the coffin suggest, Wilkites frequently fantasized about subjecting their political enemies to retributive justice. This was most apparent in 1771 when the agitation for a free press was at its height. At the end of March, the Speaker of the House, Fletcher Norton, committed two of Wilkes's City allies, Mayor Brass Crosby and Alderman Oliver, to the Tower of London. Crosby and Oliver were accused of sheltering several printers who had breached Parliamentary privilege. In retaliation, Wilkites staged a mock funeral procession which travelled through the City of London to Tower Hill. The procession consisted of two carts carrying life-sized effigies of Bute, the Princess Dowager and the Speaker of the House. A crowd of 10,000 gathered to see these 'enemies to the King and Country' hanged on a gallows before they were ceremonially beheaded and burned.[19] Moreover, images depicting the execution of Bute were a staple in print satire, both before and after this demonstration.[20] Thanks to the Temple Bar token,

we now know that similar imagined executions were engraved on coins and shared privately between middle-class Wilkites, like Edward and Thomas Allen.

The Temple Bar token therefore attunes us to the complex afterlives of public executions and deepens our understanding of Wilkite politics. Popular memories of public executions and post-mortem punishments, like those inflicted on Townley and Fletcher, made a deep impression on Londoners. However, the visual culture and ceremonial practices associated with official punishments could be subverted and repurposed by those outside the traditional political elite. In the 1760s and '70s the socially heterogeneous supporters of John Wilkes did precisely this. They seized upon the iconography of the state executions of 1746 and claimed the symbolic sites of Tower Hill and Temple Bar for their own ends. Most often, Wilkites fantasized about subjecting Lord Bute to the 'axe', to punish him for his perceived autocratic leanings.[21] Wilkite demonstrators took great relish in staging mock-executions of 'the Scotch favourite' and these highly successful street performances were then commemorated in the form of printed images and engraved coins. That Thomas Allen, a successful brewer from Wapping, was in possession of one such political token, reminds us of the participatory nature of Wilkite politics, but also of the commercial techniques which were central to sustaining Wilkes's popularity.[22] The darker side of this engraved coin, however, is the virulent Scotophobia that John Wilkes promoted, and which many Londoners, including, one presumes, Thomas Allen, revelled in. Finally, the token's imagery also hints at the ultimate weakness of Wilkes's politics. A lone figure in a tricorn hat, leaning on a stick, watches the execution closely. With this, we are reminded that the Wilkites were always more preoccupied with exorcising their enemies than with building a platform for meaningful political reform.

1 John Robinson, 'Decline and Fall of a Monument: Temple Bar', *History Today*, vol. XXXI, no. 10, 1981, pp. 54–55.

2 Regina Janes, *Losing Our Heads: Beheadings in Literature and Culture*, New York 2005, pp. 48–49; Frank McLynn, *The Jacobites*, London 1985, p. 127.

3 *London Evening Post*, 29–31 July, 2–5 August 1746; T.B. Howell (ed.), *State Trials*, vol. XVIII, London 1816, pp. 333–89.

4 Walpole to Montague, 16 August 1746, in *The Yale Edition of Horace Walpole's Correspondence,* vol. IX, New Haven, 1941, p. 45; *London Evening Post,* 2–5 August 1746; Glenn Hooper and John J. Lennon (eds.), *Dark Tourism: Practice and Interpretation*, Oxford 2017.

5 An Abhorrer of Rebellion, 'To the Author', *General Advertiser,* 7 August 1746; 'A Dialogue Between the Two Heads on Temple Bar', *London Evening Post,* 12 November 1763; British Museum Satires 4280, 'Battle of Temple Bar', 1769.

6 James Holbert Wilson, *Temple Bar: The City Golgotha,* London 1853, p. 56; Peter King, *Punishing the Criminal Corpse, 1700–1840: Aggravated Forms of the Death Penalty in England*, London 2017, p. 103. As late as 1846, elderly Londoners could still be found who remembered seeing Townley and Fletcher atop Temple Bar. See *Daily News,* 6 March 1846.

7 *Lloyd's Evening Post,* 20–22 January 1766.

8 In his will Allen left his business to his two sons and £17,500 in annuities to his son-in-law. See The National Archives (TNA), PROB 11/1221/270. For Allen's obituary see *Lloyd's Evening Post,* 8–10 August 1792.

9 London Metropolitan Archives (LMA), MS 6013/37, Land Tax Wapping St John, 1772. For the Nightingale Lane Meeting, see http://www.stgitehistory.org.uk/media/dissenters2.html (accessed 21 March 2020).

10 George Rudé, *Wilkes and Liberty*, Oxford 1962, p. 84.

11 Rudé 1962, p. 84; *The Poll of the Livery of London for Four Citizens to Represent the said City in Parliament,* London 1768, p. 4.

12 For Edward Allen (1745–1807), see City of Westminster Archives Centre, Westminster Baptisms, St Anne's Soho (1743), f. 93; LMA, CLC/B/192/F/001/MS11936/293/443040, Insured property the Parrot, Hoxton (7 May 1781); TNA, PROB 11/1465/219, Will of Edward Allen, vintner, Hoxton.

13 Rudé 1962, p. 184.

14 John Brewer, *Party Ideology and Popular Politics at the Accession of George III,* Cambridge 1976, pp. 171–72.

15 Linda Colley, *Britons: Forging the Nation, 1797–1837,* London 1992, pp. 116–17, 121.

16 John Brewer, 'The Misfortunes of Lord Bute', *Historical Journal,* vol. XVI, no. 1, 1973, p. 22; Brewer 1976, pp. 182–83.

17 *London Evening Post,* 3–6 December 1763.

18 Brewer 1976, p. 182; *Lloyd's Evening Post,* 9–11 May 1768; *Old Bailey Proceedings* online, www.oldbaileyonline.org (version 8.0, accessed 15 September 2020), July 1768, William Hawkins and Joseph Wild (t17680706-61).

19 *Craftsman or Say's Weekly Journal,* 6 April 1771; Brewer 1976, p. 184.

20 See British Museum Satires 3944, 'The Posts' (1762); 4026, 'The Seizure or give the Devil his Due' (1763); 5661, 'The Heads of the Nation' (1780).

21 *North Briton,* no. 109, 27 May 1769; no. 139, 9 December 1769.

22 Brewer 1976, p. 174.

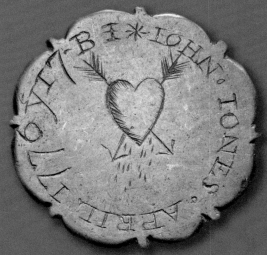
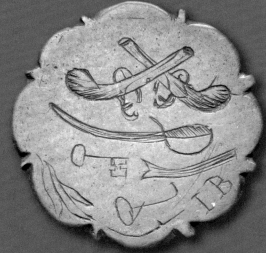

#079

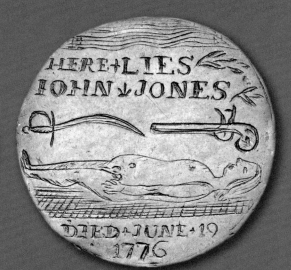

#010

12
Communities of Despair and Resistance
Newgate in 1776

Tim Hitchcock

Around 8 o'clock on a dark, March evening in London in 1776, as the American Revolution raged across the Atlantic, a thief and burglar, John Jones, was caught red-handed. He had expertly jemmied the door of Robert Reynolds's house in Chiswell Street, Moorfields, and made away with an assortment of silver and clothing – and a large leg of pork. The ensuing trial at the Old Bailey was unexceptional. Jones was sentenced to hang at Tyburn and remanded to Newgate Prison.[1] That Sessions nine men were sentenced to hang, five of whom were eventually executed:

> William Miles, for robbing James Lake of a silver watch, two coats, &c. John Jones for a burglary … Christopher Saunders, for bestiality; Daniel Greenwood, for stealing 180 guineas …; and Robert Street, for high treason, in having in his possession a dye, on which was impressed the resemblance of a six-pence.[2]

This was the 'bloody code', red in tooth and claw, but it would be over two months before the sentences were carried out. During these weeks, three of these men – John Jones, Daniel Greenwood and Robert Street, along with four others – Henry Jordon, two brothers, George and Thomas Rowney, and Thomas Jones (alias Evans) – plotted an escape. Their attempt was made just as the prison was closing for the night on Monday, 3 June, and was foiled through the intervention of Richard Akerman the keeper.[3]

Two tokens commemorating the life and death of John Jones reflect these events: his trial; the attempted escape, leading to his being 'doubel-ironed' in Newgate; and his eventual execution. Together they are part of an ongoing tradition and material culture that would flourish over the next sixty years. But they also serve very different purposes. The first, a 'love token' including what appears to be a lover's initials 'BJ/JB', is a marker

of loss, regret and bravado (#079, #010, p. 150); while the second is a powerful statement of anger and resistance. Together, these two tokens, focused on the experience of a single individual, form powerful early examples of a wider class of objects. More importantly, they reflect a moment, a single year – 1776 – in a brutal place – Newgate Prison – where a new plebeian (or prisoner) sub-culture was created, and a new spirit of resistance, rebellion and revolution was forged.

•

The first of Jones's two tokens commemorates the trial, recording the date of Jones's personal appointment with justice on 17 April 1776. The obverse side of the scalloped token depicts a bleeding heart pierced with two arrows, encircled by a date, Jones's name, and the initials 'BJ'. A bleeding heart, pierced by arrows, is a signifier of lost love, and would become a common motif on later tokens, and in criminal and maritime tattoos.[4] The reverse side prominently shows a jemmy or crow bar, a skeleton key, a wire for snagging goods through a window, a cutlass and a brace of crossed pistols, and the letters 'JB'.

This first token speaks of a certain bravado in the face of the criminal justice system, and was almost certainly created in late April or May of 1776, probably within the walls of Newgate prison itself. By 1776 the stereotype of the celebrity thief and highwayman was deeply engrained in British popular culture, going back at least half a century. The names of Jack Shepherd, John McLean and Jack Rann – 'Sixteen String Jack', executed from Newgate just two years earlier – would all have

fig. 1 John Leross token.
Private Collection

been familiar to Jones. So would the idea of 'dying game' at Tyburn: a working-class hero, murdered by the state, but cheered by the crowds.[5]

Jones's second token is different. It depicts a more brutal and visceral scene and will be discussed separately. But his first token is of a piece with four others. All celebrate convicted thieves and include similar motifs, and all were created in Newgate during late 1775 and 1776.

•

What appears to be the earliest of this group of five similar tokens was created for John Leross sometime in Autumn 1775 (fig. 1). A member of a well-known gang, Leross was convicted of attempting to 'rescue' Patrick Madan from a watch house in September 1775; and along with twelve others – including Madan – he was sentenced to five years' imprisonment in Newgate. Like Jones's first token, Leross's includes a brace of pistols, a pair of cutlasses, skeleton keys and a range of house breaking tools; the obverse side depicts a bottle, glass, two pipes and a box. The legend reads: 'JOHN

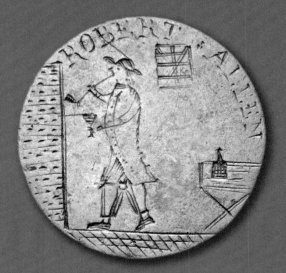 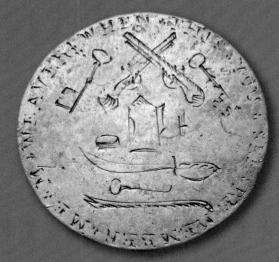

#102

There is some debate as to whether this token was made during Robert Allen's first or second period in Newgate. In chapter 12 Tim Hitchcock argues for the first spell in 1776. Alternatively, Timothy Millett offers in this note an alternative account for 1778. We have left the case open for others to consider.

Robert Allen and **John Milbourn** were indicted for breaking and entering a Holborn draper's shop overnight on 11 June 1778. They smashed glass, forced open a desk, rummaged through secret drawers and stole 95 guineas in cash and over £400 in bank notes. When surveying the damage in the morning, George Otley discovered that the thieves had left in his shop a dark lantern, a crow bar and a key. All these objects are depicted on the reverse of the coin.

Allen and Milbourn took the banknotes to a pawnbroker, who gave evidence against them. The pair was arrested on 26 June and Allen's pocket-book was found in his lodgings. In his own hand he had recorded the extraordinary expenditure of £232-5/-7d on clothes and shoes just four days after the break-in. His trunk held five new pairs of shoes and clothes with silver buttons.

Allen and Milbourn were sentenced to death. Allen's only defence was that 'the clothes are my property. I am quite innocent of the robbery'.

Source: *Old Bailey Proceedings* online, www.oldbaileyonline.org/ (version 8.0, accessed 8 March 2022), July 1778, Robert Allen and John Milbourn (t17780715-87).

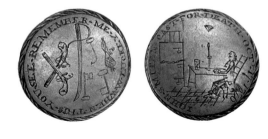

fig. 2 Thomas Kinman token. Private Collection

fig. 3 John Smitten token. Private Collection

LEROSS * FINE FOR 5 YEAR IN NEWGATE 1775 MT'.[6] Like the initials on Jones's first token, the 'MT' appears to reference a lover.

The next token in the group in probable chronological order was made for Robert Allen, who was tried for theft at the Old Bailey in April 1776. Allen was sentenced to three years' hard labour.[7] On one side, Allen's token depicts a collection of skeleton keys, a brace of pistols, a cutlass and burglar's tools; the obverse side shows Robert Allen under his name in Newgate, a pipe in one hand and a glass in the other. The legend reads: 'WHEN THIS YOU SEE REMEMBER ME M. WEAVER'. It appears to have been created almost at the same time as Jones's first token – in late April or May (#102, p. 153).

Jones's first token comes next in this series, followed by one created for Thomas Kinman. Like those for Leross, Allen and Jones, one side features a cutlass, a brace of pistols, skeleton keys and a burglar's hook, while the obverse side depicts Kinman, his legs in irons, at a table reading a book, possibly a bible. The Criminal Register would later describe Kinman as '5'6" fresh Complexion, Sandy hair, Grey Eyes, Born in Fleet Lane, Coachmaker'.[8]

Kinman was convicted in May 1776, and the legend on his token reads 'THOMAS KINMAN * CAST FOR DEATH * MAY 23 1776'.[9] Unusually, no further name or initials are included. Following a petition to the Home Office, this sentence was respited, and Kinman remained in Newgate for the time being (fig. 2).[10]

By the time Jones had been hanged in mid-June, there were at least four tokens in existence, but more were commissioned in the months that followed.[11]

The last in this series (apart from Jones's second token) was made for John Smeeton (Smeaton or Smitton), who in October 1776 was finally convicted for assaulting Robert Gapper on the Hampstead Road, after two acquittals in two months.[12] And like the others, Smeeton's includes a cutlass, skeleton key and a pair of pistols on one side, while Smeeton himself is depicted in Newgate on the reverse, sitting in leg irons, an hour glass and burning candle on the table in front of him. The legends read 'JOHN SMEETON * CAST FOR DEATH * OCT 17 * 1776; and 'WHEN YOU SEE THIS REMEMBER ME * W * LOCKEY'. Like Kinman and Allen, Smeeton's death

sentence was respited, and he too remained a prisoner in Newgate for the time being (fig. 3).

In light of the ephemeral nature of these objects, the survival of even five tokens, all created in the same place and in the same year, is remarkable. Together, they evidence the existence of a new community of both despair and resistance. These five tokens reference the trials of the men involved, and with one exception, name a loved one left behind. In the depiction of cutlasses and pistols, skeleton keys and jemmies, there is a real bravado, but there is also a certain phlegmatic resignation.

•

By 1776 the ongoing battle between Sir John Fielding, his Bow Street Runners and the criminal gangs of the metropolis was in full flood, with no clear winner. Coinciding with a dramatic crackdown on vagrancy, begging and sleeping rough, and building on Henry Fielding's establishment of the Bow Street Magistrates Office in 1749, Sir John Fielding began to implement his 'General Preventative Plan' from 1772. He concentrated the efforts of the Bow Street Runners on detecting and prosecuting felony crime. In that year he built a special courtroom at Bow Street, creating a new 'pre-trial procedure' to help secure convictions, and began putting together a register of known malefactors, with a particular emphasis on coining, burglary and highway robbery.[13] By the mid-1770s the Runners were frequently just 'rounding up the usual suspects', and expecting their growing experience in court to secure a conviction.[14] And while there is no evidence of their involvement in Jones's arrest, at least six other defendants tried alongside

him in April 1776 were on trial as a direct result of the Runners' efforts.

For many Londoners, Bow Street signified nothing beyond unnecessary violence, corruption and special pleading. As one anonymous correspondent of the *Oxford Magazine* put it, 'Sir John Fielding's is a transporting and hanging system of Police'.[15] As a result, the depiction of the tools of burglary on these tokens speaks to a critique and perspective shared with a substantial proportion of Londoners. To simply own the tools of burglary depicted on these tokens was evidence enough to secure a conviction, so bragging about your familiarity with these tools, even on an ephemeral copper token, was a significant step.[16]

The prison in which Leross, Allen, Jones, Kinman and Smeeton were held before and after trial was itself a marker in a wider evolving conflict. In 1776, Newgate Prison was in the process of being rebuilt.[17] Designed by George Dance, with a 300-foot frontage of cold rusticated stone, the new Newgate Prison would form the focus of Britain's revolutionary moment – the Gordon Riots – in June 1780, only to be rebuilt as the capital's primary gaol and the site of most executions from 1783 onwards (figs. 4 and 5).

Superficially the new prison looked well-ordered, modern and fit for purpose. But behind its awful façade lay a much older – indeed medieval – design. In the same decades that a new form of 'penitentiary' was being conceived in terms of solitary confinement, the silent system and a rigid separation of classes of prisoners, Newgate Prison was built as a series of open quadrangles and communal wards, with a tap room and the keeper's

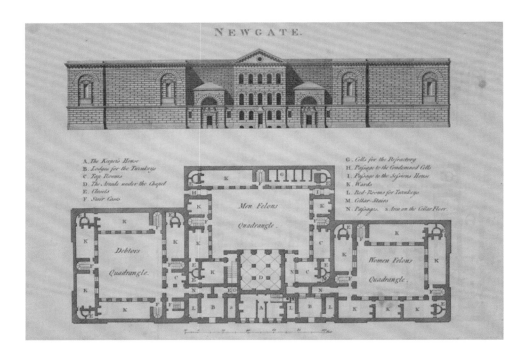

fig. 4 Plan of Newgate Prison from John
Howard, *The State of the Prisons*, 2nd edn, 1780.
British Library, Maps.Crace VIII.84

house. George Dance's Newgate was designed on
the assumption that the prisoners themselves would
organize their own wards, charging garnish money
on entry and a weekly bill for the privilege of
staying.[18] Depictions of Allen and Kinman, smoking
pipes and drinking, reflects one reality of prison life,
as does the image of Smeeton comfortably seated at
a table. Jones's experience was probably different.
He would have almost certainly been held on a
common ward in the period leading up to his trial,
and probably in one of the cells reserved for 'refrac-
tory' prisoners after his escape attempt.

Newgate was built on the assumption that
while the prison was owned by the City, it would
be leased to an independent contractor or keeper
(Richard Akerman for most of the closing decades
of the eighteenth century). Newgate was definitely
not designed as a place of punishment or reform.
It was a gaol in the traditional sense, a holding
place for prisoners as they were processed through

fig. 5 George Dance the younger. Newgate Prison. © Sir John Soane's Museum, London

the criminal justice system. In normal times, the prison would have moved to a slow annual rhythm determined by the workings of court next door. In the lead-up to each Sessions, which were held eight times a year, the population of the prison could rise to 200 felons, only to fall back to perhaps forty or fifty in the weeks afterwards. And up until the mid-1770s, imprisonment as a punishment was rare. At the Old Bailey only eleven convicts were sentenced to imprisonment between 1770 and 1775.[19]

But Spring 1776 was not normal. Even before Dance's new prison was complete, the system for which it was designed fell into crisis. In the preceding decade, an average of 263 defendants per year were sentenced at the Old Bailey to transportation, comprising over two-thirds of all sentences. But in Autumn 1775, as a result of the American Revolution, this smooth pathway to exile was suddenly closed. The last prison transport to leave London sailed in October 1775.[20] And with no way to rid the capital of its convicts, hundreds of men and women held on sentences of

transportation found themselves stuck in Newgate. In March 1776, while Jones awaited trial following his arrest, William Eden wrote to Edmund Burke: 'The fact is, our prisons are full, and we have no way at present to dispose of the convicts'.[21] For the first time in British history, a large and stable population of prisoners was created. Leross, Allen, Jones, Kinman and Smeeton were among their number.

In response, in May the government passed the Hulks Act, temporarily authorizing punishment by hard labour as an alternative to transportation. And by August 1776 Duncan Campbell had repurposed two ships, the *Justitia* and the *Censor*, as prison hulks. During the day, the able-bodied were set to hard labour, 'improving the navigation of the Thames', while at night, they were sealed 'below decks' in squalid and unhealthy conditions. By 1778, 370 convicts were being held on these two hulks, rising to 510 in the following year, substantially relieving pressure on the prisons.[22] But in Spring 1776, while Jones and the others awaited execution or a reprieve, the hulks were still in preparation and Newgate was full.

And if atrocious over-crowding, dead 'heroes' such as Jack Shepherd, the encouragement of friends and anti-establishment sentiment, were not enough to provide Jones with the inspiration for this token, he also shared Newgate Prison itself with an improbably romantic – or at least self-promoting – figure: Patrick Madan. The leader of a gang of thieves and highwaymen based in Upper Moorfields, Madan and his associates, including John Leross, were convicted of attacking a watch house and injuring several watchmen in

an attempt to rescue Madan following an earlier arrest. Unusually, all thirteen were sentenced to long periods of imprisonment in Newgate, of between three and seven years. From the beginning of 1776, Madan and his gang reputedly ran the prison. A detailed pamphlet-account of Madan's life describes how at the 'beginning of 1776... they were removed to the middle quadrangle of the new gaol of Newgate':

> Here they had plenty of room and fresh air, and... Madan erected a kind of academy in the prison, and assiduously taught the noviciates the mysteries of his trade.[23]

John Leross, Robert Allen, John Jones, Thomas Kinman and Thomas Smeeton were all in Newgate at just the moment when the criminal justice system was on the change; and just when Newgate was at its most disorderly.

•

Jones's second token was clearly designed and created following his attempted escape on 3 June. It is very different to the others. There is no mention of a love left behind or a day in court. The very words on the token are scored deeply – angrily – into the copper. And uniquely, this token explicitly references Jones's harsh treatment in Newgate and his execution. The escape attempt commemorated was perhaps inspired by accounts of Jack Shepherd's exploits half a century earlier, or by an opportunist realisation that the unfinished building was not yet fully secure; to this extent it continues the theme of the celebrity thief.

But the double irons and naked body depicted are a far cry from the scenes of smoking and drinking on the other tokens, reflecting a harsh new reality of punishment and death. The naked, dead body on the obverse side appears to reference execution and dissection.

Images of leg irons formed part of the decoration on Newgate's façade and 'ironing' a refractory prisoner was normal practice.[24] But the depiction of Jones's dead body, naked and laid out on a hatched surface, is both unusual and powerful. Even more so as Jones was not in fact subject to dissection, although following the Murder Act of 1751 many others were, including at least two men Jones would have met in Newgate.[25]

While Jones languished in Newgate, two weeks before his escape attempt, two of his fellow prisoners, Thomas Henman and Benjamin Harley, were tried and found guilty of the brutal murder of an excise officer.[26] They were executed on 27 May. While initially the bodies of both men were spirited away for dissection by William Hunter at the Royal College of Surgeons one hundred-feet south of the prison, one of them was also flayed, and sent on to the Royal Academy. Here, sculptor Agostino Carlini posed it in the character of the 'Dying Gladiator' as it set in rigor mortis. Carlini then cast the body in plaster of Paris as the basis for the creation of *Smugglerius*, a version of which remains in the collection of the Royal Academy to this day (**fig. 6**).[27]

In the small, overcrowded world of Newgate Prison, its stream of constant visitors bringing news of the outside world, the creation of *Smugglerius* in the last weeks of May, must have dampened the

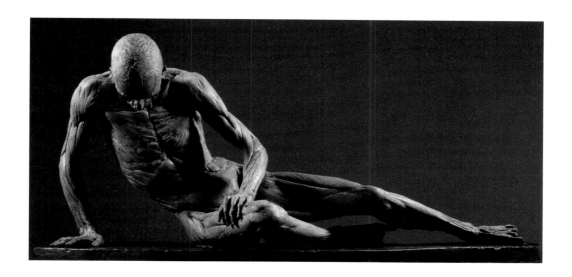

fig. 6 William Pink, after Agostino Carlini,
Smugglerius (1776, 1834). Royal Academy
of Arts, London

spirits of the most ardent of gentlemen thieves. And while the depiction of the tools of burglary can be found on all the surviving tokens, the inclusion on later tokens of an hourglass in the image of Smeeton, of Kinman reading – possibly a bible – may reflect the beginnings of a more sombre theme.

Jones's own death came, as the second token reflects, on 19 June 1776, amid all the gruesome, carnivalesque rituals of Tyburn. The *Middlesex Journal and Weekly Advertiser* published a detailed account the following day:

The devotions being ended, the prisoners were coming out of the prison, as usual, at nine o'clock, when ... at 20 minutes before ten the gloomy procession moved in the following order: Constables on foot, the Head City Marshal, in mourning, on horseback; Sheriff's Officers on horseback, and more Constables on foot; the Under Sheriff in a chariot; the first cart hung with mourning, with two of the Offenders, and on the ... cart a coffin for one of them; the second cart with two other Offenders; the sledge with Robert Street for coining; the procession closed by Sheriff's Officers and Constables.

The scene could have formed the basis for Hogarth's print *The Idle 'Prentice Executed at Tyburn* (1747).

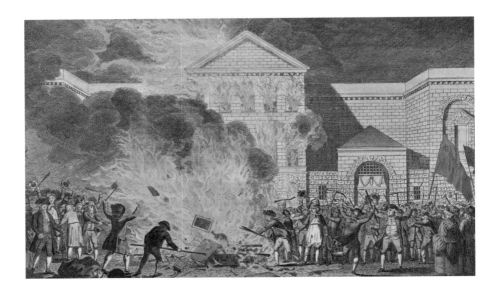

fig. 7 The Burning and Plundering of
Newgate & Setting the Felons at Liberty by
the Mob, 1780. London Metropolitan Archives

The croud assembled on this occasion was immense, in coaches, chaises, carts and on horseback, besides the prodigious numbers on foot, among them many, very many faces well known at the Public Offices [Bow Street]. The prisoners were extremely penitent, and prayed and wept incessantly. A man in the croud called out to Greenwood; but he would not lift his eye from his book.[28]

Jones did not quite achieve the common ambition to 'die game', nor did he leave a lasting reputation as a bold celebrity thief. His life and death have not much occupied historians until now. But his experience and death reflect the peculiar culture of crime and punishment associated with eighteenth-century London – a culture and a system that was in real crisis at just the moment when Jones encountered it. If five of these Newgate tokens reflect a traditional culture of resistance and celebration, Jones's second token evidences a new anger, and a new spirit of resistance.

⋅

We do not know who made these tokens and who determined their content. But we do know that many of the people imprisoned in Newgate that year would have had the skills to do so. At least ten

men and two women were found guilty of 'coining' in 1776 and would have spent long periods incarcerated in Newgate. It is also clear that coining, both as an offence and as an activity, became increasingly commonplace from the early 1770s. For most of the first three-quarters of the century, there were, on average, between two and three people a year prosecuted for coining offences at the Old Bailey. Many years saw no prosecutions whatsoever. But this changed dramatically from 1773 onwards, with 88 individuals prosecuted in just the following four years.

Practised at working with metal, coiners had all the skills required to turn a copper coin or disc into a token. We have no way of knowing which 'coiner' was responsible, but someone like Robert Street can stand in for several candidates. Street was tried and convicted at the same Sessions as Jones, and like Jones appears to have had a long history of criminality. Street's skill and role in counterfeiting is reflected at his trial in April 1776, where he was found in possession of 'a dye for a shilling and another for a half crown not finished, and a he and she, as it is called, for stamping'. The unfinished state of the stamp suggests that it was of Street's own making; his possession of a piece of soft lead 'stamped with the dies, in order to better shew the impression' confirms that conclusion. He was also found with a 'cutting press complete with the fly and block, and a he and she belonging to it; and … benches to work upon and pots to melt metal in, and files'. Together it was more than enough to convict him.[29] By the mid-1770s, the silver William III sixpence, shillings, half-crowns and crowns created during the great recoinage of the 1690s

had been in circulation for over seventy years, and their worn state made them easier to counterfeit. The art involved creating a die that reproduced a worn-looking impression on a copper blank, that could then be made to look silver through a chemical process.

•

The year 1776 created something new. For the first time in British history a large group of disaffected working men and women were brought together in enforced idleness, and treated to overcrowding, squalor, exploitation, and the spectacle of some of their number being both executed and their bodies desecrated. Leross, Allen, Jones, Kinman and Smeeton were all part of this community and the tokens that have survived speak to this moment. And while Jones died in June and was largely forgotten, he and his fellows contributed to an ongoing period of resistance.

In August 1777, Patrick Madan led a prison riot in which 'the windows were broke, and iron casements thrown in to the yard, together with innumerable brickbats'. The riot was only quelled when Richard Akerman shot Madan in the head (typically Madan survived with a flesh wound). The sense of purpose of the rioters was perhaps best captured by a female prisoner, Elizabeth West, 'the Famous Miss West', who urged them on with a 'Go it lads, go it, dash away, don't spare them! Liberty! Liberty! Liberty!'[30]

Perhaps in response to the riot, many of the men being held in Newgate were transferred to the hulks: 182 in total. But this did not solve the problem. The list of transfers, in Richard Akerman's

hand, names Robert Allen, Thomas Kinman, John Smitten (given as Smeeton) and John Leross (given as James Lecroes).[31] Although we do not know if they were directly involved, within weeks of the transfer there was an 'insurrection' among the prisoners held on the hulks. About 150 prisoners attempted to over-run their guards. Two were killed and seven or eight injured.[32]

Over the next few years escape attempts, mutinies on transport ships, and prison riots came to haunt Britain's system of criminal justice. Perhaps most significantly, in June 1780 the Gordon Rioters destroyed Newgate Prison itself and torched Richard Akerman's home (**fig. 7**).

The following decades saw the thorough reformation of the system of criminal justice with the creation of both the prison colony at New South Wales and new-style penitentiaries. But Newgate Prison, and the events of 1776, formed an important turning point in what would become a rush of rebellion and reform. John Leross, Thomas Kinman, Robert Allen, John Smitten, and most certain of all, John Jones were at the centre of this revolutionary moment.

I would like to thank Joseph Cozens for sharing his research on John Jones with me. In a volume co-authored with Robert Shoemaker I mistakenly conflated two people named John Jones and hopelessly muddled his story. See Tim Hitchcock and Robert Shoemaker, London Lives: Poverty, Crime and the Making of a Modern City, 1690–1800, *Cambridge 2015, pp. 337, 342. Cozens's research has allowed me to correct these errors.*

1 *Old Bailey Proceedings* online (*OBP*), www.oldbaileyonline.org (version 8.0, accessed March 2018), April 1776, John Jones (t17760417-8).

2 *Morning Post and Dailey Advertiser* (London), 7 June 1776.

3 *Gazetteer and New Daily Advertiser* (London), 5 June 1776.

4 See Bridget Millmore, 'Love Tokens: Engraved Coins, Emotions and the Poor 1700–1856', unpublished PhD thesis, University of Brighton 2015, Chapter 4, *passim*. The dataset of criminal tattoos included in *The Digital Panopticon: Tracing London Convicts in Britain and Australia, 1780–1925,* www.digitalpanopticon.org (accessed 16 January 2020), includes 9610 'hearts', from among 74,568 tattoo descriptions, of which 1633 are 'pierced'.

5 See Andrea McKenzie, 'Martyrs in Low Life? Dying "Game" in Augustan England', *Journal of British Studies,* vol. XLII, no. 2, 2003, pp. 167–205.

6 See Millmore 2015, pp. 215–20.

7 *OBP*, James Steward, Robert Allen and Sarah Shaw, April 1776 (t17760417-41); and Punishment Summary, 10 July 1776 (s17760710-1).

8 'Criminal Registers of Prisoners in Middlesex and the City, October 1793 – September 1794', *London Lives, 1690–1800,* NAHOCR70000CR700000021, www.londonlives.org (LL; version 2.0, accessed 13 May 2020), The National Archives (TNA), MS. HO26/3.

9 *OBP*, Thomas Kinman, April 1776 (t17760522-11).

10 LL, Old Bailey Associated Records (assocrec_115_27727), LMA SP44/94 ff.48–50, 290; 'Sessions Papers – Justices'

Working Documents', 12 April 1775 – 1 November 1777 (LMSLPS150880059).

11 A further token, #192, dated 1776 and almost certainly originating in Newgate, includes many of the same motifs, and is almost certainly by the same hand. This token is inscribed 'S PEARCE M CHAMBERS 1776' and includes an image of a man in leg irons smoking a long-stemmed pipe, with a tankard in one hand. Like Kinman's token, the obverse depicts a brace of pistols, two cutlasses and a pair of skeleton keys. This token is possibly associated with James Pierce who was tried at the Old Bailey for burglary in October of 1775 and sentenced to being branded on the hand and imprisoned in Newgate for a year. It has not been discussed in detail here because this association is uncertain. See *OBP*, James Pierce, October 1775 (t17751018-16); and LL, Old Bailey Sessions: Sessions Papers – Justices' Working Documents, 13 December 1774 – 9 December 1775 (LMOBPS45023041).

12 *OBP*, Thomas Nelson and John Smitten, September 1776 (t17760911-73).

13 J.M. Beattie, *The First English Detectives: The Bow Street Runners and the Policing of London, 1750–1840*, Oxford 2012, Chapters 4 and 5.

14 Hitchcock and Shoemaker 2015, pp. 312–16.

15 *Oxford Magazine*, vol. VIII, February 1772, p. 43.

16 Rogues and Vagabonds Act, 1783, 23 George III. c. 88.

17 C.W. Chalklin, 'The Reconstruction of London's Prisons, 1770–1790: An Aspect of the Growth of Georgian London', *London Journal*, vol. IX, no. 1, 1983, pp. 221–34.

18 W.J. Sheehan, 'Finding Solace in Eighteenth-Century Newgate' in J.S. Cockburn (ed.), *Crime in England, 1550–1800*, London 1977, pp. 229–45.

19 *OBP*, Tabulating 'Year' against 'Punishment Sub-category', between 1770 and 1775. Counting by defendant.

20 Emma Christopher, *A Merciless Place: The Lost Story of Britain's Convict Disaster in Africa*, Oxford 2010, p. 61.

21 Charles William, et al. (eds.), *The Works and Correspondence of the Right Honourable Edmund Burke*, 8 vols., London 1856, vol. 1, p. 305.

22 See Charles Campbell, *The Intolerable Hulks*; Bowie, Maryland 1993; and W. Branch Johnson, *The English Prison Hulks*, London 1957.

23 *Authentic Memoirs of the Life, Numerous Adventures, and Remarkable Escapes of the Celebrated Patrick Madan*, London 1782, pp. 24–25.

24 Walter Thornbury, 'Newgate' in *Old and New London: Volume 2*, London 1878, pp. 441–61. See illustration, 'Door of Newgate'.

25 25 Geo 2 c. 37. Hitchcock and Shoemaker 2015, p. 220.

26 *OBP*, Joseph Blann, otherwise Bland, Benjamin Harley, and Thomas Henman, May 1776 (t17760522-32).

27 Hitchcock and Shoemaker 2015, pp. 330–31. There is an ongoing debate about whose body formed the basis for the cast. See 'Smugglerius', *Wikipedia*, https://en.wikipedia.org/w/index.php?title=Smugglerius&oldid=848686394 (accessed January 16, 2020).

28 *Middlesex Journal and Evening Advertiser* (London), 18 June 1776 – 20 June 1776.

29 *OBP*, Robert Street, April 1776 (t17760417-60).

30 *London Chronicle*, 19 August 1777. See also Christopher 2010, Chapter 2.

31 LL, Old Bailey Sessions: Sessions Papers – Justices' Working Documents, December 1778 (LMSMPS506870380 – LMSMPS506870386).

32 Johnson 1957, p. 6. *London Evening Post*, 29 September 1778 – 1 October 1778.

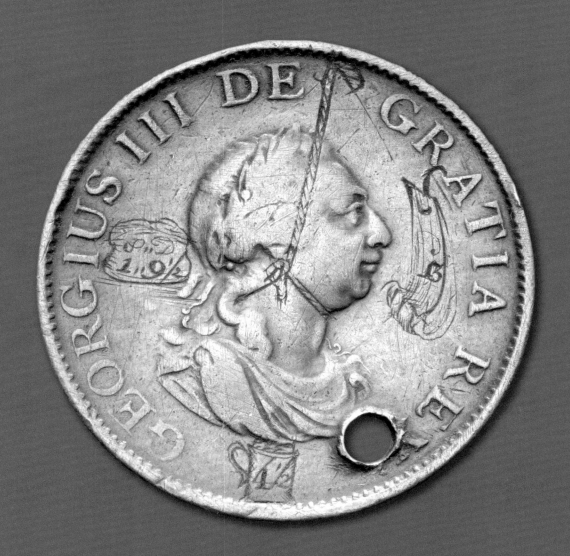

#118

13

'But O the misery of the poor, they scarcely can get bread'

Poor John Bull and the Price of Bread, Beer and Beef

Bridget Millmore

For the working population in late eighteenth century Britain, copper coins were symbols of the marketplace and wage labour, of the price of bread and beer. The act of altering one of these coins to highlight the inflated cost of living and the resulting animosity felt for King George III, immediately places Poor John Bull's engraved coin (**#118, opposite**) in a material and visual world of dissent where, as Katrina Navickas explains in Chapter 10 of this volume, these objects offered a mouthpiece for those unable to voice their opinions. As a personification of England, John Bull was a familiar eighteenth-century figure evident in a wealth of satirical material. In popular caricatures he takes a variety of stances: with a noose around his neck, breaking wind in the face of the King, tucking into a plentiful meal of roast beef, plum pudding and ale in contrast to his emaciated French counterpart. By the early 1800s, when this coin was probably modified and working people were increasingly frustrated by the violation of their customary rights, John Bull was a stock image for the downtrodden English subject, ready to criticize king and country.[1] This coin belongs to that experience of oppression and to the compulsion to blame both monarch and government for the 'distressedness of the times'.[2]

Crafted from a large copper halfpenny manufactured in 1799 in Matthew Boulton's Soho works, the coin is worn and scratched, suggesting that it was in

You be D_m'd

Vous etes une Bete

With Porter Roast Beef & Plumb Pudding well cram'd
Jack English declares that Mons. may be D_d *POLITENESS*, The Soup Meagre Frenchman such Language don't suit.
So he Grins Indignation & calls him a Brute-

fig. 1 *Politeness* by James Gillray

circulation for several years before being engraved. Interestingly it is pierced so that it can be worn around the neck, implying that the seditious nature of its modification could be hidden from or shown to others depending on their political allegiances. The surfaces have not been rubbed smooth in the style of many engraved coins featured in this book. The coin has simply been reworked by adding the familiar phrase and images that belonged to a pervasive rhetoric of protest and subversion.

On the reverse, a noose has been drawn around the King's neck, clearly expressing hostility to the monarch. A loaf of bread, a tankard of ale and a side of beef surround the royal bust, representations that evoke caricatures such as James Gillray's *Politeness* (fig. 1), which feature a well-fed John Bull with a foaming tankard of beer and joint of beef.

For those familiar with the price of food and drink at the turn of the century, the additional details – a loaf at 1s/9½d, beer at 4½ and beef at

fig. 2 *The Republican Attack* by James Gillray

13d – highlight a key message of this engraved coin: the cost of food was out of control. Traditionally a quarten loaf (weighing four pounds) cost 7d, not triple that price, as is inscribed here.[3] Extreme weather conditions and crop failures, and the government's indifference to the extortionate price of food and the erosion of the 'older moral economy', were among the factors contributing to frequent bread riots across the country.[4] The noose around George III's neck on this engraved coin

resonates with other forms of direct action taken by the mob against the King, such as the attack on his coach in 1795 as he drove through St James's Park to the House of Lords. Gillray's caricature of that event (fig. 2) brings these elements together in the form of a loaf draped in funereal black and held high on a pitchfork in the manner of an executed criminal.[5] As protests increased, Pitt took drastic action. In 1795 it became a treasonable offence to imagine the death of the King.[6] The noose on this

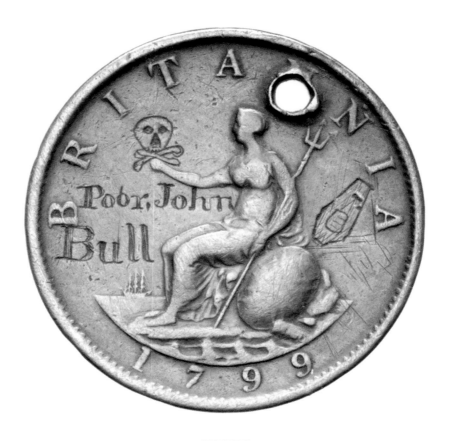

Coin #118

engraved coin was therefore in serious contempt of the new Treason Act and Seditious Meeting Act.

On the obverse of the engraved coin, the phrase 'Poor, John Bull' has been inscribed alongside Britannia with her trident, shield, Union flag and ship. With the word 'poor', John Bull becomes a pitiable, impoverished character facing inflated food prices and starvation. On Britannia's right hand sit a skull and crossbones; a coffin has been added to her left. Coin #025, discussed by Katrina Navickas, draws on the same symbolic vocabulary, but places the coffin next to the King and hangs Britannia on a gibbet.[7]

Memento mori objects, such as the coffin, skull and crossbones featured here, also appeared on contemporary mourning jewellery and gravestones

signalling the inevitability of death.[8] But on this engraved coin the memento mori are more than a reminder of mortality, they act as a warning message aimed at Britannia and, by association, at the government and the monarchy. Indeed, these emblems of death carry a powerful meaning since they allude to the demise of British national identity as Britannia quite literally stares death in the face (#118).

The alteration of this coin with words and images that attack the crown and state transform it from an object with exchange value in the marketplace and repurpose it as a seditious, indeed treasonable piece. Strong feelings of disloyalty towards King George III and anger with Pitt and his government are audaciously expressed, given the gagging laws of the time, through the words, images, cuts and grooves that subvert this coin.[9] Its portability and indeed wearability ensured that its message could remain hidden and therefore difficult to police. This anonymous historical fragment, although only 30mm in diameter, punches above its weight by gouging the desperate feelings of the marginalized into the surface of a coin, in effect by capturing the anger of a bread riot on a copper halfpenny; an extraordinary illustration of 'multum in parvo'.

'But O the misery of the poor, they scarcely can get bread' taken from the ballad 'My Old Hat' in Alun Howkins and C. Ian Dyck, '"The Time's Alteration": Popular Ballads, Rural Radicalism and William Cobbett', History Workshop Journal, vol. XXIII, no. 1, 1987, p. 21.

1 David Bindman, The Shadow of the Guillotine: Britain and the French Revolution, London 1989, pp 42–43; David Johnson, 'Review of Defining John Bull: Political Caricature and National Identity in Late Georgian England', Reviews in History, no. 360, 2003, https://reviews.history.ac.uk/review/360 (accessed 22 January 2022).

2 From the handloom weaver William Rowbottam's diaries, November 30, 1799, http://www.pixnet.co.uk/Oldham-hrg/archives/rowbottom/pages/051-page.html (accessed 22 January 2022).

3 Roy Porter, English Society in the 18th Century, London 1991, p. 317.

4 E.P. Thompson, The Making of the English Working Class, Harmondsworth 1968, p. 68; Jenny Uglow, In These Times, London 2015, p. 147.

5 See coin #106, which has Britannia's head on a stick.

6 Uglow 2015, p. 148.

7 See Katrina Navickas, Chapter 10, in this volume.

8 See engraved coin #183 in the Catalogue.

9 See the 1794 halfpenny token that satirizes the imprisonment of Henry Symonds, William Winterbotham, James Ridgway and Daniel Holt, all variously accused of seditious libel, https://www.britishmuseum.org/collection/object/C_T-6464 (accessed 22 January 2022).

Wᵐ: SEARS LETTER=FOUNDER LONDON 1746.

#254

Part four

Image and representation

#053
———

'Sir' Jeffrey [Jeffry, Jeffery] **Dunstan** became an instantly recognizable figure to late eighteenth-century Londoners. He began life as a foundling and later traded as a secondhand wig seller. His distinctive wit and physique, and his cry of 'old wigs for sale', were perfect for his other career as 'Mayor of Garrett', a mock election which took place at the beginning of each Parliament. The established order was turned on its head by a series of larger-than-life and eccentric candidates. This election generated a massively popular festival in Wandsworth, as epitomized by Samuel Foote in his play of the same name. In 1781 the *Gentleman's Magazine* reported a crowd of some 50,000 spectators. In 1785 Sir Jeffrey won the contest on the first of three successive occasions and, like Sam House (#087), he was routinely trotted out by the caricaturists to portray an image of the mob and the wrong class getting involved in politics.

I have come across a number of these coins throughout my career (including #067). Although I have not found a purpose for them, they remind me of the 'Wilkes and Liberty' coins that were common around the middle of the century. [TIMOTHY MILLETT]

14
The Graphic Image and the Popular Imagination
1780–1830

Brian Maidment

The social role of the image undergoes fundamental changes in the period between 1780 and 1830.[1] Made increasingly available through the use of relatively cheap and easy reprographic processes of wood engraving and lithography, graphic images became a central site for the discussion of complex social issues and a rallying point for oppositional and contrarian views. Two particular topics for graphic debate were the complex social issues frequently summarized as 'the taxes on knowledge' and 'the march of intellect'. 'The taxes on knowledge' comprised the stamp duty and other taxes imposed on the reporting of news, legislation that was clearly intended to limit popular access to accounts of topical political events. Originally intended as a celebratory term to encapsulate innovative technological and scientific achievement, the 'march of intellect' quickly became associated

with the social, economic and cultural aspirations of the labouring and artisan classes, aspirations that were often seen as a threat to traditional social order. Largely free from the censorship that successive governments imposed on printed texts, visual images became an important site for the expression of opinion and political allegiance.

The broadening range of socio-cultural interests apparent in late Regency and early Victorian prints stands in a complex relationship with broader strands of socio-economic and political change. While the development of literacy was understood as a necessity within an increasingly industrial and technocratic society, the visual image, drawing on the radical political discourses of the 1790s, maintained its presence alongside the word as a powerful form of political dissent in this period. Most famously expressed in the outspoken

fig. 1 Emblematic title forming part of the emblematic title page of volume 1 of *The Saturday Magazine* published by the Society for the Diffusion of Christian Knowledge in 1832

pamphlets with wood-engraved illustrations that William Hone and George Cruikshank produced between 1819 and 1821 in response to controversial political events like the Peterloo massacre and the Queen Caroline controversy, graphic satire remained a significant element within the radical tradition into the early Victorian period, often making use of vernacular graphic codes.[2] The 1820s also saw the growth of a mass-circulation illustrated periodical press aimed particularly at artisan readers, a development that culminated in the *Penny Magazine* (1832–1844), an 'informational' journal that made extensive use of wood-engraved illustrations to support its visual representation of the material world. Partially an institutional attempt to define the information appropriate for an artisan's educational needs (it was published by the Society for the Diffusion of Useful Knowledge, founded as an organization to support Whig cultural ambitions in 1826),[3] the *Penny Magazine* was launched in the same year as similar magazines with a sectarian bias (for example, *The Saturday Magazine*, published by the Society for the Propagation of Christian Knowledge), and other non-institutional serialized educational ventures such as *Pinnock's Guide to Knowledge* (fig. 1).

More commercially orientated entrepreneurs had since the early 1820s been publishing cheap magazines in which illustrations that combined instruction with visual pleasure reached out to new readers in less obviously didactic ways. Such market-led publications defined popular taste in ways that sought to combine information with entertainment.

The emergence of a mass-circulation and relatively cheap and accessible illustrated print culture was thus an essential element in both reflecting and helping to construct social change between 1780 and 1830. An uneasy alliance between word, material object and image in this period – something that is acted out in the hybridized forms of the coins and tokens that are the subject of this book – characterized a shift from an extensively pre-literate society, in which images functioned largely as symbols and signs, towards an overwhelmingly wordy and print-based society. The dialogues between word and image that took place in the process of constructing social meanings at this time were negotiated in various ways, but especially through processes of appropriation, overwriting and inscription. In such processes the popular and the vernacular were frequently appropriated and overwritten by more sophisticated discourses. The Hone/Cruikshank pamphlets, for example, brilliantly appropriated the forms and modes of illustrated children's rhymes to formulate a seditious account of contemporary politics.[4] The

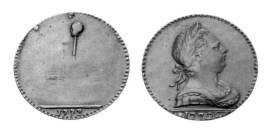

Coin #106

outspokenly furious caricatures produced by C.J. Grant in the politically tumultuous years around 1832 used the crude linear boldness of the woodcut to excoriate contemporary politicians.[5] More broadly, the rise of the wood engraving to become the dominant reprographic medium of the first half of the nineteenth century was an outcome not just of commercial good practice but also of an appropriation of a vernacular idiom for complex cultural purposes.[6] It is exactly in this period between 1780 and 1832 that the word 'illustration' makes a transition in meaning from primarily describing verbal and textual expositions of scriptural texts towards its predominant modern meaning as a term for images that serve to accompany, deepen, explain or embellish a printed text. The ascription of the image to a largely 'illustrative' function suggests the extent to which mass literacy had begun to erode the power of the visual image to convey social messages without recourse to words.

Yet during this period the visual image maintained or even originated a wide variety of expressive purposes that sustained the considerable power of the graphic against the encroachment of the word. The coins and tokens in this collection give clear evidence of the power of the visual in an increasingly print-based culture. They are often constructed as palimpsests, with the basic formal structure of coin or medal being overlaid by a variety of visual additions. Such overlaying of the original with new graphic content was sometimes a form of deliberate defacement, subverting an original meaning to new purposes which were at times politically radical in intent (#106).

Other coins and tokens assembled here used the underlying form and shape of the medal, with all the cultural histories and accumulated prestige displayed by such an object, as an opportunity to memorialize a local event or occasion – an execution, for example. Many were produced as aspects of the formulation of trade identity, used to authenticate their possessors as legitimate tradespeople. Others were love gifts and assertions of personal identity, using the implied value of coin and medal to underpin their assertion of devotion. Given these various purposes, it is no surprise that coins and tokens embodied a wide range of graphic expertise, ranging from amateur scratchings to sophisticated professional engravings. They drew on a wide variety of visual codes, ranging from the vernacular graphics of broadside ballad woodcuts to the imagistic language of radical politics and sophisticated letter cutting of professional engravers (#235).

Letter making and cutting at this time involved a number of trades, many of them requiring a high level of specialized skills, ranging from monumental masons and silversmiths through to the printers and engravers who produced sheet music,

#235 showing the kinds of vernacular graphics characteristic of the woodcuts used in ballad sheets

trade cards and stationery.[7] But the making of letters might also be undertaken by anyone with a sharp enough implement to scratch into metal.

Such considerations raise immediate issues about visual literacy and shared graphic codes in a pre- or just literate society. Using evidence that suggests that 60% of men and 40% of women could sign their name, Stephen Colclough and David Vincent argue that by the early nineteenth century, 'England and Wales had become societies in which the capacity to decode print was a commonplace'.[8] They go on to state that 'nominal literacy was virtually universal across the middling and upper reaches of society and throughout the ranks of male artisans.... Even amongst the lower orders there was a solid tradition of attainment', which they largely ascribe to 'the presence of vernacular religious literature, and the networks of chapmen'. 'Everyone had some contact with the written word' they conclude, before going on to argue that in the Victorian period, 'the most effective primer for learning to read in the critical

period when literacy levels began to take off was to be found on the streets'.[9] The streets and public spaces of course also formed a key locale in the late Georgian and Regency periods through which not just print but also a wide range of visual culture was displayed and given meaning for people with little ability – or need – to decode print. Yet it is not easy to find ways of assessing the nature and levels of visual awareness shared within past societies. Nor is it possible to have a clear sense of regional variation. It is probably too simple, given the resources available in country towns, to assume that the metropolitan population and those who lived in large urban centres were more visually aware than those who lived in the country. But London did undoubtedly dominate the production and distribution of print in the late-eighteenth and early-nineteenth century, and the visible manifestations of the trade were much more obvious in London than elsewhere.

While it is possible to assess basic literacy rates by using available sources, there is no simple equivalent that might suggest levels of shared visual understanding. The extent to which the symbols, codes and representational conventions were 'read', understood and shared by the mass of the population remains largely speculative. One interesting commentary on these issues is provided by the representations of print shop windows which appeared in caricatures between 1780 and 1830. James Gillray's *Very Slippy-Weather* (1808), the best known of these images, was used by Diana Donald as the cover illustration to her standard book on caricature and has subsequently been widely discussed by scholars (fig. 2).[10]

fig. 2 James Gillray, *Very Slippy-Weather*.
Hand-coloured etching published by Hannah
Humphrey, 1808. Courtesy of the Lewis Walpole
Library, Yale University

In this print Gillray showed a gentleman pass-er-by falling over on an icy pavement in front of Hannah Humphrey's print shop in St James's Street in the West End of London. The pedestrian's discomfiture at his sudden transformation from fashionable and dignified gentility into disarray is visualized through his scattered possessions – the thermometer held in his left hand that should have reminded him of the temperature, the money cascading from his pocket and the dropped walking stick that failed to buy him security from accident,

the wig tumbling from his head. The barking dog in the foreground of the print, a widely used visual trope used to signify the noisiness and chaotic character of the street, underlines the narrowness of the distance between day-to-day genteel self-assurance and social calamity, a much-repeated theme in late eighteenth-century social caricature. But although the image centres its composition on the hapless pedestrian, the print's more complex meanings concern Gillray's disquisition on the nature of spectatorship that provides the backdrop to the unfortunate passer-by's mishap.

Gillray's caricature shows the window and doorway of Humphrey's shop. The bow window acts as a frame for a ranked assemblage of the shop's stock of prints, many of them by Gillray himself. The glazed door offers a glimpse of a bewigged and behatted gentleman appraising a caricature for possible purchase while a shop keeper hovers attentively over him. Behind the railing that protects the shop front, five figures are surveying the window. Three, including two in colourful uniforms, are depicted entirely from behind, while to the left is a man shown in half profile, viewing the caricatures through a quizzing glass. To the right, a ragged boy with a syphilitic profile and a pair of skates under his arm, looks across the image, seemingly more focused on the line of absorbed spectators than on the enticing images in Hannah Humphrey's window. Who is looking at what in this image, and what can it tell us about the pleasures, availability and levels of visual experience in Georgian London?

The absorption of the four passers-by, rendered stationary from their perambulation by the

shop's display, is clearly acknowledged by Gillray. Hannah Humphrey's shop window is depicted as an arresting visual spectacle, a free show for any casual passer-by. In this way, sophisticated, allusive and expensive topical graphic political commentary was made accessible to all who cared to look. That the experience of viewing these prints was pleasurable is suggested by the absorption of these particular spectators. The spectators are given clear individual identities. The two uniforms belong to a soldier and a domestic servant, the cloak and whip of the right-hand figure form the accoutrements of a wagoner. The quizzing glass, hat and cloak of the left-hand figure suggest a somewhat raffish gentleman. Less easy to define is the presence of the somewhat stunted and damaged figure of the street urchin. How far these diverse figures are meant to represent a cross-section of society, brought together by a shared moment of visual pleasure, is hard to ascertain. Certainly, Gillray's image celebrates the free spectacle offered by the print shop window, but the concept of a democracy of spectatorship is undercut by a number of factors. First, using a trope that becomes more and more elaborated in caricature in the 1830s, the absorption of the viewers in a passing visual attraction also reminds us that they are simultaneously neglecting their social obligations and duties. The gaze of the street urchin, unimpressed by the colourful window display, seems to offer a not entirely approving appraisal of this motley gathering. Second, the seeming variety and social diversity implied by the distinctiveness of each individual spectator may well have been driven by artistic criteria rather than any vision of social

diversity. The print shop window gazers seem to have been selected more for the joyous variety of their headware as for any function as a metonym for a peaceable democratic gathering. Third, it is not clear that the print shop gazers have much understanding of what they are seeing, even with the aid of a quizzing glass. One of the central assumptions of caricature is that the follies and vices of contemporary society are reflected back on the viewer him or herself. The print shop window offers a mirror in which spectators might recognize their own weaknesses and shortcomings. But these particular spectators seem unaware of any moral or self-reflecting element in what they are seeing. They seem merely to be gawpers, unable to read off any deeper meaning beyond an immediate visual pleasure. And of course, outside the picture plane, the artist and the consumer/connoisseur of Gillray's print shares a sense of superior visual understanding beyond that of the street viewers assembled in the image. Meanwhile, behind the closed door that separates the wealthy prospective customer from the gawping crowd, genteel cultural exchanges are enacted and made visible to the satirical gaze of the caricaturist.

Three kinds of viewers are thus on display in Gillray's caricature. The most privileged are the artist and the knowing observer/purchaser of the print drawn together by their shared distance from, and assumed superiority to, the follies on display. The inhabitants of the shop interior form a second kind of viewer, satirized for their pretentions to aesthetic distinction, but at least sheltered within the peaceful space of genteel commercial exchange. The street spectators

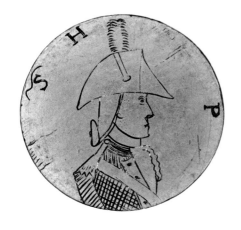

Coin #268

form a third category of viewer, indulging themselves in a passing visual pleasure. Absorbed in their act of close attention to the wares displayed in the shop window, they turn their backs on the artist's mockery of their lack of self-awareness and, by implication, failure to understand the deeply inscribed cultural and political allusions on which caricature depends. These three tiers of visual sophistication delineated by Gillray's caricature may help to construct a model of the ways in which shared or 'democratically' available complex images might be read differently depending on the educational and social level of the viewer. Recent commentators who have written about Gillray's image have used it to illustrate a bewilderingly disparate sense of the visual capacities of its original viewers. Some, like Diana Donald and Ian Haywood, have argued that the graphic codes and complexities of caricature were relatively widely available and understood by at least a broad range of the middling and artisan classes, and served a vital purpose in making the populace aware of political events.[11] Others, like David Taylor, have insisted that caricature was 'located away from the crowd and within a fairly narrow space of cultural knowingness',[12] and thus operated beyond the comprehension of all but a highly cultured elite. In looking at the collection of coins and tokens that form the centre of this book it is important to keep an open mind about the extent to which the codes, graphic language and cultural allusiveness of the visual image were available to those without extensive formal education or much knowledge of the printed word (#053, p. 172, and #268).

Very Slippy-Weather also adds the caricature shop window to the two sources cited by Colclough and Vincent as offering democratically available points of access to print culture – 'vernacular religious literature, and the networks of chapmen' – although it is important to add that both vernacular religious and broadside literature often contained graphic as well as verbal elements. But, of course, the everyday visual experience of the mass of people extended well beyond these categories even before the development of a close association between the printed text and the visual image. Many images crowded the streets. Posters and street advertisements for travelling theatrical companies, circuses and other peripatetic entertainments, many of them structured to highlight pictorial images of the pleasures to be experienced, accumulated on available fences and walls, often laid on top of each other to create a chaotic chorus of signs. Indeed, the palimpsest of street advertisements became a

fig. 3 Robert Seymour, 'The March of Intellect'
Hand-coloured etching published by Thomas
McLean 1829. Courtesy Lewis Walpole Library

repeated trope for artists and caricaturists from the 1820s on. Robert Seymour's 'The March of Intellect' of 1829, for example, depicts a busy urban street scene with the crowded inhabitants hemmed in by walls of posters vying for visual attention (fig. 3).[13]

Part of Seymour's argument in this satirical etching is that there are too many competing claims on the individual's attention as he or she navigates the London pavements, and the outcome of these visual distractions, of the mass of advertisements for local or incidental pleasures, is to divert public attention away from social duties and obligations. Seymour's commentary is given an additional dimension by his concentration on wordiness – all the overlapping posters and advertisements he delineates are printed texts without illustration. While his caricature was essentially a commentary on the dangers of the spread of

Puff *Paste*-ry !

fig. 4 'Puff *Paste*-ry' wood engraving from
The Comic Offering (Smith, Elder & Co. 1833),
p. 292, suggesting the array of visual information
that appeared on the streets in the 1830s

that was published in the 1833 edition of *The Comic Offering* (fig. 4).

By the early Victorian period, the visual cacophony of street advertising was frequently used to suggest a society lapsing into urban chaos, in which competing meanings fought out an unresolved struggle for public attention. The most famous of these images was John Orlando Parry's heroic watercolour *A London Street Scene* (1835), which showed a massive poster-festooned hoarding mainly comprising advertisements for performances. Parry's comic art shows a sustained obsession with the disparate levels of meaning constructed by the accidental overlapping of verbal and visual elements of public displays.[14] Such an interest in the visual power of public displays of lettering fascinated many Victorian writers, notably Charles Dickens. Dickens, interestingly, remained suspicious of the value of entry into literacy by means of the printed text, arguing in *Hard Times* that book learning stood in opposition to instinctive right feeling and in *Our Mutual Friend* that Boffin, the 'Golden Dustman', was better off trusting his intuitive ability to value a dust-heap than trying to enter book learning through having Gibbon's *Decline and Fall of the Roman Empire* read aloud to him. In all these cases, the word made visible by street posters was seen as part of a dangerous move from instinctual visual understanding into the fraught and potentially deceptive world of text.

The combined resources of the church and the streets provided many other kinds of visual experience for the populace at large, many of them, like gravestones and stained-glass windows, rendered

mass literacy to the entire populace, nonetheless it makes an important point about visual culture – the printed word is itself a powerful and arresting visual spectacle, even for those who have limited power to decipher its meaning.

A similar emphasis on the visual spectacle of the publicly displayed word occurs in another of Seymour's images, a small-scale wood engraving

into familiar symbolic forms that drew on well understood narratives. Pub signs and shopfronts combined the verbal and the visual to ensure that the barely literate could find their way. The dialogues of commerce drew on visual elements in the production of trade cards, letter headings, coach and ferry timetables and invoices, as well as various forms of advertising.[15] Colourful anthologies of 'Cries of London', widely used both to help children to read and to acquaint them with the street culture of London, combined educative and pleasurable elements.[16] Religious tracts were increasingly produced with illustrative content after 1800. Children's primers had long used woodcut illustrations as well as typographical theatricality to help children learn. Street literature comprised a variety of kinds of texts produced as broadside song sheets, 'garlands' of gathered lyrics or chapbooks, many accompanied by illustrations drawn from the printer's available stock of wooden engraved blocks.[17] Election posters and official proclamations sometimes added a visual image to their primarily verbal content, although the verbal content would undoubtedly have been laid out in an eye-catching way. And, of course, coins and tokens carried images that ranged from royal portraits to individual declarations of identity. All these commonplace visual forms, many of them on public display, were an integral part of the popular experience of the world and suggest at least some level of ability to read that world through visual symbols and graphic images.

A massive shift in the nature of the visual experience occurred as one of the many consequences of the transformation of the economic and industrial structure of British society between 1780 and 1830.[18] These changes were partly driven by improvements to reprographic processes that facilitated the cheap mass production of images. But the new technology being rapidly developed to exploit the potential offered by the mass circulation of print was itself driven by a widespread underlying concern with the social management of the resultant stream of publications. A wide variety of interest groups were closely engaged in this issue, ranging from religious organizations eager to maintain the Christian message; socio-political groups like the Whig-led Society for the Diffusion of Useful Knowledge looking for ways to inform and educate working people in apolitical ways; commercial interests, especially publishers, keen to exploit a new mass market for diversionary and entertaining literature; and politically engaged progressive and radical groups seeking access to news of topical events, and keen to enter public discourse. These disparate and conflicting interests partook in an extended and frequently bitter contest over the extent to which information, especially topical social and political reportage, should be available to the mass of the population (fig. 5).[19]

In an increasingly technocratic society, in which artisans, artificers and skilled workers were assuming both increased economic importance and an emergent sense of class identity and ambition, mass literacy was both essential and threatening. Mass-circulation print culture was at the same time a commercial opportunity, a sign of a progressive and enlightened democratic society, and a potential threat to the social order. The graphic image, and visual culture more generally,

fig. 5 Title page for volume 1 of *The Mechanic's Magazine* (Knight and Lacey 1823), a magazine aimed at the interests of the artisan manufacturing classes. The title page makes use of a wide range of emblematic devices and cultural allusions

had a crucial place in these huge historical shifts, especially in the 1820s and 1830s.

Nowhere was the use of visual symbols and emblems more pronounced than in the discourses of radical and dissenting politics between 1770 and 1832, where the power of the visual to influence and inform pre- or just literate groups was widely recognized. Although cheap and often radical satirical periodicals with wood engravings proliferated around the controversies created by the passing of the 1832 Reform Bill, it is difficult to assess the extent to which graphic political commentary was widely available before this time. As already suggested, caricatures, with their repeated representations of public figures, were too expensive for widespread consumption, but they were to some extent available to a wider public through displays in print shop windows. But cheaper wood-engraved prints of political events were widely distributed, forming, as Sheila O'Connell has noted, perfect vehicles for propaganda.[20] Alongside prints, other material forms, notably transfer-printed pottery, had made graphic political commentary more accessible in daily life – satirical images of Napoleon, for example, appeared widely in the early years of the nineteenth century, especially during the invasion scares of 1803 to 1805.[21] Ceramic busts and transfer-printed mugs and jugs of prominent politicians, such as William Pitt and Charles James Fox but also including reformers and radicals like Thomas Paine, allowed people to display their political allegiances in their everyday environment. It is interesting to note that some of the transfer-printed mugs and jugs devoted to Paine depict him as a demon or traitor.[22] In the aftermath of the 1819 massacre in Manchester that became known as Peterloo, images of military brutality even appeared on printed neckerchiefs.[23] In the last decade of the eighteenth century the outspoken radical Thomas Spence turned the trade token, previously used as currency, as advertisements

for businesses, and as a form of commemorative medal, into an agency of political propaganda for his views on slavery, taxation and land reform, as well as for commentary on the revolutionary events in France.[24] Marcus Wood, who describes Spence as a 'multi media satirist' notes that the form of the trade token 'adapted well to the combination of image and aphorism on a coin'.[25] In ways such as these, radical satire, largely encoded into either the conventions of caricature or the iconography of political dissent, was given an important presence in everyday experience.

In the early years of the nineteenth century, national crises such as Peterloo and the Queen Caroline controversy changed the visual representation of politics, and especially the graphic modes of popular dissent, by drawing on the vernacular history of the wood engraving. In her chapter on Peterloo in *The Age of Caricature*, Diana Donald saw the representation of the Manchester protests as 'the end of the Georgian tradition in satire', with etchings and engravings being 'too costly for mass distribution'. While Manchester had few resources for the making and distribution of prints of the event, Donald argues, 'a simple visual image could… attain an immediacy and symbolic force', which meant that 'the handful of engravings representing the episode in St. Peter's Fields have ultimately had a greater influence than the printed word in creating a mental picture of "the Peterloo massacre"'.[26] Equally powerful and accessible to popular understanding were the illustrated political tracts by Hone and Cruikshank, which along with responses from a wide range of other exuberant pamphleteers, brought a new graphic

energy into dissenting politics.[27] These hybrid publications were constructed using the dramatic black line simplifications of the wood engraving to gain an intense visual impact. Thus, in the first two decades of the nineteenth century a new visual language for discussing politics was formed that simplified graphic satire visually without losing its historical allusiveness or cultural complexity.

Common understanding of the graphic language of the prints, banners, posters and even membership cards associated with the public activities of dissent led to the mobilization of the visual signs of group identity that was a characteristic of opposition politics between the 1770s and the 1830s. Building on the playful yet deadly serious incorporation of the visual language of children's literature into the pamphlet wars of the 1820s, later radicals continued to harness a graphic vocabulary drawn from popular culture to meet their political ends. The appropriation of popular imagery for the purpose of expressing political dissent reached new heights during the turbulent years surrounding the 1832 Reform Bill, manifesting itself in an outbreak of pamphlets, broadsides and short-lived periodicals using the bold linear outlines and vernacular energy of the wood engraving. Robert Seymour and C.J. Grant, now little remembered but hugely influential in their day, were both prolific draughtsmen of the period. Grant's formal experiments included 'The Political Drama', an extended series of large-scale wood engravings that combined an apparently clumsy linearity with extensive textual elements hand-drawn on to the block to make poster-like images of startling visual impact. Seymour drew extensively for *Figaro in*

London, a weekly magazine that started in 1832, establishing a range of immediately recognizable shorthand graphic versions of contemporary politicians that recurred in his drawings. The title page for volume 1 of *Figaro in London* suggests the ways in which Seymour reduced the appearance of contemporary politicians to a few instantly recognizable lines (fig. 6).[28]

Scholars of late eighteenth- and early nineteenth-century radicalism have tended to focus on the verbal aspects of radical culture,[29] but recent work, notably that of Ian Haywood, Henry Miller and Matthew Roberts,[30] has begun to provide a much more detailed account of the ways in which dissenting politics drew on the vernacular image in order to attack the political establishment and to examine the extent to which oppositional views were enacted by means of material culture.[31]

The brief account of the trajectory of the visual culture offered to the mass public between 1780 and 1850 laid out above suggests the migration of the most potent images away from church, schoolroom and street into the bookshop, library and parlour. Late Georgian society, familiar with the long-established use of image, symbol and icon as forms of instructing, informing and managing the populace, were now increasingly literate and able to engage with illustrated print in ways that granted them enhanced agency as readers and viewers. Such increased agency was enacted through ways of reading that were often communal and collaborative, and carried out in clubs and reading rooms as well as within the Sunday School.[32] Access to news and entertainment joined more established aims such as the pursuit of useful

fig. 6 Wood-engraved illustrated title page drawn for the first volume of *Figaro in London* (William Strange 1832)

information and devotional activities as legitimate reasons for reading. Increasing access to print was combined with, and to some extent driven by, new technologies for the reproduction of illustrations. Nonetheless, such new reprographic technologies served to locate pictures primarily as the servants of texts. The role of images as a means of representing socio-political meanings accordingly took on new forms in an increasingly literate and print-based society, many of them overlaying traditional symbolic, emblematic and allusive structures with

more naturalistic and descriptive modes. By the early Victorian period, images had also become more available as a form of diversionary entertainment. Nonetheless, the graphic image in this period retained at least some of the functions associated with visual culture in a less print-based society, where emblematic and symbolic codes are readily understood even by the less educated. Such traditional functions of the visual are widely manifested in such material objects as the coins and tokens assembled and discussed here, which operate as significant acts of local and personal intervention into cultural or political history. Many of these coins and tokens perform acts of resistance to the meanings of the mass of images produced by the contemporary cultural industries. Frequently appropriating or cutting across received forms of visual information, they find both pictorial and word-based ways of memorializing or imposing identity upon particular moments of lived experience, often using clumsy but highly personal forms of expression. By inscribing letters and images into and on to the material forms provided by the metal disc, such acts of imposition give forms of meaning and identity to their makers that speak eloquently and idiosyncratically from the past.

1 Sheila O'Connell, *The Popular Print in England,* London 1999; Louis James, *Print and the People 1819–1851,* London 1976; M. Dorothy George, *Hogarth to Cruikshank: Social Change in Graphic Satire,* London 1967; Patricia Anderson, *The Printed Image and the Transformation of Popular Culture 1790–1860,* Oxford 1991.

2 Ian Haywood, *Romanticism and Caricature,* Cambridge 2013; Ian Haywood, *The Rise of Victorian Caricature,* Cham 2020.

3 Anderson 1991; Valerie Gray, *Charles Knight: Editor, Publisher, Writer,* Aldershot 2006.

4 Marcus Wood, *Radical Satire and Print Culture 1790–1822,* Oxford 1994; Edgell Rickword, *Radical Squibs and Loyal Ripostes,* Bath 1971.

5 Richard Pound (ed.), *G.J. Grant: A Radical Satirist Rediscovered,* London 1998; Haywood 2020; Brian Maidment, *Comedy, Caricature and the Social Order 1820–1850,* Manchester 2013.

6 James 1976; Celina Fox, *Graphic Journalism in England During the 1830s and 1840s,* New York and London 1988; Anderson 1991.

7 Nicolete Gray, *A History of Lettering,* Oxford 1986; Alan Bartram, *The English Lettering Tradition from 1700 to the Present Day,* London 1986. David Jury, *Graphic Design Before Graphic Designers: The Printer as Designer and Craftsman 1700–1914,* London 2012; Graham Hudson, *The Design and Printing of Ephemera in Britain and America 1720–1920,* London 2008. John Lewis, *Printed Ephemera: The Changing Use of Types and Letterforms in English and American Printing,* Ipswich 1962; Maurice Rickards, *The Encyclopaedia of Ephemera,* London 2000.

8 Stephen Colclough and David Vincent, 'Reading' in David McKitterick (ed.), *The Cambridge History of the Book in Britain: Volume VI, 1830–1914,* Cambridge 2009, p. 285.

9 Colclough and Vincent 2009, p. 296.

10 Diana Donald, *The Age of Caricature,* New Haven and London 1996; David Taylor, *The Politics of Parody: A Literary History of Caricature, 1760–1830,* New Haven and London 2018; Eirwen E.C. Nicholson, 'Consumers and Spectators: The Public of the Political Print in Eighteenth-Century Britain' in *History,* vol. LXXXI, no. 261 (1996), pp. 5–21.

11 Donald 1996; Haywood 2020.

12 Taylor 2018, p. 139.

13 Brian Maidment, 'Periodicals and Serial Publications 1780–1830' in Michael Suarez and Michael Turner (eds.), *The Cambridge History of the Book in Britain: Volume V, 1695–1830,* Cambridge 2009, pp. 498–512.

14 Janet Snowman, *John Orlando Parry and the Theatre of London,* London 2010.

15 Rickards 2000; Lewis 1962.

16 Sean Shesgreen, *Images of the Outcast: The urban poor in the Cries of London,* Manchester 2002.

17 Many examples of street literature marry a text with an entirely inappropriate block – a pastoral love lyric illustrated with a picture of a sailing ship, for example – suggesting the extent to which an image might be savoured on its own terms rather than necessarily being related to a particular text.

18 Anderson 1991.

19 Ian Haywood, *The Revolution in Popular Literature: Print, Politics and the People, 1790–1860,* Cambridge 2004. See also Anderson 1991; Alan Rauch, *Useful Knowledge: The Victorian Morality and the March of Intellect,* Durham and London 2001.

20 O'Connell 1999, p. 129.

21 Sheila O'Connell and Tim Clayton, *Bonaparte and the British,* London 2015, pp. 114–17; Stella Beddoe, *A Potted History: Henry Willett's Ceramic Chronicle of Britain,* Woodbridge 2015, pp. 88–92.

22 Beddoe 2015, pp. 106–21.

23 O'Connell 1999, p. 147.

24 Marcus Wood, *Radical Satire and Print Culture 1790–1822,* Oxford 1994, pp. 68–82.

25 Wood 1994, p. 71.

26 Donald 1996, p. 185.

27 Rickword 1971; Wood 1994, pp. 214–63.

28 Henry Miller's *Politics Personified: Portraiture, Caricature and Visual Culture in Britain c.1830–1880,* Manchester 2015, also provides a useful context for considering the portraits used on coins and tokens.

29 Kevin Gilmartin, *Print Politics: The Press and Radical Opposition in Early Nineteenth Century England,* Cambridge 1996; James Epstein, *Radical Expression: Political Language, Ritual, and Symbol in England, 1790–1850,* Oxford 1994; Iain McCalman *Radical Underworld: Prophets, Revolutionaries, and Pornographers in London, 1795–1840,* Cambridge 1988.

30 Haywood 2004; Haywood 2020; Miller 2015; Matthew Roberts, *Chartism, Commemoration and the Cult of the Radical Hero,* Abingdon 2019.

31 Haywood 2004; Haywood 2020; Brian Maidment, 'Satire, Caricature and the Radical Press 1820–1845' in Joanne Shattock (ed.), *Journalism and the Periodical Press in Nineteenth-Century Britain,* Cambridge 2017, pp. 84–103.

32 Abigail Williams, *The Social Life of Books: Reading Together in the Eighteenth-Century Home,* New Haven 2017.

The man
who did this
was born
without a
shirt
1849

#007

15

'The Man Who Did This was Born Without a Shirt'

Workers' Self-Representation on Tokens

Susan E. Whyman

Behind each surviving token there are individuals who longed to be remembered. One way to ensure that they would not be forgotten was to draw their image on a coin. Another method was to tell their life stories by engraving moments in time at key stages of their lives. When craftsmen combined texts with images, they left messages to loved ones and revealed the presence of working-class literacy. The Millett collection highlights this phenomenon, with only a tiny proportion of the 315 items bearing neither letters nor numbers. This ability to use numerals and the written word was, itself, a major characteristic of a new working-class culture.

One artisan who 'made his mark' took pride in proclaiming: 'I AM THE HARD WORKING MAN' (#099, p. 191).

We see a lamplighter in a hat and jacket, leaning on a ladder. A light is in his hand, and an oil can sits nearby. Viewers may regard him as an artisan with a livelihood and tools, a man whose labour contributes to the public good. But his employment and industry are not only central to the token, they define his social status and may subsume his personal identity.

This essay suggests that tokens were a form of contemporary life writing in its broadest sense. It included, but was not limited to, poetry, folklore, memorials and chronological autobiography, which had not yet become the dominant format. This life writing linked together fragments of images and words that appeared in family trees and bibles, carving on tombstones, and chunks of text and woodcuts from printed broadsides, ballads, songs, prints, caricatures, chapbooks, newspapers and almanacs. These fragments were found on everyday materials from pornography

to prayer books and were ripe for the picking by craftsmen.

An analysis of the tokens reveals three overlapping modes of self-representation. First, images and text, which construct a personal identity that fulfils the longing to be remembered after death; second, images and texts that record life stories, including birth, deaths, marriages and individual experiences; and third, images and texts that send messages to loved ones about social, economic and political views. When these varied autobiographical fragments are pieced together, they form universal *and* personal patterns that offer unique evidence about working-class lives. They also show varied uses and levels of literacy in ways that signatures fail to achieve.

This chapter asks why workers used tokens to construct personal identity and tell life stories, how they achieved these goals, and if this activity met social and political needs by the mid-nineteenth century. The neglected concept of self-education offers an explanation of how workers' literacy and social consciousness developed.

Texts and images that construct personal identity

Self-representation on tokens takes many forms, from lone initials, names and dates, to full-blown images with material objects that symbolize people's lives. Because visual elements are combined with texts, they also show emotions. The portrait bust of 'B' on coin #137 (p. 192), with its large staring eyes, is difficult to forget. The obverse image shows a man in irons with a pistol in his right hand and his left hand on his hip. This suggests that 'B' may be imprisoned, perhaps for highway robbery. Of course, he may just be looking out of a window, but his glaring face suggests discontent. This image attempts to draw a portrait of a specific person, so that his face will be remembered.

We find another form of self-representation in the large number of tokens that feature a man on one side and a woman on the other using objects of daily life.[1] Their aim is to depict an actual couple. But their similar layouts, clothes and poses of men with hands on their hips show that a well-known template has been copied and shared.

The images of 'TH' and 'AH' on coin #133 are an excellent example. 'TH' (p. 192) wears a hat, buttoned jacket and buckled shoes. He stares ahead, with his feet apart and his left arm on his hip, holding a cutlass. His right outstretched hand bears a cup, whilst a glass and bottle sit on a shelf. He seems to be saying: 'Welcome. Come and have a drink with me'. To his side, a double-pierced heart evokes the pleasures of family life – love, hospitality and drinking – though the usual pipe is missing. The pose in this image is repeated over and over.

The portrait of 'AH', his female companion, is dated 1782, with a pair of scales hanging from the border. They appear to be there to weigh the oval contents of her one-wheeled barrow – likely food for sale in the market. Her brimmed hat tied with ribbons, patterned dress, apron and buckled shoes show she has a livelihood and possessions. Though they are simple objects and the figures are crudely drawn, the couple confidently states their presence. We must take them as they are.

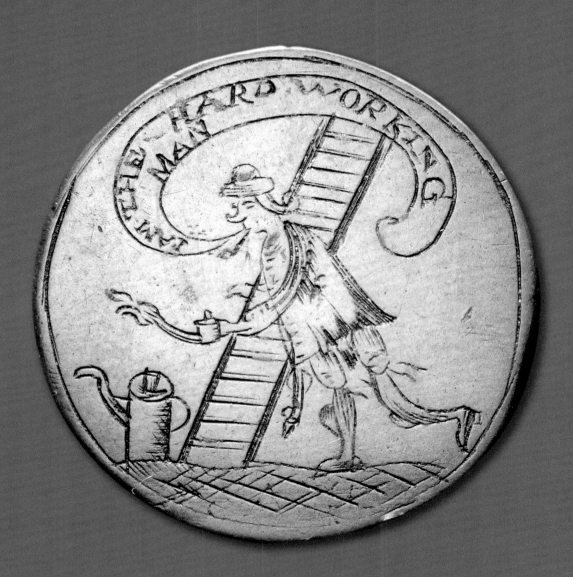

#099
———

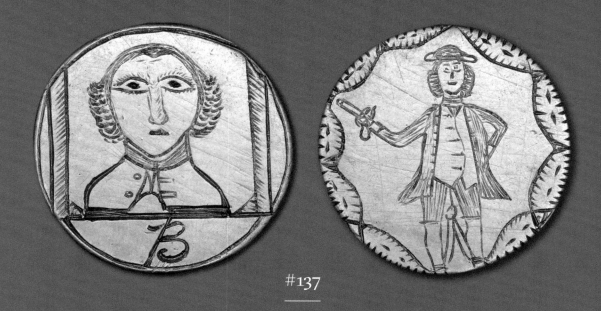

#137
———

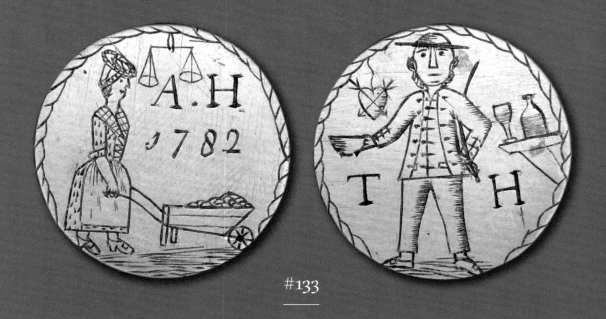

#133
———

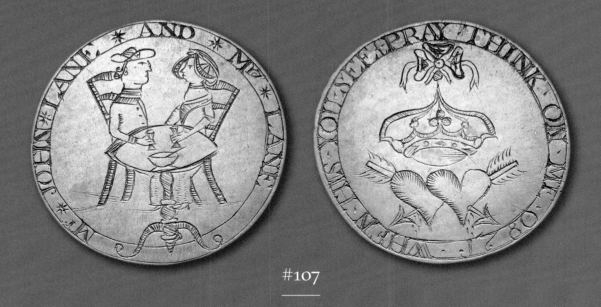

#107

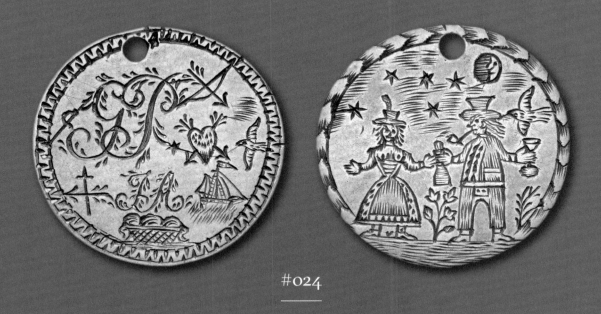

#024

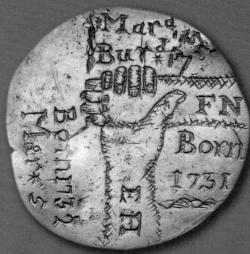
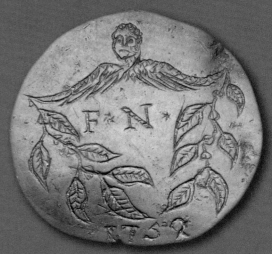

#058
———

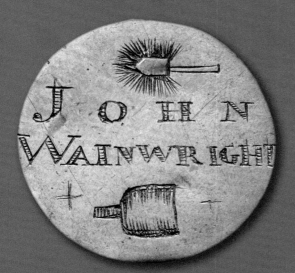
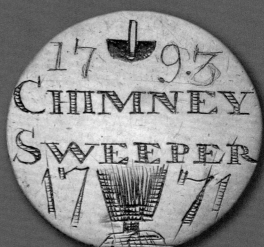

#105
———

It is interesting to compare them with #107 (p. 193), dated 1780. 'Mr*JOHN*LANE*AND* Mrs*LANE' sit looking at each other with a glass in hand, enjoying the pleasures of domestic life. Yet this couple has higher pretensions. They wear fancy hats and sit on high-backed chairs at a table with a pedestal. The furniture and the titles before their names reveal the desire for gentility and an awareness of social class. Indeed, many tokens reflect a time of social fluidity. Some, like the Lanes, imitate the gentrified middle class. Others, like 'TH' and 'AH', present themselves as simple workmen and women. Like the gentry's gilded portraits, these tokens are prized possessions to be passed down to one's family.

Yet there are more negative ways to interpret these same faces. The couple may be paying tribute to a lost way of life and pleasures that no longer exist. This is apparent on coins that reveal the couple is now separated. Of course, the miseries of life appear more explicitly in coins that relate to crime and punishment, as illustrated elsewhere in this volume. Still, there appears to be a sadness underlying these tokens that evokes melancholy interpretations.

Texts and images that record life's stories

While the carving of names and portraits is one mode of self-representation on tokens, another is the telling of life stories through a series of textual fragments and symbolic objects. Coin #024 (p. 193) creates an imaginative landscape on a starry night, with a man in the moon spreading light on two figures. His right hand and her left hand hold a central bottle, while his left hand bears a cup. The woman's hat is topped by a feather, while her partner smokes a pipe. Their poses, patterned clothes and decorative hats appear in other tokens as well. The only text on the obverse side consists of two sets of ornate initials – a large 'GP' and a smaller 'IA' (perhaps done by a professional engraver). These initials aside, both backgrounds are crowded with artefacts, which the couple cherish. The same bird flies from the obverse to the reverse side. A double-pierced heart and a bow and arrow speak of love. There is a crossed-arrow-and-pike, a leafy plant, and a plinth or basket filled, perhaps, with food. Sadly, however, a single-mast ship with sails and pennant moves across the sea, portraying the grim reality of the couple's separation. Like a memoir made up of written fragments, the token tells a life story through a series of material objects.

Coin #058 records the tale of a wedded-couple in a very different manner, offering the reader a way to observe initials and the dates of births, marriage and death. An ingenious design on the obverse side uses text and image to depict fragments of the life of 'FN' ('Born 1731'), and 'EH' ('Born 1732 Mar*5'). Their clasped hands and arms, one vertical and one horizontal, symbolize their love and express emotion. The complex design leaves little room to record the couple's wedding date ('Mar^d 175[?]') and the burial of 'FN' ('Bur^d 17[?]'). The reverse side, however, clarifies FN's death at age 21 in 1752. An angel with feathery wings and two branches encloses the initials of the deceased and proclaims an early death. Again, melancholy thoughts are embedded in the token.

fig. 1 J.L. Marks, hand-coloured engraving,
'The March of Interlect or A Dustman & Family of
the 19th Century' (n.d.). Courtesy Brian Maidment

Whether 'FN' died by accident, illness or execution we shall never know. The design on the obverse side resembles a page in a family bible, where births and deaths are recorded. It also evokes the vertical and horizontal structure of family trees. The confused design reveals the engraver's lack of experience. It shows a type of artistic struggle that is also found in early disjointed autobiographies by self-taught workers.

On coin #105 (p. 194), a third form of life narrative suggests that a worker's identity is defined by his occupation. Like a newspaper advertisement, it also serves as a trade card. The name on the coin is boldly presented in shaded block letters in a crude, but well-designed layout: 'JOHN WAIN-WRIGHT' (obverse); 'CHIMNEY SWEEPER 1793 1771' (reverse). Above the name is a sweep's brush with spiky bristles; a dustpan lies below it. The dates on the reverse side are in descending order: 1793 on top, 1771 below – a span of only 22 years. We do not know if these are birth and death dates, or are related to his time as a sweep. We do know

fig. 2 Anonymous wood engraving,
no publication details available.
c. 1832–34. Courtesy Brian Maidment

that Wainwright is proud of owning his own tools, which appear on both sides of the coin. Like a mathematical equation, Wainwright's full name, dates, occupation and tools are added together to create the sum of his identity.

This proud self-representation stands in contrast to the mocking middle-class trope of the educated dustman found in the London press by the 1820s. J.L. Marks's engraving 'The March of Interlect or A Dustman & Family of the 19th Century' (n.d.) shows a working-class family ostentatiously dressed in the latest fashion (fig. 1). They are strolling to the park and theatre, leaving their hovel and a pig behind them. The child is told not to mention the word 'dust' in public, but their origin is visible to all.[2] The 'march of intellect' responded to 'a set of socio-economic, cultural, and scientific changes that underpinned the transformations in the class structure and economic base of British society'. The eventual results of this process were mass literacy and access to print.[3] The march of intellect was a force that inspired workers'

self-education – one that the middle class hoped to control. In fact, self-taught workmen were viewed variously over time with fear, contempt or grudging admiration.

By 1834, 'The Literary Dustman', or 'Dusty Bob' (fig. 2), lolls on a chaise lounge in his elaborately decorated drawing room, reading the workman's *Penny Magazine*. Though Bob is out of place in his new-found setting, this print 'accepts social difference in an open-handed way [and] ... asserts the energy and vitality of its laboring-class subjects even as it satirizes their aspirations and pretensions'.[4] Condescending views held by the middle class have received much attention. In contrast, we glimpse more positive statements about personal identity by autodidacts on tokens.

Texts and images that send messages about social, political and economic views

Personal messages allow us to link tokens to the history of social class. A penny struck between 1797 and 1799 (#007, p. 188) was engraved in italic cursive in 1840. It needs no image to make its political point — 'The man who did this was born without a shirt 1840'. Its boldly written quotation takes plebeian literacy for granted. It also presents the liberated voice of a passionate autodidact who has his own notion of the social order. His message infers that though all men are born naked (or shirtless), they can improve themselves in self-taught ways. This man has not only become literate, he quotes and uses a literary source in a protest against his low status. With pride in his

own literacy, he claims the right to self-expression, if only on a token.

A large literature shows that by the nineteenth century, the social order was viewed as neither stable nor simple. Workers were rethinking old ideas about the possibility of social mobility. Naturally, there was anxiety in all ranks about the movement of others who lay above and below oneself in the social structure. Thus, the perceived status of the makers and subjects of tokens addresses questions about class consciousness and political power.[5] Tokens link writing, work and social class in a visual and textual way. By 1840, writing had become a new form of productive labour and a source of cultural capital. The question of who was legitimately entitled to its public expression caused heated discussion. The poor, it was long thought, had a sole duty to perform manual labour for society. Back in 1731, *The Grub Street Journal* had asked who would tend the fields and work the looms if servants wrote letters or poetry instead.[6]

The expression 'born without a shirt' sheds light on these issues.[7] How did the token's creator come to know this phrase? Why did it feature in debates between the middle and working classes? Its major nineteenth-century spokesman was the racy sporting journalist, Pierce Egan (1772–1849). He popularized the phrase in his serialized fiction about life in London which included *The True HISTORY of TOM & JERRY OR, The Day and Night Scenes of LIFE IN LONDON* (1821).[8] Initially published in monthly instalments, Egan described the couple's London pranks, setting 'the misery of low life against the ... waste and

folly of high society' in the language of the street and tavern.[9]

> The grand object of this work is an attempt to portray what is termed 'SEEING LIFE'... from the *high-mettled* CORINTHIAN of St James's, *swaddled* in luxury, down to the *needy FLUE-FAKER* of Wapping, *born without a shirt*, and destitute of a *bit of scran* in his cup to allay his piteous cravings.[10]

Once again, the chimney sweep, or 'Flue-Faker', is a central figure. By the 1820s, the exploitation of 'climbing boys', which exposed them to the hazards of dirt, danger, disease and neglect, was a well-established philanthropic concern.[11]

Pierce Egan's readers would have known the phrase 'born without a shirt'. He uses it again in 1832 in his *Book of Sports*. This time, however, he links it to the struggle for workers' rights by narrating a dispute in a lower-class dialogue between a 'costard-monger' and a duke's coachman. The poor man is pushed away from the duke's coach, but defends himself on the grounds that all beings are born equal:

> "What does I care for a duke", said he, "any more than a dustman... I am made of the same flesh and blood as any of them there dukes... why I know'd the duke when he wanted a shirt"... "You lying scoundrel!" replied the coachman, "how dare you abuse my master?"... "It is no abuse", answered the costard-monger... "Why, you stupid fool, he was born like other men – without a shirt."[12]

Egan then makes a comment that sums up the middle-class strategy to control the lower classes:

> In England, it is this sort of saucy independence which distinguishes its mob ... Let them have their *say*, and beard the great folks if it suits their whim – and contentment is the result... This... jealousy of, power of all kinds, even in the lowest ranks, peculiarly marks the national character.[13]

Egan again uses the phrase in another poor man's complaint: 'I was not... born a Swell, although I made my way into the world like the great duke of Buckingham, without a shirt to my back'.[14] Clearly, the author of coin #007 had found an apt quotation for claiming his dignity and flaunting his literacy. It sent a desperate protest against those in power and a message to loved ones that his spirit was still strong. The middle class might mock and try to control the lower classes, yet the march of intellect on a simple token could not be stopped.

Tokens and literacy

The march of intellect could only be achieved through literacy. We know that just 18 objects in the Millett collection lack evidence of letters or numbers. Modified tokens give us glimpses of working-class culture by 1840 and thus offer a way to address the defects of traditional literacy studies based solely on counting signatures. They suggest more varied forms of plebeian writing than previously imagined, as well as the more easily learned skill of reading. As Norma Clarke wrote recently,

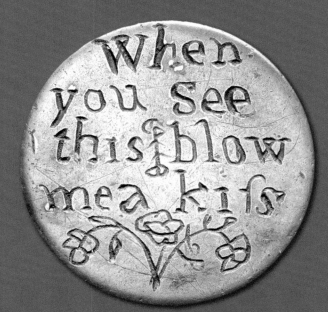

#084

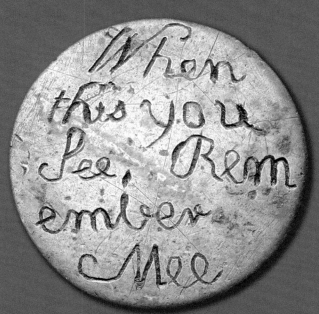

Even the most marginal and least literate of the population were able to write in some fashion … The timing of mass literacy … has to be pushed back to the 1820s at least, though that still seems late, when you consider that in 1740 Samuel Richardson constructed an entire novel in letters, supposedly written by a 16-year-old servant girl.[15]

In *The Pen and the People*, I have argued that mass literacy did not occur instantly.[16] It evolved with demand during the Industrial Revolution and the Enlightenment in different contexts and communities. David Vincent has reached a similar conclusion:

Signature literacy was already virtually universal amongst male artisans by the early decades of the nineteenth century, and every neighbourhood and village possessed … unskilled labourers familiar with the printed word. Female literacy was only ten points lower than male and … during the Victorian period … the proportion unable to inscribe their name fell to single figures.[17]

Historical methods have moved too fast to keep relying on signatures alone. Harvey Graff suggests viewing literacy as an integrated concept within a framework of cultural communication that includes cognitive psychology and historical ethnography.[18] Demand for literacy can also be studied anew with online data. David Mitch has considered literacy in relation to the provision of schools. It grew, he finds, independently of formal education, and persisted informally, even after mass schooling arrived. The idea that working families had little desire for learning is firmly rejected. Instead, Mitch argues that the benefits of education exceeded the costs, even for the lower classes.[19]

It is time to reconsider *how* people learned to read and write in particular contexts, on different levels. Roy Porter argued in the 1980s that eighteenth-century individuals had 'a highly visual awareness of the texts around them, which enabled them to recognise and read a range of words and images in a holistic way'.[20] But as Bridget Millmore notes in her study of love tokens (2015), literacy studies mainly focus on 'who could read and write. They have not investigated how the unschooled absorbed texts.' Labourers were inundated with letters and numbers on material objects, as well as printed material. Therefore:

The practice of reading and reproducing inscriptions was more about recognizing, rather than literally reading the texts. … The poor were familiar with … words, phrases, and images associated with affective objects. … Their reading involved sight and touch, and the recognition of words and images on both faces of the coin.[21]

Tokens offer evidence of reading and writing, whilst theories of visual and material literacy show us how it may have been done. Early-modern people read 'inscribed walls, pots, rings, clothes and bodies by absorbing the sense of the

object or surface, as well as the meanings of the words and images … Inscriptions were, in effect, communicated through the interplay between the words and the physical cuts in the object or surface of a token'.[22]

In addition, theories of intertextuality help us understand how people read tokens. By the 1820s, technological advances made it easy to combine text and image on a printed page. Thus, newly literate readers had experience with integrating both formats. As Roy Porter insists:

> It was never words for the literate and pictures for the unlettered. There is little evidence … from the seventeenth century onwards of the production of images independent of writing, targeted at those who could not read. What was normal, at all levels from patrician to plebeian, was the marriage of word and image … [in] chapbooks, broadsheet ballads, illustrated novels and biblical texts, trade advertisements, catchpenny prints and funeral monuments. [23]

Tokens indicate how the unschooled read and wrote texts, with different levels of expertise. Some sport lone initials and dates; others combine names, places and messages. Combinations of letters and scripts offer a range of complexity and endless variations. Superscripts, punctuation and attention to grammar abound on some; others use crude block letters. Words are wrapped around corners when they do not fit, and shaded or ornamented when they do. Misspellings are rampant, but so is correct usage. Round or italic scripts are commonly used. Some texts appear to be drafted by writing masters. These varied levels and diverse techniques demonstrate self-education in practice. Yet studies rarely mention it, as if partial literacy did not exist.

Tokens, literacy and self-education

If becoming literate took place on the road to personal improvement, self-education was required for the journey. Autodidacts acquired useful knowledge in different life stages, through print culture, trade associations and social networks. Yet the focus of studies on childhood education in formal schools misses the literacy acquired later in life,[24] along with the notion of self-taught 'rough diamonds'.[25] Self-educated artisans used crude techniques like scratching, punching and chiseling. Others made marks with nails or pin pricks that were later joined together with ink or soot.[26] Though some tokens were engraved by professionals, the most illuminating are the simple tokens by less-talented amateurs, who took pride in making products with self-taught skills.

Craftsmen may have learned to use ruled guidelines, pre-cut stamps and ornaments in other trades.[27] Still, the basic process was akin to apprenticeship – learning by seeing and doing, imitating others and copying templates.[28] Coin #084 (p. 200) shows how a new writer struggled to fit 'Remember' and used a variant spelling for 'mee'. 'When this you See, Remember Mee' is, of course, a well-known verse, with many variations.[29] Still, this writer created an original text. In four places,

the first letter of the word is capitalized. Then, italic cursive is mixed with unattached letters. Finally, a comma is placed between the two lines of poetry. Both giver and receiver likely received pleasure from this carefully-made object.

Another original token is found in #077. This silver marriage token has been crafted by more than one engraver. One side, dated 1797, has two elaborate sets of initials, 'WB to MAB', in the centre. It was executed by an expert and contains a verse in italic script: 'This and the Giver be thine for Ever'. On the top of the reverse, we see *'A Husbands Gift'* in cursive. But below it is a scratched design and message by an untrained hand. It contains a poem written in crude block letters: 'DEAR NANCY I BEG YOU WILL THIS TAKE/ AND KEEP IT FOR YOUR HUSBAND'S SAKE'. The groom may have paid for a pre-inscribed message on the reverse, then filled in his own poem beneath it. It is written like a letter but contains a standard verse. Its shaded letters, mixed script and different levels of expertise suggest it was done by an autodidact who had seen the text elsewhere. Finding short scraps of poetry was easy to do. Nancy's gift shows how an artisan absorbed a text and engraved it. It also reveals that self-education was embedded in daily life. Today, with new databases collecting such evidence of self-taught writers, self-education will turn into an important topic.[30]

Conclusion

Tokens engraved by self-taught artisans offer unique evidence of working-class life and emotions. In fact, writing was a skill that came easily to some craftsmen, whose hands were carefully trained to make their mark on objects. Inscribing a loving message on a gift proclaimed the author's artistry, literacy and affection.

It is useful to compare tokens with other forms of life writing, especially workers' autobiographies. By the 1820s, they were numerous enough to attract middle-class mockery and manipulation. In the 1980s, research by David Vincent, John Burnett, David Mayall and Nan Hackett unearthed 'an archive comprising more than a thousand works written before the end of the nineteenth century and a similar number from the first half of the following century'.[31] More recently, Emma Griffin's *Liberty's Dawn* and Jane Humphries' *Childhood and Child Labour in the British Industrial Revolution* have shown that autobiographies were written by a wide range of tradesmen from every region in Britain. They were not the products of a narrow elite within the lower classes.[32]

Attention has been given to working-class spiritual or radical autobiographies. But a third strand of life writings contain 'a more relaxed and less visible tradition of oral story-telling'.[33] They give fragments of anecdotes, gossip, forebears' stories, drinkers' tales, adventures, bad behaviour and just plain entertainment. Like folklore and homey literature in dialect, this type of memoir has much in common with tokens, as a genre. Some lives appear in a form that was mediated by middle-class critics, who changed the author's original meaning.[34] Sadly, these writings were controlled by others; happily, this is not true of tokens.

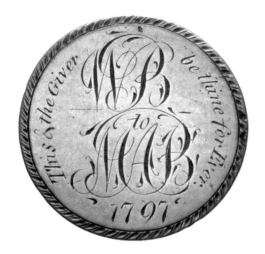 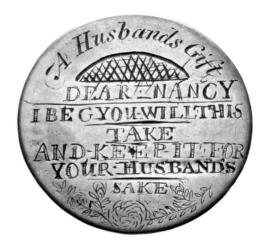

Coin #077

In addition, texts on tokens help us to understand *how* the process of literacy evolved. They show lower-level tasks like writing fragments, not essays. We also see partial or lesser levels of competency, like knowing the alphabet, copying, transcribing and using images to support text. We, thus, need to redefine the skills that must be mastered in order for someone to be deemed literate. These tasks should include and validate informal modes of learning. This will help us to map a new life cycle of education that embraces an intense pursuit of literature later in life.

Paul Murphy insists that 'with few exceptions… working class journalists and critics were autodidacts'. Joseph Gutteridge learned to read from signboard literature on public houses and ships.[35] E. Parnell, a Methodist leader, taught himself to

read from gravestones. Others deciphered letters and numbers on street signs, price tags, clock dials, calendars, notices, directions, labels and recipes. Tokens neatly fit into this type of category.[36] Then, as now, useful knowledge that fills basic needs, lies at the heart of literacy.

Martha Vicinus thought the march of intellect led to a 'different attitude towards oneself and others … As print becomes a normal means of communication, those who cannot read are barred from vital contacts. Those who can are given new powers.'[37] Others note that self-taught writers regarded poetry as a 'personally redeeming force … offering consolation, self-expression, the possibility of fame … or social status', as well as moral and aesthetic awareness.[38] On the other hand, the newly literate were plagued by failures, self-doubts

and a feeling of not belonging, in either their past or present worlds. This malaise was also true of artisans who engraved scenes of happy families. Many were recording domestic pleasures that had been lost through separation. Nonetheless, tokens record literacy and social progress for some workers. What is more, their urge to construct identities and create acts of being remembered were painstakingly achieved. Tokens help us see that once the march of intellect started, it became an unstoppable force.

1 There are more couples in the collection with similar borders and layouts. In #134, 'Luke Hurst, 24 January 1787', has the same stance, but smokes a pipe; Elizabeth Young is in profile with hand on hip with a bird. In #136, Richard Trible holds a pipe and mug of ale, whilst Sarah Clark in hat and dress stands with hands on her hips. In #131, 'GEORGE HARVEY BORN NOVEMBER 8 1777' stands with hand on hip holding a walking stick and boots. In #132, 'John [Burn], 1 May 1787', holds a long pipe in the same stance with hand on hip and legs apart.

2 Brian Maidment, *Reading Popular Prints 1790–1870*, Manchester 2001, fig. 14, pp. 69–70.

3 Brian Maidment, 'Imagining the Cockney University: Humorous Poetry, the March of Intellect, and the Periodical Press, 1820–1860', *Victorian Poetry*, vol. LII, 2014, pp. 21–39 (p. 21).

4 Maidment 2001, pp. 82, 89–90.

5 John Ehrman, *The Younger Pitt*, vol. II, London 1969, pp. 131, 151. See also the work of Alexandra Shephard, Phil Withington and Keith Wrightson.

6 William Christmas, *The Lab'ring Muses: Work, Writing and the Social Order in English Plebeian Poetry, 1730–1830*, London 2001, pp. 20–26; Clifford Siskin, *The Work of Writing: Literature and Social Change in Britain, 1700–1830*, Baltimore 1988.

7 *Oxford English Dictionary Online*, https://www.oed.com/ (accessed 9 November 2019), mentions having a shirt on one's back as early as Chaucer's *Wife of Bath's Tale, c.*1396. Not to have one meant 'no goods or possessions, not even the necessaries of life'.

8 Pierce Egan, *The True HISTORY of TOM & JERRY OR, The Day and Night Scenes of LIFE IN LONDON* (1821). Egan also edited and wrote the preface for the third edition of *Grose's Classical Dictionary of the Vulgar Tongue, Revised and Corrected, with the Addition of Numerous slang phrases, by Pierce Egan*, London 1823.
 I thank Gary Oddie for this reference.

9 Pierce Egan, *Oxford Dictionary of National Biography*, https://doi.org/10.1093/ref.odnb/8577 (accessed 9 November 2019).

10 *The True History of Tom & Jerry*, p. xii.

11 *The Reports of the Society for Bettering the Condition and Increasing the Comforts of the Poor*, fifth edition, vol. I, London 1811, pp. 124 –30.

12 Pierce Egan, *Pierce Egan's Book of Sports, and Mirror of Life: Embracing the Turf, the Chase, the Ring, and the Stage: Interspersed with Original Memoirs of Sporting Men, etc.*, London 1832, p. 62, https://catalog.hathitrust.org/Record/006568046 (accessed 29 December 2019).

13 Egan 1832, p. 62.

14 Egan 1832, p. 210. There are many others, for example: 'I candidly confess, that I was born without a shirt to my back, or even a shoe to my foot', in *Young Hocus, or the History of John Bull during the years… 1789, and A novel by Sir W- L-, K- with notes*, London 1790, p. 63; *Notes and Queries*, seventh series, x, 13 September, 1890, p. 208: 'In the *Dover Telegraph*, Aug. 6, there is "in the reign of Charles I. a mayor of Norwich sent a man to gaol for saying the Prince of Wales was born without a shirt"'.

15 Norma Clarke, 'I ham sorry', *London Review of Books*, vol. XLI, no. 15, 1 August 2019, p. 34.

16 Susan E. Whyman, *The Pen and the People*, Oxford 2009.

17 David Vincent, 'Working-class Autobiography in the Nineteenth Century' in Adam Smyth (ed.), *A History of English Autobiography*, Cambridge 2016, p. 167.

18 Harvey Graff et al. (eds.), *Understanding Literacy in its Historical Context: Socio-cultural History and the Legacy of Egil Johansson*, Lund, Sweden 2009, pp. 244, 255–57.

19 David F. Mitch, *The Rise of Popular Literacy in Victorian England: The Influence of Private Choice and Public Policy*, Philadelphia 1992, pp. xiv, xx–xxi.

20 Roy Porter, 'Seeing the Past', *Past & Present*, vol. CXVIII (1988), pp. 186–205.

21 Bridget Millmore, 'Love Tokens: Engraved Coins, Emotions and the Poor 1700–1856', unpublished PhD thesis, University of Brighton 2015, p. 141. I have relied on Millmore's Chapter 3 in my discussion of the relationship between literacy and tokens.

22 Millmore 2015, p. 142; see also Juliet Fleming, *Graffiti and the Writing Arts of Early Modern England*, London 2001, p. 80.

23 Porter 1988, p. 189.

24 Paul Thomas Murphy, *Toward a Working-Class Canon: Literary Criticism in British Working-Class Periodicals, 1816–1858*, Columbus, Ohio 1994, p. 16.

25 Whyman 2009, and *The Useful Knowledge of William Hutton: Culture and Industry in Eighteenth-Century Birmingham*, Oxford 2018.

26 Michele Field and Timothy Millett (eds.), *Convict Love Tokens: The Leaden Hearts the Convicts Left Behind*, Kent Town, South Australia 1998, pp. 17–24, 56; Millmore 2015, p. 114.

27 Field and Millett 1998, p. 20.

28 Millmore 2015, p. 128.

29 See Maxwell-Stewart in this volume.

30 Brian Maidment, *The Poorhouse Fugitives: Self-Taught Poets and Poetry in Victorian Britain*, Manchester 1987, p. 18.

31 Vincent 2016, pp. 166.

32 Vincent 2016, pp. 167–68; Emma Griffin, *Liberty's Dawn: A People's History of the Industrial Revolution*, New Haven 2014; Jane Humphries, *Childhood and Child Labour in the British Industrial Revolution*, Cambridge 2010.

33 Vincent 2016, p. 172.

34 Stephen Colclough, 'Victorian Print Culture Periodicals and Social Lives' in Smyth 2016, pp. 242–43.

35 Murphy 1994, pp. 14–15.

36 Mitch 1992, pp. 45, 117.

37 Martha Vicinus, *The Industrial Muse: A Study of Nineteenth Century British Working-Class Literature*, New York 1974, p. 29.

38 Maidment 1987, p. 186.

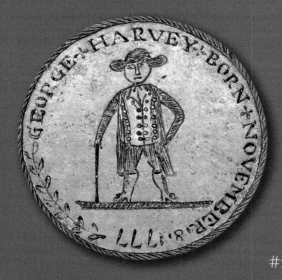

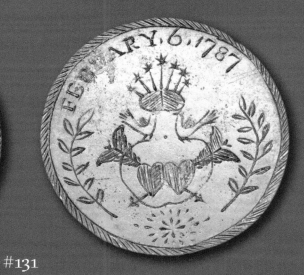

#131

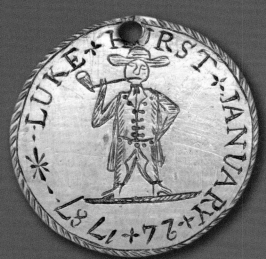

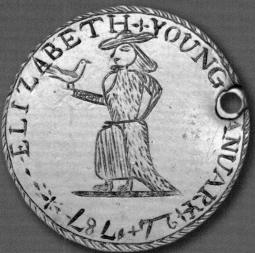

#134

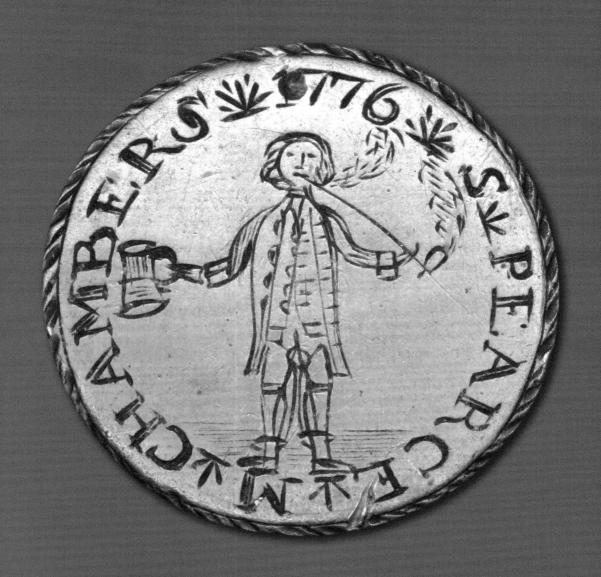

#192

16
The 'Shackled Good Fellow'
A Self-Portrait of Liberty and Imprisonment

Bridget Millmore

An image of the 'good fellow' featured widely in eighteenth-century popular material culture. A seated or standing man at his leisure, with a long churchwarden pipe in one hand and a foaming tankard of ale in the other, he appeared in alehouse ballads and chapbook illustrations, on tobacco labels and transfer print pottery, in the form of a toby jug and on engraved coins.

He sits alongside other characters, such as Toby Philpott, John Bull and Martha Gunn, who act as a shorthand for a particular identity and, in the case of the 'good fellow', for a set of well-understood male behaviours and values. This essay brings together a group of engraved coins from the Catalogue to introduce this imagery and then presents further variant examples that subvert it into the 'shackled good fellow'. Working outwards from the objects, the aim is to build a picture of how this distinctive iconography was understood.

As Susan Whyman argues in Chapter 15 of this volume, engraved coins were inscribed with familiar images from everyday life, and their meanings were communicated and comprehended through a shared visual culture. She discusses how, in terms of working identities, engraved coins acted as a form of 'proud self-representation'. The Millett Catalogue depicts a range of trades and occupations, from sailor and soldier to blacksmith, bricklayer, carpenter, chimney sweep, engraver, leather worker, linen draper, saddler, stick maker and weaver.[1] On several pieces, work identities and values are expressed by the tools of a trade: the blacksmith's anvil, the bricklayer's trowel, the chimney sweep's brushes and the weaver's loom.[2] These tools not only conveyed the men's day-to-day work; contemporaries would also have recognized a broader culture and values. The 'good fellow' with pipe and drink is an extension of this

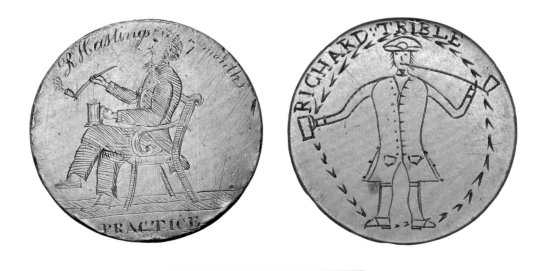

Obverse of engraved coins
#061 and #136

practice. It draws from the same lexicon of symbols and images to portray a proud working man at rest. Sitting in a relaxed pose, R. Hastings (#061), for example, smokes the long churchwarden pipe, which was particularly suited to leisure, rather than the shorter pipe associated with work.[3] Richard Trible (#136), with arms wide open, sports a long tailcoat and tricorn hat, clearly wanting to impress and show off his material comforts.[4]

For the working man seeking to forge and strengthen bonds with fellow workers and neighbours, drinking in the alehouse was a performative act of fellowship.[5] In early modern ballads the 'good fellow' demonstrated his conviviality through rituals of drinking, in toasts, songs, competitive games and even the use of bespoke

drinking vessels. To be accepted as a 'good fellow' involved not just drinking and smoking but also conforming to a set of shared values.[6] The 'good fellow' was proud of his status in the alehouse and had a sense of belonging to a fraternity of 'good fellows' who prized sociability, hard work, loyalty, liberal spending and self-control.[7] The ballad *The Hearty Good Fellow* captures in words the imagery engraved on to these coins : 'With my pipe in one hand, and my jug in the other, / I drink to my neighbours and friend.'[8] The song describes working hard and spending freely, a social code of defiant joviality. It emphasizes the importance of financial self-reliance: 'Then I'll laugh, drink, and smoke, and leave nothing to pay.' In this context, the financially independent 'good fellow' was

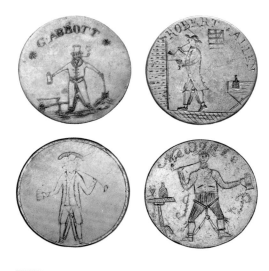

Examples of 'shackled good fellows':
#054, #102, #135 and #192

keen to differentiate himself from others in the alehouse. However, it would be unwise to take the words of a song at face value.[9] They might reflect hoped-for behaviours rather than lived experiences, given that financial transactions relied on credit and some recreational drinking left wives neglected and children hungry.[10] For those giving and receiving engraved coins, the values and behaviour associated with this imagery were instantly recognizable, whilst, at the same time, viewed with a certain amount of pragmatism.

In Chapter 12, Tim Hitchcock discusses five engraved coins which belong to what he terms a 'plebeian subculture' of resistance and revolution. Subversion of the image of the 'good fellow' by the addition of leg irons offers further evidence

of that spirit of resistance. The examples opposite (#054, #102, #135, #192) show prisoners shackled from the waist down.[11] From the waist up, however, they continue to exhibit the familiar characteristics of the 'good fellow'. They appear in good spirits, standing tall and proud, with a pipe in one hand and a drink in the other; some walk about (#102; #108, p. 214). In merging the sociable drinking man and the prisoner in irons into one figure, the shackled 'good fellow' presents a simultaneous depiction of liberty and imprisonment. It conveys a powerful message of self-control and defiance.

There is no hint of oppression or diminishment in these portraits, especially if compared to other examples where prisoners express despair and remorse.[12] The figure of a man in irons who is still free to enjoy his pipe and beer captures a sense of the prisoner's defiant attitude towards those who imprisoned him. Moreover, it expresses an ability to transcend discomfort and confinement.

Of the examples illustrated here, Rob Clark's was made from a copper halfpenny (#135), and dated 1753, illustrating that the image of the 'shackled good fellow' was already well-established. Three further engraved coins crafted from copper halfpennies were produced between 1776 and 1785: M. Chambers's and S. Pearce's (#192) dates from 1776; Robert Allen's (#102) from the period 1776–78 when he was imprisoned in Newgate; and William Hurt's (#108) from 1785 when he was tried for highway robbery and sentenced to death.[13] Hurt was executed before the Debtor's Door at the Old Bailey on 3 March 1785.[14] The remaining three examples, crafted from copper 'cartwheel' pennies, were made after

1797, probably by felons awaiting transportation to Australia. Although it is not always possible to make a definitive link to records of a crime or sentence, many convict tokens are readily identifiable on account of their distinctive punched style of engraving as demonstrated by R. Musgrove's coin (#202, p. 216).[15]

Interestingly, Allen's and Hurt's engraved coins are very similar in design. Both are inscribed with the image of the 'shackled good fellow' walking left, within a prison cell featuring a barred window and reinforced door. They contrast the hemmed-in prison cell with an ambulant, smoking and drinking prisoner. The 'shackled good fellow' demonstrates how these men wished to be remembered: as resilient in the face of the punishment imposed on them (#102, p. 153; #108, p. 214).[16]

Hurt's engraved coin also has similarities with another piece in the Catalogue, that of John Steward (#138, p. 215). Both depict a highway robber on horseback, wearing a long coat adorned with buttons and a shallow crown hat, and pointing a pistol. Steward's image has the addition of a whip and a large carriage wheel, the latter indicating the highway setting. Steward, also spelt Stewart, aged 21, was tried in 1778 for highway robbery.[17] He was found guilty and sentenced to death, alongside Robert Allen (#102).[18] Whilst Allen was hanged in October that year, Steward's punishment was respited and two years later, in 1780, he was sent to the hulks.[19] Steward reappears in the Old Bailey records in 1781 when he was tried for highway robbery and sentenced to hang at Tyburn.[20] He was executed at 9.15 am on 18 October 1781, addressing the crowd to protest his innocence

to the last.[21] Instead of the 'shackled good fellow', Steward's coin is engraved on the reverse with a portrait of a couple, John and his wife Ellenor, standing either side of a low fence. She is wearing a bonnet, dress and fringed shawl, and carries a bag. John is dressed in a short jacket and hat, and his legs are in irons. They face one another, and he is affectionately holding her outstretched hand. The scene alludes to their anguish as they face a desperate future with the fence between them, Ellenor free and John in irons; a poignant image to leave behind.

Close examination of this selection of engraved coins raises questions about how they were crafted and whether some of them were produced by the same hand. Allen's and Steward's are clearly linked by their crime and punishment; they were fellow robbers and Newgate inmates. Although there is little written evidence, the 1836 Prison Inspectors' reports do provide information from Newgate gaol, where engraved coins were referred to as 'penny pieces' and 'leaden hearts'. Inspectors' interviews mention prisoners spending time making engraved pieces for friends as memorials and 'pricking figures or words on them'.[22] The 'prisoners amused themselves by smoking, walking about and talking, grinding down halfpence and cutting them into the shape of hearts to give to their friends'.[23] Inmates proficient in engraving, either through working in trades that employed the skill or being practised in the art of counterfeiting, were well positioned to supply a market for engraved coins. Perhaps they even offered a choice of templates to which an individual's name, dates and message could be added. Millett explores

the possibility that prisoners learnt from each other and offers examples of engraved coins with similar designs but slightly different execution.[24] The Newgate interviews also describe how prisoners passed on skills and knowledge. One man explained that, among other things, he could have learnt how to make 'bad money'. In other words, learning how to engrave a coin from another felon was highly likely.[25]

Whether confined in Newgate or transported to Australia, these prisoners' self-representations display strength and resilience. This may have allayed the fears of loved ones whilst still acknowledging the prisoner's anger. The crafting of these personalized objects involved the erasure of the King. The rubbing away of the royal bust, reducing the coin to a metal disc, destroyed a material manifestation of royal power and a visual symbol of the monarch that was recognizable in a familiar object. It also eroded the King's political authority to control the universally recognized monetary value of a coin such as a halfpenny. Indeed, it could be argued that the apparent ease with which people rubbed away the monarch's bust was an act of deliberate defiance towards a government and its figurehead.[26]

Engraved coins are small intimate objects to be held and turned over and over in the hand. They are an individual expression, either made directly or to a specification. They give voice to private experience and, in the case of prisoners, to a shared experience of injustice and conflict. The addition of chains to the lower part of the body instantly conveys, without the need for words, feelings of defiance and resistance. It encapsulates in one figure a sense of pride and of contempt for those who judged them, alongside a tension and sense of remorse for the family duties they could no longer perform. Those left holding engraved coins inscribed with the 'shackled good fellow' were fluent in the visual and material literacy needed to read and understand their meanings, immediately recognizing the subversive and affective imagery. These were the parting gifts of separation, exile and loss, kept and treasured by those left behind. Engraved coins provided a site of commemoration and remembrance; a site where the 'shackled good fellow' could stand defiant evermore and loved ones could contemplate those 'tho absent not forgot.'[27]

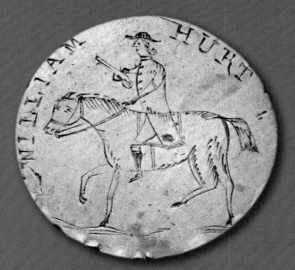
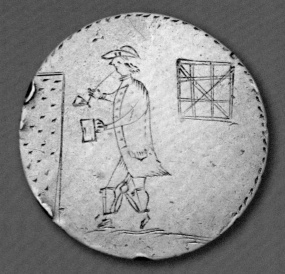

#108

On 12 January 1785, **William Hurt** was convicted of a highway robbery that had occurred five days earlier. Hurt had stopped Mr Walker and his family, Quakers, in their coach on the road from Southgate to Edmonton, demanded their watches and purses, and threatened to blow out their brains. Hurt had an accomplice who managed to escape the scene and no evidence was produced against him.

Although represented by the enterprising and successful defence barrister William Garrow, there was much evidence against Hurt. He had been chased from the scene of the robbery and cornered in a field when his horse refused to jump the hedge. The description of Hurt and his accomplice escaping towards Tottenham includes some nice local detail: when they came to 'some trees called the seven sisters, they turned to the left hand'.

Hurt was hanged on 3 March 1785 at Newgate.

Source: *Old Bailey Proceedings online*, www.oldbaileyonline.org/ (version 8.0, accessed 8 March 2022), January 1785, trial of William Hurt and William Kenton (t17850112-51).

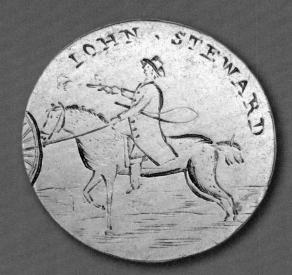
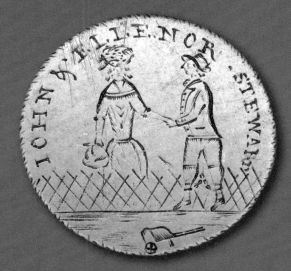

#138

According to the Old Bailey indictment, **John Stewart** (21) committed highway robbery on 3 June 1778 when he assaulted Vezey Bishop outside Stoke Newington, near the Hare and Greyhounds pub, and stole from him six shillings. Stewart was working with an accomplice. Interestingly, Bishop states in his evidence that at the time of the theft he had a pocket-piece with him, which he was very anxious to keep. He concealed it by dropping it along with a half-guinea.

At the time of the robbery, the assailant had a handkerchief tied around his face, leaving only his eyes visible. Much of the evidence against Stewart therefore centred around his clothes, particularly a great coat which he was determined not to be wearing at the time of the identity parade arranged by the local justice.

Stewart was found guilty and sentenced to death, with the prosecutor seeking the King's mercy on account of his youth.

On 8 October, Stewart's sentence was respited and he was sent to the hulks. In Chapter 16, Bridget Millmore links a second trial for highway robbery in 1781 to the same John Stewart.

Fifteen were sentenced to death at the Old Bailey session on 15 July 1778. They included Robert Allen (#102), whose token closely resembles Stewart's. William Hurt's token from 1785 (#108) suggests that this style of token persisted in Newgate for an extended period.

Sources: *Old Bailey Proceedings* online, www.oldbaileyonline.org (version 8.0, accessed 8 March 2022), July 1778, John Stewart (t17780715-4); John Stewart and John Vandersall (t17810912-67); Punishment Summary, April 1778 (s17780429-1).

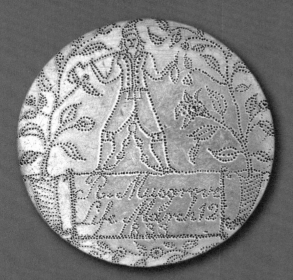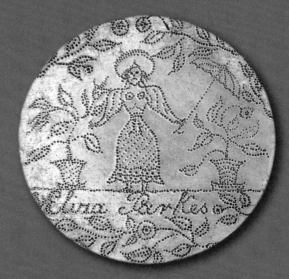

#202

The token for **Richard Musgrove** (or Masgrave) is noteworthy for its distinctive quality of pin pricking, clearly produced by the same hand as one for Daniel Bates, now in the National Museum of Australia. Both men were tried in March 1833 at the Warwick General Sessions, where Musgrove was convicted of stealing 'in a dwelling house'. He was 22 years old.

His uncle, Robert Moore Parkes, a Birmingham jeweller, submitted two petitions on his behalf. Musgrove had been orphaned aged eight when his parents died in the East Indies. His father had previously served in the Peninsula War (1807–14). The boy had been employed by and lived with his uncle for eight years. Grounds for clemency included the fact that this was a first offence, he was thoroughly reformed and he had offers of a house and employment if released. A 'Memorial signed by all the ministers of the Church of England in Birmingham' also vouched for his character.

Musgrove was transported to Bermuda, a harsh destination where convicts worked on construction of the naval dockyards.

Source: National Museum of Australia, token for Daniel Bates, object number 2008.0039.0142.

1 It is rare to find an occupation alongside a woman's name on engraved coins. For a discussion of Betty Hamer, Blackworker, see Bridget Millmore, 'Love Tokens: Engraved Coins, Emotions and the Poor 1700–1856', unpublished PhD thesis, University of Brighton 2015, pp. 210–14.

2 Tim Hitchcock draws attention to a different set of tools of the trade. He discusses five engraved coins that feature the tools of a thief including skeleton keys, jemmies, pistols and cutlasses.

3 Information from the Science Museum, https://collection. sciencemuseumgroup.org.uk/objects/co156720/ churchwarden-pipe-with-box-shropshire-england-1880-1910-churchwarden-pipe (accessed 22 January 2022).

4 Whyman discusses several engraved coins that feature couples and where the man is depicted with pipe and drink. They use the same 'good fellow' imagery but in a different setting from those I discuss in this essay, see Chapter 15 in this volume.

5 Mark Hailwood, *Alehouses and Good Fellowship in Early Modern England*, Woodbridge 2014, Chapters 3 and 4, *passim*.

6 The phrase 'THREE GOOD FELLOWS' is inscribed in retrograde on coin #193, a record of the friendship between P. Beamey, G. Thompson and G. Skarratt in 1812.

7 Although recreational drinking was dominated by masculine values, there are references to all-female and mixed-gender drinking. Hailwood 2014, Chapter 3, *passim*.

8 The 'Hearty Good Fellow', Roud number v9352, *Broadside Ballads* online, http://ballads.bodleian.ox.ac.uk (accessed 22 January 2022).

9 For a discussion of ballads, expected behaviours and engraved coins, see Millmore 2015, p. 179.

10 Hailwood 2014, pp. 208–09.

11 The chains between leg irons were often held up at the waist. Irons were heavy and noisy, and caused chafing. For more details on wearing leg irons, see https://sydneylivingmuseums.com.au/taxonomy/ term/18636#object-107666 (accessed 22 January 2022); https://www.royal-arsenal-history.com/woolwich-arsenal-prison-hulks.html (accessed 22 January 2022).

12 Millmore 2015, pp. 238–43.

13 *Old Bailey Proceedings* online (*OBP*), https://www. oldbaileyonline.org (version 8.0, 25 June 2021), January 1785, William Hurt (t17850112-51), and Punishment Summary 3 March 1785 (s17850112-1).

14 *Whitehall Evening Post* (London), Thursday 3 March 1785. Condemned prisoners in Newgate Prison passed through the iron Debtor's Door to reach the scaffold.

15 See also the engraved coin with the name R. Musgrove in the British Museum, https://www.britishmuseum.org/ collection/object/C_1952-0904-203 (accessed 22 January 2022). The Acworth Collection at Maidstone Museum has another engraved coin dated 1827 with the name G. Abbott, https://lovetokens.omeka.net/items/show/24 (accessed 22 January 2022). Both coins were crafted from copper pennies.

16 See the National Museum of Australia convict love token collection for more examples of the 'shackled good fellow', http://love-tokens.nma.gov.au (accessed 22 January 2022).

17 *OBP*, July 1778, John Stewart (t17780715-4). The Digital Panopticon has a record for John Steward alias Stewart, https://www.digitalpanopticon.org/ life?id=oar168130Steward (accessed 22 January 2022).

18 *OBP*, July 1778 (s17780715-1).

19 The Digital Panopticon, https://www.digitalpanopticon. org/life?id=obpt17780715-4-defend79 (accessed 22 January 2022).

20 *OBP*, September 1781, John Stewart and John Vandersall (t17810912-67).

21 *St James's Chronicle* (London), 18 October 1781.

22 'Reports of the Inspectors Appointed under the Provisions of the Act 5 & 6 Will. IV. c. 38, to Visit the Different Prisons of Great Britain', House of Commons Papers; Reports of Commissioners 117–1 (1836). p. 63.

23 'Reports of the Inspectors', 1836, pp. 57–58.

24 Michele Field and Timothy Millett (eds.), *Convict Love Tokens: The Leaden Hearts the Convicts Left Behind*, Kent Town, South Australia 1998, p. 18.

25 'Reports of the Inspectors', 1836, p. 64.

26 For further discussion about the representation of the monarch on coinage, see Leora Auslander, *Cultural Revolutions: The Politics of Everyday Life in Britain, North America and France*, Oxford 2008, pp. 20–21. Colin Haselgrove and Stefan Krmnicek, 'The Archaeology of Money', *Annual Review of Anthropology*, 41, 2012, pp. 235–50.

27 https://lovetokens.omeka.net/items/show/106 (accessed 22 January 2022).

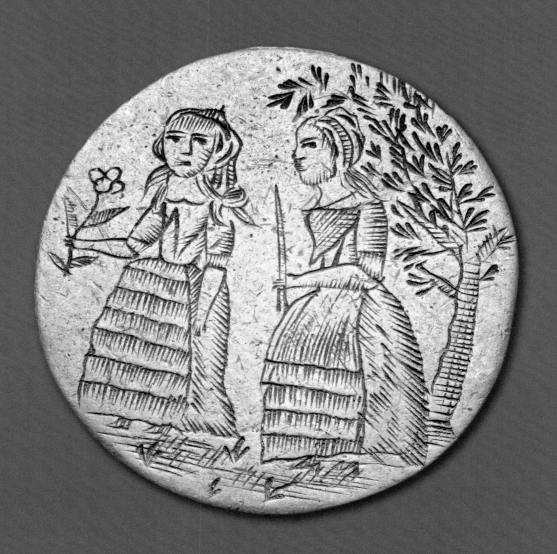

#023

Part five

The Catalogue

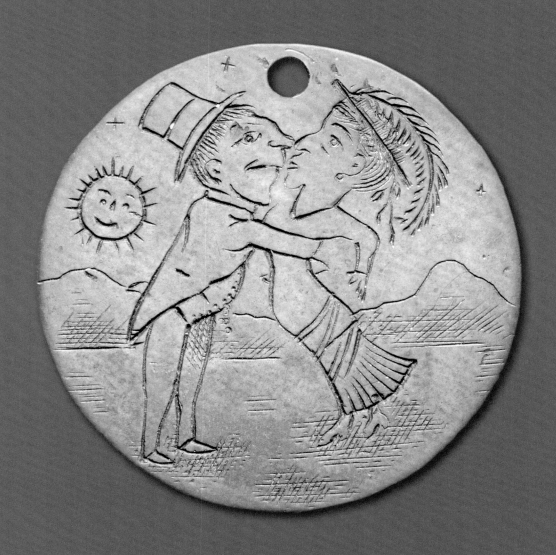

#009

17
Token Collections
History and Taxonomy

Gary Oddie

This chapter considers general aspects of the Millett collection of engraved coins and compares it with other private and public collections. Most areas of numismatics have standard catalogues that are created and refined over many generations of study, but engraved coins are largely unique. Every collection of them is individual and prone to the vagaries of the manner in which they were acquired and the collector's own preferences. Over the past century several collections of engraved coins have been built, with some ultimately donated to museums and others dispersed through auctions. As a result, it is not possible to create a standard text and this has led to some ambiguity of terminology.

We begin therefore with a few terms that have been used to describe coins that have been modified. Typically coins and tokens are struck in a press using dies and are then released into circulation. The original designs of most pieces just wear away through contact with other coins or tokens. Some pieces are taken from circulation and re-worked using metal tools. A mass-produced, hand-crafted modification, based on the original coin design and intended to be given away and circulated, makes a re-engraved coin. Other modifications intended for wider circulation include counterstamping with a metal punch to revalue or validate a piece,[1] or countermarking with a metal punch to add a political or advertising message.[2] If the added design is hand-engraved and clearly for a singular purpose relating to a moment in time, and the piece is intended to be given and kept, it is usually called a 'love token'. Most items in the Millett collection fall into this latter category.

David Thornbury Batty's idiosyncratic catalogue, published in instalments between 1868 and 1884, is almost unusable in its paper form but can be searched digitally to reveal about 400 'engraved' pieces.[3] The descriptions cover just the text and no other details. Ella Pierrepont Barnard (1864–1934) published the first detailed list of engraved coins

and much of her collection is now in the British Museum.[4] In 1922, Thomas Sheppard catalogued Hull Museum's 307 pieces, which were lost when the museum was bombed during the Second World War.[5] An unfinished article by Rev. W.H. Acworth from 1941 was eventually published in 2003; his collection of 188 engraved, countermarked and modified coins now resides in Maidstone Museum.[6] Many coin and token auctions include a few engraved coins, and early sales often grouped many pieces or a whole collection as a single lot.[7] There have been just three sales where major collections have been catalogued prior to dispersal: Vorley (1994), Law (2015) and Barker (2016).[8] In addition to the evidence found in catalogues, detailed study of typefaces and styles of decoration has made it possible to estimate the date of an engraved piece within a decade or two.[9] Bridget Millmore's doctoral research has brought many of the British publications together to develop a very interesting discussion of the emotional and social contexts in which modifications were made, along with the messages hidden in some of the engraved designs.[10] Whilst this chapter focuses on engraved pieces with a British provenance, engraved coins are also known from other countries.[11] Recent surveys of the tokens that parents left as identifiers with their babies at Europe's Foundling Hospitals, for example, also include several coins that have an engraved legend or design.[12]

It is possible for collectors to focus on a particular theme, such as coins engraved with the names of convicts transported during the eighteenth and nineteenth centuries,[13] or depictions of naval subjects,[14] or to specialize in a distinct group of pieces, such as engraved shillings.[15] However, when a general collection is formed, the material often accumulates without a formal structure. Until 2018, the Millett collection had no list, catalogue, tickets or obvious order.

The Catalogue

The first step was to create a simple working catalogue. Each piece was given a unique number, the pieces were photographed and the photographic reference included for the obverse, reverse and edge, where appropriate (just one piece in the collection has a skillfully worked edge, #300). The entry then describes how the coin has been modified, although it should be noted that there can be some ambiguity in determining the obverse and reverse sides of a design. The writing and engraving styles are summarized along with a comment about the method used to create the design. About half of the pieces in the collection bear an engraved date, often just the year. Some pieces are wholly pictorial; others have text in the form of cursive script, block letter forms, a cypher, a monogram or a mixture of letter forms. All text in the Millett collection uses the Roman alphabet and the English language predominates: one piece includes French (#236), and two bear Latin mottoes (#030, #143). Only six pieces bear countermarked designs impressed using simple punches or more complex compound punches. These are typical of the mass-produced engraved and countermarked coins that circulated widely after the first quarter

of the nineteenth century and continued to make sporadic appearances into the twentieth.

As a general collection, which falls under the generic term of 'love token', it can be divided further into different classes. These allow common styles and the work of an individual producer to be identified.

The final part of the working catalogue is a description of the undertype or host coin: country, denomination, date (or range) of that issue, the metal, diameter and weight. A host coin is only identified if there are sufficient vestiges of the undertype to be certain. Pennies manufactured in 1797 by Matthew Boulton at the Soho Mint in Birmingham weighed one ounce when issued (28.3 grams): their considerable weight and their raised rims gave rise to the name 'cartwheel penny'. They were struck in such numbers that they dominated the copper coinage in circulation for many decades, gradually wearing smooth and providing a suitable host for engravers. Whilst it is likely therefore that many pieces around 35mm in diameter and weighing about 27 grams originated as pennies, this is not sufficient for the host to be described as such. The catalogue notes the grade or condition of both sides of the coin and any signs that the piece has been deliberately smoothed prior to engraving, along with any piercings and their location relative to the design. If the piercing respects the engraved design, then the coin was probably intended to be suspended or worn.

The collection's strength lies in hand-engraved and singular pieces from the period 1750–1850. The following discussion analyses its chronological range, before comparing it with other collections. The final section proposes a taxonomy for classifying engraved coins thematically.

The distribution of engraved dates

Of the 315 engraved tokens in the Millett collection, 161 include an engraved date. These range from 1736 to 1848. **Figure 1** shows their distribution.

There are two clear peaks in the production of dated engraved coins, with 33 pieces from the 1780s and 22 pieces from the 1830s. **Figure 2** gives equivalent data for the British Museum collection of engraved coins and for the National Museum of Australia (NMA) collection of convict transportation tokens.

The Millett and British Museum collections share a common peak around 1790. The second peak in production of dated pieces, around 1830–50, corresponds with the convict transportation tokens in the NMA, confirming their significance as a proportion of the current Millett collection.[18]

Widening the net, **Table 1** adds five further collections of engraved tokens to the study: the pieces catalogued in the Vorley, Law and Barker sales, the Powell collection[19] and the Oddie collection of engraved shillings.

The Vorley sale included many hundreds of undated, engraved coins (mostly silver 3d and 6d). These showed just a name or initials and many of them date to the period 1885–1914. Excepting this unusual group, the overall pattern for a general collection of engraved tokens is a roughly equal number of dated and undated pieces.

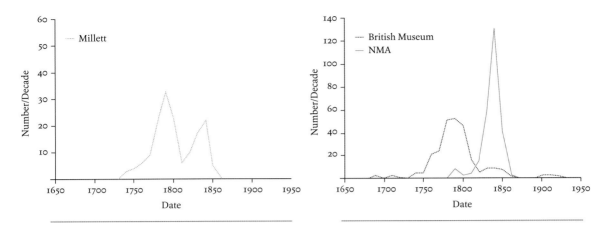

fig. 1 Distribution of engraved dates in the Millett collection by decade.[16]

fig. 2 Distribution of engraved dates in the British Museum collection and NMA collection.[17]

	Dated	Undated	Total	Date Range
Millett	161	154	315	1736–1848
British Museum	254	251	505	1688–1916
National Museum of Australia	261	47	308	1780–1856
Vorley	220	2328	2548	1666–1918
Law	136	146	282	1723–1904
Barker	250	339	589	1708–1909
Powell	168	147	315	1712–1919
Oddie	218	257	475	1638–2017

Table 1 Summary of collections of engraved coins and the range of engraved dates.[20]

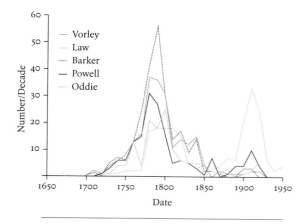

fig. 3 Distribution of the engraved dates in the Vorley, Law, Barker, Powell and Oddie collections.

Figure 3 shows the date distributions of the five collections.

There will be some duplication of coins between the earlier and later collections as pieces have passed from one generation of collectors to the next, but the impact of this on the overall dating pattern is minor. All the collections show a similar peak around 1780–89 and all decline to very small numbers by around 1850. The early collections (Vorley and Barker) also show larger numbers of dated engraved coins around 1830–40; the more recent collections (Oddie and Powell) reveal a further group from 1870–1920, a peak around 1900 and a rapid decline towards the middle of the twentieth century. The British Museum collection, which lacks the later peak, reflects the periods during which the contributing collections were formed. Of the 505 pieces catalogued, 345

are from the Ella Pierrepont Barnard collection (1864–1934, catalogued in 1918 and accessioned in 1952), and the remainder are mostly from other early donations.[21]

A taxonomy of engraved coins

Classification is the most problematic aspect of the cataloguing process. Often only those who commissioned or carried out an engraving knew what was intended. Two centuries later, some pieces may fall into more than one class, and others, now separated from their original context, may be completely misinterpreted. The first attempt to categorize engraved coins, based on analysis of the Oddie, Powell, Vorley and Barker collections, was made just a few years ago and presented at the 2017 Token Congress. That scheme was subsequently refined and reordered through discussions with other collectors to produce the sequence presented here.[22] In some instances, specialist knowledge of, for example, contemporary clothing, prints and personalities, prompted a reassessment of an initial allocation. Stylistic similarities, such as those found between convict love tokens, also suggested additional classes for several pieces.

For each class, the number of pieces in the Millett collection is given in square brackets, along with specific examples. As several of the pieces fall into more than one class, the totals below come to somewhat more than 315 pieces. The range of engraved dates (1736 to 1848), the distribution between copper, silver and brass pieces (274 Cu, 33 Ar, and 6 brass are identifiable), and the absence

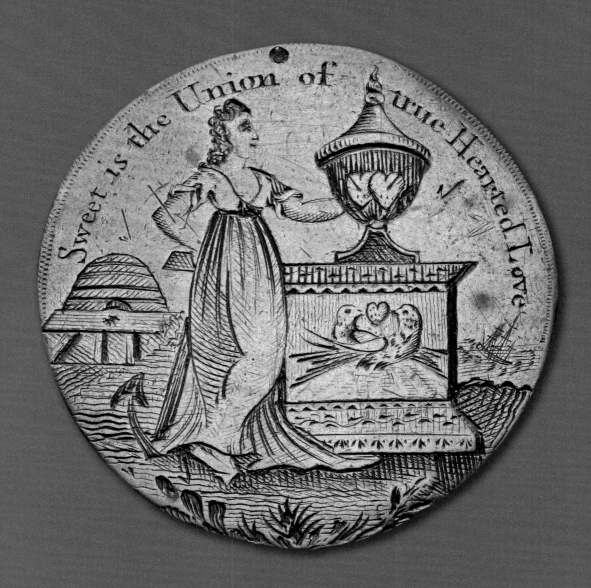

#002

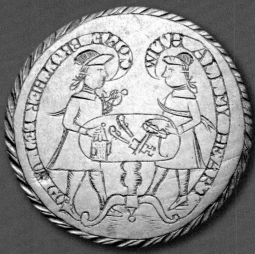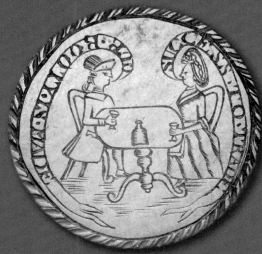

#011
———

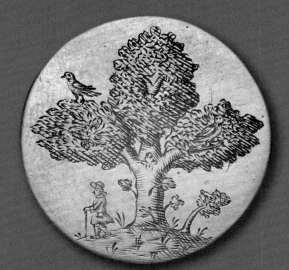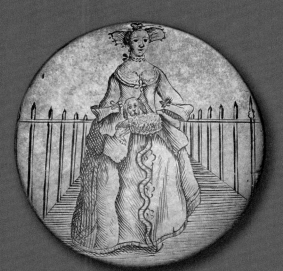

#012
———

of any bronze pieces (UK base metal coins struck after 1860), may explain why several classes in the general scheme are not represented in this collection. Their absence reinforces conclusions about the types of people who engraved coins and the period in which they were made.

Pieces that bear messages or images of **Love** form a large group [69]. Often exhibiting two names or sets of initials (#029, #032), one or more hearts (#180), a pierced heart (#278), a bleeding heart (#002, #130), or a flaming heart (#234), the designs are very diverse. A cherub appears on one piece (#224), doves on several (#150, #280), and the courting couple on others (#004, #230). Some explicitly state the word 'love' (#196), or 'a token of love' (#288). Explicit statements of commitment are found on tokens that declare **Chastity** [2] or fidelity with a message that proclaims 'spotless innocence' (#076) or 'I love my choise to well to change' (#294). These tokens may also be associated with separation and love.

Tokens celebrating a **Marriage** [16] almost always give the names of the couple along with the exact date of the marriage (#016, #090). Gifts to the bride and groom can be in silver (#077, #120) or copper (#066). Some pieces also state the location of the event which makes tracing the family simpler, though not always guaranteed (#245). The separation of a couple caused by **Divorce** or infidelity [0] is a very rare message on an engraved coin, with no examples in the Millett collection.[23]

Another large group of engraved coins celebrate the **Birth** of a child [29]. These were usually commissioned or engraved by parents, relatives or friends of the family. As well as a date of birth, baptisms, christenings, birthdays and coming of age fall into this class. Some pieces record more than one birth (#149). A higher proportion of tokens in this class are on silver hosts, 6 of the 29 (#003, #005), and some incorporate finely engraved designs (#140, #187). Others are more primitively created, much in the style of the convict transportation tokens (#227, #244). An unusual technique is to hammer up the edge of the host coin and then engrave the legend on to the edge. There is a single specimen in the collection (#300), although other pieces are known, typically celebrating a birth in the period 1750–1800.[24] When first analysing the Millett collection, two pieces were noteworthy for having an engraved date of birth that predated the earliest date of issue of the host coin or token (#148, #248). Other examples with this characteristic have since been found. Two further pieces in the collection, also relating to birth, are distinctive with the design left in relief and the fields filled in with a black japanning or enamel (#306, #307).

Coins engraved in the context of **School and Education** [1] are rare in the period covered by the Millett collection. Mementoes of attendance, prizes, awards or specific activities are more commonly found following the 1870 Education Act. There is just one piece in the Millett collection and it relates to Oxford University (#144).

The Millett collection spans the period of Britain's industrial revolution and a class is given to those pieces that display legends and designs relating to **Employment and Industry** [29]. The engraved design may specify a trade such as 'letter founder' (#112), 'wind up jack maker' (#115), 'chimney sweep' (#105), 'linen draper' (#155), a 'dealer in sugar and coins' (#126), or just an

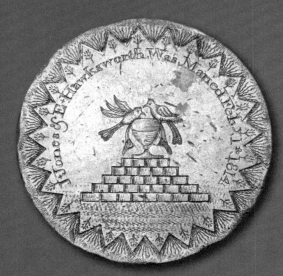
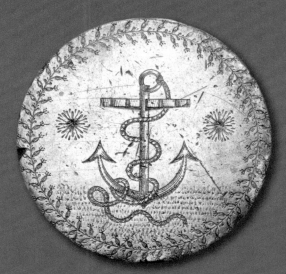

#027

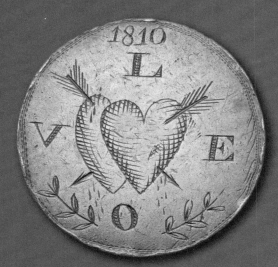
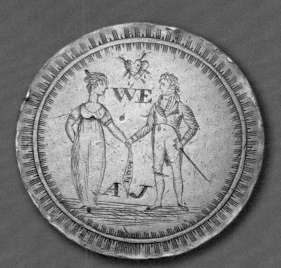

#029

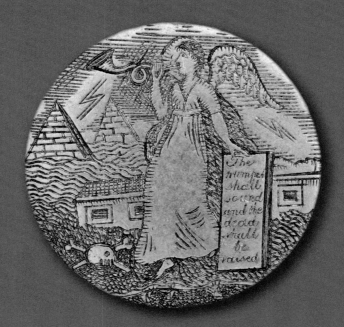

#183

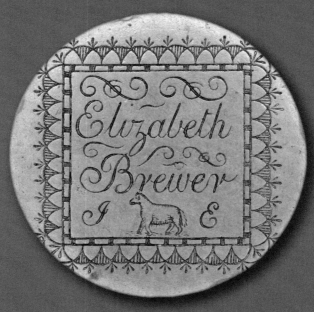

economic identity, a 'hard working man' (#099). Others show people at work, weaving (#242) or juggling (#081). A related group of tokens served the purpose of **Advertising** [6]. These were possibly made in quantity to be given away, or as deposits or receipts for goods or services. Two different London addresses are given on the functional tokens of 'Blunt, Operator for the teeth' (#303, #304 and #305), whereas 'Curtis of Reigate, carpenter and turner' is a finely engraved piece (#270).

Pieces that state or imply a familial relationship are placed in a class called **Family** [3]. In the Millett collection, #062 shows a mother and two daughters of the White family. Other pieces include the word 'brother' (#011, #066, and #169), but also fall into a different class. The practice of naming relatives – mother, father, cousin, sister etc. – is more commonplace on engraved coins of the early twentieth century.

A large group of pieces in the collection refer to **Separation** [34]; this class covers any event that parted a couple, family members or friends. Engravings often include phrases such as 'When this you see Remember Me'. Some bear simple text (#198, #310); others are more ornate, showing a domestic scene (#107) or a working scene (#113). A few show sailors about to set sail (#018, #024). Following further research, a number of these pieces may also qualify for the **Maritime** or convict **Transportation** categories. Many of the pieces in these three classes are dated and contribute to the second peak in the date distribution around 1830 shown in **fig. 1**.

Pieces that refer to **Maritime** activities [23] – to the navy, ships and life at sea – have their own class.

Several name and illustrate ships such as the *Rose* (#086) and the *Wasp* (#065); others bear contemporary messages such as 'Success to Rodney's fleet' (#085), or show sailors (#069, #071) and their departure to sea (#129). Further research has shown that the *Backhouse* (#056) traded in enslaved people.

Convict **Transportation** tokens [44] form a special group. These were created as a memento of people separated through the criminal justice system for a term of years or possibly life. This catalogue records pieces acquired by Millett since 1998. Most of them are quite simply engraved or pricked (#169), but one shows a fine engraving of the 'transporte' ship (#057). Some pieces refer to a 'foreign country' (#176, #181) and to being transported (#311, #314, #315).

Pieces with a legend or design that indicates some criminal activity, or its consequences, fall into the class of **Crime and Punishment** [26]. This significant group includes hanging in chains (#203), a beheading at Temple Bar (#015), prison escape (#010), tools of the criminal trade (#079), being cast for death (#182), the execution of Henry Fauntleroy for forgery (#034), celebrating ill-gotten booty (#011), highwaymen (#138) and their imprisonment (#102, #108), and Newgate prison (#226). These, like the convict transportation coins, are over-represented in the Millett collection.

A large class of engraved coins **Name** one or more people [29] but give no other indication of purpose or meaning. Some are quite plain (#214, #222), while others show finely worked images (#021, #160), including animals (#022) and a hunting scene (#031). A similar group is made

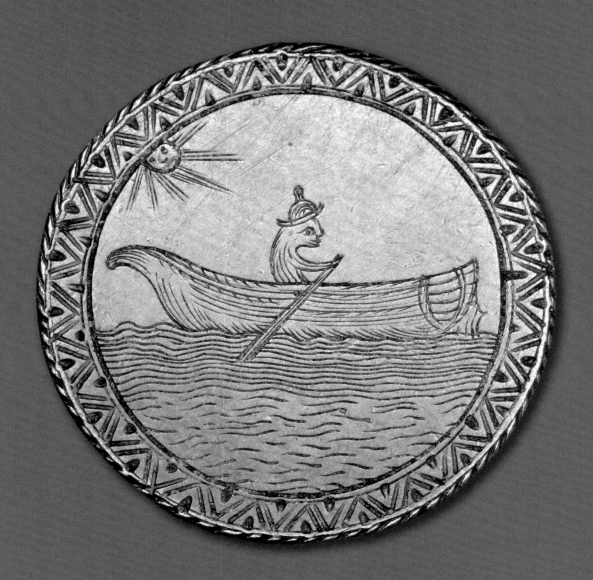

#130

up only of **Initials** [13]. Designs range from basic letters (#262), an artist's initials (#223) and a pair of initials (#282), to pieces with enigmatic images (#281), a naval bust with an unnamed building (#268), a portrait (#124) and a hunting scene (#255). Unless the name is very rare or the initials unusual, they are challenging to research, even when accompanied by an engraved date. Compared to more general collections, the Millett collection, with its preference for visually and textually interesting pieces, significantly under-represents these two classes.

Some engraved coins bear a **Message** [15] from one person to another that does not fall into the **Love** category. Subjects include 'Respect' (#237), a thank you from 'EH to HW for fastening her shoe string' (#205), 'Heartfelt gratitude' (#172), health and long life (#164, #006), a cryptic message about a couple (#163), 'Success Attend' (#141), an imperative 'Kiss Mee' (#093), and others whose meaning is now lost (#012).

Pieces that depict or name **Buildings** other than churches [0] and refer to the fabric of the building or activities related to it, such as construction, formal opening or demolition, can be grouped together. This is an unusual class, which typically appears late in the nineteenth century, and is not represented in the Millett collection.[25] A separate category, **Church** [3], covers ecclesiastical buildings (#239), or activities related to religion (#285). Pieces showing very fine engravings of Gloucester cathedral (#238) are known in several collections, possibly all from the same hand, suggesting the work of an enterprising local engraver.[26]

Engraved pieces can carry a specific **Moral** message [1]. C. Brown, who 'loves the juice of the cane' calls on 'Marther' (Martha, mother?) to think of him (#040). Determining the class for this item evolved during the cataloguing process, with Love and Separation added, and convict Transportation another probable context.

The **Politics** class [32] covers designs or legends relating to political activity, elections, radical causes and so on. These pieces are over-represented in the Millett collection. They range from overt messages, such as 'Down with the Rump' (#017), 'Distruction still to Dingley and his mill' (#013), 'Pitt's deserts' (#111) and Tom Paine hanging from a gallows (#019), to evidence of social unrest, with '"Gibbs" Ld Mayor pelted with rotten eggs 1845' (#037). Anti-establishment sentiments appear (#036, #042) and radicals such as Frost (#064) and John Wilkes (#241) are celebrated. Only a very small number of pro-monarchy engraved pieces counter this (#087, #088).

Some legends or designs fit into the **Humour** category [5], although changing historical and social contexts tend to weaken the jokes. One piece quotes from Miller's jests (#161) whilst another shows the effects of drunkenness (#053); a later engraving shows Queen Victoria smoking a pipe. Though dated 1805, a piece engraved specifically for Tim Millett in the style of a convict transportation token is of much later manufacture (#175). **Satire** [4], a special case of humour, often at the expense of politicians, royalty and the higher social classes is found in the description of George IV as 'Patron of vice and frivolity' (#048). Another piece

#242

shows a finely engraved monkey with the legend 'Risum Teneatis Amici?' ('Friends, can you help but laugh?', #143) taken from the satirical *Art of Politics* first published in 1729. Though not named, Jeffrey Dunstan appears twice, spanning humour, politics and satire (#053 and #067).

References to **Sport** [3] and other forms of recreation are much more commonplace after the late nineteenth century. Engraved pieces in the Millett collection include a hunter with his faithful dog (#068) and bull baiting (#235).

Military activities [2] appear more frequently from the late nineteenth century, linked to the Boer War and 1914–18 War. One piece in the Millett collection appears to compare the funding of army and navy (#127).[27] A reference to the battle of Portobello in 1739 (#096) falls into the class of **War** [1]. **Parades and Public Events** [0], a largely military category, first appear on engraved coins late in the nineteenth century and are absent from this collection.[28]

Engraved coins on the subject of **Death** [13] may be a simple record (#246), a display of open grief (#001), or a finely engraved design incorporating an angel (#183). Some reveal more of a story, such as dates of birth, marriage and death (#058) or a man 'kill'd by his own gun' (#101). Though not represented in the Millett collection, engraved coins were also given as **Bequests** [0] either as a memento or to signify that the recipient has been cut off with a shilling.[29]

Heraldic pieces [2] show a coat of arms, or other heraldic design, sometimes with a motto (#219, #257). These are much more common on engraved silver pieces so are under-represented in the Millett collection.

Pieces that name a place and mark an event there fall into the class **Places and Souvenirs** [2]. Thomas Galloway, an American juggler and harlequin, performed at 'Sydney Gardens' in 1826 (#046); more obscurely, William and Anne Brigden were 'Quartered at … the Vine at Hillingdon' in 1779 (#100).

High-quality engravings, possibly apprentice-ship pieces, are placed in **Art** [6] when there is no other indication of use. These pieces display very diverse engraving styles (#033, #094, #185 and #286). **Menagerie** [1] covers pieces decorated with animals, birds, fish etc, which may again be apprentice or artistic work. The Millett collection has just one (#060).

Tags [3] made from coins to identify ownership are usually pierced, so that they can be attached to a person, animal, clothing or other object, and engraved with a name, address etc.[30] Through further research at the Vinters' Company, a few pieces fell into this class as labels for keys (#114, #301, and #302).

Finally, there are engraved pieces that do not fit into any of the above classes. **Other** [7] contains a coin that has been swallowed (#153), a seal matrix (#030), pieces with retrograde engravings, possibly practice work by a copperplate engraver (#139, #142), and a calendar medal (#154). All are unusual enough not to warrant a separate class.

In any system of classification, alternative arrangements are possible. Some pieces span several categories. An additional class, **Entertainment,**

could be created, pulling in pieces from other groups and subdivided according to the type of event (hangings, theatres, races, shows etc.) and whether payment was required. **Menagerie** could be re-figured into Natural World to include gardens, flowers, landscapes etc. Many classifications could be further divided, to capture references to gender and social class, in both giver and receiver. The more detailed and specific the system becomes, the more likely it is that an engraved piece will fit into more than one class.

Conclusions

The collection of engraved coins presented here has been formed with an eye for quality and the unusual, either in the message, the design or the stories that it tells. As such it over represents political topics, separation, convict transportation and crime and punishment, and underrepresents pieces which are less easy to research, such as those that show only names or initials. The collection reflects the circumstances in which it was created, with its early direction set by what Millett found in Baldwin's basement, and its current, evolving form shaped by growing interest in convict tokens, which led to a substantial number of coins leaving the collection in 2008.

The distribution of engraved dates is consistent with the range found in older collections covering the period c.1750–1850. The main peak falls around 1780–1790; a secondary peak, between 1830–1840, can be attributed to convict transportation tokens. Pieces in the Millett collection fall into the classes typical of other collections and consistent with its date distribution. It is dominated by pieces engraved on copper and there is an absence of bronze undertypes that were produced after 1860. Some classes, therefore, that are only found during a later peak of 1870–1920 are not represented in the Millett collection, and examples of other categories, such as war and sport, are few in number.

In making this book, the authors have chosen to discuss specific topics and coins. But during the process, other information also came to light, such as genealogical details, similarities between pieces engraved by the same hand, and connections with items in other collections. Where possible, descriptions of individual coins captures this information in brief notes. Many of the pieces have a much bigger story than can be included here and it is hoped that these clues will encourage further research and publication.

1 Harrington E. Manville, *Tokens of the Industrial Revolution: Foreign Silver Coins Counterstamped for Use in Great Britain, Circa 1787-1828*, London 2001.

2 James Gavin Scott, *British Countermarks on Copper and Bronze Coins*, London 1975.

3 D.T. Batty, *Batty's Catalogue of the Copper Coinage of Great Britain, Ireland, British Isles and Colonies, Local & Private tokens jettons, &c: Volume 2* (1877–1884) https://archive.org/stream/battyscatalogue01battgoog/battyscatalogue01 battgoog_djvu.txt (accessed 24 March 2021).

4 Ella Pierrepont Barnard, 'Examples of Engraved Coins selected from a collection formed by Mrs Ella Pierrepont Barnard', British Numismatic Journal, vol. xiv, 1918, pp. 151–98. British Museum Collection online: the search term 'Love Token' produces 547 results, of which 505 are relevant to this study, https://research.britishmuseum.org/research/collection_online/search.aspx (accessed 9 February 2020). The public-facing search engine is less functional than that accessed inside the British Museum. The search term 're-engraved coin' and production place 'British Isles' produces 551 results, of which 505 are relevant to this study. Thanks to Tom Hockenhull, email, 3 February 2020.

5 Thomas Sheppard, 'Catalogue of Love Tokens and other engraved pieces in the Hull Museum', *Transactions of the Yorkshire Numismatic Society*, vol. no. 2, no. 4, 1922, pp. 109–29.

6 Rev. W.H. Acworth, 'An unfinished article on Love Tokens (1941)', Token Corresponding Society Bulletin, vol. 7, no. 7, 2003, pp. 286–93, https://www.thetokensociety.org.uk/pdf2/Volume_seven.pdf (accessed 11 February 2020).

7 Sotheby's, 18 December 1934. Mrs Pierrepont Barnard decd. Lot 164. 'A cabinet containing a collection of about 490 Coins and Tokens in silver and copper, engraved as keepsakes, love tokens, records of births, deaths and marriages, and others, with representations of ships, etc., mostly eighteenth- and nineteenth-century, a curious lot almost impossible to again get together.' The lot sold for £9 to Tinchant. This is likely to be Paul Tinchant (1893–1981), a coin dealer and collector based in Brussels who sold and donated coins to the British Museum between 1925 and 1945. It may be a sub-set of this group that entered the British Museum collection in 1952.

8 D.G. Vorley. Bonhams, 13 December 1994, lots 1–131; R. Law. DNW, 11 February 2015, lots 327–34 and 13 May 2015, lots 1257–1288; A. Barker. St James's Auction 37, 27 June 2016, lots 342–582.

9 Lloyd L. Entenmann, *Love Tokens as Engraved Coins*, Audubon, New Jersey 1991.

10 Bridget Millmore, 'Love Tokens; Engraved coins, emotions and the poor 1700–1856', unpublished PhD thesis, University of Brighton, 2015, https://research.brighton.ac.uk/files/4757430/Bridget%20Millmore%20PhD%20Final.pdf (accessed 30 December 2019).

11 American engraved coins first appeared around 1850: Entenmann 1991.

12 Janette Bright and Gillian Clarke, *An Introduction to the Tokens at the Foundling Museum*, London, 2011; Linda Everaert, *Foundling Tokens: A Numismatic Survey*, Belgium 2015.

13 Michele Field and Timothy Millett (eds.), *Convict Love Tokens: The Leaden Hearts the Convicts Left Behind*, Kent Town, South Australia 1998. Whilst these pieces are connected with Australian transportees, research has shown a small number in other collections linked to the American colonies (pre-1776), Bermuda and Gibraltar.

14 Sim Comfort, *Forget Me Not: A Study of Naval and Maritime Engraved Coins and Plate* (1745–1918), London 2004.

15 Gary M. Oddie, 'Towards a classification of engraved coins', *Token Corresponding Society Bulletin*, vol. xii, no. 7, 2018, pp. 269–78; https://www.thetokensociety.org.uk/pdf2/Volume_twelve.pdf

16 Each decade is formatted on the following lines: 1 January 1730 to 31 December 1739 etc.

17 British Museum Collection online; NMA.

18 See Chapter 2 in this volume. Millett sold his collection of convict love tokens to the National Museum of Australia in 2008.

19 D. Powell, personal communication 15 January 2017.

20 Oddie 2018, numbers revised to include acquisitions up to March 2021; Vorley 1994; Law 2015; Barker 2016.

21 73 from the L.A. Lawrence collection (1857–1949), 33 from the F. Parkes Weber collection (1863–1962, accessioned 1906) and 10 from the Montague Guest collection (1839–1909, accessioned 1907).

22 Oddie 2018.

23 Ibid.

24 Barker collection lots 534–36, Oddie collection.

25 Oddie 2018.

26 Barker lots 527 and 528, Oddie collection.

27 K. Linch and M. McCormack (eds.), Britain's Soldiers: Rethinking War and Society, 1715–1815, Liverpool 2014.

28 Oddie 2018.

29 Ibid.

30 Ibid.

Catalogue

Timothy Millett Collection of Engraved Coins

Gary Oddie

with additional contributions
from Sarah Bendall, Timothy Millett
and Sarah Lloyd

The Timothy Millett collection comprises 315 coins kept in a mahogany cabinet. In the absence of a more compelling sequence, this Catalogue follows the order in which the pieces are stored in the cabinet. Sorting by date would have left the undated pieces (about half of the total) in one group; sorting by the denomination of the host coin (approximately by metal and size) requires some arbitrary judgements when the host cannot be identified with certainty. Arranging the objects according to a classification scheme becomes problematic when pieces fall into more than one category, or when existing knowledge, subsequent research or association by style might suggest a different allocation and thus sequence.

Chapter 17 explains the process of cataloguing and gives detailed explanations of the terms used below. Every entry in this Catalogue has a consistent format as shown on the following page.

The left-hand column gives a description of the piece, which is illustrated life-size on the right. Each piece has a unique three-digit catalogue number.

The description begins with the catalogue number. The obverse (**Obv.**) details follow. Conventionally the obverse side of a coin or token is easy to determine as it names or shows the issuing authority. Where a modified piece is engraved on one side only, that side is taken as the obverse, irrespective of the design of the host coin or token. When engraved on both sides the intentions of the engraver are not always obvious. In that case, the Catalogue designates one side as the obverse.

Typical catalogue entry
Catalogue no.
Obv. Details of Obverse image
Rev. Details of Reverse image
Details Coin dimensions and material
Host Details of original coin where visible
Ref. Author(s) who have referenced this piece

Added letters, words and numerals are transcribed and indicated by the use of quotation marks. Text that proved difficult to read, especially initial letters, is given in parentheses to indicate a probable interpretation, for example '[F S]'. Text that is now illegible due to wear or damage is indicated as '[…]'. Upper- and lower-case letters are included as such, but not font sizes, font types, line breaks or superscripts. Underlining is noted.

Other parts of the design are described without the use of quotation marks: images, marks and modifications, where metal has been moved (engraved, pricked, scratched, punched). Where there is some uncertainty in the design element this is indicated by '(?)'. Several pieces show a distinct groundline in the design and the term for the area below this is the 'exergue', often used for a date or a name.

In the same manner the reverse (**Rev.**) details are given. In many cases the reverse has had no modifications and a simple description of the state of the original coin is given, ranging from worn to very worn, to a smooth surface. A sample of these are illustrated in the Catalogue.

The **Details** of the piece cover metal, diameter and weight, along with reference to any piercing. If the piercing respects the engraved design then it is described as 'pierced for suspension', otherwise it is just 'pierced'.

The **Host** is ascribed if some vestige of the original coin or token can be seen. Several of the pieces are based on eighteenth-century tokens which are only identifiable by the legend on the edge. Pieces that are around 36mm diameter and weigh about 25g were probably cartwheel pennies but are not described as such unless some part of the initial design remains.

The final entry is a cross reference (**Ref.**), where relevant, to those authors who discuss the piece in their chapters.

A Note on Coins and Denominations

Britain adopted a decimal coinage in 1971. At that time, very worn silver coins dating back to the recoinage of 1816/17 and similarly worn bronze coins dating back to 1860 were still in circulation. During the period covered by this book, money was expressed in pounds (L), shillings (s), and pence (d). One shilling was equal to 12 pence; 20 shillings were equal to one pound. A crown piece was worth 5 shillings (abbreviated as 5/-); a half crown was 2/6. Thus 1s or 1/- stands for a shilling and 1d for a penny.

001 **Obv.** 'SARAH HOLFORD DIED
March 14 1811 in her 61st YEAR', on
plinth with urn. Woman wearing
informal morning dress with high
neckline and frilled collar, leaning
on plinth pointing at legend with
right hand. Bare tree with flower to
left, wreath around.
Rev. 'Mr Thos Holford died Decr.
10th 1815 Aged 34 Mr John Wm.
Holford died Septr. 25th 1816 Aged
30', spray of 8 leaves above and
below.
Details Cu, 43.0mm, 39.24g.

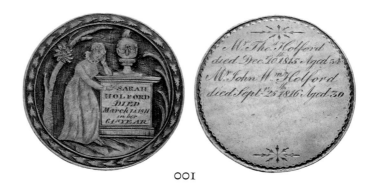

001

002 **Obv.** 'Sweet is the Union of true
Hearted Love' above woman in neo-
classical gown with high waistline,
of a type popular from the 1790s
to 1815, her right hand on hip, left
hand on urn with two pierced
hearts, plinth with two doves and
heart. Three-masted ship at sea on
the right, anchor and beehive to left;
wreath below.
Rev. 'Of all your Sex I have respects
my Dear for none BUT YOU I
cannot tell you the affects of Love
I bear for You', within ornamental
wavy border.
Details Cu, 42.6mm, 17.81g, pierced
for suspension.

002

003 **Obv.** 'Saml. Harwood BORN June
17 1758', in cartouche to left. Man
with staff and dog walking towards
cottage with smoking chimney. Sun
rising over distant hill; tree to right.
Rev. 'S 1777 H' engraved across bust.
Details Ar, 38.6mm, 27.19g.
Host UK, 5/-, 1676.
Ref. Dyer

003

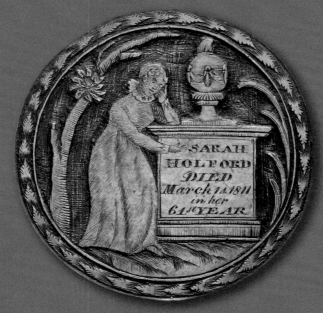

#001

———

All three were buried in St Anne's Soho, Westminster.

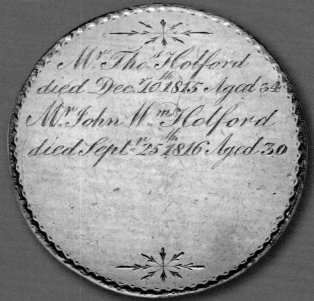

004 **Obv.** '[F S]' on either side of a plinth showing a bow and quiver of arrows, carrying a double-pierced heart, motto 'LOVE' across the middle. Woman to left wearing a round gown with a chemisette that covers her neckline, right hand on hip, left hand on motto; man to right wearing a jacket (possibly double-breasted) and trousers, with stick or crop in left hand, right hand on motto. Shaded groundline, spray above and below.
Rev. Original coin.
Details Cu, 35.8mm, 25.98g.
Host UK, 1d, 1797.
Ref. Dyer

004

005 **Obv.** 'Elizabeth Clement born Decr. ye. 10: 1774 Great Saling Essex', within ornate border.
Rev. Original worn coin.
Details Ar, 39.6mm, 26.83g.
Host UK, 5/-, 1695–56.
Ref. Lloyd

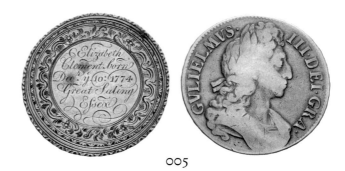

005

006 **Obv.** 'A LITTLE HEALTH A LITTLE WEALTH A LITTLE HOWSE AND FREEDOM AND AT THE END A LITTLE FREND AND LITTLE CAUSE TO [NEED] THEM', within a circular border of triangles.
Rev. Three-legged circular table carrying jug and bottle. To left, woman sitting on high-back chair, right hand raised with tall glass, 'E W' above; to right, man sitting on high-back chair, pipe in left hand, right hand raised with tall glass, 'W W' above. Cherub with bow facing right, arrow in flight at man. Extra initials 'T' at Cherub's feet and 'B' behind man's hat. Hatched floor pattern below.
Details Cu, 35.5mm, 23.6g.

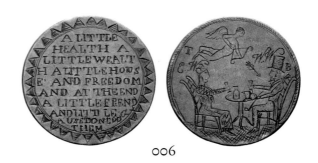

006

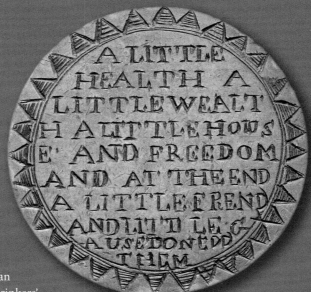

#006

The obverse side bears an anonymous rhyme or drinkers' toast. Richard Jefferies noted it inscribed on the side of an 'old English' mug in *Nature Near London* (1883, p.214).

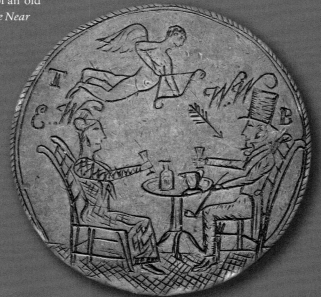

007 **Obv.** 'The man who did this was born without a shirt 1840'.
Rev. Original worn coin.
Details Cu, 35.7mm, 25.78g.
Host UK, 1d, 1797.
Ref. Dyer, Whyman

008 **Obv.** 'ROGER O'CONNOR REX', replacing original legend, wreath of shamrocks added to portrait.
Rev. Date and legend removed. 'IRELAND INDEPENDENT' added along with three shamrocks to top of harp.
Details Cu, 34.0mm, 16.10g, pierced for suspension.
Host Ireland, 1d, 1822.

009 **Obv.** Man in tall hat and tails facing right, holding and kissing; woman in feather hat and dress of later nineteenth century. Hills in background with sun to left. Hatched ground.
Rev. Smooth surface.
Details Cu, 30.7mm, 6.43g, pierced for suspension.

010 **Obv.** 'HERE ✶ LIES IOHN ✶ IONES DOUBEL ✶ IRONED FOR ATTEMPTING TO. BREAK-OUT-OF 1776 NEWGATE', above man lying on ground in breeches, waistcoat and coat; legs in irons.
Rev. 'HERE ✶ LIES IOHN ✶ IONES', with sprigs, above cutlass and pistol, and naked man on hatched ground. 'DIED JUNE 19 1776' in exergue.
Details Cu, 32.8mm, 9.04g.
Ref. Rowson, Hitchcock

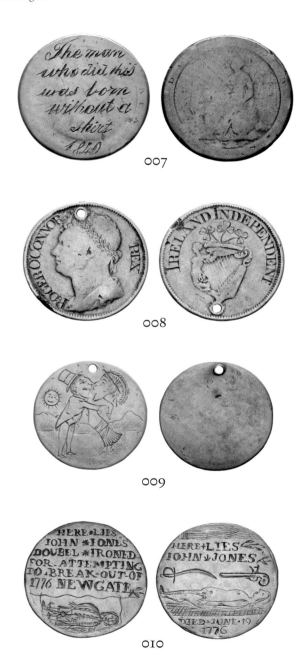

007

008

009

010

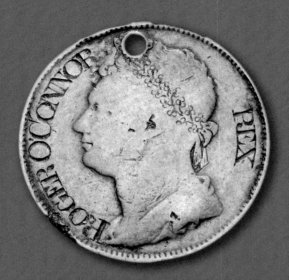 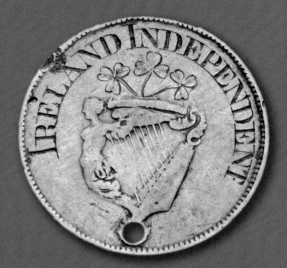

#oo8

Roger O'Connor (1762–1834), Irish nationalist, joined the United Irishmen in the 1790s with his brother Arthur. This was followed by his arrest and imprisonment. During the 1810s he maintained his radical associations while embroiled in various financial scrapes.

In 1822 O'Connor published *The chronicles of Eri, being the history of the Gael, Sciot Iber, or Irish people: translated from the original manuscripts in the Phoenician dialect of the Scythian language*, a work described by the *Oxford Dictionary of National Biography as* 'mainly, if not entirely, the fruit of O'Connor's imagination'. The text describes the author as 'head of his race, and O'Connor, chief of the prostrated people of his Nation'. This coin, which bestows the title 'Rex' on Roger, may well have been produced at the time of publication.

Roger O'Connor was father of the Chartist Feargus O'Connor.

011 **Obv.** Oval pedestal table with two feet; two pistols on the table. Man to left in long coat and (bicorn?) hat, cutlass under left arm, right hand holding lantern. Speech banner with retrograde 'COME BROTHER LET US GO'. Man to right holding bunch of two keys and a lock pick in left hand on table; jemmy under his left arm. Speech banner 'WITH ALL MY HEART'. Shaded ground and engraved border.
 Rev. Oval pedestal table with two feet; a bottle on the table. Man to left in long coat and hat, sitting in high back chair, holding glass in right hand. Speech banner with retrograde 'OUR. BOOTY. IS. MADE'. Woman to right wearing an English (?) mantua gown, necklace and a fashionable cap or bonnet, sitting in high-back chair, holding glass in left hand. Speech banner 'SUCCESS. TO. TRADE'. Shaded ground and engraved border.
 Details Cu, 27.8mm, 7.31g.

012 **Obv.** Tree on shaded ground with tufts. Man with long coat, hat and walking stick standing below facing left. Bird on left branch facing left. Bird in right hand branch facing right.
 Rev. Woman in a low-cut mantua gown (probably a front-fastening English gown) fashionable between the 1750s and 1780s, worn with a contrasting petticoat that has been decorated with pinked trimming underneath. She has a choker necklace and muff, and may have a shawl around her elbows. She walks forwards carrying a dog. Perspective railings to left and right, with shaded ground.
 Details Cu, 28.3mm, 8.38g.

013 **Obv.** 'James Ross 1769', with border.
 Rev. 'DISTRUCTION. STILL. TO. DINGLEY. & HIS MILL.' around tower windmill with four sails, door and windows.
 Details Cu, 27.4mm, 8.33g.

014 **Obv.** 'ROOM FOR CUCKOLDS HERE COMES MY LORD MAYOR', with a man's face with beard, hair and horns above.
 Rev. Smooth surface, silhouette of host coin just visible.
 Details Cu, 29.4mm, 8.8g, pierced.
 Host UK, 1/2d, 1672–75.

011

012

013

014

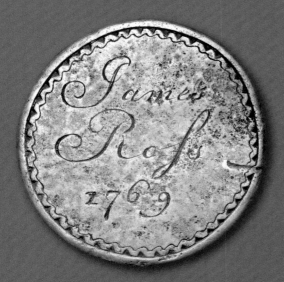
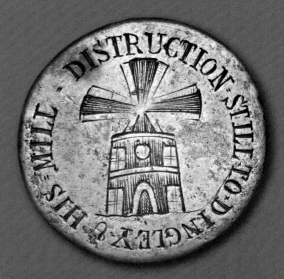

#013

In the turbulent politics of the 1768 general election, when Parliament repeatedly expelled John Wilkes, it seemed that **Charles Dingley** (1711–1769) would stand against Wilkes at a second Middlesex by-election in March 1769. Their feud was well-aired in the press and depicted in caricatures, including *A Perspective and Political View of the Timber Yard at L-e* (April 1769), in which Dingley and Wilkes exchange remarks whilst the Magna Carta and Bill of Rights are sawn in half. In the background of the print, as on this coin, is the wind-powered sawmill that Dingley had built at Limehouse in 1767 and for which he received a gold medal from the Society of Arts. Five hundred sawyers fearing for their livelihood attacked the mill six months later on 10 May 1768, the same day that soldiers fired on a pro-Wilkite crowd in St George's Fields, Southwark. While the two events may not have been directly connected, Dingley's activities brought together Wilkes, crowds and machines in the heady political mix represented here. In February 1769, Parliament paid Dingley £2000 compensation for his mill; in the same year attacks upon mills were brought within the provisions of the Riot Act. [KERRY LOVE]

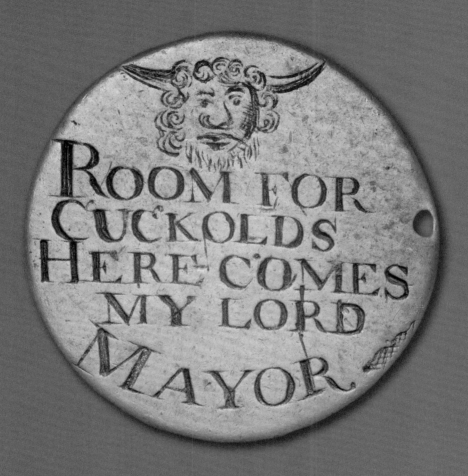

#014

According to Thomas Pennant (*Tour of Wales* 1770–3, published 1810), the origins of this phrase lie with **Sir Thomas Myddelton** (1550–1631): 'Thomas... became lord mayor of London, and was founder of the family of Chirk-castle. It is recorded, that having married a young wife in his old age, the famous song of *Room for cuckolds, here comes my lord mayor!* was invented on the occasion' (p. 168). Myddelton, Lord Mayor in 1613, married four times. His last wife was Anne Wittewronge, the widow of a London brewer.

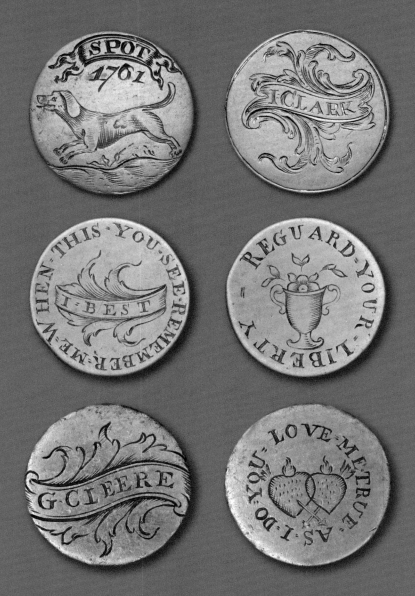

#022, #159, #234

A group of coins with similar design motifs.

015 **Obv.** 'ED ALLEN TO THS ALLEN 1774', above view of ornate archway (Temple Bar). Two heads on spikes above. Man kneeling with head on block, held down by standing executioner's left hand. Executioner has axe in right hand, right foot on coffin. Man in long coat with walking stick and hat (tricorn?) to right.
Rev. Original worn coin.
Details Cu, 28.5mm, 8.67g.
Host UK, 1/2d, 1770–75.
Ref. Dyer, Cozens

016 **Obv.** 'RT. BAGGS' above double-pierced heart and 'EH. BAGGS' below; wreath border with two flowers.
Rev. 'Married March 4th. 1775', in wreath.
Details Cu, 27.2mm, 8.75g.

017 **Obv.** 'Down with The Rump 1747'.
Rev. 'God Bless pc &'.
Details Cu, 28.4mm, 8.29g.
Host UK, 1/2d, 1694.
Ref. Dyer, Navickas

018 **Obv.** 'AA' in wreath.
Rev. Man and woman facing, holding right hands, her left hand on his shoulder, his left hand pointing to a three-masted ship to right. In addition to a feathered hat, she is probably wearing a round gown with higher waistline typical of the 1790s in polka-dot fabric. Man wears sailor-striped trousers, waistcoat, jacket and hat. Houses and church with steeple to left; rowing boat in sea to right. Shaded ground.
Details Ar, 28.7mm, 4.39g, pierced for suspension.
Ref. Maxwell-Stewart

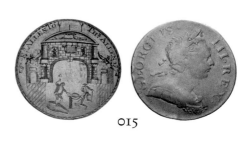

015

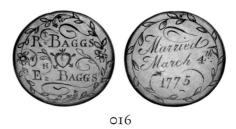

016

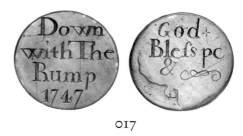

017

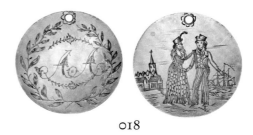

018

019 **Obv.** 'Tom Paine', above man hanging from a gibbet in a palisade.
Rev. Ornate design and shading with central flower.
Details Cu, 27.1mm, 7.33g.
Ref. Navickas

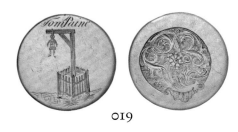

019

020 **Obv.** 'K : D', above sheep on ground.
Rev. Portly man facing right, wearing a buttoned waistcoat with shirt underneath, his right hand on hip. Tankard of foaming beer with open lid in his left hand. His hat carries a candle radiating light. Butcher's steel and knives hanging from his waist.
Details Cu, 27.9mm, 7.23g.

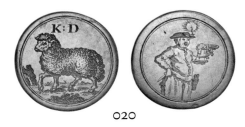

020

021 **Obv.** 'Charlotte Cotton 1765'.
Rev. Woman wearing a very fashionable outfit of the mid-eighteenth century. It consists of a mantua gown (possibly an English gown or sacque back gown) with contrasting petticoat underneath, worn over an oblong-shaped hooped underskirt. She wears an apron that has been pinned to the front of her bodice, and a fichu tucked into the neckline of her gown to cover her décolletage. She also has a choker necklace and a small cap or other headpiece. Fan in her right hand; shoes visible on shaded ground.
Details Cu, 28.4mm, 8.49g.

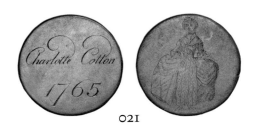

021

022 **Obv.** 'SPOT' in banner; '1761' below. Dog running left on shaded ground.
Rev. 'I:CLARK', in ornate cartouche.
Details Cu, 27.8mm, 6.86g.

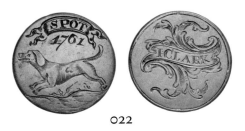

022

023 **Obv.** 'MARY HEATH Born August 4th 1780', in ornate border.
Rev. To left, woman 3/4-facing and holding flower in right hand; to right, woman facing left with stick (?) in left hand. Both are wearing gowns with kerchiefs or fichus tucked into the neckline. The front of their skirts is either a tiered petticoat underneath or an apron with gauze ruffles. Their shoes are visible on shaded and tufted ground. Tree to far right.
Details Cu, 27.5mm, 7.3g.

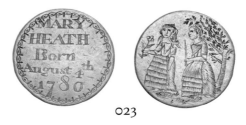

023

024 **Obv.** Ornate 'GP' to left. To right, bow and arrow, double-pierced heart, bird and single-masted ship. '[I]A' above a basket; arrow and pike to left. Ornate border.
Rev. On the left, a woman facing forward, with feathered hat, her breasts exposed in the style of printed broadside ballads of the seventeenth century. Man beside her wearing hat, with pipe in mouth and glass in left hand, looking to his right. His right hand and her left hand hold a bottle (?) in the centre. Bird to far right; five stars and shaded crescent moon in shaded sky. Shaded ground and ornate border.
Details Ar, 24.9mm, 3.81g, pierced for suspension.
Ref. Whyman

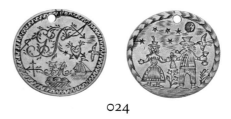

024

025 **Obv.** Original design removed. Double gibbet with boot to left and Britannia to right. Solid ground. All copper cut and riveted to the coin; Britannia cut from a coin.
Rev. Legends removed. Coffin to left and axe to right of the King's portrait, both riveted to the coin.
Details Cu, 28.5mm, 9.61g.
Host UK, 1/2d, 1770–75.
Ref. Navickas, Cozens, Millmore

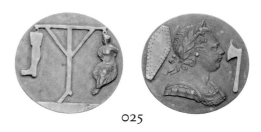

025

026 **Obv.** 'Damn Tooke TD'.
Rev. 'T, 4'.
Details Ar, 20mm, 1.76g.
Host UK, 6d, 1695–1701.
Ref. Navickas

026

027 **Obv.** 'J. Jones & E. Hawksworth Was Married Feby 1st 1814', around two birds facing, on the edge of a cup on a brick plinth. Shaded ground and ornate border of triangles.
Rev. Fouled anchor on shaded seabed within ornate wreath border.
Details Cu, 48.1mm. 103g.

028 **Obv.** All retrograde: Royal arms, crowned lion above, rampant lion to right, unicorn to left. 'DIEU ET M DROIT' in banner below. 'Thos Willson' below.
Rev. Retrograde: 'Miss Beauty &c', below a bust of woman facing left, on hatched background.
Details Cu, 48.1mm, 16.22g.

029 **Obv.** Woman to left wearing a round gown with high 'empire' waistline very common in the Regency period, in a light-flowing fabric such as muslin, cotton or lightweight silk that clings to the body. Man wearing breeches, a coat with long skirts/tail and a cravat, holds a cane in his left hand. Both are dressed in typical fashions of 1810. They hold in their hands a cloth with the motto 'LOVE'. Two bleeding hearts doubly pierced above, initials 'WE' and 'AJ' between. Shaded ground and ornate border.
Rev. Two bleeding hearts doubly pierced; 'L O V E' around; '1810' above, sprigs below.
Details Cu, 40.9mm, 47.3g.

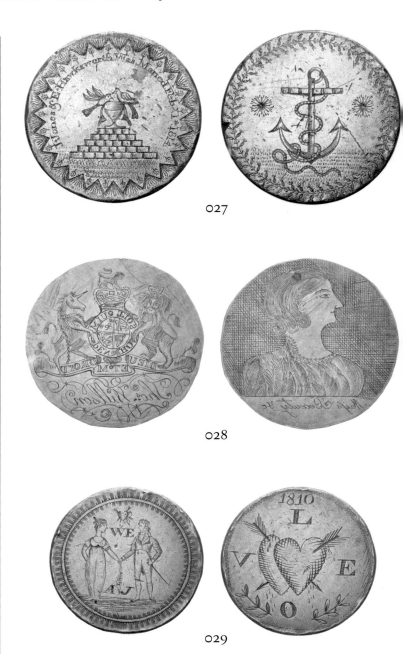

027

028

029

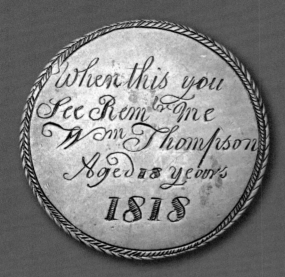
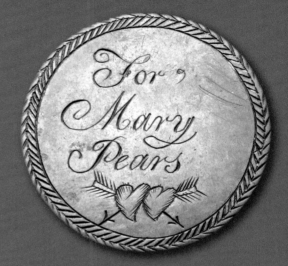

#035
————

William Thompson, born c. 1800 and a 'carver and gilder' by trade, was accused in February 1818 of stealing two sheets (value 10s) from a Knightsbridge garden, where they had been hung out to dry. Imprisoned in Newgate, he was convicted in April at the Old Bailey and sentenced to seven years' transportation. Thompson was moved to *The Leviathan*, a hulk or floating prison, at Portsmouth on 20 April 1818. He sailed on *The Dromedary* on 11 September 1819, arriving in Tasmania in January 1820.

Barely a month after he arrived, he was assigned to the 'Gaol Gang' for one month as a punishment for attempting to rob the Government garden at Launceston. In 1822, he was a Government employee. The final trace of him is as a labourer in Sydney in 1825.

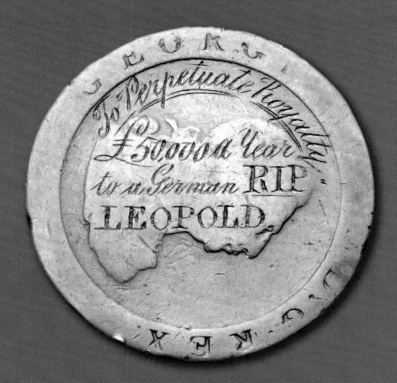

To Perpetuate Royalty,
£50,000 a Year
to a German RIP
LEOPOLD

#038

Prince Leopold of Saxe Coburg (1790–1865) married Princess Charlotte (1796–1817) in 1816. Charlotte was the only child of George, Prince of Wales, future George IV, and Caroline of Brunswick. Her death in childbirth the following year prompted outpourings of public grief and broke the direct line of royal succession. Parliament granted Leopold an annuity, but when he left the country to become the first King of the Belgians in 1831, its renunciation became a point of contention, debated for example by the reformed House of Commons in 1834. Reference on this coin to Leopold as 'a German' highlights the extent to which the Hanoverians had become accepted as 'British' and the malleable nature of royal nationality in this period. Coin #050 also complains about the annuity. [KERRY LOVE]

Source: https://api.parliament.uk/historic-hansard/commons/1834/feb/11/prince-leopolds-annuity

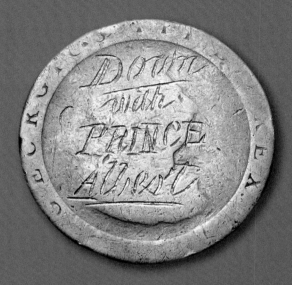

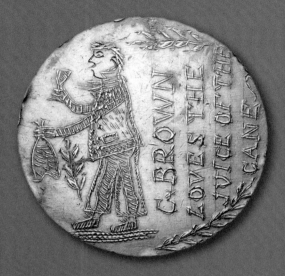

#039

An attack on **Prince Albert**, Queen Victoria's consort, whose unusual constitutional position raised concerns about undue influence and political meddling. [KERRY LOVE]

#040

The style of engraving is quite distinctive and flamboyant. It is similar in style to a love token of 1820 in the collection of the National Museum of Australia (object number: 2008.0039.0043).

030 **Obv.** All retrograde and incuse:
'. SIGILLVM : RONALDI COATES.'
around a shield and bird design.
Rev. Similar.
Details Cu, 40.9mm, 45.37g.

031 **Obv.** 'Willm. Daviss 1811', in central
circle surrounded by ornate fronds,
two birds above. Ornate border.
Rev. Man in typical hunting garb,
with coat and long boots, holding
gun across waist. One dog lying at
his feet, another sitting to the right
facing him. Tree to left, tree with
bird to right. Ornate twisted rope
border.
Details Cu, 41.6mm, 50.2g.

032 **Obv.** 'S CHARD AND S NAPKIN',
around two pierced hearts and two
flower stalks.
Rev. 'MY HART . IS FIXT . I
. CANNOT RANG . I . LIKE .
MY CHOICE . TO . WELL TO
. CHANG 1783', with a central
incuse panel featuring large incuse
countermark '19', with arrows,
double-pierced heart and other
motifs.
Details Cu, 39.2mm, 17.68g.

030

031

032

033 **Obv.** Three well-dressed men standing at a tree, two smoking cigars, one a pipe. The two men on the right appear to be sailors; the middle figure wears white trousers, jacket and collar reminiscent of naval clothing. Shaded and tufted ground.
Rev. Smooth surface.
Details Cu, 39.8mm, 13.91g.

034 **Obv.** 'FAUNTLEROY The Robber of Widows & Orphans HANGED at Newgate 1824' in centre, with 'Such be the Fate of all Bilking Bankers & Agents.' around.
Rev. Original worn coin with damage to sky and Britannia.
Details Cu, 35.7mm, 26.77g.
Host UK, 1d, 1797.
Ref. Dyer, Millett, Poole

035 **Obv.** 'When this you See Rembr me Wm Thompson Aged 18 years 1818'.
Rev. 'For Mary Pears', above two hearts doubly pierced.
Details Cu, 35.8mm, 24.91g.
Ref. Millett

036 **Obv.** 'Willm 4th. The Idiot King'
Rev. Original worn coin.
Details Cu, 36mm, 28.04g.
Host UK, 1d, 1797.
Ref. Navickas, Dyer

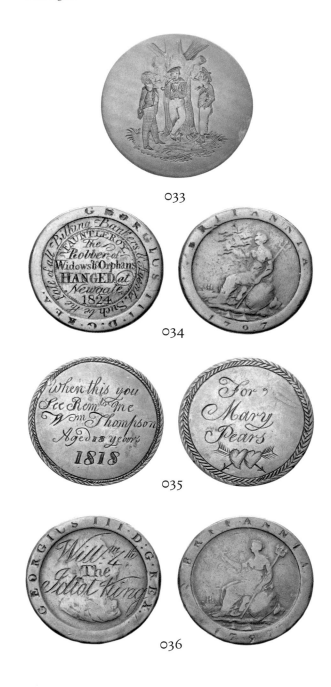

033

034

035

036

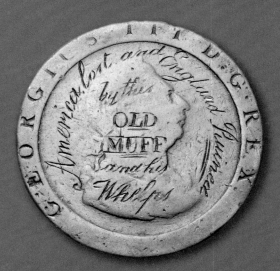 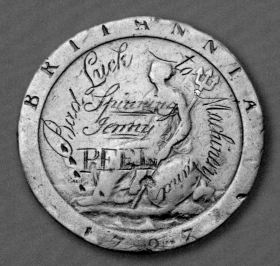

#042

George III, 'OLD MUFF', is blamed here for Britain's defeat in the American Revolutionary War (1775–1783), the implication being that he resembles female genitals rather more than a man. This is a scurrilous version of a common complaint that moral weakness, corruption and, in the language of the time, 'effeminacy' had lost Britain its colonies. The 'Whelps' (a term with previous anti-Jacobite connotations) are the King's brood of 15 children, the eldest of whom was already making a dissolute name for himself during the American conflict. The reverse side expresses hostility to mechanization.

The spinning jenny, invented initially for domestic use but soon acquired by cotton manufacturers, became an important symbol of worker grievance. The fortunes of the Peel family were established by Robert 'Parsley' Peel (1723–1795), who pioneered new textile technologies and factory spinning. His son Robert (1750–1830), the 1st Baronet, was also commercially astute and entered politics in 1790 as MP for Tamworth. In Parliament he promoted the first British factory regulation. His son, the 2nd Baronet, was twice Prime Minister of the United Kingdom. [KERRY LOVE]

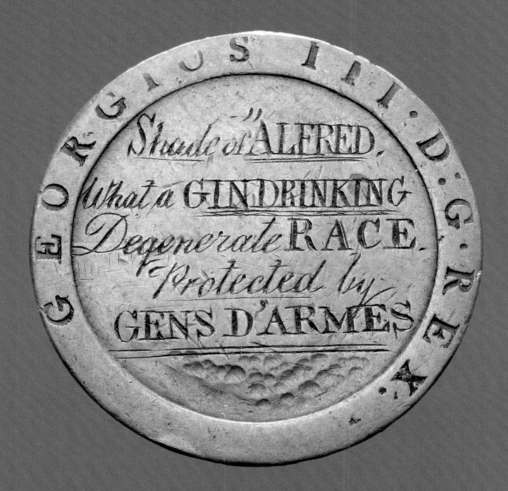

#043

A combination of seemingly disparate references. The slogan starts with a nostalgic appeal to the ghost of King Alfred, moves on to recent corruption and the pernicious effects of intoxicating drink, and finishes with a staple of 1790s anti-French imagery and propaganda, the *gens d'armes*. The overall message seems to be that a nobler Anglo-Saxon past, perhaps implicitly its 'ancient liberties', had been lost to immorality, cowardice and despotism.

037 **Obv.** '"Gibbs" Ld Mayor pelted with
Rotten Eggs 1845'.
Rev. 'Gibbs' above Britannia's shield
engraved as a face.
Details Cu, 35.7mm, 25.6g.
Host UK, 1d, 1797.
Ref. Millett, Dyer

038 **Obv.** 'To Perpetuate Royalty. £50,000
a Year to a German RIP LEOPOLD'.
Rev. Original worn coin.
Details Cu, 36mm, 26.69g.
Host UK, 1d, 1797.
Ref. Navickas

039 **Obv.** 'Down with PRINCE Albert'.
Rev. Original worn coin.
Details Cu, 35.8mm, 26.6g.
Host UK, 1d, 1797.
Ref. Navickas, Dyer

040 **Obv.** 'PRAY THINK OF ME MY DEAR
MARTHER', with 'CB' separated by two
hearts doubly pierced, all within wreath.
Rev. 'C * BROWN LOVES THE JUICE
OF THE CANE' to the right, within a
wreath. Man standing, facing left, bottle
in left hand, glass in right hand.
Details Cu, 35.9mm, 23.57g.

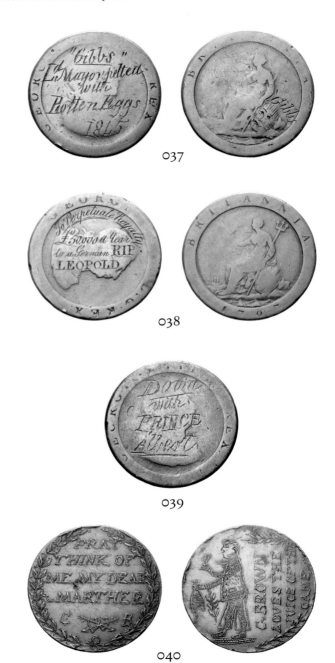

037

038

039

040

041 **Obv.** 'MS When this you see Remember me', in swirl design.
Rev. 'Until I safe return to thee SS July 1830'.
Details Cu, 35.8mm, 23.79g.

042 **Obv.** 'America lost and England Ruined' around 'by this OLD MUFF and his Whelps'.
Rev. 'Bad Luck to Machinery and' around 'Spinning Jenny PEEL'.
Details Cu, 35.8mm, 26.9g.
Host UK, 1d, 1797.
Ref. Navickas

043 **Obv.** 'Shade of "ALFRED What a GIN DRINKING Degenerate RACE Protected by GENS D'ARMES', added where portrait has been removed.
Rev. 'HBB MW'.
Details Cu, 35.9mm, 28.3g.
Host UK, 1d, 1797.

044 **Obv.** All retrograde: 'Joseph Fletcher Leather Gilder at the KINGS ARMS in St Pauls Church Yard'.
Rev. All retrograde: 'Joseph Fletcher Leather Gilder [at] the KINGS ARMS [in] St Pauls Church Yard'.
Details Cu, 37.3mm, 13.3g.

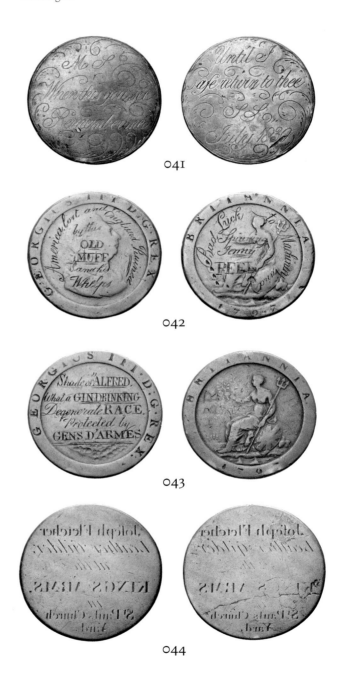

041

042

043

044

#044

Joseph Fletcher was apprenticed in 1709 to John Rowland, one of the most prominent leather gilders in the City of London. Within a week of gaining his freedom, he had placed an advertisement in the *London Gazette*: 'Leather Gilder to His Majesty … maketh and selleth all Sorts of Hangings for Rooms and Stair-cases, Chairs, Settees and Screens, of the newest Fashion' (11 December 1716).

His surviving products include a six-leaf screen, decorated in the Bizarre style generally associated with silks rather than gilt leather, and a set of gilt wall hangings from 1723 for the dining room at Longnor Hall, Shropshire. A similar set was until 1845 in the Saltonstall House, Branford, Connecticut, one of the colonial governor's residences.

For part of his career Fletcher was in partnership with John Conway. The British Museum has an invoice from Fletcher and Conway, dated 1732 (Object number Heal,78.8). Fletcher died in 1732.

Source: *Dictionary of British and Irish Furniture Makers, 1500–1914*, https://bifmo.history.ac.uk/

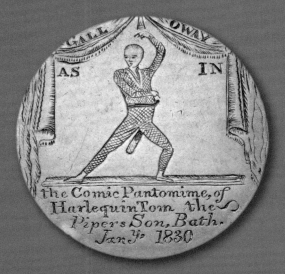

#046

'The Sydney Gardens, Vauxhall, Bath'. The Bath Vauxhall Gardens were laid out as pleasure grounds in 1790 and visited by Jane Austen. The Kennet & Avon Canal was cut through in 1810.

Harlequin shows were popular across Britain and Ireland. *Harlequin Tom the Piper's Son* was a comic pantomime by prolific author, composer, arranger and performer William Reeve (1757–1815). The work was printed in London by J. Lowndes in 1820. The near-complete chronological list of productions at the Theatre Royal, Bath, contains numerous references to *Harlequin* during the early nineteenth century. A group of references to *Harlequin Tom the Piper's Son* occur between 26 December 1829 and 23 January 1830, the period indicated on this coin. But the index links none of these entries specifically to Galloway, nor to his juggling skills (it is tightrope walking that is mentioned alongside the pantomine).

This coin may be associated with #081.

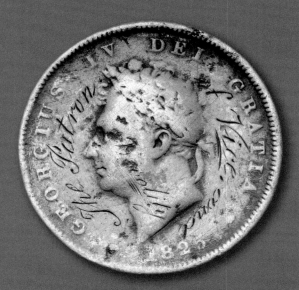 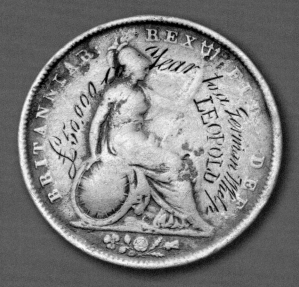

#050
———

When critics raked over **George IV**'s unsavoury reputation (see also #048), his interest in the arts, extensive collections and passion for exotic architecture lent themselves to mockery. Far from a discerning patron, he presides over corruption and emptiness. The reverse side criticizes the annuity Parliament granted to Leopold, widower of Princess Charlotte (see also #038), a 'whelp' who is therefore less than a man. There's a whiff of xenophobia around Leopold, a *German* whelp, and an echo of the time Parliament had to pay off George's debts. Taken together, the two figures reveal the parlous state of Britain and its monarchy. [KERRY LOVE]

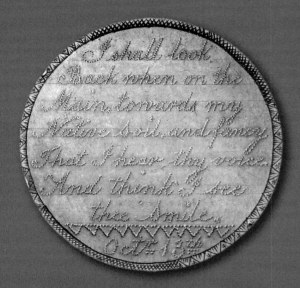
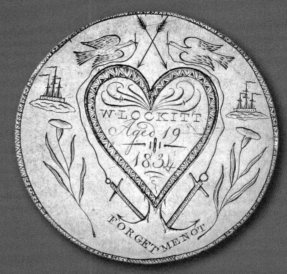

#052

This coin has a clearly engraved name, an age and date, and makes explicit reference to a sea voyage and separation. All the signs suggest a convict sentenced to transportation, but there is no matching 'W. Lockitt' in the convict registers.

The dates on the coin do, however, work for a William Lockey, sentenced at the Middlesex Sessions in March 1834 to seven years' transportation for larceny. He sailed on the *Hooghley*, arriving in New South Wales in November 1834. The discrepancy in name may be an instance of variant spelling.

According to the Convict Indents for New South Wales, Lockey was born in Hertfordshire and a Protestant. Able to read and write, he was a 'printer's boy' who stole a book. He had a previous conviction, for which he had spent a month in prison. He was just over 5ft tall with a ruddy, freckled complexion, brown hair, hazel eyes, a scar on his left jaw and some pockmarks on his nose (from smallpox).

In 1827 he was working as a labourer. In 1842, aged 27, he gained his Certificate of Freedom. He was now 5ft 2 inches tall and had sandy whiskers.

045 **Obv.** 'A present For Joh[n] C[...]n', in wreath.
Rev. Urn with two hearts, on plinth within small wreath, depicting an altar of love. Two birds above and bow with two arrows. Simple wreath border.
Details Cu, 35.9mm, 24.24g.
Ref. Lloyd

046 **Obv.** Top, and forming a proscenium arch, 'Mr T. GALLOWAY the Celebrated American JUGGLER'. Man on his knees on stage juggling balls and clubs. 'As Performed at the Sidney Gardens, Vauxhall Bath 1826', in exergue.
Rev. 'GALL OWAY AS IN The Comic Pantomime, of Harlequin Tom the Pipers Son, Bath. Jany. 1830', man on stage framed by curtains.
Details Cu, 35.9mm, 23.75g.

047 **Obv.** Pipe and puffs of smoke added to head of Victoria, 'I Love' on hairband, 'Shag' on jawline.
Rev. Original coin.
Details Cu, 34.1mm, 18.84g.
Host UK, 1d, 1841.
Ref. Dyer

048 **Obv.** 'Patron of Vice and FRIVOLITY.' added to field, 'The Fine English Gentleman' added to portrait.
Rev. Original coin.
Details Cu, 34.1mm, 17.86g.
Host UK, 1d, 1826.
Ref. Dyer, Millett

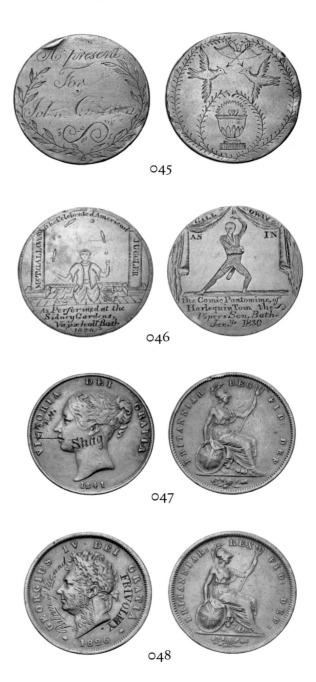

045

046

047

048

049 **Obv.** 'The Fate of Fauntleroy to all Insolvent Bilking Bankers & Agents' added to flattened coin.
Rev. Original worn coin, slightly flattened.
Details Cu, 34mm, 16.96g.
Host UK, 1d, 1806.
Ref. Millett, Poole

050 **Obv.** 'The Patron of <u>Vice</u> and <u>Frivolity</u>'
Rev. '£50,000 a Year to a German Whelp LEOPOLD'.
Details Cu, 34mm, 17.83g.
Host UK, 1d, 1825.
Ref. Navickas, Dyer

051 **Obv.** 'Success to Earl Howe May our King live long & our Constitution never Die', in border of chevrons.
Rev. Ornate design and border, indistinct central initials 'M[N]', small cartouche at bottom with house and tree.
Details Cu, 33.7mm, 25.92g.
Host UK, 1d token, 1787–91.

052 **Obv.** 'I shall look back when on the Main, towards my Native soil, and fancy That I hear thy voice And think I see thee smile'; in exergue, 'Octr. 13th', all finely pricked into the surface.
Rev. 'W. LOCKITT Aged 19 1834', in a central heart, 'FORGET ME NOT' below. Two doves above carrying anchors on ropes. Crossed arrows above. Three-masted ship at sea and flower with stem on either side.
Details Cu, 35.8mm, 24.71g.

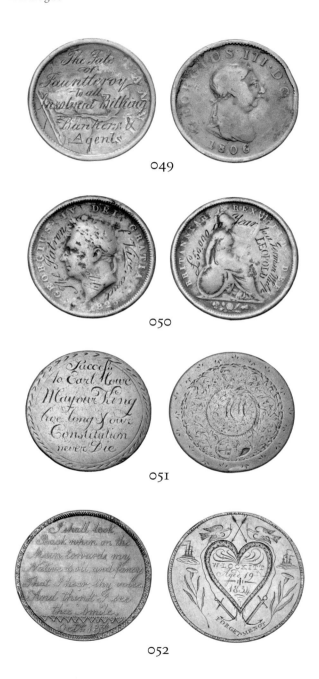

049

050

051

052

053 **Obv.** Smiling man in long coat walking left with tankard of foaming beer in right hand.
Rev. Unhappy knock-kneed man facing with raised left hand.
Details Cu, 33.7mm, 25.66g.
Host UK, 1d token, 1787–91.
Ref. Maidment

054 **Obv.** 'JNO ABBOTT CAST FOR DEATH FOR BURGALARY THE XI OF JANY 1827'.
Rev. '✱ G. ABBOTT ✱' above a man, facing, in leg irons, pipe in mouth, shovel in left hand, tankard of beer in right hand. Wheelbarrow to left on shaded ground.
Details Cu, 35.6mm, 24.05g.
Ref. Millett, Millmore

055 **Obv.** 'JOHN SPIRES 180 [...]', on rock below tree to left. One dog lying on ground, another poised, both looking at two birds in flight; another bird perched in the tree.
Rev. Hunting dog in undergrowth moving to the right, two birds in flight.
Details Cu, 36.0mm, 14.67g.

056 **Obv.** 'Success to the Backhouse', above a three-masted ship under sail on a shaded sea.
Rev. 'WILLIAM ECCLESTON 1791'.
Details Cu, 33.9mm, 28.25g.
Host UK, 1d token, 1787–91.
Ref. Lloyd

053

054

055

056

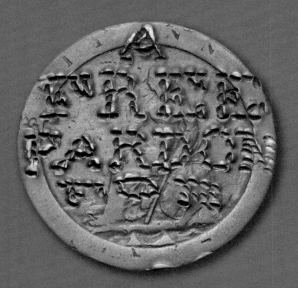

#064

This is one of seven known tokens associated with **John Frost** (1784–1877). Frost was a prosperous woollen draper and tailor in Newport, South Wales. Having mixed in radical circles in Bristol and London during his youth, he was active in reform politics in Newport from the 1820s, including a local branch of the Political Union of the Working Classes established in 1831. Elected a town councillor in 1835, he served a brief term as mayor in 1836.

In 1838 a national campaign to extend political rights to working men coalesced around the six demands of the People's Charter; its supporters were 'Chartists'. In March 1839 Frost attended the Chartist convention in London as delegate for Monmouthshire and emerged as a national leader. In November he led 3,000 armed working men, chiefly miners, in an attempt to release Chartist prisoners held in a Newport hotel. The guards opened fire. This was known as the Newport Rising: twenty were killed and about 125 arrested. Frost and the other two leaders were found guilty at a special assize and sentenced to be hanged, drawn and quartered.

Following intense public pressure, their sentences were commuted to transportation for life. They were sent to Port Arthur in Tasmania on the convict ship *Mandarin*. In 1856 all three were granted an unconditional pardon, although Frost was the only one to return to Newport, where he was given a hero's welcome. He never returned to radical leadership.

All the known tokens convey an intense sense of campaigning and public pressure. [TIMOTHY MILLETT]

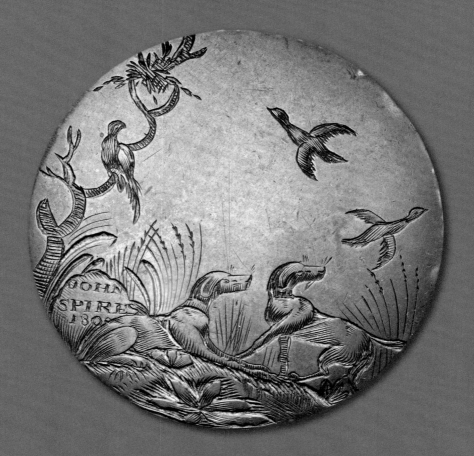

#055

———

The British Museum collection includes an advertising token produced by the engraver John Peplous. It features a hunting dog and bird, which bear a strong resemblance to this piece. Peplous worked from Lisle Street, Leicester Square, alongside other engravers, including Laykauff whose trade card for a gunmaker in Wigmore Street carries a similar vignette. Scenes such as these exemplify craft links between eighteenth-century engravers and gunmakers (see also #068 opposite).
[TIMOTHY MILLETT]

British Museum object numbers: 1952,0904.205; Heal,69.28.

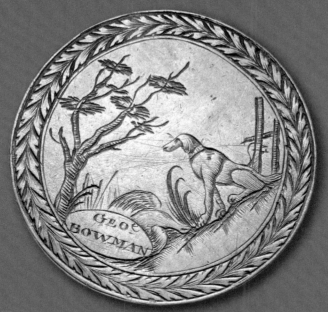

#o68
———

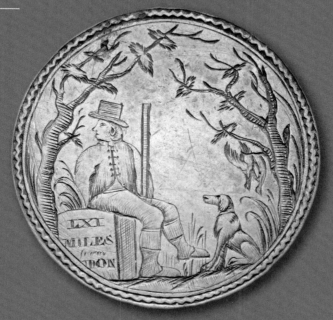

057 **Obv.** 'Tho time may pass and years may fly & every hope decay and die & every joyful dream be set but thee I never can forget'.
Rev. 'Accept this from an unfortunate Transporte', below three-masted ship flying Royal Ensign, wavy sea.
Details Cu, 35.6mm, 23.07g.

058 **Obv.** Two clasped hands, 'FN Born 1731 to right, EH Born 1732 Mar ★ 5' to left, and 'Mard 175[...] Burd★17[52]' above.
Rev. Angel with wings and two branches around 'F★N★', with '1752' below.
Details Cu, 33.0mm, 6.11g.
Ref. Whyman

059 **Obv.** 'Thommas Kelsall Was Born Febrery The 9 1773', in ruled border, tools of trade (?) below.
Rev. Man riding a goose (?) with saddle, reins, and whip. Hatched ground, 1795 below.
Details Cu, 33.8mm, 27.47g.
Host UK, 1d token, 1787-91.

060 **Obv.** Dog in relief, in ornate scrollwork.
Rev. Ornate symmetrical foliate design.
Details Cu, 35.4mm, 22.61g.

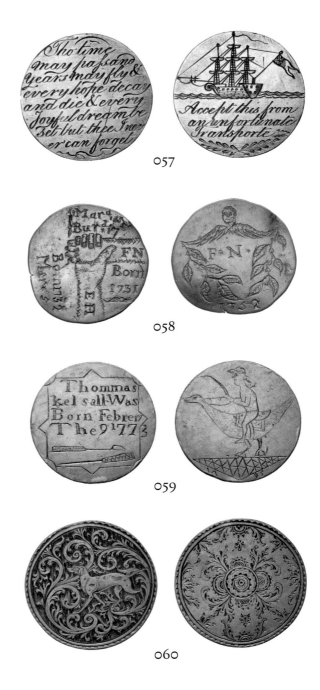

057

058

059

060

061 **Obv.** 'R Hastings 7 months', man sitting in chair cross-legged, pipe in right hand, tankard of foaming beer in left; 'PRACTICE' in exergue.
Rev. Original worn coin.
Details Cu, 35.9mm, 25.94g.
Host UK, 1d, 1797.
Ref. Millmore

062 **Obv.** 'Jno, White Susanah White Elizth, White Ann White', in ornate border.
Rev. Woman on the left wearing a robe à la Polonaise (characterized by the gathered outer skirts at the back into three puffed sections). The broad-brimmed hat seems to be a 'Lunardi' or 'balloon' hat, its puffed crown created with lightweight fabrics and decorated with trims such as ribbon. Gown and hat date to the 1780s. Two girls facing her on the right. Groundline and simple border.
Details Cu, 33.5mm, 6.02g.

063 **Obv.** 'Her Soul has Soer'd to Everlasting Bliss, Who unto me a Preasant made of This; The Preasant kind Her Love & Care ye same which I in Duty Will Whist I am alive PROCLAME E∗K', within a border of a snake chasing its tail; 'Engraved by H. Barnard for Esther Kingston' below.
Rev. Tooled hair on original worn William and Mary portraits.
Details Ar, 33.0mm, 13.06g.
Host UK, 2/6, 1689–90.

064 **Obv.** 'A FREE PARDON FOR'.
Rev. 'NOBLE FROST'.
Details Cu, 35.8mm, 27.07g.
Host UK, 1d, 1797.

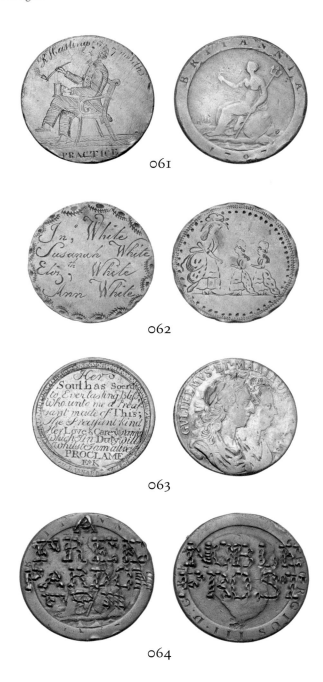

061

062

063

064

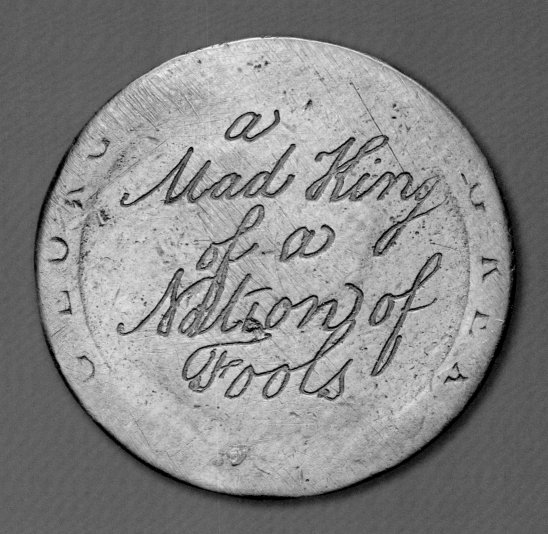

#072

A succinct statement of political disaffection and crisis. George III's periods of mental incapacity (1788-89; 1810-20) generated a power vacuum, controversy over the Prince of Wales's role as Regent, and a general sense of national malaise.

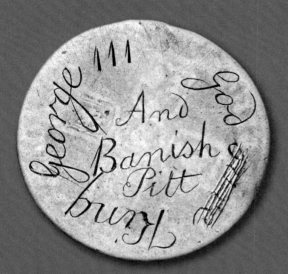

#087

These modifications have a probable date of 1784. It was the year of the first balloon flights in Britain and of the first Parliamentary general election since the American War. In the highly politicized Westminster constituency, Charles James Fox ran on a platform of opposition to Prime Minister William Pitt (the elder). His energetic supporters included the beautiful and sophisticated society leader the Duchess of Devonshire, and Sam House, a radical publican.

Sam House was a colourful and recognizable figure in the second half of the eighteenth century, with his eccentric appearance, bald head and inability to speak in any company without swearing. Previously a supporter of John Wilkes, he renamed his pub on Wardour Street 'The Intrepid Fox'. His rallying cry was 'I am a publican and a Republican'. The Intrepid Fox operated as a pub on this site until 2006.

Caricaturists were very fond of House's appearance, earthy and uncouth, and often placed him alongside the Duchess of Devonshire, who was subjected to particularly hostile and obscene commentary. The Duchess was accused of unnatural, unwomanly behaviour, including buying votes with kisses; House apparently bought votes with drink. His figure became shorthand for the 'mob' in the same way as Sir Jeffrey Dunstan (#053). The British Museum has 64 images of House in its print collection.

With a date of 1784, the other side's 'Banish Pitt' may refer to election controversy over Pitt's proposal to levy a tax on those who employed maid-servants. [TIMOTHY MILLETT]

065 **Obv.** 'Success to the Wasp Captn. Belsex', above single-masted boat under sail on a shaded sea. Thin outer circle.
Rev. Man in frock coat and woman in a gown seated at a round pedestal table with tea set. Dog to right on shaded ground, tea kettle to left. Small trees behind. Thin outer circle.
Details Cu, 33.7mm, 26.25g.
Host UK, 1d token, 1787–91.

066 **Obv.** 'John Mance & Sarah Waugh. Married 17 October 1819. Constancy & Love O Happy Happy Day', around clasped hands with cuffs.
Rev. 'A Memento from a Brother. Mrs Sarah Mance with this trifle accept a Brothers love from Thomas Mance'.
Details Cu, 35.7mm, 24.07g.

067 **Obv.** '[I]C'
Rev. Knock-kneed man, facing, with a sack or rope over his right shoulder and left hand raised. His stockings, which are too big or stretched, are falling down.
Details Cu, 33.5mm, 19.21g.
Host UK, 1d token.
Ref. Lloyd

068 **Obv.** 'GEOe BOWMAN', to the left, in an oval set below a tree with a dead bird at the side. To the right, a dog sitting on shaded ground facing left with a fence behind. Ornate border.
Rev. Man in typical hunting clothing, gun barrel in left hand, sitting on a milestone, 'LXI MILES from [LON]DON', and looking over his right shoulder. Dog sitting at his feet. Tree to left; tree with two dead birds hanging from branch on the right. Shaded ground with tufts. Ornate border.
Details Cu, 36.9mm, 22.67g.

065

066

067

068

069 **Obv.** 'E, TAYLOR,'.
Rev. Three-masted ship with Royal
Ensign to left. Sailor walking to the right
with cane under right arm and left arm
raised, a purse in hand.
Details Cu, 34.0mm, 22.9g.
Host UK, 1d token, 1787–91.

070 **Obv.** 'Preliminaries of Peace Sign'd
between Great Britain & France Oct's
1801', added where portrait has been
removed. 'BENJN. ABBOTT', in relief
in rim. Dove with olive branch above.
Rev. Original coin.
Details Cu, 36.0mm, 27.32g.
Host UK, 1d, 1797.

071 **Obv.** 'Samuel Worthington Born March
1 1793', above village scene of houses,
trees, fences and gates; in exergue a pot
with trailing plants.
Rev. Sailor standing on land, facing,
glass in raised right hand, hat in left.
Rear of ship with ensign to left, rowboat
in shaded water to right.
Details Cu, 35.9mm, 20.8g.

072 **Obv.** 'A Mad King of a Nation of Fools'
Rev. Original worn coin.
Details Cu, 35.7mm, 24.77g.
Host UK, 1d, 1797.
Ref. Navickas

069

070

071

072

073 **Obv.** 'CAPN FRANK CUNDY OF
THE PRINCESS CHARLOTTE'.
Rev. 'ARRIVED AT BRISTOL ON
FRIDAY 24 AUGUST 1821'.
Details Cu, 36.0mm, 28.27g.
Host UK, 1d, 1797.

074 **Obv.** '<u>Down</u> with the <u>Catholics</u>'.
Rev. Original very worn coin.
Details Cu, 35.8mm, 25.18g, large
central piercing.
Host UK, 1d, 1797.
Ref. Dyer

075 **Obv.** 'Charles and Mary HIGGINS
Harrow. Ally Aldgate 1773', within
decorative border.
Rev. 'Ann Higgins Died. Sepr. ye.
6. 1772', in decorative border with
flower design.
Details Br, 31.9mm, 11.24g.

076 **Obv.** 'Thus like the dove let
Constancy and truth And Spotless
Innocence Adorn Your Youth', above
a bird and sprigs.
Rev. Woman in dress with large
bustle, wearing hat, facing man in
tails, stockings and hat. Her two
hands are reaching for his left hand.
Ornate border.
Details Br, 31.6mm, 5.12g.

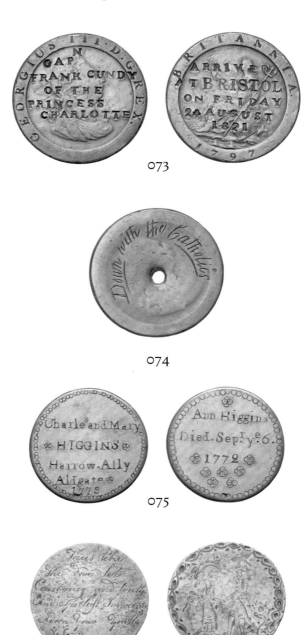

073

074

075

076

077 **Obv.** 'This and the Giver be thine for
Ever' around 'WB to MAB 1797', simple
border.
Rev. 'A Husbands Gift' above 'DEAR.
NANCY I BEG YOU. WILL. THIS
TAKE AND. KE∗EP. IT. FOR YOUR.
HUSBAND'S SAKE', wreath below.
Details Ar, 33.1mm, 11.09g.
Ref. Whyman

078 **Obv.** 'When this You See
REMEMBER ME'.
Rev. 'B'.
Details Ar, 33.3mm, 13.87g.
Host UK, 2/6, 1696.

079 **Obv.** 'IOHN. IONES. APRIL. 1776
Ye 17. B[J]∗', around a double-pierced
bleeding heart.
Rev. Crossed pistols, cutlass, key,
jemmy and lock pick; '[J]B' below and
to the side.
Details Cu, 28.1mm, 6.62g, edge
modified to look like a flower.
Ref. Hitchcock

080 **Obv.** 'Humpy Fenn Born March 14
1759', ornate border.
Rev. 'hand in hand heart in heart
like true lovers never part 1774', above
clasped hands and two hearts.
Ornate border.
Details Cu, 28mm, 7.61g.

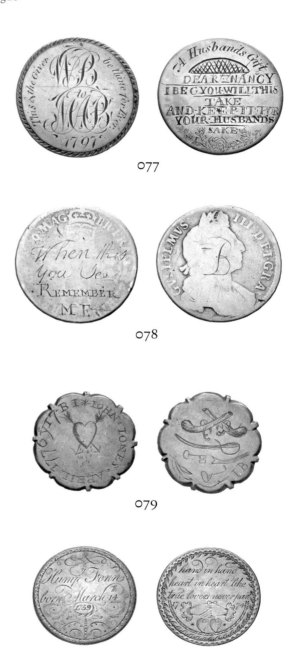

077

078

079

080

081 **Obv.** Man on stage in chequered costume, club (?) in right hand, left hand raised. Curtains drawn back; chequered floor.
Rev. Original worn coin.
Details Cu, 28.1mm, 8.5g.
Host UK, 1/2d, 1695–1701.

082 **Obv.** 'WILLIAM & SARAH . PEARCE.' Young man to left wearing stockings, breeches, waistcoat and coat, and hat; cane in his right hand. Woman to right, with her right hand holding his left arm, wearing gown typical of 1790s, a fichu draped over her shoulders and crossed over the front. She also wears a broad-brimmed hat (probably decorated with trims and ribbons). House and dog to right.
Rev. Two doves billing in a basket of flowers. '1790' below.
Details Cu, 27.5mm, 7.14g.

083 **Obv.** 'WD', arranged on either side of a standing figure.
Rev. Double-arched bridge broken in two places. Man with pickaxe on the left; man in hat with stick standing on the right. Building with signboard to far left.
Details Cu, 27.4mm, 7.97g.

084 **Obv.** 'When you see this blow me a kiss', with a bunch of flowers.
Rev. 'When this you See, Remember Mee'.
Details Cu, 27.4mm, 7.63g.
Ref. Whyman, Holloway

085 **Obv.** 'Success to RODNEY'S Fleet'.
Rev. Original very worn coin.
Details Cu, 28.8mm, 8.48g.
Host UK, 1/2d, 1740–54.

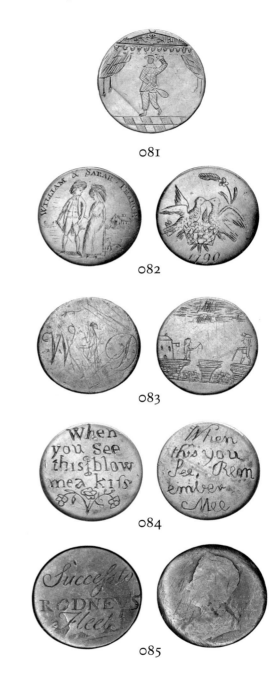

081

082

083

084

085

086 **Obv.** 'TR', with leaf embellishments and wreath border.
Rev. Three-masted ship under sail, 'Rose 1791' in exergue.
Details Ar, 25.6mm, 3.85g, pierced for suspension.

087 **Obv.** 'God save King George III and Banish Pitt' (word 'save' scratched out).
Rev. 'Sam House' around hot air balloon with basket and flag.
Details Ar, 25.5mm, 5.57g.
Host UK, 1s, 1676–77.

088 **Obv.** 'LONG LIFE to WILLIAM 4th.'
Rev. Original worn coin.
Details Ar, 26.3mm, 5.32g.
Host UK, 1s, 1697–78.

089 **Obv.** 'William ✶ COOK Born Febry. 12th. 1808', on plinth; angel with torch above. Britannia with shield and spear standing on left, attired in classically inspired dress, common for the Regency period.
Rev. 'Maria Ann ✶ COOK Born Novbr. 11th. 1811.', on plinth. Angel with torch above. Again, Britannia with shield and spear standing on left.
Details Ar, 25.6mm, 3.49g, pierced for suspension.
Ref. Millett

090 **Obv.** 'Willm. Wells & Mara. Tomkins MARRIED YE. 26TH JULY 1772'.
Rev. Original coin.
Details Ar, 25.7mm, 5.3g.
Host UK, 1s, 1711–14.

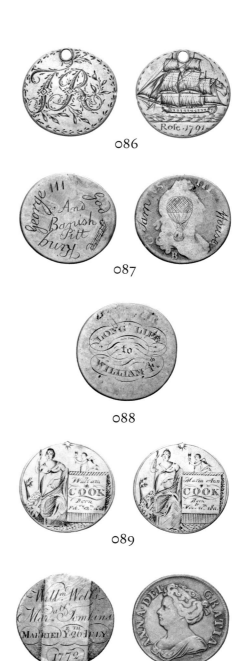

086

087

088

089

090

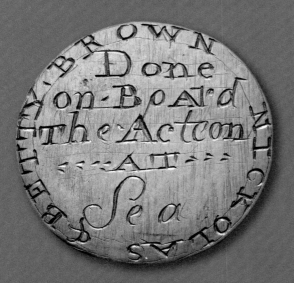
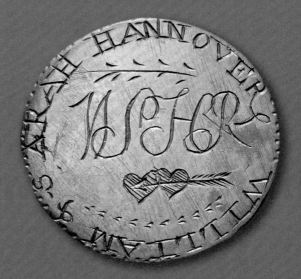

#097

The name *Acteon* was regularly re-used by the eighteenth-century navy. Vessels include a '6th-rate', 36-gun ship launched in 1757, which saw service in the West Indies, including Antigua, during the Seven Years War (1756–63); it was sold off and broken up in 1766. Another *Acteon*, stranded during naval action off Charlestown South Carolina in 1776, was burnt to prevent it from falling into enemy hands; yet another, built in 1779, was stationed in Jamaica by 1783.

Possible identifications for the names include a shipwright, William Hannover, who died at Antigua.

His widow and executor, Sarah wrote to the Navy Board on 8 September 1769 requesting payment of a monthly pension. He is very probably the William Hannover born in 1727 in Alverstoke, near Portsmouth, and married to Sarah Darr in 1748. Sarah Hannover remarried in 1771.

Sources: The National Archives, Discovery Catalogue, Navy Board In-Letters: description of records in ADM106.

091 **Obv.** 'Joshua Johnson.'
Rev. 'Barnsley June 4th', around cross with '1774' in quarters.
Details Ar, 25.1mm, 4.74g.

092 **Obv.** 'To my Soul Evy. word conveys a Dart, Throh ye Ear, into ye Heart; Every Feature gives Desier, Evy. Breath blows up the Fire, Evy. Motion charms ye Sight; Oh! Thou Heav'n of all Delight. Sarah Wint London'.
Rev. Original coin.
Details Ar, 24.8mm, 5.04g.
Host UK, 1s, 1707–11.

093 **Obv.** 'J∗Brown', sprigs above and below. Burning heart between two counterstamped faces.
Rev. 'kiss mee', between two sprigs.
Details Cu, 28.5mm, 8.80g.
Host UK, 1/2d, 1750.
Ref. Holloway

094 **Obv.** Man's bust facing left, hatched background.
Rev. 'N' and other faint designs.
Details Cu, 27.3mm, 8.17g.

095 **Obv.** 'PL' above 'MB' clasped hands to left, 'JOIN HANDS'; two hearts to right, 'JOIN HEARTS'.
Rev. 'LOVES ∗ INVENTION', in banner below scene with bird carrying letter from tree on right to house on left.
Details Cu, 28.0mm, 7.35g.

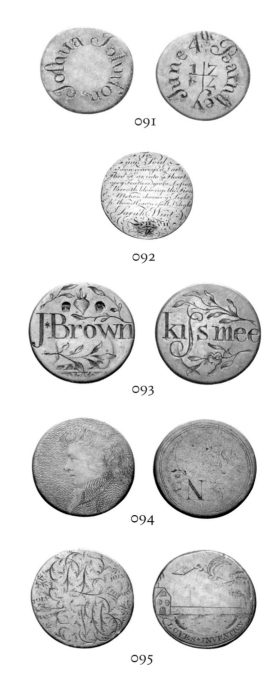

091

092

093

094

095

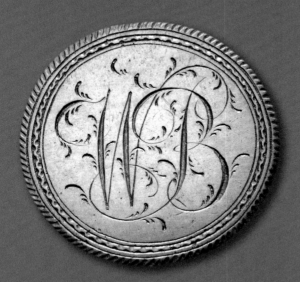 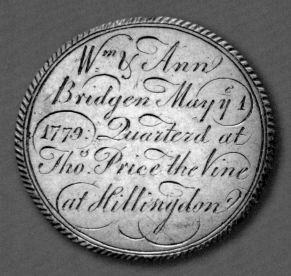

#100

William Bridgen (1709–1779), a member of the Cutlers' Company, was Alderman for the ward of Farringdon Within in the City of London (1754–79) and Lord Mayor in 1763–64 during the turbulent period of John Wilkes's political ambitions. Bridgen was a wine merchant with premises in Mincing Lane. He died in October 1779.

Hillingdon was an important staging post on the London-to-Oxford road, with two hostelries, both opposite the parish church: the Vine Inn on the junction with Vine Lane and the Red Lion. [TIMOTHY MILLETT]

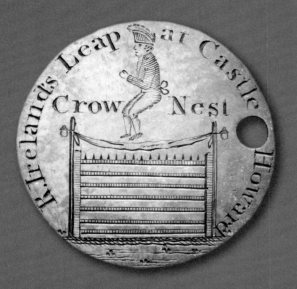
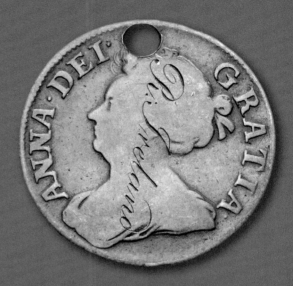

#104

According to the *Yorkshire Gazette*, the Castle Howard steeplechase dated to 1841. In 1843, 'the chases being concluded, the vast concourse of people repaired to the old Crow Nest, which was crowded more than rookery ever was in this world'. This token is a souvenir of a specific sporting feat, which, like the races, would have attracted considerable bets, with plenty of eating and drinking at the local inn. The style of dress, with a military-style shako hat, may suggest a date earlier in the nineteenth century.

Source: *Yorkshire* Gazette, 18 March 1843.

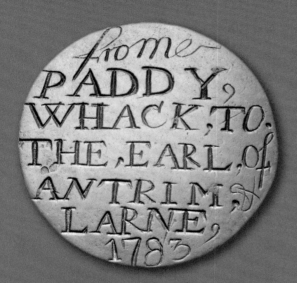

#109

'Paddy Whack' was a derogatory British term for an Irishman, a stereotypical figure who stood for his nation in dialogue with John Bull. In 1783, alongside moves to give the Irish Parliament greater legislative independence, George III created the Order of Saint Patrick. The Earl of Antrim, who preferred to remain a knight of the Order of the Bath, declined to join. A letter prominently placed in the *Dublin Evening Post*, 15 March 1783, and signed 'Paddy Whack', accused the Earl of mean-spiritedness, lack of Irish patriotism and drawing a 'blot' on to his 'escutcheon'. [KERRY LOVE]

#112

A **William Sears**, letter-founder from Aldersgate London, made a clandestine marriage on 11 October 1737. The ceremony, conducted in environs of Fleet Prison, bypassed the usual legal requirements and enabled the couple to marry quickly and without giving prior notice. Whether or not he was the same William Sears who produced this token, the maker's anti-Jacobite sympathies are clearly expressed in the figure of the Duke of Cumberland on this piece, crafted a year after the defeat of Stuart forces at the Battle of Culloden. A letter-founder cast metal type for use in printing.

096 **Obv.** 'Porto Bello * Taken * Nov. 22nd 1739'.
Rev. Smooth surface.
Details Cu, 28.5mm, 7.15g.
Ref. Millett

097 **Obv.** 'NICKOLAS & BETTY . BROWN'
around 'Done on . Board The Acteon AT Sea'.
Rev. 'WILLIAM & SARAH HANNOVER'
around 'NSHR'; two hearts pierced by
an arrow.
Details Cu, 27.8mm, 8.42g.

098 **Obv.** 'THOMAS MANEKE MARY PAGE' in
banner around central urn; '25' to left, '1786'
to right.
Rev. 'MARY PA', cutlasses, two hearts
doubly pierced and crossed cutlasses, all in
wreath.
Details Cu, 27.3mm, 7.05g.

099 **Obv.** 'WILLIAM AND MARY SAGE'.
Rev. Man with short coat facing left, leaning
on ladder, lamp in hand; 'I AM THE HARD
WORKING MAN' in banner. Oilcan on
hatched floor.
Details Cu, 28.0mm, 6.24g.
Ref. Whyman

100 **Obv.** 'Wm. & Ann Bridgen May ye
1 1779: Quarterd at Thos. Price the Vine
at Hillingdon', with ornate border.
Rev. 'WB', in ornate border.
Details Cu, 28.7mm, 7.34g.

096

097

098

099

100

101 **Obv.** 'Thos. Howes kill'd by his own gun
27 Jany 1784'.
Rev. Original worn coin.
Details Cu, 28.8mm, 9.76g.
Host UK, 1/2d, 1775.

102 **Obv.** 'ROBERT * ALLEN', above a man in
hat with leg irons, glass in left hand, smoking
pipe in right hand. In a room with a barred
window and a table with a bottle on it.
Hatched floor.
Rev. 'WHEN THIS YOU SEE REMEMBER
ME M WEAVER', around crossed pistols, two
keys, lantern, cutlass, lock pick and jemmy.
Details Cu, 27.8mm, 7.55g.
Ref. Millett, Millmore, Hitchcock

103 **Obv.** 'ELIZH. WATLIN BORN. JULy.
16*1769', wireline outer border.
Rev. Woman in gown with contrasting
stomacher and apron tied around her waist,
facing, right hand on hip, flower in raised
left hand. Ornate border.
Details Cu, 27.9mm, 8.12g.

104 **Obv.** 'R. Ireland's Leap at Castle Howard',
around 'Crow Nest'. A man in military-style
hat shown in profile as he jumps a length of
cloth tied above a spike-topped gate.
Rev. 'R. Ireland'.
Details Ar, 25.3mm, 5.1g, pierced for
suspension.
Host UK, 1s, 1707–11.

105 **Obv.** 'JOHN WAINWRIGHT', sweep's
brush above, dustpan below.
Rev. '1793 CHIMNEY SWEEPER', above;
'1771', below; other tools.
Details Cu, 26.7mm, 6.69g.
Ref. Millett, Whyman

101

102

103

104

105

106 **Obv.** Original legend removed, groundline and '1772' taken from another coin and rivetted on below bust.
Rev. Britannia's head shaved and on a stick, groundline and original date '1773' retained in exergue, rest of original design and legend removed.
Details Cu, 29.2mm, 8.41g.
Host UK, 1/2d, 1773.
Ref. Maidment, Millmore

107 **Obv.** 'Mr * JOHN * LANE * AND * Mrs * LANE', around a man and woman, both in hats with glass in hand, sitting on high-backed chairs at a round pedestal table with bowl.
Rev. 'WHEN · THIS · YOU · SEE · PRAY · THINK · ON · ME · 1780 ·', around a crown suspended from a knot; two hearts doubly pierced below.
Details Cu, 28.3mm, 7.25g.
Ref. Maxwell-Stewart, Holloway, Whyman

108 **Obv.** 'WILLIAM HURT', above man with pistol, on horse riding left.
Rev. Man in leg irons, tankard in left hand, pipe in right; prison cell with barred window and studded/reinforced door.
Details Cu, 28.1mm, 7.91g.
Ref. Millett, Millmore

109 **Obv.** 'from PADDY WHACK, TO. THE. EARL. of ANTRIM, & LARNE, 1783'
Rev. Original very worn coin.
Details Cu, 29.3mm, 7.29g.
Host UK, 1/2d, 1770–75.

110 **Obv.** 'Alice Williams LIVERPOOL 1782', three-masted ship on sea above with rowboat to right.
Rev. 'LOVE & LIVE And Pleasure GIVE', three-masted ship on sea above.
Details Cu, 27.5mm, 7.35g.

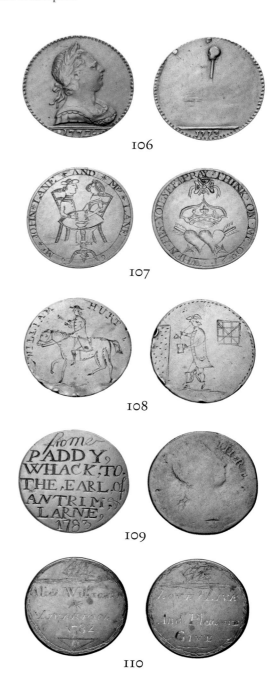

106

107

108

109

110

111 **Obv.** 'No Triple TAX'.
Rev. 'PITTs Deserts', above man on gallows, '1797', in exergue.
Details Cu, 27.5mm, 6.89g.
Ref. Navickas

112 **Obv.** 'Wm. SEARS LETTER=FOUNDER LONDON 1746', around bust of man in tricorne hat, military dress and partially visible Order of the Garter (?). Hatched field and initials 'DC'.
Rev. Original coin.
Details Cu, 27.6mm, 8.34g.
Host UK, 1/2d, 1740–45.

113 **Obv.** 'HOLT·MATE·LET·US·DRINK· WILLIAM·FRENCH', around; 'I·SHELTON', in exergue. Saw pit with two men above, one with a tankard; one man below, ladder to right.
Rev. 'WHEN THIS YOU SEE REMEMBER ME', around two hearts doubly pierced, crown above, two flowers with stems below.
Details Cu, 27.9mm, 7.8g.

114 **Obv.** 'T. JONES RENTR. WARDN. 1769'.
Rev. 'VINTNERS WINE·PORTERS BOX'.
Details Cu, 28.3mm, 6.9g, pierced for suspension.

115 **Obv.** 'J. Spencer Smoake & Wind Up Jack Maker 1791'.
Rev. Blacksmith with raised hammer at anvil facing left, hearth behind, chequered floor.
Details Br, 27.1mm, 7.25g.

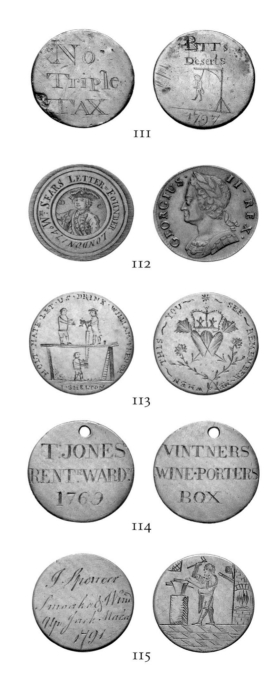

111

112

113

114

115

116 **Obv.** 'Edwd Spaughton 1794 And Eliz
Spaughton 1794'.
Rev. 'My love is true to None but you',
around a man and woman facing one
another. Woman wears an English gown
with contrasting stomacher and petticoat
underneath; her right hand on her hip,
left hand in man's right hand. He wears
stockings, breeches, waistcoat, coat and hat;
his left hand in his pocket.
Details Cu, 29.4mm, 11.28g.
Host UK, 1/2d token, 1789–92.

116

117 **Obv.** 'When This You See, Then Think of
Mee.' around ornate 'EH'.
Rev. 'My Heart With The, Shall Ever Bee
1778' around wreath with two hearts.
Details Cu, 27.8mm, 7.31g.
Ref. Maxwell-Stewart

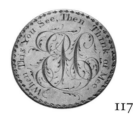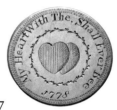

117

118 **Obv.** 'Poor. John Bull' to left, skull and
crossed bones in Britannia's right hand,
coffin behind to right.
Rev. Noose drawn round the King's neck.
Loaf of bread with '1S 9½D' to left; tankard
with '4½' below; '13d' on meat hanging from
a hook in front of the King's face.
Details Cu, 30.6mm, 12.42g, pierced.
Host UK, 1/2d, 1799.
Ref. Millmore

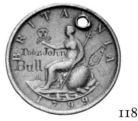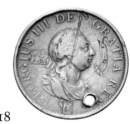

118

119 **Obv.** 'Dear Sister when this you see, think
on me, when I am in a foreign country.
∗ W ∗ Howell ∗', with wreath below.
Rev. Original coin.
Details Cu, 28.6mm, 8.27g.
Host UK, 1/2d, 1807.

119

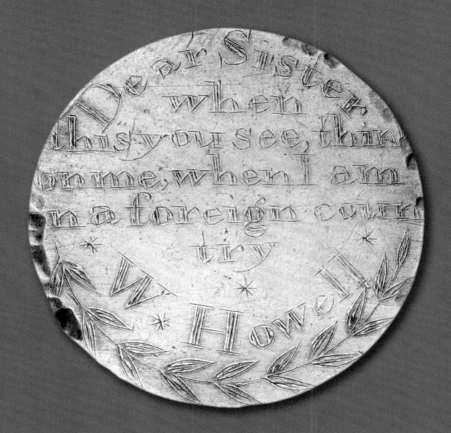

#119

One of a series of tokens produced by the same hand in Bristol around 1820–21.

William Howell was convicted of larceny at Bristol City Quarter Sessions in July 1821 and sentenced to seven years. He sailed to New South Wales on the *Shipley*, arriving in March 1822. By June 1823 he had been sentenced to 12 months in the penal settlement of Port Macquarie, established in 1820 for the worst offenders.

The following year he was assigned to a free settler and veteran of the Peninsula campaign, Lt. Edward Close, who founded the town of Morpeth, now part of Maitland. He received his certificate of Freedom in 1828 and remained around Maitland, where he was described as a Protestant labourer.

Source: New Wales State Archives & Records, 'Convict Penal Settlements'.

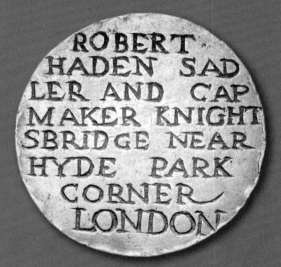
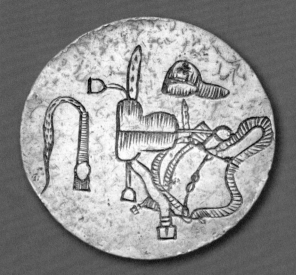

#121

Robert Haden (also spelt Hayden) served a seven-year apprenticeship with Richard Raithby, a sadler of St George's Hanover Square. His apprenticeship premium of £31 10s, paid in March 1769, was evidence of the master's status and the trade's business prospects. By the 1790s, Haden was established in Knightsbridge, where he received the summons to sit on the jury of a Westminster Coroner's Inquest Jury on 23 February 1798.

Source: *City of Westminster Coroners Inquests* on the London Lives database.

120 **Obv.** 'The gift of MRS. SPARROW on her Wedding Day July 19th, 1799 to her Sister Estr. Cooper', within wreath.
Rev. Original coin.
Details Ar, 25.8mm, 5.38g.
Host UK, 1s, 1743–58.
Ref. Holloway

121 **Obv.** 'ROBERT HADEN SADLER AND CAP MAKER KNIGHTSBRIDGE NEAR HYDE PARK CORNER LONDON'.
Rev. Whip, saddle, stirrups, harness and cap.
Details Cu, 28.9mm, 8.40g.

122 **Obv.** 'Robert Stephenson Mare Street Hackney 1777', ornate border.
Rev. Man, facing, in waistcoat, long coat and breeches; his stockings are held up with garters tied in bows at the knee. He stands on one leg, smoking pipe, right hand on hip, left hand outstretched. Ornate border.
Details Cu, 27.7mm, 7.75g, pierced.
Ref. Millett

123 **Obv.** 'Success to the Alfred', star above, square and compass to left, and book to right.
Rev. Original worn and damaged coin.
Details Cu, 28.6mm, 8.20g, pierced.
Host UK, 1/2d, 1770–75.

124 **Obv.** 'DW FOR EVER', in field around half-bust of man wearing tricorn hat and military dress, with partial wireline border. Later damage to hat.
Rev. 'M*R*DECEMr*THE*22*1747', around central design, with ornate border.
Details Cu, 27.9mm, 6.80g.

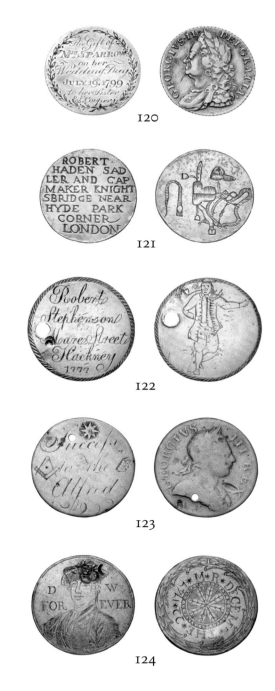

120

121

122

123

124

125 **Obv.** 'The Patron of Vice and Frivolity'.
Rev. 'Tax Eaten Country'.
Details Cu, 28.1mm, 9.51g.
Host UK, 1/2d, 1826.
Ref. Navickas, Dyer

125

126 **Obv.** 'John Shield Junr. Dealer in Tea
Sugar and Coins.'
Rev. 'The best price given for Guineas.
NB Politics taught.'
Details Cu, 27.0mm, 7.88g.
Ref. Dyer

126

127 **Obv.** Man, possibly a sailor, with hat
and pigtail facing left, bowl in left hand,
smoking pipe in right hand. Spotted
dog to right. Ground line.
Rev. Soldier facing left with cutlass
in left hand, purse (?) in right hand;
behind him a small drummer boy in
same uniform. Ground line.
Details Cu, 27.9mm, 6.7g.

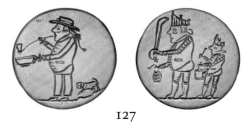

127

128 **Obv.** 'JAMES HE[WLS] & MARY
SHARP', around man with stick under
right arm, offering bowl with left hand
to woman in gown with hat worn over
the top of a cap.
Rev. 'LOVE UNITED', around crown
suspended from a bow; two hearts
doubly pierced below.
Details Cu, 27.4mm, 6.04g.
Ref. Holloway

128

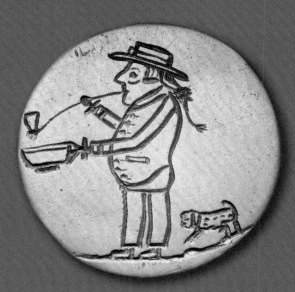 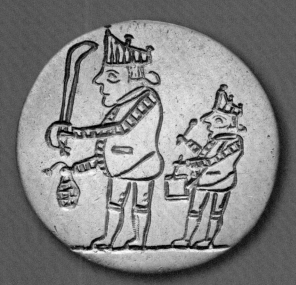

#127

The man on the obverse might be navy (trousers, hat) whereas those on the reverse appear to be grenadiers (tall hat). The coin may have a political message: the beloved navy is underfunded (as implied by a begging bowl), whereas the hated army consume our taxes (here carrying a moneybag). The message would be even more pointed if the soldiers were German, as this was a major source of controversy during the Seven Years War (1756–63).

With thanks to Matthew McCormack.

129 **Obv.** 'The Sailors Departure', around woman in gown with breasts exposed and sailor in petticoat trousers; they raise their glasses either side of a round pedestal table with candlestick and bottle. Man has stick under right arm. Ornate border and hatched ground.
Rev. Three-masted ship flying Royal ensign. 'Isis' above. Ornate border.
Details Ar, 32.4mm, 13.24g.
Host UK, 2/6, 1696–1701.
Ref. Millett

130 **Obv.** 'Willm Fisher & Sarah Goldsmith', around '1781' bleeding heart doubly pierced. Ornate border.
Rev. Animal (?) wearing a hat, rowing boat to left. Sun to left. Ornate border.
Details Cu, 27.6mm, 7.5g.

131 **Obv.** 'GEORGE∗HARVEY∗BORN∗ NOVEMBER.8.1777', and a partial wreath around man wearing a hat, waistcoat, coat, breeches and stockings. He stands facing out, with stick in right hand. Ground line. Border.
Rev. 'FEBRUARY. 6. 1787', and wreath around two hearts doubly pierced with floral (?) outline, two doves and seven stars above. Border.
Details Cu, 29.3mm, 7.78g.
Ref. Whyman

132 **Obv.** 'John [Burn] May 1 1787', around man in hat and long coat, facing out, smoking a pipe held in right hand. Narrow border.
Rev. Two hearts doubly pierced with floral (?) outline, two doves and five stars above. Narrow border.
Details Cu, 27.8mm, 7.25g.
Ref. Whyman

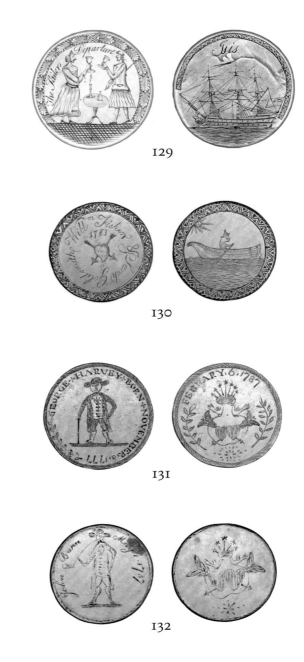

129

130

131

132

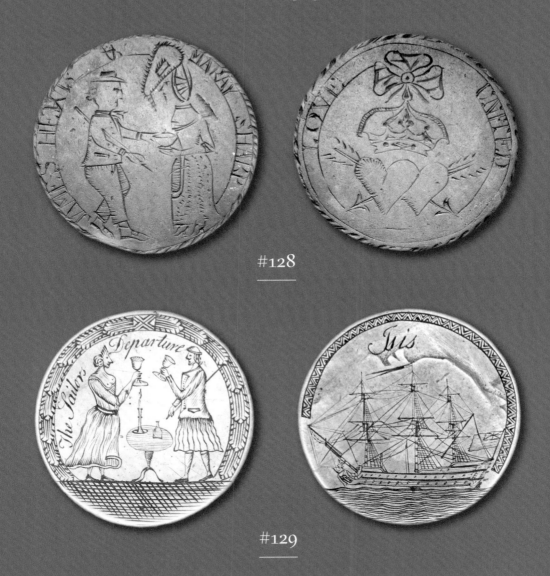

#128

#129

The name *Isis* was also re-used by the eighteenth-century navy (see #097), with at least two different vessels carrying it: a captured French Ship re-named *Isis* in 1747 and in service until sold in 1766; another, a 50-gun ship, stationed off Quebec in 1777 and in the East Indies in 1783.

Source: The National Archives, Letters to the Navy Board; *Steel's List of the Royal Navy* (1783).

133 **Obv.** 'TH', arranged either side of man, facing, in hat, waistcoat, coat and trousers. Bowl in right hand outstretched, cutlass under left arm. Double-pierced heart to left; shelf with glass and bottle to right. Border.
 Rev. 'A.H 1782', alongside woman in spotted gown with contrasting stomacher, white apron, checked neckerchief tucked into the front of the bodice, and small brimmed (probably straw) hat towards the front of her head, over a cap. Pushing a loaded wheelbarrow to right. Scales above. Border.
 Details Cu, 28.3mm, 7.8g.
 Ref. Millett, Whyman

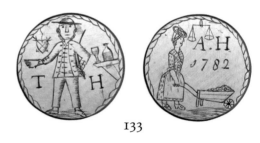

133

134 **Obv.** 'LUKE HURST JANUARY 24 1787', around man in coat and hat, smoking a pipe held in right hand. Groundline, border.
 Rev. 'ELIZABETH YOUNG JANUARY 24 1787', around woman in gown and hat facing left with bird on outstretched right hand and left hand on hip.
 Details Cu, 28.6mm, 7.56g, pierced for suspension.
 Ref. Whyman

134

135 **Obv.** 'Robt Clark 1753', crossed cutlasses above, crossed pistols below. Border.
 Rev. Man, facing, in leg irons and wearing long coat; pipe in left hand, tankard in right. Border.
 Details Cu, 28.3mm, 7.22g.
 Ref. Millmore, Millett

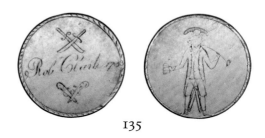

135

136 **Obv.** 'RICHARD : TRIBLE', simple wreath around man facing out in long coat and hat, smoking a pipe held in left hand, tankard in outstretched right hand.
 Rev. '****SARAH CLARK***' around woman facing out in striped gown (probably an English gown), with contrasting stomacher. She also wears a white apron and small hat; hands in front.
 Details Cu, 28.2mm, 7.53g.
 Ref. Millmore, Whyman

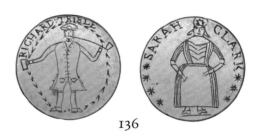

136

137 **Obv.** Man, facing, in leg irons and long coat, waistcoat, breeches and hat. Pistol in outstretched right hand, left hand on hip. Ornate border.
Rev. 'B' below bust of man looking through window (?).
Details Cu, 28.1mm, 8.08g.
Ref. Whyman

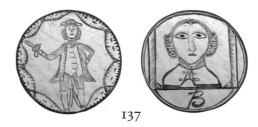

137

138 **Obv.** 'IOHN . STEWARD', above man riding horse to left, pistol in outstretched right hand, crop under left arm. Wheel (?) to far left. Shaded ground.
Rev. 'IOHN & ELLENOR . STEWARD' above couple separated by a hatched fence. Woman behind fence in hat and bodice, facing forward, bag in right hand. Man in leg irons, wearing a hat, holds her left hand. Shaded ground with wheelbarrow below.
Details Cu, 28.7mm, 8.03g.
Ref. Millett, Millmore

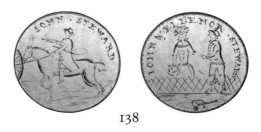

138

139 **Obv.** All retrograde: 'B Stilla I Sculpt GOSPORT'.
Rev. All retrograde: 'Flow, Ex [...]'.
Details Cu, 27.5mm, 6.12g, style as #142.
Host UK, 1/2d, 1695–1701.

139

140 **Obv.** 'MISS.MARY.FAULKNER.BORN. JULY.24.1750', around country scene with church (?) to left, central tree and dwellings to right. Ground and tracks (?) in foreground.
Rev. Original coin.
Details Cu, 28.9mm, 9.2g.
Host UK, 1/2d, 1746–54.

140

141 **Obv.** All in relief in banners: 'SUCCESS
 ATTEND. MARY REED. & JOHN.
 HAMMOND.' Machined border.
 Rev. Britannia standing, facing, right
 arm raised, left arm on chest. Anchor to
 left. Machined border.
 Details Cu, 28.6mm, 6.36g, machined
 and toothed rim.
 Host UK, 1/2d, 1773.

142 **Obv.** All retrograde: 'ELIZ STILL
 GOSPORT Hants'.
 Rev. All retrograde: 'BENJAMIN'
 above 'HANTS Gosport, SJJ n […]'.
 Details Cu, 27.9mm, 7.3g, style as #139.

143 **Obv.** 'RISUM TENEATIS AMICI?'
 (*Friends, can you help but laugh?*),
 around monkey wearing shirt and hat,
 holding knife in right hand and ring (?)
 in left; shaded ground.
 Rev. 'LW'.
 Details Cu, 27.6mm, 6.64g.

144 **Obv.** 'Dr G: Royce D: of Bristl. P: of
 Oriel Coll:', border.
 Rev. 'Dr T. Dunster Warden of Wad:
 Coll: Oxn.', border.
 Details Ar, 21.4mm, 2.26g.

145 **Obv.** 'WHARE SWEETNESS TH[…]
 WITH INOCENCE UNITE', around
 'FAIRY', and three-masted ship sailing
 left.
 Rev. 'HE BE', below three-masted ship
 sailing left.
 Details Ar, 24.5mm, 3.16g, pierced for
 suspension.

141

142

143

144

145

146 **Obv.** 'A Gift from Sarah Curtis', wreath
below, stars around.
Rev. Original token.
Details Cu, 21.9mm, 3.51g.
Host UK, 1/4d token, pre-1834.

147 **Obv.** 'A KEEPSAKE from C. MORRIS to
N. HASEL', with 'June 1837' at sides; ornate
stippled border.
Rev. 'The Absent are to Memory Dear'
around 'FORGET ME NOT'. Stippled border.
Details Cu, 21.8mm, 3.51g.

148 **Obv.** '✶ ELIZTH. MITCHELL ✶ BORN
AUG. 11. 1780.', around 'ILC' with ornate
outer and inner borders.
Rev. Original coin.
Details Ar, 20.9mm, 2.71g.
Host UK, 6d, 1787.
Ref. Dyer

149 **Obv.** 'Thomas Smith Born MarH 2: 1739
Elizabeth Weigall Born: MarH. 16 1739'.
Rev. Rustic scene featuring dwellings, trees
to left and right, and dog running on river
bank; boy (?) in rowing boat, bird, on water.
Details Ar, 25mm, 4.76g.

150 **Obv.** 'John Price & Catherine Cullen Octr.
17. 1786', with ornate border.
Rev. Two hearts doubly pierced; two doves
above, bow below. Ornate border.
Details Br, 27.4mm, 6.96g.

146

147

148

149

150

151 **Obv.** 'Mr. T. Snelson, Reigate 1795.'
Rev. 'TS', in ornate roundel.
Details Cu, 28.3mm, 8.82g.
Host UK, 1/2d token, *c.*1787–95.

152 **Obv.** '*WILLIAM*BROWN*AND*HANNER
BENTON', around cross of feathers (?).
Rev. 'WHEN.THIS.YOU.SE.REMEMBER.
ME.', around two hearts doubly pierced;
crown above. Border.
Details Cu, 28.1mm, 6.86g.

153 **Obv.** 'James Bracy Perry Swallowed this
Novr 9. 1784'.
Rev. Original worn coin.
Details Cu, 28.0mm, 7.83g.
Host UK, 1/2d, 1746–54, pierced for
suspension.

154 **Obv.** Calendar Medal.
Rev. Original worn coin.
Details Ar, 31.9mm, 4.24g, pierced for
suspension.
Host UK, 1s, 1551–53.
Ref. Dyer

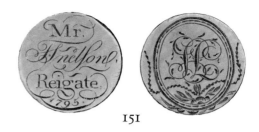

151

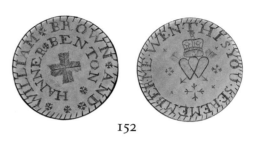

152

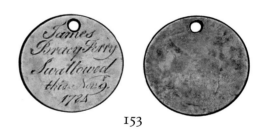

153

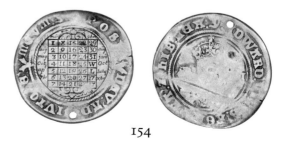

154

155 **Obv.** 'Fassett & Addison Linen Drapers
No14 Ludgate St London'.
Rev. 'W*F Nov 12 1790'
Details Cu, 27.6mm, 6.47g.
Host UK, 1/2d, 1695–1701.
Ref. Dyer

156 **Obv.** Man rowing across water towards
building on far bank with sign 'WINE'. Tree
and fence on near bank.
Rev. Original coin.
Details Br, 24.8mm, 3.62g.
Host Germany, Münster, 3 Pfennig, 1739–60.

157 **Obv.** '[…] Allen Killy […] 19', and
indecipherable text.
Rev. Original worn coin with pricked field.
Details Cu, 28.6mm, 7.53g.
Host UK, 1/2d, 1806.

158 **Obv.** 'NANY SNIPE 1793', border.
Rev. 'WHEN LOVERS MET THER TALK
IS SWEET', border.
Details Cu, 27.1mm, 6.57g.

159 **Obv.** 'WHEN.THIS.YOU.SEE.
REMEMBER.ME.' around 'I. BEST' in
banner.
Rev. 'REGUARD.YOUR.LIBERTY' around
two-handled cup with flower and leaves.
Details Cu, 27.6mm, 9.11g.

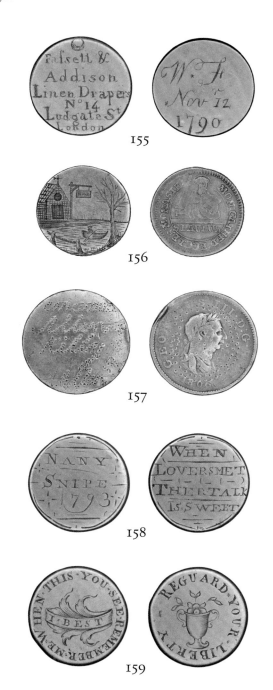

155

156

157

158

159

160 **Obv.** 'The Revd. JOHN CONDER. DD, Hindall Delt et Sculpt' around an oval with finely engraved man facing left, wearing a full wig and clerical bands. Legend retrograde.
Rev. Original coin.
Details Cu, 28.5mm, 8.65g.
Host UK, 1/2d, 1770–75.
Ref. Lloyd

161 **Obv.** 'Sirrah says a justice to one brought before him, you are an Errant Knave; says the Prisoner, Just as your worship spoke the clock struck two. L Pugh & […]'
Rev. Original worn token.
Details Cu, 29.2mm, 11.15g.
Host UK, 1/2d token, 1787–94.

162 **Obv.** 'JOSEPH.BROWN.AND. ELIZABETH.[H]ALL OFF' around man in coat and hat to left, facing woman in gown, apron and large hat on right. Both with arms outstretched. '1785' in shaded ground.
Rev. 'MY.MIND.IS.FIXT.I.CANNOT. RANGE.I.LIKE.MY. CHOICE. TO.WELL.TO.CHANGE' around two birds bringing sprigs together.
Details Cu, 28.2mm, 6.91g.

163 **Obv.** 'When 2 E's and 2H's meet They make a happy Pair complete'.
Rev. 'Doubtless 3 H's and 1 E Would still a happier Couple be'.
Details Cu, 26.8mm, 5.57g.

164 **Obv.** 'Long may you live. &,, Happy may you be.' around Geo Booth London. Ornate inner and outer border.
Rev. 'GB', with ornate border.
Details Cu, 28.8mm, 7.00g.

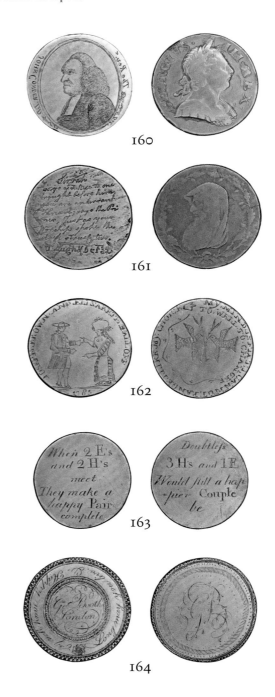

160

161

162

163

164

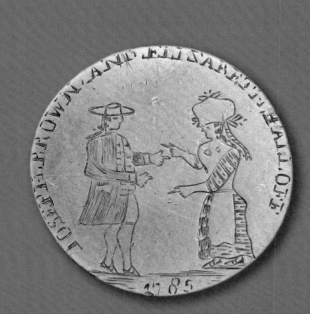

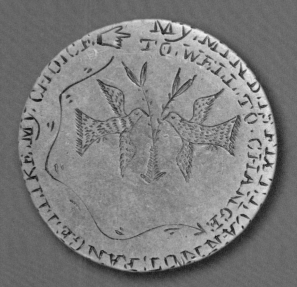

#162

At least three tokens are known for 1785, engraved by this very distinctive hand.

Just one **Joseph Brown** was tried at the Old Bailey in 1785 for breaking into a house adjacent to Bushy Park, Richmond-upon-Thames. Brown and an accomplice were spotted by neighbours whose dog detected the suspects lying in the grass. They jumped the wall but Brown was caught and taken to the Maidenhead Inn (now the Duke's Head) on the edge of the park. The prisoner claimed that he had been on his way to Kingston when detained by the neighbours.

Found guilty, Brown was sentenced to death because the property stolen was valued at over 40s. His sentence was initially respited, but he was hanged on 6 July 1785 at Newgate. [TIMOTHY MILLETT]

Source: *Old Bailey Proceedings* online, www.oldbaileyonline.org (accessed 17 March 2022), May 1785, Joseph Brown (t17850511-8).

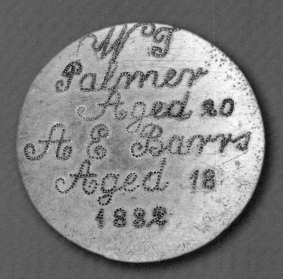
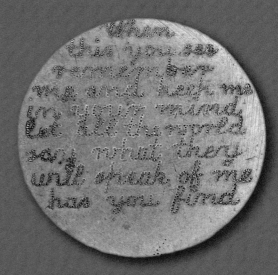

#166

William Palmer's pin-pricked token can be located in a specific prison milieu. It was made by the same hand that crafted one for Benjamin Sparks and two for Thomas Burbury. Palmer was convicted at the Warwickshire Quarter Sessions for larceny on 8 March 1832 and sentenced to seven years' transportation. At the Warwick Coventry Assizes on 24 March 1832, Burbury (a weaver) and Sparks (a whitesmith, who worked with tin-plated iron) were convicted of rioting, machine breaking and burning a steam-powered factory. It was one of the last outbreaks of organized protest against industrial manufacture in England and was heavily punished in law.

Palmer and Sparks were transported on the *Planter*, arriving in New South Wales in October 1832. Burbury was sent on the *Gulnare* to Tasmania, where he disembarked in 1833.

National Museum of Australia object numbers: 2008.0039.0124; 2008.0039.0125; 2008.0039.0134.

165 **Obv.** 'THE HAPPY COUPLE' around man in long coat and hat on left, facing right. Woman in gown, facing, on right, left hand on hip, her right hand holding his left hand. 'WE C' in central space. Simple dotted border.
Rev. 'INDUSTRY AND FIDELLITY' around 'HC 1789', with flower and sprigs above.
Details Cu, 29.2mm, 8.01g, pierced for suspension.
Ref. Holloway

166 **Obv.** 'W J Palmer Aged 20 AE Barrs Aged 18 1832'.
Rev. 'When this you see remember me and keep me in your mind let all the world say what they will speak of me has you find'.
Details Cu, 35.7mm, 23.54g.

167 **Obv.** 'A Token Of Love From N[…] To Jane Pa[…]ds', with pricked design below and simple pricked border.
Rev. 'No Pen Can Write No Tongue Can Tell The Aching Heart That Bids Farewell 1832', with pricked wreath below and simple pricked border.
Details Cu, 35.6mm, 21.21g.

168 **Obv.** 'Mary Ashford. 23 Keep this till you see me HA 1826', with pricked wreath around and heart at top.
Rev. Original coin.
Details Cu, 35.9mm, 26.29g.
Host UK, 1d, 1797.

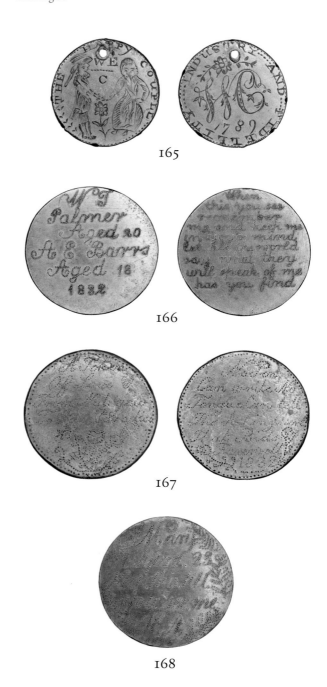

165

166

167

168

169 **Obv.** 'W Eliza B' in wreath, double-pierced
 heart above and below, star at top.
 Rev. 'A Token of love from my <u>Brother</u>'
 above fouled anchor in wreath. 'Sep 6th
 1832' below, initials 'SE' to left.
 Details Cu, 35.8mm, 24.60g.
 Ref. Millett

170 **Obv.** 'William Street Born September
 19. 1809 Aged 21. years' around a woman
 on the left holding basket and facing
 forward, and a man with hat and long
 coat facing her; cane or umbrella in his
 left hand, touching hat with right hand.
 The stippled design also looks like a
 head facing right.
 Rev. 'Elizabeth Cannon Aged 52 Mary
 Ann Cannon Aged 17' around a wreath
 of leaves, flowers, and bees; central
 beehive, 'Industry' above.
 Details Cu, 35.5mm, 24.5g.

171 **Obv.** 'When this you see – Remember
 me, & bear me in your mind, Let all the
 World, say what they will; speak of me as
 you find. From E. March to W. Jackson'.
 Rev. Original coin.
 Details Cu, 35.9mm, 25.44g.
 Host UK, 1d, 1797.

172 **Obv.** 'This is in Commemoration of
 Heartfelt Gratitude to the Almighty God
 in Grateful remembrance of a Recovery
 from a Severe & most dangerous
 Affliction Experienced by Joseph
 Braham Anno Domino Augt. 29th. 1831',
 with ornate border.
 Rev. Smooth surface, possible traces of
 previous engraving.
 Details Cu, 35.5mm, 19.41g, pierced for
 suspension.

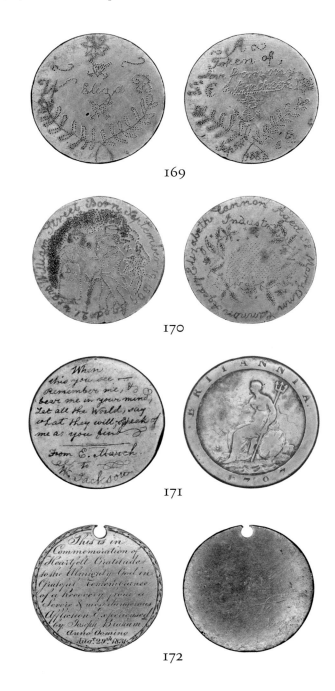

169

170

171

172

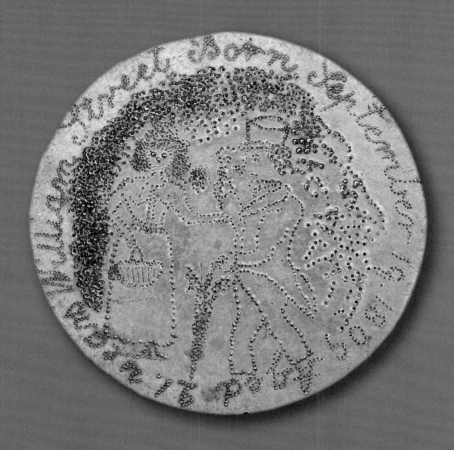

#170

———

A **William Street** was convicted at the Warwickshire Assizes in March 1831 for stealing a pair of breeches. He had a previous conviction and was sentenced to death. Instead, in October he was transported to Tasmania, arriving in 1832.

His 'Gaol Report' in Tasmania described him as having a 'Bad Character' and listed numerous offences, including abusive language, drunkenness, refusal to work, theft and absence without leave. He was imprisoned, whipped, put in a chain gang and then finally removed from the district in 1843. He received a conditional pardon in 1849.

Source: Tasmanian Archives, Conduct Registers of Male Convicts arriving in the period of the Assignment System (CON31), available online.

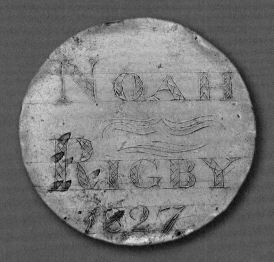
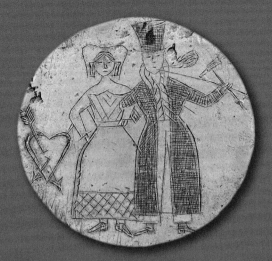

#180

Noah Rigby's name, distinctive for the first half of the nineteenth century, plus what seems to be his year of birth recorded here, links this token to the following life story.

Noah Rigby was baptized in 1827 in Blackburn, Lancashire. The 1841 census recorded him aged 16, working in a Bolton cotton factory. With others, he was charged with vagrancy (1843), theft from a shop (1844), and stealing (1845). Tried on that last occasion, the *Bolton Chronicle* reported that 'Both prisoners displayed considerable ingenuity and great hardihood in cross-examining witnesses and appealing to the Jury. Guilty. The Recorder in passing sentence observed on the previous appearances of the prisoners. Quin had been there five times, and Rigby eight times. They had passed a considerable part of their time in prison for the past two years. It would be no mercy but mistaken kindness to allow them to remain longer in the country and he sentenced them each to seven years'

transportation. Rigby, who had interested the court in his favour by his show of intelligence, as he left the dock turned and bestowed a violent malediction on the Judge.'

Rigby sailed on *Equestrian* to Tasmania on 30 June 1845.

The Tasmanian archives describe him as a Protestant who could read and write a little. He was a labourer, 5ft 4 inches tall, with a ruddy complexion, dark brown hair and brown eyes. He had scars on his right eyebrow, on the back of his right wrist and on his upper lip.

Noah Rigby first worked on the Probation Gang. He was reprimanded in November 1846 for 'being out of his berth and lighting his pipe contrary to orders'. He got his Certificate of Freedom in 1852 and died in Kensington, Victoria, Australia in 1891.

Sources: *Manchester Times*, 16 December 1843; *Manchester Courier*, 21 December 1844; *Bolton Chronicle*, 19 April 1845.

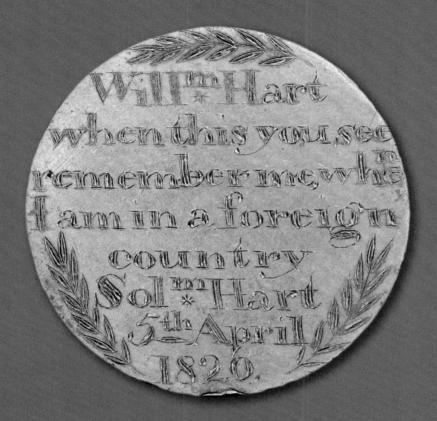

#181

Solomon Hart was found guilty of burglary in Bristol. Initially sentenced to death, he was sent to the prison hulk *Justitia* at Woolwich in August 1820 and sailed on the *Elizabeth*, which arrived in New South Wales on 31 December 1820.

Australian convict records record Solomon Hart as born in Somerset circa 1795. The most likely candidate is the son of Samuel and Mary Hart of Compton Bishop, who was baptized at Axbridge on 19 February 1793. Samuel Hart was a baker.

Soloman Hart worked as a baker in Australia and received a conditional pardon on 1 October 1842. He was 5ft 3 ½ inches tall, with a dark, ruddy complexion, black hair and hazel eyes.

With thanks to Caroline Gurney

Source: Tasmanian Archives, Conduct Registers of Male Convicts arriving in the period of the Assignment System (CON31), available online.

173 **Obv.** 'Emilia Hunt Born 17th* Sept 1816 and departed to her eternal rest 23rd* May 1820' above double-pierced heart and wreath.
Rev. Original coin.
Details Cu, 35.9mm, 26.36g.
Host UK, 1d, 1797.
Ref. Dyer

174 **Obv.** 'When this you See remember me When I am in JS' within ornate border.
Rev. 'Slavery J. Bishop Aged 19 J. Scott 1826'.
Details Cu, 36mm, 25g.

175 **Obv.** 'When This you see Remember Me And on no Account Forget my Discount!'
Rev. 'Tim Millett 21 Oct 1805 Transported For Leaving Baldwin's.
Details Cu, 33mm, 17g.
Ref. Millett

176 **Obv.** 'A Token of [...] from W [...] Smith to JH [...] Feby 1830', with wreath border.
Rev. 'When this you see Remember me when in a foreign Country 1830', with wreath border.
Details Cu, 35.9mm, 24.3g, pierced for suspension.
Ref. Lloyd

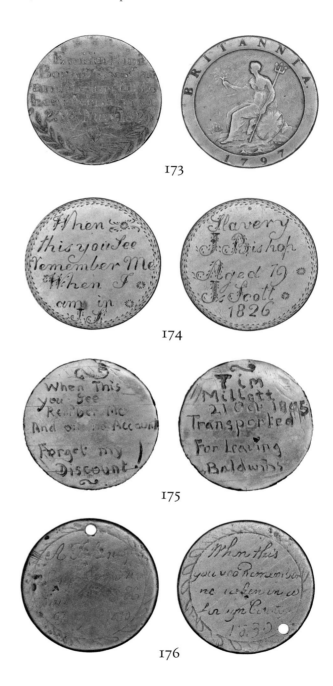

173

174

175

176

177 **Obv.** 'THOs. OLIVER AGED. 15. 1826.' Plinth on brick base with heart; two cornucopias.
Rev. 'MARGt. OLIVER' above cross, crossed arrows, stars, two doves and heart; plinth on brick base with crossed arrows depicting an altar of love.
Details Cu, 35.9mm, 21.13g.

178 **Obv.** 'Wm Thornley Born April 6th 1782✶'.
Rev. Heart with two arrows embedded, simple wreath.
Details Cu, 35.9mm, 24.40g.

179 **Obv.** 'John Price Aged 23 Years', below double-pierced heart and two doves, simple wreath.
Rev. 'JP HM' around heart with four arrows in ornate shield.
Details Cu, 35.8mm, 23.77g.

180 **Obv.** 'NOAH RIGBY 1827.'
Rev. Man and woman arm-in-arm, facing forward. Woman wears gown and apron, hair curled on crown of head with ringlets dangling down, in style typical of the period. Man wears boots, trousers, waistcoat, coat and top hat. He is smoking a long pipe in his left hand. Doubly pierced heart to left.
Details Cu, 35.8mm, 25.26g.

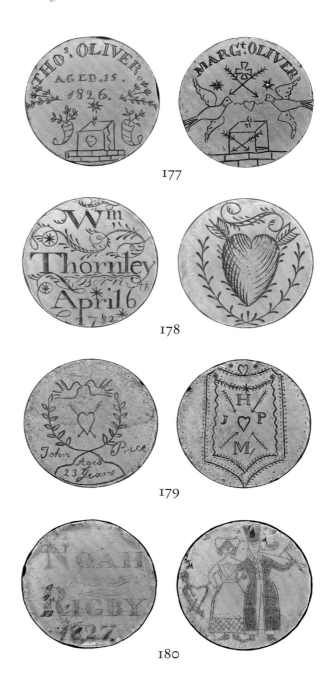

177

178

179

180

181 **Obv.** 'Willm Hart when this you see remember me, when I am in a foreign country Solm Hart 5th April 1820', three short wreaths around.
Rev. Original coin.
Details Cu, 35.9mm, 27.53g.
Host UK, 1d, 1797.

182 **Obv.** 'Wm Kelly Reported and Left to Suffer the 19 Feby 1818' within border.
Rev. 'Cast for Death the 17th Jany for Soft' above pot with foliage. Hatched ground. Border.
Details Cu, 35.8mm, 23.94g, attempted piercing on reverse.
Ref. Millett

183 **Obv.** 'Elizabeth Brewer JE', with lamb below, in ornate square border.
Rev. 'The trumpet shall sound and the dead shall be raised', on a stone tablet held by a winged angel in a high-waisted flowing Regency gown, blowing a horn. Houses behind, pyramids (?) in wavy sea, lightning in shaded sky. Skull and crossed bones on hatched ground at angel's feet.
Details Cu, 34.0mm, 15.46g.
Ref. Dyer, Millmore

184 **Obv.** 'DEAR.BETSY.PLEASE. TO.KEEP.THIS AROUND IN REMEMBERANCE OF YOUR UNFORTUNATE TRUE LOVER ISAAC FLAY AGED 22 1828', name partially scratched out.
Rev. Original worn coin.
Details Cu, 33.4mm, 20g.
Host IoM, 1d, 1798, 1813.

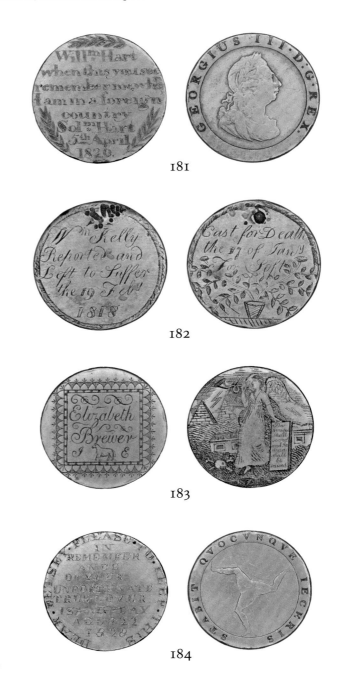

181

182

183

184

185 **Obv.** All in relief: ornate wreath of leaves and flowers around garden scene of tree, pot of flowers, squirrel and flying bird.
Rev. Original token with some damage.
Details Cu, 34.4mm, 15.3g.
Host UK, 1d token, 1812.
Ref. Dyer

185

186 **Obv.** 'Edward Orton Born Jany. 18. 1830 Aged 1 Year', crude wreath.
Rev. 'Tho time may pass & years fly & every hope decay & die & every joyful dream be set yet thee I never can forget'.
Details Cu, 36.2mm, 23.04g.

186

187 **Obv.** 'Elizabeth.Medcalf.Born.January 23.1788.' around Hope leaning on an anchor. Small boat and hills in background.
Rev. Soldier, possibly a hussar, on horse rearing to left, sword in raised right hand. Hatched ground.
Details Cu, 35.9mm, 19.93g.

187

188 **Obv.** 'The Reptiles of the earth have exhausted every strain to Banish'.
Rev. 'me from this earth all their efforts are vain J Star[t...]'.
Details Cu, 35.6mm, 24.10g.

188

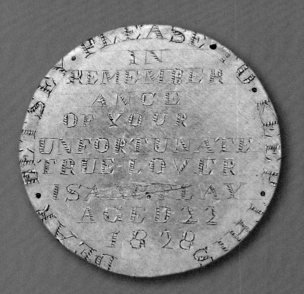

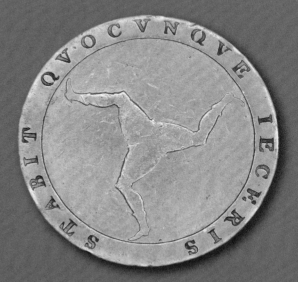

#184

Isaac Flay married Elizabeth Lintern on the 17 February 1823 at St George's, Bristol; presumably, Lintern is the 'Betsy' named on the token. In 1828 he was accused with two others of breaking into the Bristol workshop of Benjamin Pratten and stealing 'leather of various descriptions', which he then tried to sell. This was not his first offence.

Found guilty and sentenced to seven years' transportation, Flay was sent in June to the *Justitia* prison hulk at Woolwich. Flay died in 1828 and never made it to a convict ship.

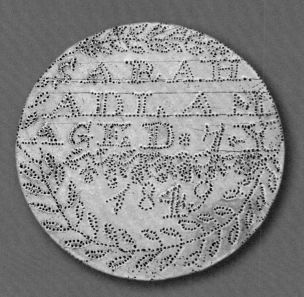
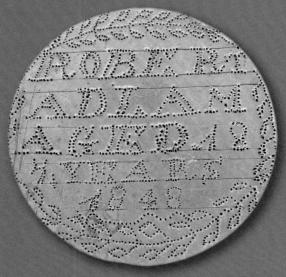

#189

This token was made for one of **Robert Adlam**'s two sisters, Sarah. The 1841 census recorded the family in Norwich.

In 1848 Robert, aged 17, and three other teenagers were convicted in Norwich of breaking into Lakenham old church and stealing a looking glass, two printed books, two glasses and other minor items. They subsequently sold the looking glass for sixpence. This was not Adlam's first offence. Three of the four boys were sentenced to seven years' transportation.

On arrival in Tasmania, Adlam's trade was recorded as 'imperfect shoemaker'. He had numerous tattoos, including 'S. Adlam', 'John Adlam', 'Robert Adlam', anchors, a ship, sailor and flag.

He received his ticket of leave in 1852 in the name of Thomas Edwards, alias Adlam. It had already been revoked when he was tried in Melbourne in 1855 for stealing money. He was sentenced to three years' hard labour.

189 **Obv.** 'SARAH ADLAM AGED*7*Y 1849', in stippled wreath.
Rev. 'ROBERT ADLAM AGED 12 7 YEARS 1848', in stippled wreath.
Details Cu, 34mm, 12.20g.
Ref. Dyer

190 **Obv.** 'To flourish in my native bower, to blossom round my cot, to cre-ate a little tower could they forget me, not the ocean will between me roam'.
Rev. 'and distant is my lot and should I never see you more dearest forget me not J. Baker'.
Details Cu, 35.8mm, 24.01g.

191 **Obv.** 'I:C:E White was Married the 11 of April 1829', in simple wreath.
Rev. 'When this you see remember me and bear me in your mind let all the People say what they will you speak of me as you have found', in simple wreath.
Details Cu, 35.7mm, 25.04g.
Ref. Maxwell-Stewart

192 **Obv.** 'S PEARCE M CHAMBERS 1776' around man, facing, in leg irons smoking pipe in left hand, tankard in right hand.
Rev. Crossed pistols, crossed keys and two cutlasses.
Details Cu, 28.7mm, 7.80g.
Ref. Hitchcock, Millmore

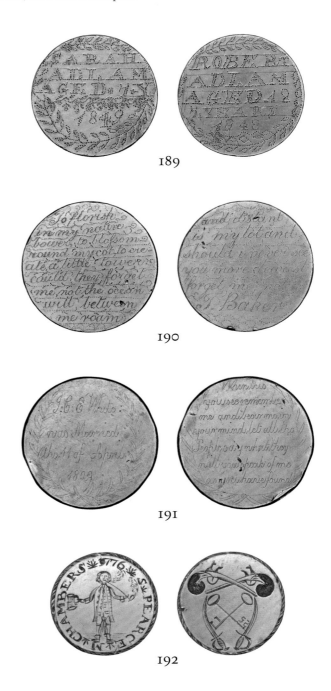

189

190

191

192

193 **Obv.** All retrograde: 'P. BEAMEY. G.
THOMPSON. G. SKARRATT. THREE
GOOD FELLOWS. 1812.'
Rev. Smooth surface, with shadows of
letters from obv.
Details Cu, 28.0mm, 7.64g.
Ref. Millmore

194 **Obv.** 'Edwd Davies Aged 18 years 1818',
with two hearts doubly pierced. Narrow
wreath border.
Rev. 'When this you see Rembr me
When I am far beyond the Sea', with
narrow wreath border.
Details Cu, 35.8mm, 25.70g
Ref. Millett

195 **Obv.** 'JM', in ornate wreath.
Rev. Basket of flowers, leaves below.
Outer circle.
Details Ar, 25.4mm, 4.29g.

196 **Obv.** 'Crown'd with Love. Joind by
Friendship.' Overlapping hearts marked
'W.W' and 'P.S'.
Rev. Worn original coin.
Details Cu, 27.9mm, 9.12g, pierced for
suspension.
Host UK, 1/2d, 1729–39.

197 **Obv.** 'MW 1787', groundline.
Rev. 'LOVE & Unity', two hearts
doubly pierced.
Details Cu, 26.9mm, 7.85g.

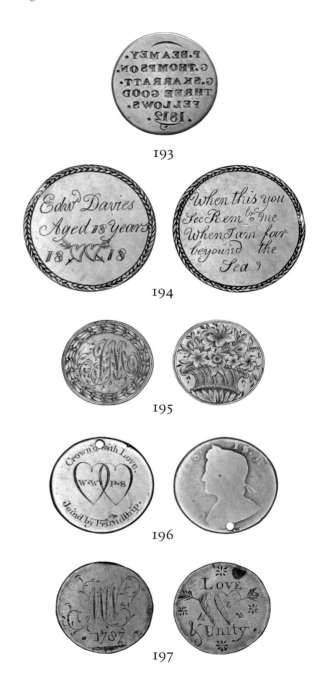

193

194

195

196

197

198 **Obv.** 'Sarah Harrison Nottingm.
1786'.
Rev. 'When this you see Remember
Me', with small flower and sprig
decoration.
Details Cu, 27.0mm, 7.91g.

199 **Obv.** 'NO TURTLE DOVE HATH,
FIRMER LOVE' around a dove with
sprig in mouth, standing on branch.
Rev. 'HD', fox running to left below.
Details Cu, 27.8mm, 7.25g.

200 **Obv.** 'JOHN TRIGG
TRANSPORTED FOR 7 YEAR'.
Rev. 'Tried at HERTFORD NOVR
29 1832'.
Details Cu, 35.8mm, 24.55g.

201 **Obv.** 'WHEN THIS. YOU. SEE
REMEMBER ME. WHEN I AM. IN
A FOREIGN'.
Rev. 'COUNTRY ANN DENMAN'
above a heart.
Details Cu, 35.8mm, 23.49g.

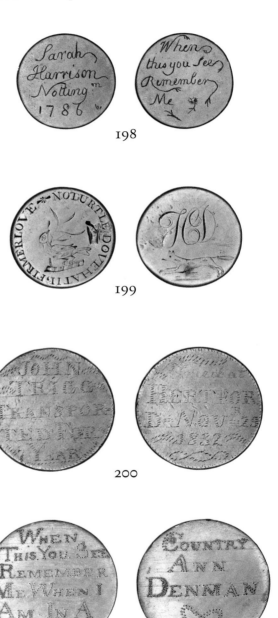

198

199

200

201

202 **Obv.** 'R. Musgrove, Life March 12
1833', in rectangular box. Man standing
facing, in leg irons, pipe in right hand,
bag in left hand; leafy surround.
Rev. 'Eliza Parkes', in exergue. Woman
in gown with breasts exposed, standing
facing, umbrella in left hand; plants in
pots either side, leafy surround.
Details Cu, 35.9mm, 22.44g.
Ref. Millmore

203 **Obv.** 'L CURTIS ALIAS CURTEL
HUNG IN CHAINS NEAR SARUM
MAR. 14 1768.' around a tall gibbet
with man hanging in chains; '26 [f]'
below groundline.
Rev. 'FOR THE ROBBERY &
MURDER OF WOLF MYARS' around
central, partially shaded circle, 'Decr 28
1767'.
Details Cu, 39mm, 18.49g.
Ref. Poole

204 **Obv.** '[IS]' beneath headland with
Hope in a Regency gown, leaning on
fouled anchor overlooking three-
masted ship on distant sea. Simple
border.
Rev. Three-masted ship flying ensign
under sail in ornate wreath.
Details Ar, 39.5mm, 22.05g.
Host Spanish/American Dollar.
Ref. Maxwell-Stewart

205 **Obv.** 'The gift of E.H to H.W for
fastening her shoe string'.
Rev. Worn original coin.
Details Cu, 35.4mm, 23.71g, pierced for
suspension.
Host UK, 1d, 1797.
Ref. Dyer

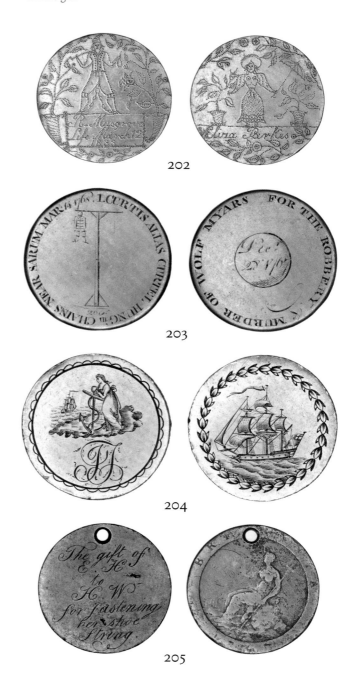

202

203

204

205

206 **Obv.** 'From John Paddison to Harriott Spark', above two hearts doubly pierced. Simple wreaths below and above.
Rev. 'When this you see remember me and bear me in your mind, let all the world say what they will speak of me as you find'. Wreath with thistles and roses below, simple wreath above.
Details Cu, 35.7mm, 22.51g.

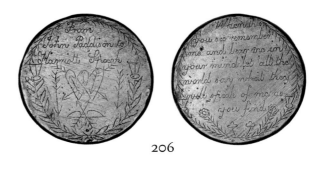

206

207 **Obv.** 'DEAR.EMMA.WERE.I.IN. HEAVEN.WITHOUT.MY.GOD WOULD.BE.NO.JOY.TO.ME.AND. WHILS.THIS.WORLD.IS.MY ABODE.I.LONG.FOR.NONE. BUT.THEE BLESSD.JESUS.LET. IT.EVER.BE.THY.CHIEF.DELIGHT. TO.FOLLOW.ME.'
Rev. 'JB 1841'.
Details Cu, 33.9mm, 14.63g.
Host UK, 1d, 1806–07.

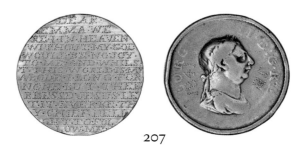

207

208 **Obv.** 'matthews stick maker. No 13 Oxford Street.'
Rev. Very worn original coin.
Details Cu, 28.0mm, 8.02g, pierced for suspension.
Host UK, 1/2d, 1695–1701.

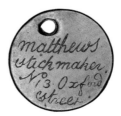

208

209 **Obv.** 'Charles Ward WARWICK' around 'August, 16. 1784'.
Rev. 'CW 84'.
Details Br, 29.2mm, 4.35g, central piercing and perforated outer edge.

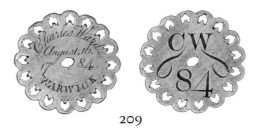

209

210 **Obv.** 'James MaddisonBell Born
August 6th. 1795'.
Rev. Very worn, almost smooth
original coin.
Details Cu, 28.2mm, 7.74g
Host UK, 1/2d, 1729–1739.
Ref. Dyer

211 **Obv.** 'Sarah Gibbs Born Aprl. 26 1771'.
Rev. 'Saml. Tanner Born Decr 21 1767',
simple line outer circle.
Details Cu, 27.5mm, 7.41g.

212 **Obv.** 'When this you see remember
me untill I gain my liberty For E:
Johnson F Curry', in simple wreath.
Rev. Three-masted ship under sail,
shaded sea.
Details Cu, 35.8mm, 24.44g.

213 **Obv.** All retrograde: 'Jas Green
Bricklayer', above a collection of tools:
trowel, mallet, ladder, plumb bob,
square.
Rev. Smooth surface.
Details Cu, 27.2mm, 7.37g.
Ref. Lloyd

214 **Obv.** 'Susanah Packer, Albourn', sprig
above and below.
Rev. 'SP' in large wreath.
Details Cu, 28.4mm, 7.81g.

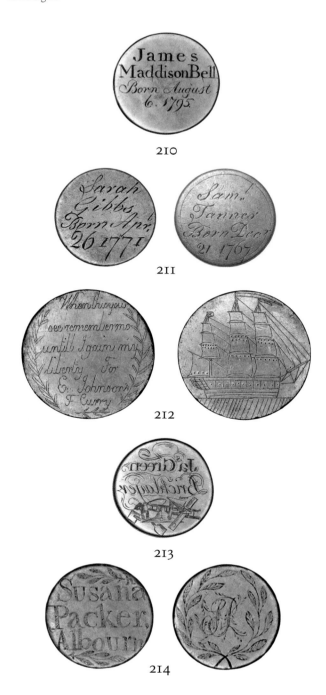

210

211

212

213

214

215 **Obv.** 'Ann Hewitt 1781'
Rev. House to left, tree to right, shaded
ground, birds flying in shaded sky.
Details Cu, 27.6mm, 7.57g

216 **Obv.** 'R*BROWN' above single heart
doubly pierced; '1793' below.
Rev. Very worn original coin, almost
smooth.
Details Cu, 27.6mm, 7.54g.
Host UK, 1/2d, 1719–24.
Ref. Dyer

217 **Obv.** 'SOPHIA BROOKSHAW born July
11th. 1778', cartouche below.
Rev. Original coin.
Details Ar, 21.1mm, 2.69g, pierced for
suspension.
Host UK, 6d, 1743–58.

218 **Obv.** '17. Elizabeth Brame Ipswich 76.'
with wreath border.
Rev. 'EB', simple border.
Details Cu, 28.1mm, 8.06g.

219 **Obv.** Shield with lion's head facing in 1st
and 4th quarters, urn and buckles in 2nd
and 3rd quarters.
Rev. Vestiges of host coin flattened by
punch from obv.
Details Cu, 25.7mm, 4.89g.
Host UK, 1/2d, 1672–75.
Ref. Dyer

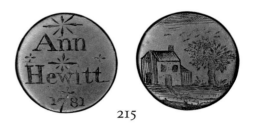

215

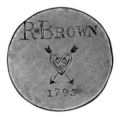

216

217

218

219

220 **Obv.** 'Mr: Thos: Cole: Aprl: ye: 5: 1767',
crimped border.
Rev. Sprig of flowers, ornate border.
Details Cu, 28.1mm, 7.61g.

221 **Obv.** 'E. Willing' in exergue. Tree to
right, two birds flying left, carrying
string in beaks, bird in tree, dead bird on
ground. Ornate border.
Rev. Bird standing facing left, sprig in
beak, ornate border.
Details Cu, 29.6mm, 6.91g.

222 **Obv.** 'E Shelston Ailsworth 1774', sprig
above.
Rev. 'ES', bird on branches, sprig in
mouth.
Details Cu, 26.0mm, 7.75g.

223 **Obv.** 'WB OCT 28 1768', below stag's
head facing left.
Rev. Head of a hunting hound
facing right.
Details Cu, 27.8mm, 9.49g.

224 **Obv.** 'Endless Flame', above cherub to
left 3/4 facing right, torch in right hand.
Plinth to right carrying two hearts, one
in flame and pierced. Bow on ground.
Rev. Original coin.
Details Cu, 28.3mm, 6.37g.
Host UK, 1/2d, 1770–75.

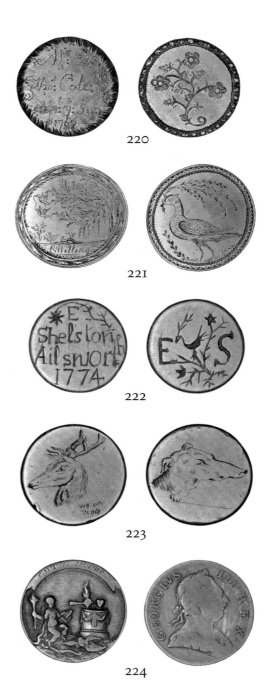

220

221

222

223

224

225 **Obv.** Warship with guns sailing left, smoke from chimney, shaded sea. Cartouche with 'R ‑ ‑ ‑ ‑ ‑ N.' below.
Rev. Original coin.
Details Ar, 23.6mm, 4.65g.
Host UK, 6d, 1915.
Ref. Dyer

226 **Obv.** 'Newgate JP', above man facing forward in leg irons, pipe in right hand, tankard of foaming beer in left hand. Pedestal table with bottle and glass to left.
Rev. Border of triangles, indecipherable scratches.
Details Cu, 35.9mm, 24.9g.
Ref. Millmore

227 **Obv.** 'MATILDA TOWNSEND BORN MAY 30 1826', wreath below.
Rev. Original coin.
Details Cu, 35.9mm, 23.66g.
Host UK, 1d, 1797.
Ref. Dyer

228 **Obv.** 'To his Dear Mother JOHN ADAMS, Son of John & Mary Adams, Born Jan. 19. 1805.' Double-line border.
Rev. 'A Heart that can feel for another' below a double-pierced heart, line border.
Details Cu, 35.7mm, 24.18g.

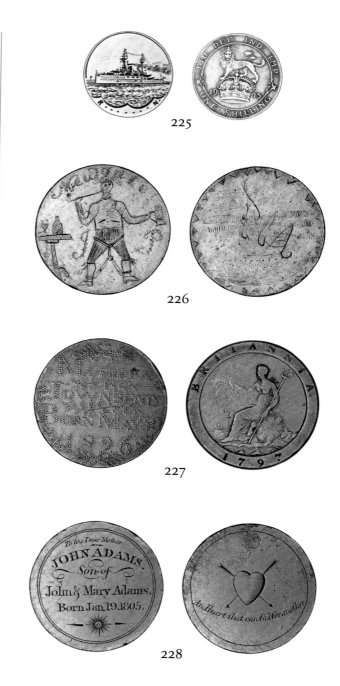

225

226

227

228

229 **Obv.** 'David Allen, Mary Allen April 9th. 1807' around 'CONFUSION to him Who persecutes the brave, For he that does so Is an arrant KNAVE'.
Rev. Original coin.
Details Cu, 35.9mm, 26.26g.
Host UK, 1d, 1797.

230 **Obv.** 'When in the world again we sever May we meet in bliss for ever'.
Rev. Man striding from left, hands outstretched towards woman in bonnet. Shaded ground, tree and house on horizon, hill and wayside cross (?) to left.
Details Cu, 35.6mm, 21.13g.

231 **Obv.** 'JOHN ALLEN BORN JANUARY 28 (1795)'
Rev. Original coin hammered flat.
Details Cu, 36.3mm, 25.43g, pierced for suspension.
Host UK, 1d, 1797.
Ref. Dyer

232 **Obv.** 'WHEN.THIS.YOU.SEE.THINK. ON.ME, W. GRIFFITHS.1826.' around heart and cross in simple wreath, with 'N' on heart.
Rev. Large 'CH' countermark.
Details Cu, 33.9mm, 15.61g.
Host UK, 1d, 1807.
Ref. Dyer

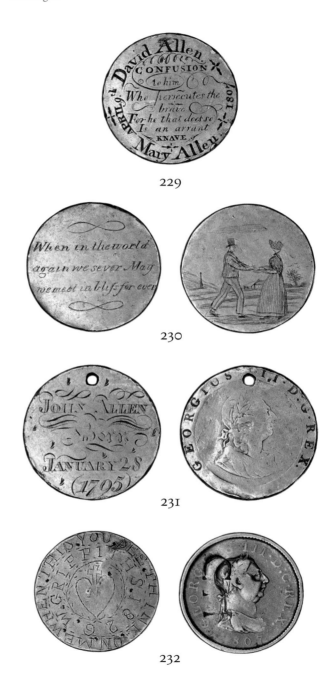

229

230

231

232

233 **Obv.** 'CR' and 'TR' in simple wreath and geometric border.
Rev. 'When this you see rEMEMBEr ME tho many a league Perhaps we be' around wreaths with two hearts doubly pierced. Geometric outer border.
Details Cu, 35.8mm, 21.21g.

234 **Obv.** 'G.CLEERE' on foliate banner.
Rev. 'LOVE.ME.TRUE.AS.I.DO. YOU' around two flaming hearts doubly pierced.
Details Cu, 27.7mm, 9.16g.

235 **Obv.** 'Mr George Edge & his old bitch Lady [Bayrazors] Berrad' around two men at left in hats, one with stick in left hand urging on a dog biting nose of bull chained to a peg. Shaded ground.
Rev. Two men in hats and tail coats looking on as two dogs fight. Shaded ground, branches above with acorns.
Details Cu, 35.7mm, 23.67g.
Ref. Maidment

236 **Obv.** 'M. Atkinson born Novemr 30th. 1756'.
Rev. 'L'AMOUR NOUS UNIT', above two birds standing on plinth with two hearts pierced.
Details Cu, 27.3mm, 5.24g.

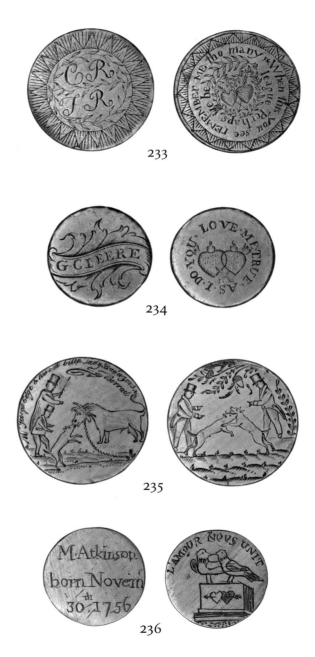

233

234

235

236

237 **Obv.** 'M*G A Trifle.Shews Respect', ornate wavy border.
Rev. 'INNOCENCE' above, 'IH' below horse (?) lying on ground, tree behind. Ornate wavy border.
Details Cu, 30.0mm, 10.96g.

238 **Obv.** Gloucester Cathedral.
Rev. Original medal.
Details Ar, 35.4mm, 13.95g.
Host UK, Queen Anne Accession Medal, 1702.

239 **Obv.** Gloucester Cathedral (?).
Rev. Original coin.
Details Ar, 21.6mm, 2.12g.
Host UK, 6d, 1703–11.

240 **Obv.** 'B, Wood. Engraver upon Silver, Copper, Brass, or Steel.'
Rev. Damaged original coin.
Details Cu, 34.9mm, 15.82g.
Host UK, 1d, 1806–07.

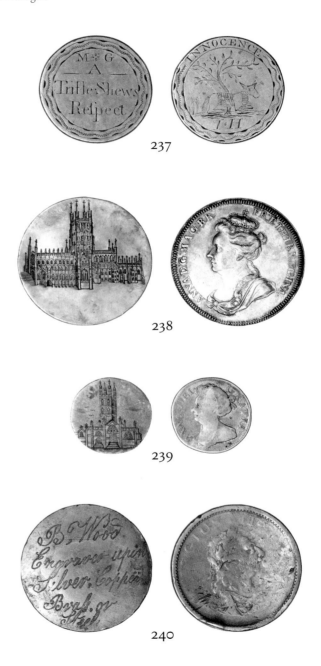

237

238

239

240

241 **Obv.** '[WI]LKIS FOR LIBERTY 4[5]'.
Rev. Smooth surface with some file marks.
Details Cu, 28.2mm, 8.93g.
Ref. Navickas

241

242 **Obv.** Two men weaving with a very large hand loom, '1796' below.
Rev. Woman in high-backed chair, cat at her feet, spinning or winding yarn on a table-top machine; fireplace, mantlepiece, fire guard and shelves with plates to right. Picture on wall, basket behind chair. All in square frame, '1746' above, fainter '1746' to right.
Details Cu, 52.7x41.6mm, 14.64g, pierced for suspension.

243 **Obv.** 'NO LANDLORDS'.
Rev. Three oval countermarks containing man on horse, two greyhounds, and a hare, all running left.
Details Cu, 28.5mm, 8.1g.

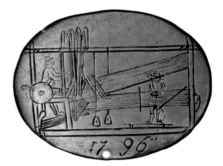

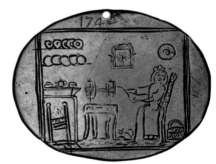

242

243

244 **Obv.** '.JOHN.FINNEY.SON.
OF.TIMY FINNEY.BORN.AUGT
9.1831'.
Rev. Original worn token.
Details Cu, 34.3mm, 16.32g.
Host UK, 1d token, 1813.
Ref. Dyer

245 **Obv.** 'JULY 23 THOMAS ALYMER
SHEPERD FLEMPTON'.
Rev. 'HARIOT ALYMER HIS
WIFE AD.28.1838'.
Details Cu, 36.0mm, 23.68g.

246 **Obv.** 'Col. Forbes OB, Jany. 5th. 1785
Agd, 65'.
Rev. 'EP'.
Details Cu, 32.9mm, 12.94g.
Host UK, 2/6, 1696–1701.

247 **Obv.** 'Wilm Shackelford Whitehead'
in geometric border.
Rev. 'JOIND IN FRIENDSHIP
CROUND WITH LOVE' around
two birds perched on edge of
fountain (?), pierced heart either
side.
Details Cu, 27.5mm, 7.8g.

244

245

246

247

248 **Obv.** 'Jonathan Bowker Born Apl.
26 1782', simple wreath below.
Rev. Original token.
Details Cu, 33.6mm, 27.61g.
Host UK, 1d token, 1787.
Ref. Dyer

249 **Obv.** 'John & Elizabeth Okell',
around 'Married May 30th 1789'.
Rev. 'JOE' initials triad above
'1789'.
Details Cu, 33.5mm, 26.12g.
Host UK, 1d token, 1787–91.

250 **Obv.** 'FOR MARY COLLY
SCARBROUG DEC ye 5 1771'.
Rev. 'I*H M*C'.
Details Ar, 25.4mm, 4.34g, pierced
for suspension.

251 **Obv.** 'John Foster Elizabeth
Wicherly', in ornate border.
Rev. 'hand in hand, heart in heart
like true love is never Part' around
two hearts, clasped hands, '1774'.
Simple border.
Details Cu, 29.1mm, 7.34g

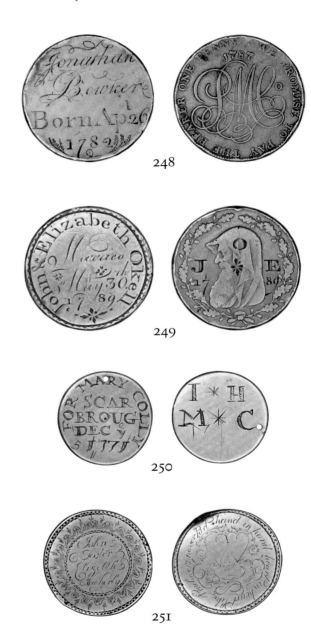

248

249

250

251

252 **Obv.** 'May we have in Our arms Whom We love in Our hearts, Catharine Shearer [Edinr?] 1783, My heart is true to non but you', around two hearts.
Rev. 'George Dun', above cannon on carriage on shaded ground.
Details Cu, 27.2mm, 7.11g.

253 **Obv.** 'ROBERT MOTT', in ornate border.
Rev. Large wheatsheaf, shaded background, simple border.
Details Cu, 27.3mm, 5.60g.

254 **Obv.** 'ONCE THESE TWO HEARTS IN LOVE WAS JOIND NOW ONE IS FREE THE OTHER CONFINED', around a plinth with a heart depicting an altar of love. Another heart with two wings above.
Rev. 'REB 1788', in ornate border.
Details Cu, 27.4mm, 5.09g.

255 **Obv.** Stag running left, chased by two dogs.
Rev. 'JS', in floral style.
Details Cu, 28.2mm, 7.28g.

256 **Obv.** 'LOVE TRUE', around two hearts in simple wreath.
Rev. 'GHL 1779', in border.
Details Cu, 27.8mm, 7.26g.

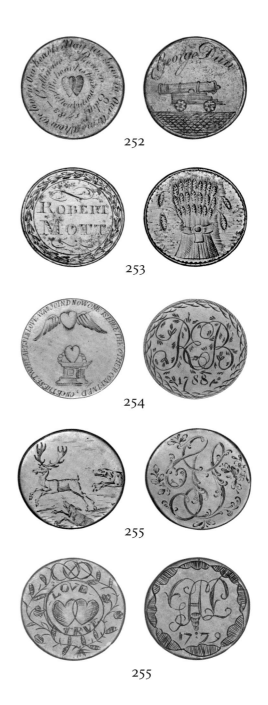

252

253

254

255

255

257 **Obv.** Large ornate crown.
 Rev. Worn original coin.
 Details Cu, 28.8mm, 9.93g.
 Host UK, 1/2d, 1695–1701.

258 **Obv.** Bust of man facing left. Simple border.
 Rev. Smooth surface.
 Details Cu, 27.3mm, 7.16g.

259 **Obv.** 'John Mason London 1765'.
 Rev. Christ hanging from cross between
 decorative motifs. Ornate border.
 Details Cu, 27.4mm, 6.55g.

260 **Obv.** 'Lewis Davis Jane Hail 1775'
 Rev. Original coin.
 Details Cu, 28.4mm, 8.86g.
 Host UK, 1/2d, 1770–75.
 Ref. Dyer

261 **Obv.** Fox on haunches, looking upwards at
 foliage. Broad engine turned border.
 Rev. Original coin, worn and damaged.
 Details Cu, 28.7mm, 6.97g.
 Host UK, 1/2d, 1806–07.

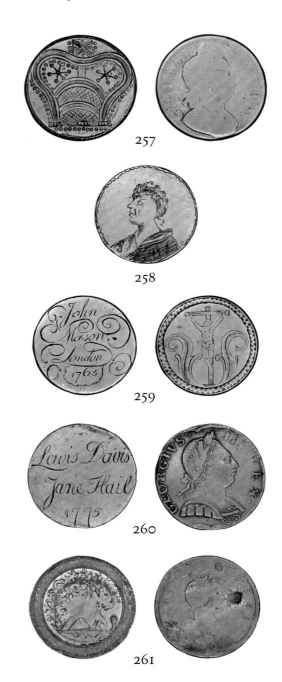

257

258

259

260

261

262 **Obv.** 'T.E.R Mar. 13 1742'.
 Rev. Original worn coin.
 Details Cu, 27.8mm, 7.14g.
 Host UK, 1/2d, 1694.
 Ref. Dyer

263 **Obv.** Dog walking left on shaded ground
 towards branch, bent over, with detail now
 scratched out.
 Rev. Three-masted ship sailing right on
 shaded sea.
 Details Cu, 27.3mm, 7.15g.

264 **Obv.** 'Sarah BLACKEDER 1759' above
 angel's head with wings.
 Rev. 'SB' on ornate device.
 Details Cu, 27.2mm, 8.17g.

265 **Obv.** 'J M BAKER'.
 Rev. 'Bound April 12 1797'.
 Details Cu, 26.7mm, 6.35g, pierced for
 suspension.

266 **Obv.** 'J·D', with crude flower above, heart
 and simple wreath below.
 Rev. 'W∗T', above heart and simple wreath.
 Details Cu, 27.3mm, 8.61g.

262

263

264

265

266

267 **Obv.** 'John Burges'.
Rev. 'Sabridgeworth Herts'.
Details Cu, 27.4mm, 8.06g.
Host UK, 1/2d, 1719–24.

268 **Obv.** 'S H P' around naval bust
facing right.
Rev. Four-storey building with
central tower on shaded ground.
Details Cu, 36.0mm, 18.11g.
Ref. Maidment

269 **Obv.** 'JT DIED Jan 21 1829' on fallen
memorial. Willow tree to right, hilly
scene in background.
Rev. Original coin.
Details Cu, 33.8mm, 14.99g.
Host UK, 1d, 1806.
Ref. Dyer

270 **Obv.** 'Curtis, Reigate,'.
Rev. 'CARPENTER TURNER &c'
in banner that makes the shape of a
swan facing left.
Details Cu, 26.8mm, 6.24g.

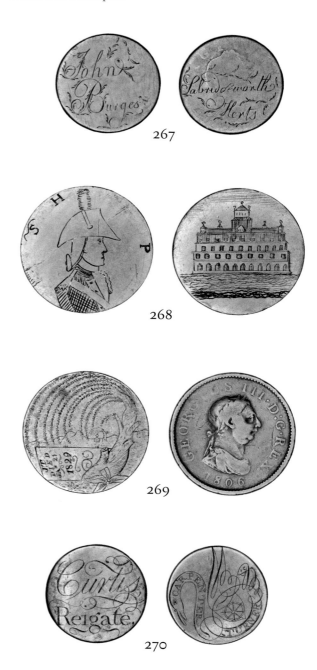

267

268

269

270

271 **Obv.** 'Sarah Weaver 1764 [JW]' within a
floral design.
Rev. Smooth surface, possible faint
trace of silhouette.
Details Cu, 27.4mm, 6.14g.

271

272 **Obv.** '[IT]', within beaded border.
Rev. '[LL]'.
Details Cu, 27mm, 7.14g.

272

273 **Obv.** 'Joseph, Till, March, ye 2[5]th,
1736'
Rev. Man sitting in chair blowing
a horn in his left hand, staff in his right,
sword on belt. Chequered floor.
Details Cu, 28.6mm, 8.81g

273

274 **Obv.** 'Agness Gorden aged 16 years
the 11 of July 1797', within geometric
border.
Rev. Two hearts pierced, bird with
sprig in beak. Ornate border.
Details Cu, 32.6mm, 21.84g.
Host UK, 1d token, 1787–91.
Ref. Dyer

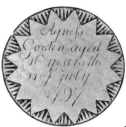

274

275 **Obv.** Wheatsheaf on a signboard (?), sickle above. Border.
 Rev. 'JW', either side of a man carrying a cylinder (barrel, dustbin?) on shoulder. Ornate border.
 Details Cu, 27.6mm, 7.61g.

276 **Obv.** 'SARAH WOTTAN FORGET ME.NOT AD 22', with a small flower motif.
 Rev. 'CHRISTOPHER . AD . 22' around 'HARRISS', and a small flower motif.
 Details Cu, 35.9mm, 23.77g.

277 **Obv.** 'The Fate of FAUNTLEROY to all the Bilking East India Agents'
 Rev. Original worn coin.
 Details Cu, 35.8mm, 26.5g, pierced for suspension.
 Host UK, 1d, 1797.
 Ref. Poole, Dyer, Millett

278 **Obv.** 'IB JW', pierced heart dividing '1795', and bow below.
 Rev. Original very worn coin.
 Details Ar, 32.9mm, 12.86g.
 Host UK, 2/6, 1696–1701.

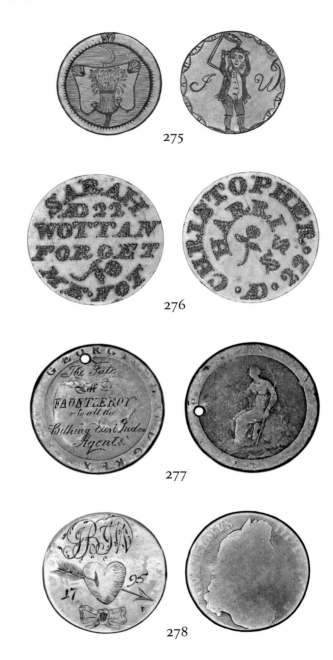

275

276

277

278

279 **Obv.** 'Willm. Lycken'.
Rev. '1st June 1788'.
Details Cu, 26.5mm, 7.74g, edge raised and modified.
Host UK, 1/2d, 1740–54.

280 **Obv.** Two hearts containing 'W' and 'R' with crossed arrows below, two birds above. Border.
Rev. Man standing facing left with gun at shoulder. Dog reaching up, birds flying around edge, tree to right.
Details Cu, 36.0mm, 25.55g.

281 **Obv.** 'CB ANNO 1787', in exergue. Empty chair, brushes above and either side. Border.
Rev. Shield with arms comprising two trees, bird above. Crown above, foliate garniture around. Concentric border.
Details Ar, 41.4mm, 26.82g.

282 **Obv.** '.R.L..N.L..1835.' with letter 'N' retrograde.
Rev. Original worn coin.
Details Cu, 35.9mm, 26.22g.
Host UK, 1d, 1797.
Ref. Dyer, Millett

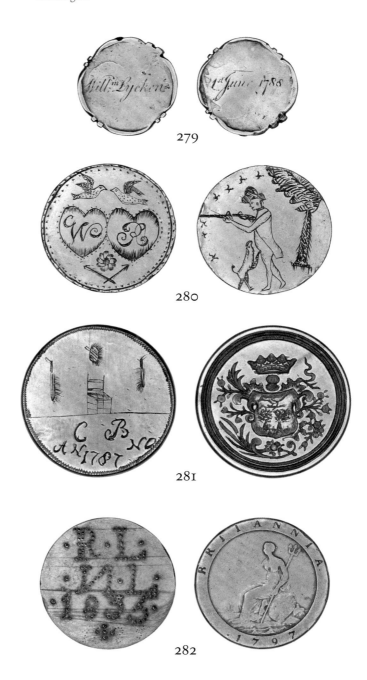

279

280

281

282

283 **Obv.** All retrograde: 'S. Eddy' in centre, with 'Portrait Painter & Gives instructions in drawing on Resenable Termes'.
Rev. Original worn coin.
Details Cu, 35.8mm, 25.69g.
Host UK, 1d, 1797.

284 **Obv.** 'John Horn Born Jany 14 1788', with geometric border.
Rev. Original coin.
Details Cu, 40.9mm, 54g.
Host UK, 2d, 1797.
Ref. Dyer

285 **Obv.** 'RECEPTION OF THE ARCHBISHOP 1791', with border.
Rev. Smooth surface.
Details Ar, 34.6mm, 5.93g, pierced for suspension.

286 **Obv.** Portrait of Prince Regent (George IV), facing, with medal and Garter Star. Shaded effect.
Rev. Hatched surface.
Details Cu, 35.7 × 30.2mm, 8.94g.
Host UK, 1/2d, 1806–07.

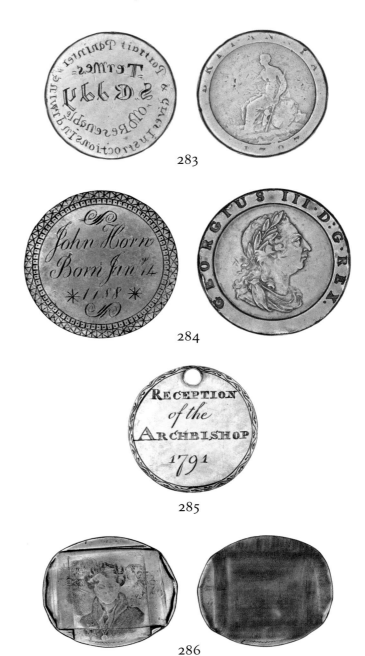

283

284

285

286

287 **Obv.** 'WHEN THIS YOU SEE.
REMEMBER.ME.AND.BEAR. ME
IN.YOUR.MIND NOT.TO
Rev. FORGET.YOUR.ABSENT.
FRIEND.NOW.HE.IS.CLOSE
CONFIN.D MK EG'.
Details Cu, 35.7mm, 24.01g.

288 **Obv.** 'J.P E.P 1824' around two
hearts doubly pierced.
Rev. 'A TOKEN OF LOVE' around
two doves holding a letter in their
beaks.
Details Cu, 35.6mm, 22.52g.

289 **Obv.** 'Confined within strong walls.
Convicted by perjury and when im
in a foreign'.
Rev. 'land dear friends Remember
me. Robert Hartless. Aged, 41, 1839
prepare to meet thy god'.
Details Cu, 35.7mm, 23.28g.
Ref. Dyer

290 **Obv.** 'One of three coins found in a
Cabinet of the late Lord Nelson on
board HMS Victory'.
Rev. Original very worn coin.
Details Cu, 35.5mm, 25.68g.
Host UK, 1d, 1797.

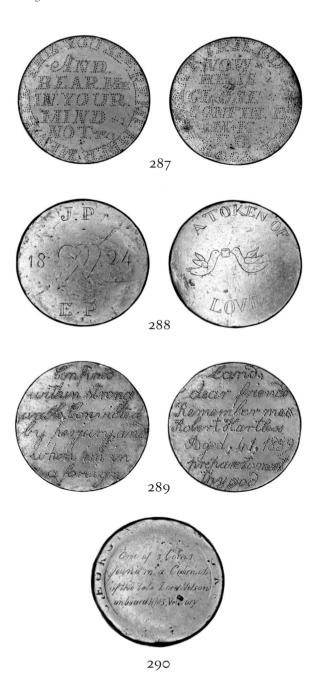

287

288

289

290

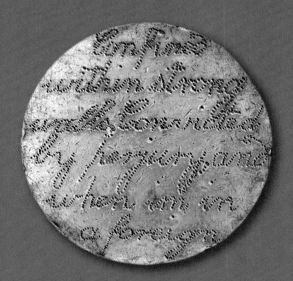
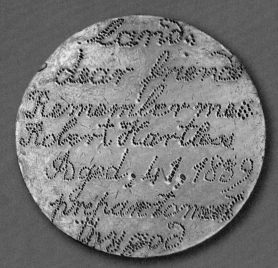

#289

Robert Hartless was probably transported twice. In January 1820 he was convicted at the Leicester Borough Quarter Sessions of receiving stolen goods. He was sent to the prison hulk *Justicia*, moored at Woolwich, and sailed on the *Shipley* to Tasmania, arriving in September 1820.

A record made on the *Shipley* described Hartless as a native of Leicester, a wool comber and sorter, 22 years of age; 5ft 4 inches tall, dark ruddy complexion, black hair and dark eyes. He received his Ticket of Leave in 1829 and Certificate of Freedom in 1834. Anne Hartless was born on 13 February 1830 to Robert and Susanna Hartless, at Green Ponds (now Kempton), Tasmania.

Then, in March 1839, the year this token was made, Robert Hartless, 45, was convicted at the Leicester Quarter Sessions of stealing wool and sentenced to transportation for life. This time he went to the prison hulk *Fortitude*, where he was described as a wool sorter, widowed, able to read and write, and of 'character v bad… transported before'. In December 1839 he arrived in New South Wales on board the *Barrosa*.

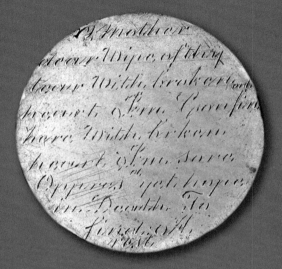
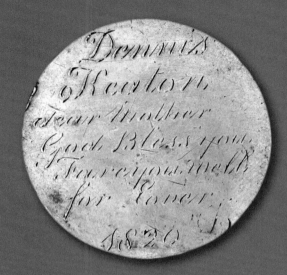

#296

Dennis Keaton was hanged at Newgate prison on 29 March 1820 for the crime of 'uttering' or passing forged banknotes.

In Autumn 1819, Edward Voss (18) and Dennis Keaton (17) went on a spending spree around London and its environs, including Hampton, Ilford, Stratford Green, Plaistow and Limehouse. Voss dressed as a naval officer and 'the boy' Keaton acted as his servant. They were finally arrested at the Three Daws in Gravesend. At their trial an inspector from the Bank of England identified 17 forged notes passed by the pair.

#314

William Fegen, aged 29, was sentenced to seven years' transportation at the Warwick Borough Sessions in January 1842, for theft from a dwelling house.

On the prison hulk *York*, moored at Gosport, he was described as a painter and glazier. In October 1842 he was sent to Gibraltar on the *Owen Glendower* which served as a hulk with the prisoners labouring on dockyard construction.

291 **Obv.** 'JUNE 14th 1833', above woman dressed in gown and hat, facing man in tall hat, holding hands. 'E.S. & G.S.' below.
Rev. 'When this You see Remember me When I am far AWAY'
Details Cu, 35.8mm, 23.91g, attempted piercing on obverse.

292 **Obv.** 'Dear Sister keep this in Remembr-ance of me'
Rev. 'Edward Cowell A 18 Sentenced 7 years 1838 July 2nd'
Details Cu, 35.7mm, 23.51g.
Ref. Dyer, Lloyd

293 **Obv.** 'Charles Mance Aged 21 Years', with feather and sunburst filler design.
Rev. 'There's something awful in the word Adieu When breath'd to those that I do love so true', with feather filler design.
Details Cu, 35.9mm, 23.78g

294 **Obv.** 'WILLIAM TOUNG & ELZABETH CHETHAM' around two hearts doubly pierced, bowl of fruit above; two birds with sprigs below. Ornate border.
Rev. 'The World his Whide for Me to range, I love my choise To well to change', heart and wreath below, ornate border.
Details Cu, 35.8mm, 22.26g.

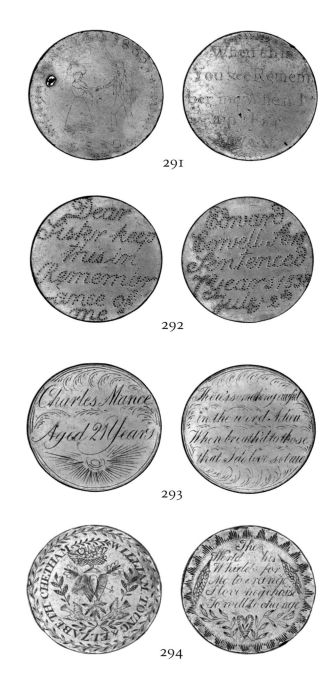

291

292

293

294

295 **Obv.** '[…]' around man [with a pipe in his right hand, tankard of foaming beer in left]. Small hearts at either side of feet.
Rev. 'WHEN THIS YOU SEE REMEMBER ME WHEN I AM FAR AWAY'.
Details Cu, 35.8mm, 23.93g.

296 **Obv.** 'Dennis Keaton dear mother God Bless you Fare you well for Ever 1820'.
Rev. 'Mother dear wipe of thy tear With broken heart I'm confin here. With broken heart I'm sore Oppresd yet [hope] in Death. To find [A] rest'.
Details Cu, 35.9mm, 23.97g.

297 **Obv.** 'GEORGE YOUNGS NICHOLS FORGET.ME NOT.NORWICH'.
Rev. 'LOVE.LIBERTY and FRIENDSHIP' around a large crown.
Details Cu, 35.8mm, 24.24g, pierced with a square hole.

298 **Obv.** 'CL when this you see think on me'.
Rev. 'until I get my liberty WF 1830'.
Details Cu, 35.9mm, 23.87g.

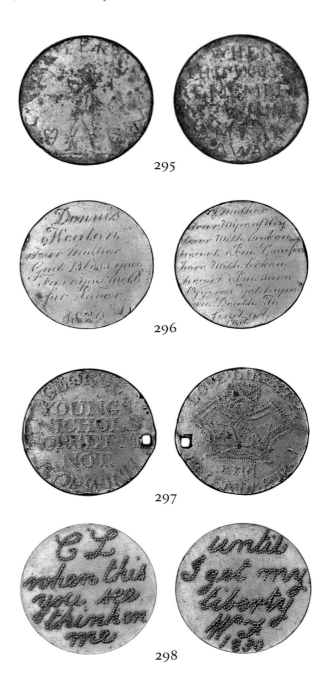

295

296

297

298

299 **Obv.** 'ML when this you see think on me'.
Rev. until I get my liberty WF 1830'.
Details Cu, 35.8mm, 24.85g.

300 **Obv.** Original coin.
Rev. Original coin.
Edge 'H: NORMAN BORN 27 SEP: 1777'.
Details Cu, 24.9mm, 9.30g.
Host UK, 1/2d, 1772, edge raised and engraved.
Ref. Dyer

301 **Obv.** 'RENTER WARDEN'.
Rev. 'SEAL'.
Details Cu, 27.8mm, 7.32g, pierced for suspension.
Ref. Lloyd

302 **Obv.** 'RENTER WARDEN'.
Rev. 'SILVER BRANCHES'.
Details Cu, 28.2mm, 6.97g, pierced for suspension.
Ref. Lloyd

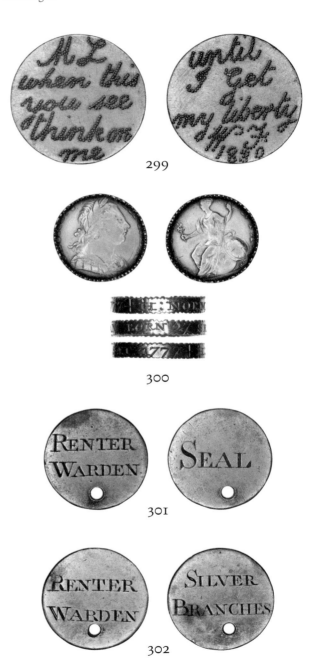

299

300

301

302

303 **Obv.** 'Blunt. Operator for the Teeth and Bleeder Great Windmill Street near Brewer Street Golden Square'.
Rev. Smooth surface with a few scratches.
Details Cu, 27.4mm, 6.74g.

304 **Obv.** 'Blunt. Operator for the Teeth and Bleeder Great Windmill Street near the Haymarket London'.
Rev. Smooth surface.
Details Cu, 27.8mm, 7.48g.

305 **Obv.** 'Blunt. Operator for the Teeth and Bleeder Great Windmill Street near Brewer Street Golden Square'
Rev. Smooth surface.
Details Cu, 27.4mm, 7.03g.

306 **Obv.** 'HENRY SAVORY BORN 3 MAY 1786' around HS in ornate design. Whole design in relief, infilled with black Japanning.
Rev. Outer rim and legend removed. Central dimple from lathe centre used to remove outer rim and legend.
Details Cu, 35.9mm, 24.22g.
Host UK, 1d, 1797.

307 **Obv.** 'MARY SAVORY BORN 3 JUNE 1781', intertwined snaking legend 'THE NOBLEST ORNAMENT OF HUMANKIND, VIRTUE'S THE CHIEFEST BEAUTY OF THE MIND' around 'MS' with whole design in relief, infilled with black Japanning.
Rev. Original coin.
Details Cu, 35.8mm, 25.49g.
Host UK, 1d, 1797.

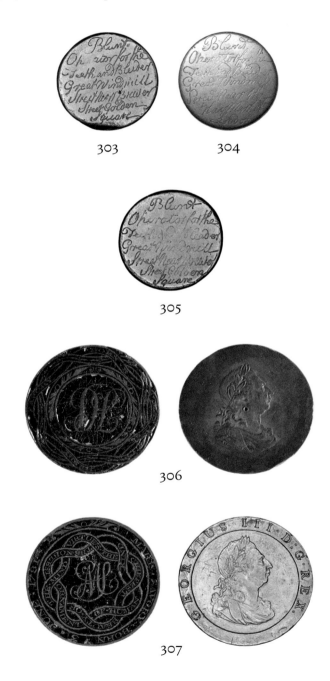

303 304

305

306

307

308 **Obv.** 'William Pritchett to Caroline Hens age 20 1833', above two hearts doubly pierced.
Rev. 'When this you se remember me and bear me in your mind let all the world say what they will don't prove to me unkind'.
Details Cu, 35.8mm, 24.58g.

309 **Obv.** '[…] Small a loving heart is worth it all Thos Dunn aged 38 Elizabeth Dunn age 38', with a cup, pipe and heart below.
Rev. 'Dear Wife Kindly take this gift of mine. the gift I give and hope is thine although I value it', with hatched area below.
Details Cu, 35.7mm, 24.16g.

310 **Obv.** 'Willm Bower Chesterfield 1793' with small decorative stars.
Rev. 'When this you see Remember me *H*B*' with 'I*M' in exergue.
Details Cu, 33.6mm, 26.61g.
Host UK, 1d token, 1787–91.

311 **Obv.** 'J[…] Wood[…]ar Was Transported For Life April 5 1834'.
Rev. Original coin with pricked surface.
Details Cu, 34.0mm, 15.76g.
Host UK, 1d, 1806.
Ref. Dyer

308

309

310

311

312 **Obv.** 'WHEN THIS YOU SE
REMEMBER.ME.WHEN.I.AM.
FAR.AWAY', within crude wreath.
Rev. 'GA TO MA 1827', around a
double-pierced heart.
Details Cu, 35.9mm, 25.12g, pierced
for suspension.

313 **Obv.** 'T. curey When this You se
rmember me when I am Far awaY
G. Buros'
Rev. Original worn coin.
Details Cu, 35.9mm, 25.58g.
Host UK, 1d, 1797.

314 **Obv.** 'the 73 Ridgment the Sawsey
green as pitty a One as ever was
Seen we Beat them in the art of
Driling and allways'
Rev. 'game to Spend A Shilling.
Wm Fegen Transpoted 7 years Jany
6 1842'
Details Cu, 35.8mm, 23.9g.
Ref. Dyer

315 **Obv.** 'Peter Hart Aged 22 1833
transported for [7] years August 7
1833', leafy design.
Rev. 'When this you see rember me
& bear me in your mind let all the
world say wat they will dont prove
to me unkind'
Details Cu, 34.1mm, 16.08g, pierced
for suspension.
Ref. Dyer

312

313

314

315

Index

Index of tokens

A note on the Collection Highlights

Timothy Millett selected the Collection Highlights for their historical interest and visual impact. In many cases, it was possible to discover the circumstances in which specific coins were engraved and the histories of those named on them. Those details are captured in short notes accompanying an enlarged image. Unless attributed to a single author, these descriptions were produced collaboratively by Barbara Abbs, Timothy Millett and Sarah Lloyd.

Research on the Collection Highlights drew heavily on the resources listed below. Individual notes reference any significant additional sources of information.

Sources

Oxford English Dictionary Online
https://www.oed.com/

Oxford Dictionary of National Biography
https://www.oxforddnb.com/

The Digital Panopticon: Tracing London Convicts in Britain and Australia, 1780–1925 https://www.digitalpanopticon.org/ (which links to several commercial, subscription genealogical databases)

London Lives, 1690 to 1800 https://www.londonlives.org/

Old Bailey Proceedings online: The Proceedings of the Old Bailey, London's Central Criminal Court, 1674 to 1913 https://www.oldbaileyonline.org/

National Museum of Australia, Collection of Convict Love Tokens http://www.love-tokens.nma.gov.au/

Convict Records of Australia https://convictrecords.com.au/

State Records and Archives, New South Wales, Convicts Index https://www.records.nsw.gov.au/archives/collections-and-research/guides-and-indexes/convicts-index

Libraries Tasmania https://libraries.tas.gov.au/archive-heritage/guides-records

British History Online https://www.british-history.ac.uk/

The National Archives; some of the following are available online via subscription genealogical databases: Prisons HO8; Letter Books HO9.

Lloyd's Register of Ships https://hec.lrfoundation.org.uk/archive-library/lloyds-register-of-ships-online/

The British Newspaper Archive https://www.britishnewspaperarchive.co.uk/

Photographic credits

All photos by Dave Cousins, copyright Timothy Millett, except p. 48: image courtesy Dix Noonan Webb Ltd; *p. 100:* photo Wiltshire Museum, Devises; *p. 100:* photo Dave Cousins; *p. 104, fig. 3:* British Museum, 1613421398; *fig. 4:* Jack Relph; *fig. 5:* Geoff Harris; *p. 110:* photo Jason McCarthy, National Museum of Australia; *p. 236:* photo Gary Oddie; *p. 157, fig. 5:* © Sir John Soane's Museum, London; *p. 159, fig. 6:* © Royal Academy of the Arts London; *p. 160, fig. 7:* London Metropolitan Archives

First published 2022

Text © the authors 2022

All rights reserved

No part of this book may be reproduced, stored in a retrieval system, or transmitted
in any form or by any means, electronic, mechanical, photocopying, recording, or
otherwise, without the written permission of the publisher, except for the purpose of
research or private study, or criticism or review.

ISBN 978-1-911300-94-6

British Library Catalogue in Publishing Data

A CIP record of this publication is available from the British Library

Produced by Paul Holberton Publishing, London

paulholberton.com

Designed by Paul Sloman

Printed by Gomer Press, Llandysul

Front cover and frontispiece:
Tokens from Timothy Millett's collection. Photo Dave Cousins

Back cover:
Coin #254, obverse